50 Fast Digital Photo Techniques

GREGORY GEORGES

50 FAST
DIGITAL PHOTO
TECHNIQUES

Hungry Minds™

Best-Selling Books • Digital Downloads • e-Books • Answer Networks • e-Newsletters • Branded Web Sites • e-Learning
New York, NY ◆ Cleveland, OH ◆ Indianapolis, IN

50 Fast Digital Photo Techniques

Published by
Hungry Minds, Inc.
909 Third Avenue
New York, NY 10022
www.hungryminds.com

Library of Congress Control Number: 2001090627

ISBN: 0764535781

Printed in the United States of America

10 9 8 7 6 5 4

1V/SR/QW/QR/IN

Distributed in the United States by Hungry Minds, Inc.

Distributed by CDG Books Canada Inc. for Canada; by Transworld Publishers Limited in the United Kingdom; by IDG Norge Books for Norway; by IDG Sweden Books for Sweden; by IDG Books Australia Publishing Corporation Pty. Ltd. for Australia and New Zealand; by TransQuest Publishers Pte Ltd. for Singapore, Malaysia, Thailand, Indonesia, and Hong Kong; by Gotop Information Inc. for Taiwan; by ICG Muse, Inc. for Japan; by Intersoft for South Africa; by Eyrolles for France; by International Thomson Publishing for Germany, Austria, and Switzerland; by Distribuidora Cuspide for Argentina; by LR International for Brazil; by Galileo Libros for Chile; by Ediciones ZETA S.C.R. Ltda. for Peru; by WS Computer Publishing Corporation, Inc., for the Philippines; by Contemporanea de Ediciones for Venezuela; by Express Computer Distributors for the Caribbean and West Indies; by Micronesia Media Distributor, Inc. for Micronesia; by Chips Computadoras S.A. de C.V. for Mexico; by Editorial Norma de Panama S.A. for Panama; by American Bookshops for Finland.

For general information on Hungry Minds' products and services please contact our Customer Care department within the U.S. at 800-762-2974, outside the U.S. at 317-572-3993 or fax 317-572-4002.

For sales inquiries and reseller information, including discounts, premium and bulk quantity sales, and foreign-language translations, please contact our Customer Care department at 800-434-3422, fax 317-572-4002 or write to Hungry Minds, Inc., Attn: Customer Care Department, 10475 Crosspoint Boulevard, Indianapolis, IN 46256.

For information on licensing foreign or domestic rights, please contact our Sub-Rights Customer Care department at 212-884-5000.

For information on using Hungry Minds' products and services in the classroom or for ordering examination copies, please contact our Educational Sales department at 800-434-2086 or fax 317-572-4005.

For press review copies, author interviews, or other publicity information, please contact our Public Relations department at 317-572-3168 or fax 317-572-4168.

For authorization to photocopy items for corporate, personal, or educational use, please contact Copyright Clearance Center, 222 Rosewood Drive, Danvers, MA 01923, or fax 978-750-4470.

 is a trademark of
Hungry Minds, Inc.

To my wife Linda. While I often take her for granted, I never forget that she is my never-ending source of support, encouragement, and happiness. I am so very fortunate to have her as my travel partner for our extraordinary trip through life. Together we have been to so many places and seen so much worth photographing — and we have photographs to prove it!

FOREWORD

Since the advent of the personal computer revolution, PCs have become a common and powerful tool of our everyday lives. In the early days, home computers were used mainly for word processing, accounting, and games. By the late-1990s, their use had expanded to include email and Web surfing.

Now another revolution is taking place, fueled by the affordability of high-quality digital cameras and scanners. A home computer hobbyist user can now perform simple and sophisticated image processing, producing photo-quality output from a home printer or over the Internet.

Adobe Systems pioneered professional image processing with Adobe Photoshop, which today remains the industry standard tool for anyone working in digital photography, fine art, commercial art, and web graphics. With digital cameras and scanners selling at a rate of more than 10,000 a day, it became apparent that not everyone obtaining these devices is an imaging professional. Ease of use and technique guidance became larger issues, and thus Adobe Photoshop Elements was designed.

Adobe Photoshop Elements is intended for the new generation of digital photo users, offering features designed specifically for amateur photographers, hobbyists, and businesspeople who want an easy-to-use yet powerful digital imaging solution.

50 Fast Digital Photo Techniques is the perfect step-by-step guide for anyone seeking straightforward, clear techniques for impressive fine-art photo effects. The initial chapters cover the basics that are the foundation to anyone doing image processing—amateurs and professionals alike. The subsequent chapters gradually rise in level of techniques explored, introducing the user to even more creative effects. Yet, regardless of sophistication, the techniques from the front to the back of the book are uniformly accessible, *and* they're illustrated with the author's own beautiful photography (included on the accompanying CD-ROM, along with a tryout for Photoshop Elements).

Since Photoshop Elements and *50 Fast Digital Photo Techniques* share ease-of-use *and* power, I'm confident that you'll enjoy both products.

Cris Rys
Engineering Manager, Adobe Photoshop Elements
Adobe Systems, Inc.

PREFACE

This book is named *Fifty Fast Digital Photo Techniques* — it presents fifty relatively simple, yet useful, digital photo techniques that can be done *quickly.* While the fifty techniques use Photoshop Elements, most of the techniques can be used with any of the more advanced image editors such as: Adobe Photoshop (Versions 4, 5, 5.5, and 6), Adobe Photoshop LE, Corel PHOTO-PAINT, Corel Painter, Jasc Software Paint Shop Pro, or Ulead Systems PhotoImpact.

This book is for any one who shoots pictures with a digital camera, uses a scanner to scan film or photographs, or gets digital images from a local or online photofinisher. It is for those who want to make the best possible images for printing or for sharing online. This book is for those with or without a photo-quality printer. It is for those who want to post digital photos to a Web page or want to share their digital photos via e-mail. It is for beginning through advanced digital imagers. This book is for those who want to create fine-art prints suitable for selling in a gallery. It is for you — whether you want to create personal images or business images.

WHY THIS BOOK WAS WRITTEN

When I first began using digital image editors, I quickly became astounded at how powerful they were and how many things could be done with them. Sadly, though, I also became aware of how long it took to get a good understanding of what all the filters, commands, and tools were capable of doing. The learning curve was way too steep and too time-consuming; yet, I really wanted to obtain the incredible results these tools were capable of providing.

After deciding I needed lots of help, I did what most people in my situation do. I visited local bookstores and looked for books that would help me learn how to do all the things that I wanted to do. Although I found many books, nearly all of the available books were not much more than equivalent versions of a user manual. The books methodically cover each and every menu item, tool, and feature ad nauseam.

Admittedly, much of the content was good to know, but all the books lacked the crucial element I was looking for — step-by-step techniques for doing real-world things. When I then turned to the Internet, I found hundreds of "Photoshop" technique sites. Initially, I

was excited at how many sites the search engines returned. Before long, I couldn't tolerate looking at another site showing how to make rusted metal, drop shadows, neon-lit text, rounded pipes, or similar techniques. After several years of unsuccessful searching for a good source of useful techniques, I decided that *I* would write a book on fifty useful techniques. This is the book that I wished I had a few years back, and I hope this is the book *you* are looking for now.

THIS BOOK IS NOT LIKE MOST OTHER "PHOTOSHOP" TECHNIQUE BOOKS

Although many Photoshop or digital image editor books are available, they typically have anywhere from 250 pages to over 1,200 pages. Yet, the number of actual usable step-by-step techniques you find in these books is minimal. When sitting down to edit a digital photo, I usually want to do something specific to it. For example, I may want to turn a digital photo into a watercolor painting, or into a line drawing. Perhaps my goal may be to radically change the color, or even make a hand-colored black and white print. Most other "Photoshop" technique books offer very few such practical and usable techniques.

In contrast, this book offers the following:

- Fifty fast step-by-step techniques for your digital photos
- Thirty-two pages of color "before" and "after" images
- Over 100 full-sized, unedited "royalty-free" original digital photos created from a variety of digital cameras and scanners
- Over a dozen in-depth "feature" discussions
- Special text formatting that allows you to read just the actions needed to complete the technique without having to read all the other informative text, thereby enabling you to complete each technique quickly
- Over 250 figures, including screen-shots
- Image Editor Feature Translation Tables that list blend modes, menu commands, palettes, and tools to help readers use any one of the six leading image editors and successfully complete most of the fifty techniques
- A companion CD-ROM that includes 30-day try-out versions of Adobe Photoshop Elements, Jasc Software Paint Shop Pro, and Ulead Systems PhotoImpact
- Internet browser-based slide show presenting all fifty "before" and "after" images
- A companion Web site (`www.reallyusefulpage/50techniques`) where you may get online updates or corrections, find digital photo resources, and submit your work for possible inclusion in an online Readers' Gallery
- An author-moderated online forum for discussing techniques and sharing tips with other readers to further advance your image editing knowledge
- An ICQ pager number for occasional online "chats" with the author of the book via ICQ Instant Messenger

WHY YOU MAY WANT TO USE A DIGITAL IMAGE EDITOR

No matter how you get your digital photos (scanner, digital camera, scanning service company, or from a friend or business colleague), chances are good that your photos can be improved. Common problems fixed with an image editor include: color cast problems, under- and over-exposure, tilt, and even lack of sharpness.

Besides "fixing" your photos, an image editor will also allow you to apply a variety of effects to transform your digital photos. An image editor is also useful for preparing your digital photos to be used online on a Web page or as an attachment to an e-mail.

The more things you learn to do to your images, the more you'll find uses for them. For example: print photos on T-shirts, make greeting cards, add images to a newsletter, put images on Web pages, send electronic postcards featuring digital photos, or make a fine-art print suitable for hanging on a wall.

WHAT COMPUTER HARDWARE AND SOFTWARE WILL YOU NEED?

When it comes to digital image editing, the axiom "the more the better" applies. Digital image editing is an activity that will consume lots of disk space, RAM, monitor pixels, and computer processing cycles. Fortunately, powerful computers with lots of RAM, enormous hard drives, and large monitors are getting less and less expensive. At a minimum, you'll need a computer that meets the requirements specified by Adobe for use of Photoshop Elements, or as specified by the vendor of your image editor if you are using an image editor other than Elements. Adobe recommends the following requirements for Windows:

- Pentium II or faster Intel processor
- Microsoft Windows 98, Windows 98 Second Edition, Windows Millennium Edition, Windows 2000, or Windows NT 4.0 (requires Service Pack 4, 5, or 6a and Internet Explorer 4.0, 5.0, or 5.5)
- 64 MB of RAM
- 130 MB available hard-disk space
- Color monitor capable of displaying thousands of colors
- CD-ROM drive

For Macintosh, Adobe recommends the following:

- PowerPC processor
- Mac OS software version 8.6, 8.7, 9.0, 9.0.4, or 9.1
- 64 MB of RAM
- 130 MB of available hard-disk space
- Color monitor capable of displaying thousands of colors
- CD-ROM drive

If you use a computer that matches these minimum requirements, you may find you'll enjoy trying the techniques in this book much more if you have 128MB or more of RAM, and 500MB or more of available disk space. The cost of adding additional RAM or adding an additional hard drive can be relatively low in today's competitive computer marketplace. A 30-gigabyte hard drive sells for under $130, and depending on the type of RAM you need, you can buy 128MB of RAM for as little as $100.

To determine if you need more RAM, listen to your hard drive when editing an image. If you can hear it being used, then you know that there is not enough RAM as the image is being shuffled back and forth between RAM and the hard drive. Your RAM requirements will be roughly three to five times the size of the largest images that you edit. This is in addition to the RAM required for your operating system and image editor. Just as very, very rough examples, you can get by with 64-96MB RAM if you're editing digital camera images for use on the Web, while you'll probably want 256MB RAM or more if you're working with large images that will be printed as 8" x 10" prints on an inkjet printer.

If you have a relatively slow processor, adding additional RAM can significantly increase the processing speed and hence help you to avoid the long waits that can occur when digitally editing images *if* you currently do not have sufficient RAM. If you spend much time editing digital photos, you'll find the investment to be more than worthwhile.

Once you have a fast computer with enough RAM and hard drive space, you will find a re-writable CD-ROM drive to be one of the most useful (and in my view essential) peripherals for those doing digital image editing. A re-writable CD-ROM drive allows you to easily back-up your digital photos, to share them with others, and to make space on your hard-drive. Re-writable CD-ROM drives can be purchased for under $150. Remember that when you begin to store your digital photo collection on your computer hard drive it is, possible to lose everything if you have problems with your hard drive. If you value your digital photos, you need to back them up to a removable storage device of some type such as a CD-ROM.

The monitor and graphics card you use is also very important to successful and enjoyable image editing. If you primarily work with images that are 1,600 x 1,200 pixels or smaller, you may find it acceptable (or possibly not) to work on a 14" or 15" monitor with 800 x 600 pixels. If you are working on larger images, you'll find that a 17" or larger monitor with at least a 1,024 x 768 pixel workspace to be far more useful. Although there are larger monitors than 19" monitors, I have been extremely happy with the 19" monitor that I use. It is big, but not too big, and that is good because I still have some desk space left.

Surprisingly, a photographic-quality printer may be the least necessary peripheral in your digital darkroom, even if it is the most fun. You may think I am kidding! Nevertheless, there are two increasingly viable alternatives to having a photographic-quality printer of your own. First, you can complete all your image editing and write your images to a CD-ROM. A fast-growing number of photographic service businesses will take your CD-ROM and create excellent prints for you. An even better approach is to use one of the many online digital photo-processing services. If you have a high-speed connection to the Internet, you can

upload large digital files to one of the many online photofinishers. They will then print your photos and mail them back to you within a few days. Some of these digital photofinishers (not all of them) make quite good prints for very little money. In fact, some of them will print your images and post them to an Internet site for you, for the price of shipping and handling.

If you were reading carefully, you will have noticed that I did say this: you *may* not need a photographic-quality printer, but having one of your own will possibly make your work far more fun and enjoyable. Although I do use online services, I can't imagine not having my own printer. The good news is that some of the best photographic-quality printers cost as little as $300 to $500.

Oh yes, for those of you that might want to ask the question: Is it better to use a PC or a Mac? My answer is the computer that you have or know how to use is the better one. Without a doubt, there are differences between the two platforms, but there aren't any clear-cut reasons why the PC or the Mac is better at doing digital image editing. Therefore, have it your way and enjoy using the computer that you will be most comfortable and successful using — that will be the best one for *your* digital image editing.

NOTES TO MAC USERS

The great news for Mac users is that Adobe has historically offered both PC and Mac versions of all their products. The differences between the PC and Mac versions of Photoshop Elements are minimal. The Mac screen shots will look slightly different from the PC screen shots shown in this book. In addition, the two most often used keys on a PC's keyboard, Alt and Ctrl, have Option and Cmd keys for their equivalents on the Mac keyboard. Otherwise, there are not any significant differences you need to be concerned about. In short, this book is equally useful to PC and Mac users.

CONVENTIONS USED IN THIS BOOK

To make this book truly a book of fifty *fast* techniques, considerable effort and thought was put into the format so that each technique could be completed as quickly as possible, while still providing you with all the necessary content to help you understand what it is you are doing.

The first page of each technique shows "before" and "after" images and gives you details about the original photo(s.) The "About the photo" section like the one on this page gives you valuable information about the camera, the lens, and the film that was used, as well as how the image was digitized if the original photo was shot on film. It also provides information on the image file type and size.

The thirty-two-page color insert shows full-color "before" and "after" images for thirty-two techniques. Each page offers a technique title and a brief description of the technique. Each image has a color plate number such as CP 21.

ABOUT THE PHOTO

About the Photo: "Blue Heron Does Balancing Act IV," EOS1v, 300mm f/2.8, Kodak 100 ASA Supra negative film scanned with Polaroid SprintScan 4000, 1,600 x 2,400 pixel image size, 11.5MB .tif file.

Throughout the text, when an image is referenced as a **Figure**, and when that image is also shown in the color insert section, a color plate number will follow in parenthesis, which allows you to quickly locate the color image in the color insert section. In the following example, you will find **Figure 31.2** as a black and white image within a page of the figure reference, or you could turn to the color insert figure numbered "CP 35" and view the color image.

■ The final image shown in **Figure 31.2 (CP 35)** looks . . .

As you go through the techniques, you'll find that each technique has numbered steps with headings telling you exactly what you will accomplish in each step. All "actions" (steps you must take) are shown in bold type, indicating they are things that you need to choose, type, press, click, or do.

A step may have substeps to make the step easier to follow. Any informative content that does not include things that the reader must do is not indented.

Each time a command, menu, or tool needs to be selected and there is a shortcut for it, the PC shortcut will be shown in parenthesis immediately following the bold type. For example, the shortcut for the following command would be to press the **L** key while holding down the **Ctrl** key. Alternatively, you could choose **Enhance**, then **Brightness/ Contrast**, and finally the **Levels**.

■ Select **Enhance** ➢ **Brightness/Contrast** ➢ **Levels** (**Ctrl**+L) to get . . .

ACKNOWLEDGMENTS

Getting a quality book written, published, and into the hands of readers is no small task. While the author is often considered the main "creator" of a book, many other people have considerable involvement and provide significant contributions along the long and arduous path. It is only when everyone works together, putting his or her best talents and efforts forth, that a book idea can be transformed into a book that will be highly valued by readers.

In the case of this book, I have been fortunate and thankful to have the help and assistance of the following people.

Carole McClendon of Waterside Productions, my book agent who fine-tunes my ideas and keeps me in book contracts.

Mike Roney, Hungry Mind's Acquisition Editor who accepted my book proposal, added his own valuable ideas, and provided a steady stream of guidance throughout the writing and production process to help make it the book that it is.

Russell Williams, the Technical Editor, whose photographic expertise and intimate knowledge of Photoshop Elements helped to keep the contents accurate and each and every technique clear, efficient, and do-able.

Amanda Munz, the Project Editor, who was my everyday interface with the rest of the team. Her e-mail prodded me on when it was needed, and made me occasionally smile when that was needed. Most important, she managed all the "behind the scenes" stuff like development editing, technical editing, author review, and copyediting.

Robert Campbell, the Copy Editor, who made sure that my words made good sentences, that my sentences made good paragraphs, and ultimately that the text is clear and reads well.

Susan Doering, Product Manager at Adobe, who provided me all the information and support that I needed to write a book about Photoshop Elements.

Christie Evans, Associate Project Manager at Adobe who did a brilliant job of keeping me up-to-date with current beta releases of Photoshop Elements and for making sure that I got answers to questions when I needed them.

CONTENTS AT A GLANCE

CONTENTS

CHAPTER 1: CREATING A MASTER IMAGE 1

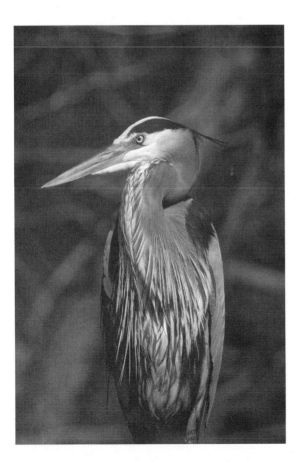

CHAPTER 2: QUICK AND EASY TECHNIQUES 35

CHAPTER 4: COMBINING TWO OR MORE IMAGES 83

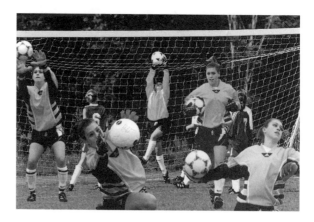

CHAPTER 5: TECHNIQUES FOR PEOPLE PICTURES 111

Syracuse Vs. NC State 54-53

CHAPTER 6: TRADITIONAL PHOTOGRAPHIC TECHNIQUES 139

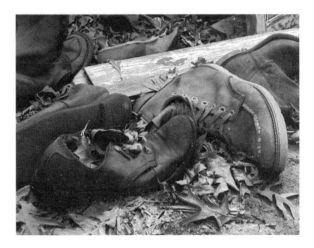

CHAPTER 7: NATURAL MEDIA TECHNIQUES 165

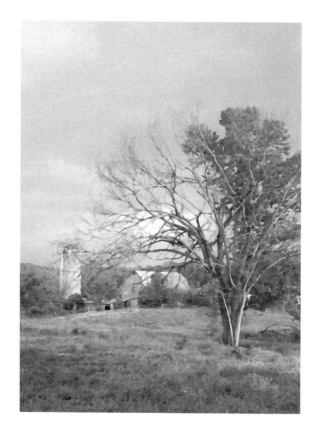

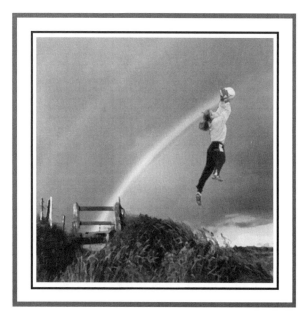

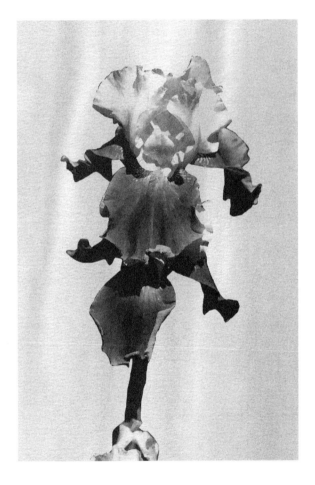

INTRODUCTION

Although it may be tempting to skip this Introduction and go directly to the techniques, you almost certainly will be better off by reading it before you begin the techniques. It offers valuable pointers that will help you throughout the fifty techniques and later when you begin creating your own techniques and working with your own digital photos.

WHAT IS A DIGITAL PHOTO?

Throughout the book, I have used the terms "digital photo" and "digital image" interchangeably, as they mean roughly the same thing. All digital photos are digital images, but not every digital image is a digital photo. Digital images can be created without the use of a camera, and hence it would be inappropriate to refer to them as digital photos.

A digital photo is any digital image that was in one way or another initially made with a camera, either a film camera or a digital camera. Negative and slide film, as well as photographic prints, can be scanned with a variety of scanners (for instance, flatbed, film, or drum) to make digital photos, which also may be referred to as digital images. The techniques in this book all require one or more digital photos, but it does not matter if they were initially taken with a film camera or a digital camera.

OVERVIEW OF THE TECHNIQUES

The fifty techniques in this book have been grouped into nine chapters. While it is possible to do the techniques in any order, I suggest that you complete all of the techniques in Chapter 1 first — especially if you are relatively new to digital image editing. Chapter 1 will help you learn how to create a *master image* — an image that is well-exposed, straightened, cropped and sized as desired, and otherwise ready to be used as intended. A master image is also frequently the starting point for many of the rest of the techniques in this book. The seven techniques in Chapter 1 also mirror the seven steps that you might take to make an image the best it can be.

Chapter 2 offers five techniques that are quick and easy, so that anyone can experience near-instant success (well, okay, within a few minutes anyway). You can do the techniques in the other seven chapters in any order that you'd like. They all are fast and fun, and they

are not progressive. In other words, it is not important that you complete one of the earlier chapters before one of the later chapters. Each technique largely stands on its own.

My bet is that you will know Photoshop Elements quite well by the time you have completed all the techniques. By then, you should be well on your way to becoming a master of the tool and able to create your own techniques and develop a style of your own.

WHAT DIGITAL IMAGE EDITOR SHOULD YOU USE?

All of the techniques in this book require an advanced image editor. By *advanced* I mean an image editor that offers considerable control over each of the effects, rather than a simple push button "apply the filter" kind of editor. It is also important that your image editor give you the ability to create, manage, and blend layers. The following six image editors match these criteria and can be used to complete most, but not all, of the fifty techniques, with the exception of Photoshop Elements, which can handle them all.

 Adobe Photoshop (Version 4, 5, 5.5, and 6)
 Adobe Photoshop LE
 Adobe Photoshop Elements
 Corel PHOTO-PAINT
 Jasc Software's Paint Shop Pro
 Ulead's PhotoImpact

Although any one of these image editors may be used, only one will enable you to carry out all fifty techniques — Photoshop Elements. Not only was this book written using Photoshop Elements, but Photoshop Elements offers a number of features that are not found in any of the other image editors, including Adobe Photoshop 6.

Photoshop Elements has a street price of $99, and Adobe offers a special upgrade price for owners of Adobe Photoshop LE. Adobe Photoshop LE would be the easiest editor to use to complete the techniques besides Photoshop Elements. However, be aware that there are some differences in the user interface (menu names, dialog boxes, and so on) between the two products. Photoshop LE also does not offer many significant new features, such as Photomerge, Save for Web, Picture Package, and Web Photo Gallery, that are in Photoshop Elements.

Adobe Photoshop 6 and earlier versions offer many features not found in Photoshop Elements, and vice versa. *Most*, but not all, of the techniques can be completed with any of the Adobe Photoshop versions, but there will be user interface differences that will make it more difficult to follow the step-by-step directions than if you used Photoshop Elements.

If you decide to use an image editor other than Photoshop Elements, you should be aware that there will be varying degrees of difference between what the technique requires you to do and how it can be done with your editor. Although Photoshop Elements offers features and capabilities that are not offered by other image editors, these other image

editors likewise have features and capabilities not offered by Photoshop Elements. Over the past five years, I have used all of the advanced image editors and have found that each one of them has strengths. In fact, I have been known to take one image and do a few things with one image editor, then to open it and perform a few things with one or more other editors. With this approach, you get to use the best features from all of them.

THINGS YOU OUGHT TO KNOW BEFORE BEGINNING THE TECHNIQUES

What should you know about your digital image editor before you begin these techniques? That is an excellent question, and it raises a serious philosophical question about teaching methods.

When I took my first watercolor painting class, the teacher did not methodically cover every aspect and feature of each and every tool, paint, and painting surface. Instead, we learned a few important basics, such as how to fill a brush with color, how to mix colors, how to hold the brush — then we began painting a painting. During the process of completing a few paintings, I learned all kinds of things about the paints, the brushes, the paper, and so on. The great thing about this approach was that it was fun, because I was completing a painting while learning the basics.

I believe that you can successfully learn how to use Photoshop Elements by just "digging in" and doing the techniques. By the time you have finished thirty or forty of them, you'll be on your way to becoming a successful user of the application. However, I think that you will probably even do better if you take some time to peruse the Photoshop Elements manual, online help, and the Hints palette. You should be ready to begin the techniques once you have a good understanding of the following topics, because these they are not covered in the techniques.

- Your computer's operating system file structure (that is, folders and files)
- How to get around the work area
- The toolbox
- Viewing modes
- The Navigator
- The tool options bar
- How to use shortcut keys
- How to use "undo" features
- How to create, merge, and manage layers
- How to select colors, gradients, and textures

If you are using an image editor other than Photoshop Elements, you will need to learn the same things about your image editor. With a clear understanding of these basics, you will have much more fun doing the techniques.

ABOUT THE IMAGES ON THE CD-ROM

Most of the "before" images on the CD-ROM are unedited digital photos. They have been created with a wide variety of scanners and digital cameras. They are provided in their original sizes and formats so that you can see first-hand what the files are like and how they can be edited, as well as the differences between them. For example, you'll learn the differences between the images created on a desktop scanner, a film scanner, a 1,600 x 1,200 pixel consumer-level digital camera, and a 3.25 megapixel professional-level digital camera.

The objective of most of the techniques this book, is to make a quality print on a 240 dpi photographic-quality inkjet printer. Consequently, the image files are large files, often 12MB or more. If you are working on a slow PC, or you find that you have memory limitations or screen desktop space limitations that prevent you from using these full-sized images, reduce the size of the image before beginning the technique. If you don't know how to reduce the size of an image, read Technique 1.

When you begin a technique, I suggest that you copy the entire technique folder from the companion CD-ROM to your hard drive. Not only will this make your work faster, but it will also allow you to keep organized folders of your work. If you have enough available hard drive space, you may want to copy the entire contents of the **\techniques** folder to your hard drive.

NINE THINGS TO CONSIDER BEFORE BEGINNING THE TECHNIQUES

This section includes nine valuable tips that will make your digital imaging more successful and just may save you from ruining a favorite digital photo.

1. DIGITAL PHOTO EDITING IS BOTH AN ART AND A SCIENCE

The highly complex mathematical engines that power digital image editors may make it seem like using one of them is more science than art. But that is not the case. The driving controls, or user interfaces, of these advanced image editors provide so many possible combinations and permutations of filters and commands that it makes these tools capable of creating an almost limitless variety of images. The more you use a product like Photoshop Elements, the more you will be amazed at what you can do.

Therefore, my claim is that using Photoshop Elements is more art than science! If you have ever painted with watercolors, you will know that some watercolor papers work better than others. You'll also know that some colors of watercolor paint blend differently with other colors. As you experiment more with watercolors, you will get many unexpected results — some of which will be wholly unacceptable and others will be very exciting. Using a digital image editor is very much like using a natural medium such as watercolor paints. The successful watercolor painter is one who works hard, thinks

creatively, and continually experiments with techniques, tools, and media. The successful digital photo editor does too!

One caveat is in order here. You may not like the settings I've chosen for these techniques. Remember, you have the control of the variables. If the settings that I have suggested don't match your taste, change them. Creating great digital images, like creating a fine art painting or fine art photograph, is a matter of the tastes of the creator *and* of the viewer.

By this time, you may have the notion that it will take lots of time and energy to master an image editor. Yes, it will, to *master* one; but this book is about doing fifty useful and *fast* techniques. Therefore, you are quite likely to find plenty of success no matter what goals you may have.

2. SOME TECHNIQUES WON'T WORK WELL ON SOME DIGITAL PHOTOS

Each digital photo has a number of key characteristics that may (or may not) make it possible to get good results when using one of the techniques in this book. Image size matters. Level of file compression matters. Image sharpness and contrast also usually matter. Depending on what you are trying to do and what filters, commands, or tools you are using, you will get varying results with different digital photos.

On lower-resolution images, many special effects filters, such as **Poster Edges** or **Watercolor,** will make details disappear entirely, whereas on high-resolution images, the effects may be so subtle as to be unnoticeable. Therefore, be aware that you may not get the results you want or expect when following techniques like those you will find in this book or when you use them on your own digital photos — they may be better, or they may be worse.

As you become more experienced with the many filters, tools, and commands, you will learn how you can compensate for such variables as image size, image contrast, or brightness. This is one of the reasons why this book includes such a wide range of images. You'll find small 50KB images suitable for use only online, 3MB images taken with a consumer-level digital camera, and large 8–14MB files that were created with a professional digital camera or a high-resolution film scanner.

An experiment worth trying is to take one of the larger images on the companion CD-ROM and apply a filter like the **Sumi-e** brush or **Dry Brush.** Then, reduce the image to a much smaller size that would be appropriate for use as an attachment to e-mail or for a Web page and study the difference. Then reduce the same large image, apply the same filters to the reduced image, and consider how it differs from the image that was filtered while full-sized.

The frequently used sharpen filters are also very susceptible to producing undesirable results when used on an image that is later resampled (enlarged or reduced). Image size really does matter.

For photo-realistic images, you usually get the best results working at the resolution of your original image (which should be high enough for your final planned use) and then down-sampling at the end for online use if necessary. For techniques involving artistic

filters, you may get better (or at least more dramatic) results by down-sampling to 100 dpi before applying the filter and then resampling back up to 300 dpi or so if you're going to print the image before proceeding with subsequent steps. This approach, too, will have its limitations. Any time you increase the size of an image by over 150 to 200 percent, you will begin to lose the clarity you had in the original image and you will begin to see pixelation, where there once was detail.

3. COLOR MANAGEMENT IS IMPORTANT

Some people are just not as picky about colors as I am. Others (like me) care a lot if there is even a tiny change from the desired color. Depending on where you fit in this spectrum, you may (or may not) want to spend time setting up your computer to properly manage color before doing the techniques in this book.

Color management is a process where all of your hardware is adjusted so that colors remain consistent everywhere, from your scanner or digital camera, to the computer screen, to your color printer. If you are *not* using color management and you adjust the controls on your computer monitor, you will see how substantially you can change colors. Now imagine how those colors might turn out on a color printer. Obviously, changing the colors on your monitor will have no effect whatsoever on the colors that will be printed on your printer. Yet, you'll make color changes to your digital photos in terms of what you see on the screen. Consequently, your prints may be printed in all kinds of unexpected colors. By contrast, when you use color management, the colors that you see on your monitor will closely match the colors that you will get from your printer, allowing you to get the colors from your printer that you see on your screen.

Another important point to make here is that I have created the images for this book using a color-managed workflow. Unless you use color management, you may not see the same colors I saw when creating the images. For this reason alone, I suggest you do two things. First turn on color management in Photoshop Elements by selecting **Edit ➤ Color Settings** (**Shift**+**Ctrl**+**K**) to get the dialog box shown in **Figure 1**. Select **Full Color Management – Optimized for Print**. Click **OK** to apply the setting.

Second, I suggest that you use Adobe Gamma. **Figure 2** shows the front screen of Adobe Gamma, where you are given two options for adjusting your monitor and setting up a color profile. Adobe Gamma works for both Windows and Mac operating system environments. Color management can be a complex topic even for professionals, and because this is not a book on color management, I'll suggest you learn more about this topic by

choosing **Help** ➤ **Help Contents** (**F1**) to get the **Help** screen. After clicking **Search** to get the search box, type "**color management**" in the **Find Pages Containing** box, and then click **Search** to list all of the topics covering color management. You can also learn more about the Adobe Gamma utility on Adobe's Web page at: `www.adobe.com/support/techguides/color/gamma/main.html`

If you turn on color management and you properly adjust your monitor using Adobe Gamma, you are much more likely to see images on your screen that match the images that I saw on my screen.

4. ALWAYS PRESERVE YOUR ORIGINAL IMAGES

One of the most common errors made by those new to digital imaging is to open original digital photo files, make changes to them and then save them over the orginal file. This makes it impossible to ever again gain access to the original digital photo.

The fact is, even though your original digital photo may not look good to you, it will have the most "picture data" that you will ever have. Once you begin applying filters, you begin destroying some of the original picture data. Granted, your image may look better to you after your editing, but you still have destroyed some picture information that you may want later. What you think looks good today may not look good to you tomorrow. As you complete more of these techniques and begin to master your digital image editor, you will get better at making your digital photos look good. Destroying your original file is like destroying the negative used to make a photographic print. Any future copies will always be less good than they could have been.

My strong recommendation to you is to always save your original digital photos — do not edit them and then save the file. After opening an original image, save it to a different folder, or rename the photos so that you can always return to the original digital photo as you get more competent with your image editor and you refine your techniques.

5. BE CAREFUL WHEN SAVING A FILE

Whenever you select **File ➢ Save** (**Ctrl+S**) or **File ➢ Save As** (**Shift+Ctrl+S**), you run the risk of losing something! While this may be exactly what you want to do, you also run the risk of doing something you don't really want to do. Here are a few cases where you need to be especially careful when saving a file:

■ If you open a file and edit it, and then save it using the same filename, you will write the new file over the original file. If the file you opened was your original digital photo, you may have lost some picture data that you can never recover, as noted in preceding point 4.

■ Any layers that you may have created in an image will only be preserved if the file is saved in the Photoshop file format (.psd) or in the TIFF format (.tif). In each case, make sure that there is a check in the **Save Layers** box as shown in **Figure 3**. Saving your file in any other format will cause the image to be flattened, and so you will lose the layers permanently. To enable the layers capabilities when using the TIFF format, you may need to select **Edit ➢ Preferences ➢ Saving Files**, and then place a checkmark in the **Enable Advanced TIFF Save Options** box.

■ When saving a file to a compressed file format like .jpg, you degrade the quality of your image. Consequently, you should also save and keep a copy of the original file in an uncompressed file format such as .psd, .bmp, or .tif. The simple rule to abide by: never re-edit .jpg files, unless you have no other option.

■ If you increase your file size to make a print, make sure you save your original image first. After making the print, you can just close the enlarged file. If you were to save it,

you would have a file that included interpolated data and consequently it would be less good than the original image at full size.

6. SIZING AN IMAGE TO MAKE A PRINT

One of the most confusing aspects of digital photography concerns image and print sizing. While there is a lot to learn about this topic, you will be able to do what you need to do if you understand the settings on Photoshop Elements' **Image Size** dialog box shown in **Figure 4**.

To learn how to use these settings, select **Help ➢ Help Contents** (**F1**) to get the help window. Select **Contents** and then select **Printing**. When using the **Image Size** dialog box, you should be aware of the effects of re-sizing an image. If you increase the size of an image by more than 150-200%, image quality will begin to noticeably worsen.

When you use the **Image Size** feature to enlarge an image, Photoshop Elements must "interpolate" or fill in parts of the image where there was previously no image. It does this using one of the three selectable methods shown in the **Resample Image** method box. For photographic images, you will get the best results with the **Bicubic** setting. It is the slowest but most precise method, resulting in the smoothest tonal gradations.

The important point to note is that when you enlarge an image to make a print, it will not be as good as the full-size or original image. Consequently, you should not save the file using the original file name and folder, as you will replace the original with an interpolated and inferior copy! The best strategy is to just size your image when you want to print it, and then close the file without saving it once your prints are complete. Doing this will allow you to get the print size you want while preserving your original digital photo and keeping the file size as small as possible.

7. ABOUT PRINTERS AND PAPER

Once your collection of digitally edited digital photos begins to grow, you will probably want to print them on your own photo-quality printer. There are many photo-quality printer vendors and an even greater number of printer models. While I generally hesitate to make specific vendor or product recommendations without knowing more about what the user intends to do with them, I can say that you'll generally do well with an Alps, Canon, Epson, or HP photo-quality printer. In particular, you should consider the Epson printers, as they seem to have a remarkably good combination of features, print quality, and print longevity. Also, you should only consider those printers that have four or more different colors of ink.

Once you select a printer, it is *very important* that you match your printer with the proper ink *and* paper! The best results will only be obtained with the proper combination and printer settings. Many photo-quality printers and the recommended inks will not produce acceptable results on certain kinds of papers. Check with your printer vendor to learn about their paper and ink offerings to get good results. You can also buy excellent papers from other paper vendors who are happy to guide you in your selection of papers for your specific printer. For exceptional quality fine-art papers and service, consider the following paper vendors:

- Digital Art Supplies – www.digitalartsupplies.com
- Legion Paper – www.legionpaper.com
- Media Street – www.mediastreet.com
- Red River Papers – www.redriverpaper.com
- Pictorico – www.pictorico.com

If you are using an Epson printer, you should try using Epson papers (in addition to those offered by the vendors noted above), because the combination of an Epson printer, Epson inks, and one of the better Epson papers, will result in some of the best possible prints that you can get from any desktop printer. To find a paper that you like and that works well with your printer, buy a sample pack of ten or 20 different papers. Once you select a couple of papers, I strongly suggest that you learn how to get the best results from them by trying a variety of printer settings. Most printers come with software that provides you with lots of settings to get the results that you want. Once again, experimentation is the key to success.

8. USE THE INTERNET — YOU LIVE IN A DIGITAL WORLD, TAKE ADVANTAGE OF IT

If you have a traditional photography background and you are used to shooting a roll of film, then dropping it off to get it processed and printed at a local photo-finishing lab, consider thinking digital! There are so many advantages to working with digital photos if you have a good image editor and a fast connection to the Internet.

There are all kinds of online digital photo-sharing sites, online digital photo contests, digital photo galleries, and much, much more. Use your favorite search engine site and search using the word "photography" to find a myriad of Web sites that will help you to do more with your digital photos. Digital photos and the Internet were made for each other — so, get more enjoyment from your image editing by using the Internet.

9. LEARNING TO EDIT DIGITAL PHOTOS WILL TAKE SOME TIME AND EFFORT

"In every human endeavor, what you invest in is what you get. Trying to do something is what creates the ability to do it. . . . So it is the willingness to surrender to the struggle, not talent, that defines an artist." — Connor Cochran

Connor Cochran's quote is particularly appropriate for those who aspire to become competent with their digital image editor and to be able to create artistic work. It can be done by almost anyone; however, it will take time and perseverance. My hope is that this book will provide you with the inspiration and some basic techniques to get you started on a long and fun path to successful digital photo editing. Have fun with the techniques!

CHAPTER

1

CREATING A
MASTER IMAGE

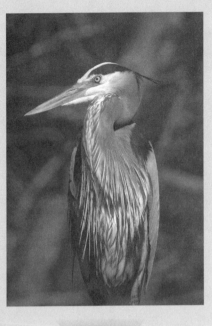

This chapter, and the seven techniques it contains on creating a master image is the single most important chapter in the book. If you just want to make a digital photo be the best it can be, then these techniques will help you to achieve your objective. Creating a good master image is like a good foundation to a building, it allows you to use other techniques to enhance a digital photo. If you start with a poor-quality foundation, your building may crumble!

Technique 1 shows you how to properly orient, straighten, crop, and size your image for its intended use. Removing dust, scratches, and other unwanted items in an image is the topic of Technique 2. Technique 3 illustrates how you can adjust the color and saturation of any color in an image, whereas Technique 4 shows how to increase tonal range and overall image contrast. Removing unwanted color casts is the lesson to be learned in Technique 5. You'll learn how to sharpen images in Technique 6, and in Technique 7, you'll learn how to use the **Clone Stamp** tool to fix and replace parts of an image. Once you have been through these seven steps, you'll know how to make a master image!

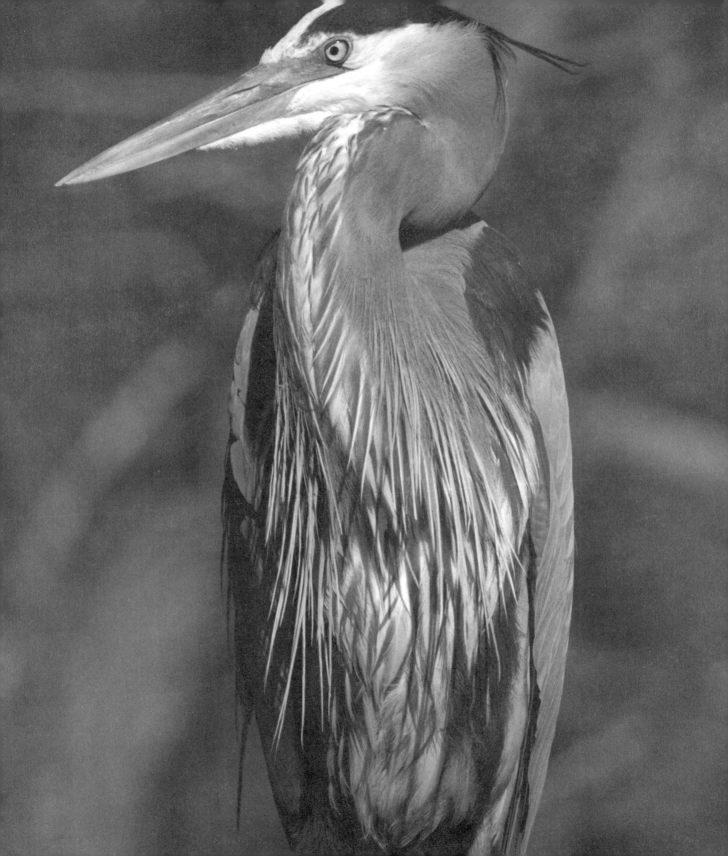

GETTING YOUR IMAGE INTO SHAPE

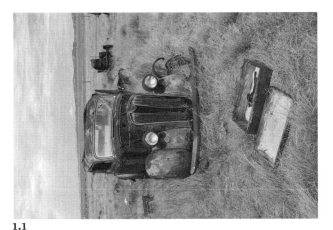

1.1

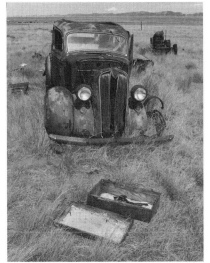

1.2

ABOUT THE PHOTO

"Empty and Abandoned," Canon A2E, 28-105 f/3.5-4.5 zoom lens, Kodak print film, negative scanned with Polaroid SprintScan 4000, 1,550 ¥ 2,350 pixels, 10.4MB .tif file

A s you read this book, you'll find that I have had a long-time fascination with old rusty cars. I do not know why they fascinate me as they do. Maybe it is the look of abandonment or the rich red-brown rust colors. Whatever it is, I've taken lots of photos of old cars like the one shown next to the open suitcase.

This particular photo will be used both here and in Technique 17 in Chapter 3. For now, your objective is to just get it into "shape." In other words, you will orient the image properly into portrait mode. Then, you will make it straight. You will next crop it as needed, make the image the right size for the intended use, and add extra canvas for a title. Finally, you will save the file in the most appropriate file format. All of these tasks are generally the first steps you should take when creating a master image.

STEP 1: OPEN FILE

■ Select **File**➤**Open** (**Ctrl+O**) to display the **Open** dialog box. After double-clicking the **/01** folder to open it, click the **suitcase-before.tif** file to select it, and then click **Open**.

STEP 2: TURN THE IMAGE 90 DEGREES TO A PORTRAIT ORIENTATION

When scanning with a film or flatbed scanner (or when shooting with a camera), you will often end up with an image that is in portrait mode, instead of landscape mode, or vice versa. Orienting it properly is simple.

■ Select **Image** ➤ **Rotate** ➤ **Canvas 90° Right** to properly orient the image.

STEP 3: STRAIGHTEN THE IMAGE

The horizon slopes to the left just a slight bit, so the image needs to be straightened. Getting an image straight can be a hit-and-miss kind of task. Once you straighten a few images, you will get pretty good at guessing how much the image needs to be rotated. Until then, you just have to guess an angle, rotate it, and try it again until you get it correct.

1.3

■ Before you rotate an image, I suggest that you change the background color to a color that contrasts with the image — usually white or black. When you begin to crop the image, you can more easily see the part of the image that will be cropped. To set the current background color to black, click the icon (a small black square over a small white square) just below the **Foreground** color box in the toolbox (**D**). Then, click the **Switch Foreground and Background Colors** (**X**), which is the two-headed arrow icon.

■ Select **Image** ➤ **Rotate** ➤ **Canvas Custom** to get the **Rotate Canvas** dialog box shown in **Figure 1.3**. Since the horizon slopes down to the left, you'll need to rotate the canvas to the right approximately 2.5 degrees. Type **2.5** into the **Angle** box and click **Right**, and then click **OK**. It now appears to slope to the right almost as much as it sloped to the left before. To undo the rotation, select **Edit** ➤ **Step Backward** (**Ctrl+Z**). This time, you'll rotate the image half as much. Once again select **Image** ➤ **Rotate** ➤ **Canvas Custom** and try a **1.2** setting this time. Click **OK** and the image should now look level.

STEP 4: CROP IMAGE

■ Click the **Square Marquee** tool (**M**) in the toolbox. Now, you should see the options toolbar shown in **Figure 1.4**. Click **Style** and select **Constrained Aspect Ratio**. Since you want to end up with an image that has the same proportions as an 8" × 10" photo, set **Width** to **8** and **Height** to **10**. Make sure that **Feather** is set to **0**.

■ Click inside the image in the lower-right corner and drag the selection marquee up and to the left

1.4

until the selection marquee looks similar to the one shown in **Figure 1.5**. If the selection marquee isn't quite as you want it, you can move it by tapping on the arrow keys to move it one pixel per tap. Should the selection be completely wrong, click outside the selection and make a new selection. Once you are satisfied with the location of the marquee, select **Image ➢ Crop** to crop the image.

STEP 5: RIGHT-SIZE THE IMAGE

"Right-sizing" an image simply means making it the right size for its intended use. If the image is to be used on the Internet, you will want to make it the right size as measured in pixels. In this case, you are going to need to make the image the right size for being printed as an 8" × 10" print on an inkjet printer that requires 240 dpi.

- Select **Image ➢ Resize ➢ Image Size** to get the **Image Size** dialog box shown in **Figure 1.6**.
- If a checkmark is not in the **Constrain Proportions** box, click inside the box to place a checkmark.
- The image ought to now be approximately a 1,500 × 1,900 pixel, 8.0MB file. With **Resolution** set to **240**, the print size is only about 6.25" × 7.75". To make an 8" × 10" print, type **8** into the **Width** box and **Height** should automatically change to **10**. You should also make sure that there is a checkmark in the **Resample Image** box and that **Bicubic** is selected as the resample method.

Before clicking **OK** to apply the settings, check to see the new file size, which may be seen at the top of the **Image Size** dialog box. It should be 13.2MB. That is just about 1.7 times larger than the original 7.9MB image. Generally, you can safely increase an image by a factor of two without seeing substantial image degradation. Any image size increase over two, chances are good that your image will not look as

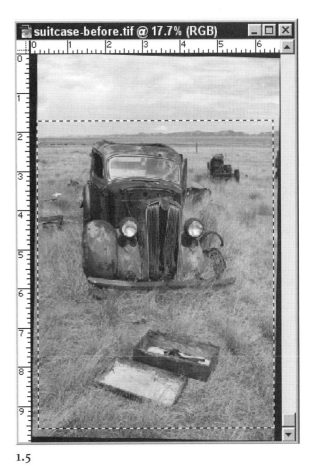

1.5

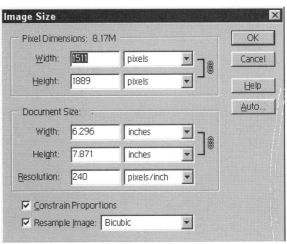

1.6

good as the original. This is a very general guideline, so don't take it as a truth in all cases.

- Click **OK** to increase the image size.

Now that you've learned how to use the rotate **Canvas Custom, Square Marquee, Crop,** and **Image Size** commands or tools, I should tell you that you can use a tool to do what you did in Steps 3 through 5 in a single step! One of the strengths of Photoshop Elements is that there are often many ways of completing any given task. As you become more proficient with Photoshop Elements, you will find that it is better to know your options. This allows you to choose the approach that is best suited for your needs.

Therefore, let's look at doing Steps 3 through 5 with the **Crop** tool.

- Close the **suitcase-before.tif** document window without saving it.
- Select **File ➢ Open** (**Ctrl+O**) to display the **Open** dialog box. After double-clicking the **/01** folder to open it, click the **suitcase-before.tif** file to select it, and then click **Open**.
- Select **Image ➢ Rotate ➢ Canvas 90° Right** to properly orient the image.

You are now ready to use the **Crop** tool.

- As the **Crop** tool is easier to use when the whole image is showing, select **View ➢ Fit on Screen** (**Ctrl + 0**).
- Click **Crop** tool (**C**) in the toolbox and you will get the **Crop** options bar shown in **Figure 1.7**. As the objective is to create an 8" × 10" print that will be printed on a 240 dpi printer, type **8, 10,** and **240** into the **Width, Height,** and **Resolution** boxes respectively.

- Using the **Crop** tool (**C**), click inside the image in the upper-right corner where you want to start cropping. Drag the selection marquee down and to the right to make a marquee that approximates the area of the photo that you want to crop as shown in **Figure 1.8**.

As soon as you place a selection marquee on an image, the **Crop** tool options bar will change and give you the option of placing a checkmark in the **Shield cropped area** box, which will darken the image outside the cropped area to make it easier to see your selection.

- To rotate the marquee to level the horizon, move the cursor outside the marquee until the cursor turns into a double-headed curved arrow. Then click and rotate the marquee until the top line is parallel with the horizon line.
- To scale the marquee, drag a handle until the cropped size is correct.
- To move the marquee to another position, place the cursor inside the marquee, and drag. You can also use the arrow keys to move the marquee one pixel at a time.
- Once the marquee is where you want it, click the **OK** button in the **Crop** tool options bar. Alternatively, you can press **Enter,** or double-click inside the marquee to crop the image.

You have now accomplished the same thing that you had previously done in Step 3 through Step 5. To confirm that your image is the correct size, you can select **Image ➢ Resize ➢ Image Size** to get the **Image Size** dialog box. You should see that you now have an image that is 8" × 10" at a 240dpi and that it is about 13.2MB. Click **Cancel** to continue to the next step.

Width: 8 in Height: 10 in Resolution: 240 pixels/inch Front Image Clear

1.7

STEP 6: ADD ¾" BORDER TO THE BOTTOM OF THE IMAGE

Adding additional "canvas" to your image is a task that you'll often want to do. Whether you are in need of enough room to add one or more additional images or you just want to add a ¾" border for some text, the process is the same.

- Before adding extra canvas, you need to select the color of canvas that will be added. In this case, you want to use white. So, click the **Set Current Colors to Black and White** icon (**D**) at the bottom of the toolbox.

- Select **Image** ➢ **Resize** ➢ **Canvas Size** to get the **Canvas Size** dialog box shown in **Figure 1.9**. Type **10.75** in the **Height** box and click the middle box in the top row of the nine boxes that look like "tic-tac-toe" grid. This will select the anchor point. Checking this anchor point forces the extra ¾" white space added to the height to be put on the bottom of the image where we want it.
- If you aren't able to see the entire image, select **View** ➢ **Fit on Screen** (**Ctrl+0**).
- You can now use the **Type** tool (**T**) to add any text you may want to add. I chose to add a title for the image using one of the dark browns selected with the **Eye Dropper** tool (**I**) directly from the image.

Once you get the hang of the not-so-intuitive **Canvas Size** box, you'll be able to add extra canvas to an image with ease. Should you want to add an equal amount of space all around the image, click in the center box and the added space will be allocated equally all around the image in a single operation. This capability is covered extensively in Chapter 8.

1.8

1.9

1.10

STEP 7: SAVE FILE

■ To save the file, select **File** ➤ **Save As** (**Shift+ Ctrl+S**) to get the **Save As** dialog box. Select an appropriate folder, name the file, choose a file format, and then click **Save** to save the file.

Saving your file in the right folder under an appropriate name *and* saving it in the best file format are very important. Once you have selected the folder of choice and have named the file, you select the type of file format by clicking **Format** to get the options menu shown in **Figure 1.10**. Select *.PSD to get the native Photoshop format, .BMP is the format of choice for many Windows applications, and .TIF is a good file format for both Windows and Mac environments. Should your image be destined for the use on the Internet, or for use as an attachment to e-mail, use the .JPG, .PNG, or .GIF formats — these formats give you the option of compressing the image to make it smaller and faster to download.

REMOVING DUST AND SCRATCHES

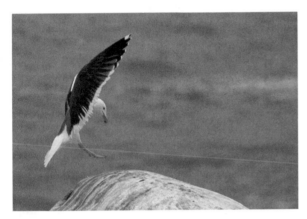

2.1

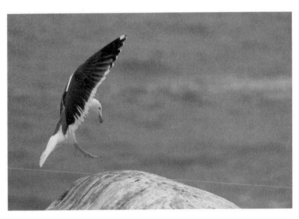

2.2

ABOUT THE PHOTO

"Seagull Landing," Canon EOS1v, 300mm f/2.8, Provia 100F slide film, scanned with Polaroid SprintScan 4000, 2,400 ¥ 1,600 pixels, 11.0MB .tif file

One of the advantages of using a digital camera is that you consistently get clean digital images that are free from dust and other unwanted particles. Unfortunately, it is difficult to get a perfectly clean scan using a film or desktop scanner. Even if you use air blower brushes and air dust guns, you often have dust and other particles on your digital photos. This problem is shown in the seagull image. (Should you decide to use a service to do your scanning, you will still find that you occasionally have to remove the dreaded dust particles that have a tendency to cling to photos and film.)

Most digital image editors have several tools that make it easy to remove dust, splotches, drips, scratches, or other undesirable "things" on your digital photos. Depending on the types of undesirables that you wish to remove, and the image itself, one tool is likely to do a better job than the others. The **Clone Stamp** tool and the **Dust & Scratches** filter are the two most frequently used tools for this purpose.

The **Clone Stamp** tool allows you to *clone* an undamaged or "good" part of the image over the top of any unwanted dust and particle areas. It is an easy tool to use, but it may not be the best tool if there are lots of dust particles to remove, or when it is hard to find the perfect "clone" source to use. On the other hand, the **Dust & Scratches** filter is most useful when an image has lots of small dust particles or light scratches to remove. It can remove them all at one time.

Once you know how to use it, the **Dust & Scratches** filter is one of the more amazing filters. If you don't use it correctly, you can damage your photo by adding blur where you don't want it. As Technique 7 shows how the **Clone Stamp** tool may be used, we'll use just the **Dust & Scratches** filter in this technique. This is the best tool to use to clean this image.

2.3

2.4

STEP 1: OPEN FILE

■ Select **File** ➢ **Open** to display the **Open** dialog box. After double-clicking the **/02** folder to open it, click the **gull-before.tif** file to select it and then click **Open**.

STEP 2: REMOVE THE TEXTILE FIBER ON THE NECK OF THE GULL

■ Click **View** ➢ **Actual Pixels** (**Alt+Ctrl+0**) to enlarge the image to full size.
■ If the **Navigator** is not visible, select **Window** ➢ **Show Navigator**. Then, using the **Navigator** as shown in **Figure 2.3**, look all around the image by clicking and dragging the black box in the **Navigator's** thumbnail image to see what needs to be removed.

Sadly, this digital photo has bits and pieces of stuff all over the image, including a piece of textile fiber on the neck of the gull, all over the image. Not to worry, you can make it all go away!

■ Using the **Navigator**, move the head of the gull into the middle of the workspace as shown in **Figure 2.4**.
■ Click the **Lasso** tool (**L**) in the toolbox. Click and drag the selection marquee around the unwanted fiber on the neck of the gull, as shown in **Figure 2.4**.
■ Select **Filter** ➢ **Noise** ➢ **Dust & Scratches** to get the **Dust & Scratches** dialog box shown in **Figure 2.5**. Type in **1** for **Radius** and **0** for **Threshold**, or drag both sliders all the way to the left.

The way to get the best results from the **Dust & Scratches** filter is to set **Radius** to **1** pixels and **Threshold** to **0** levels. Then, increase the **Radius** slowly until the unwanted dust particles or scratches disappear. Drag the **Threshold** slider all the way to the right. You will once again see the unwanted dust

particles and scratches. Slowly drag the **Threshold** slider back toward the left until the unwanted arti-facts once again disappear. This two-step process ensures that the unwanted artifacts are removed and that the filter has not blurred the selected part of the image excessively.

You may find that there is no setting at which you can get rid of all the unwanted stuff without blurring the image. To get the best possible results, first use the **Clone Stamp** tool (**S**) for big unwanted items. Then, use the **Dust & Scratches** filter to get rid of the smaller stuff. Many Photoshop users try the **Dust & Scratches** filter a few times and decide that it causes

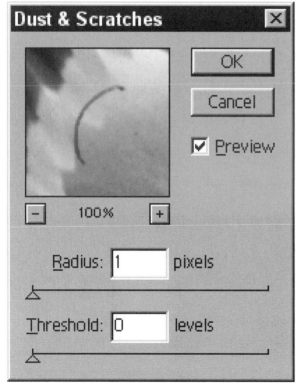

2.5

too much blur. However, if this filter is used properly, it can be a very useful and effective filter.

- Drag the **Radius** slider to the right until you see the fiber disappear. At a **Radius** of **5** or **6**, the fiber is almost gone. At a setting of **7**, it disappears completely.
- Now drag the **Threshold** slider all the way to the right to **255** levels. Slowly drag it back to the left until you once again see the fiber disappear. It becomes almost unnoticeable at a setting of **20** levels. Click **OK** to apply the settings.

STEP 3: REMOVE DUST PARTICLES AND TEXTILE FIBERS IN THE SKY AREA

We could have selected all of the sky and the neck of the gull to remove all the unwanted items at once. However, I chose to first remove the fiber on the gull's neck to make sure that the setting did not cause any blurring to any of the gull's feathers which are highly susceptible to the **Dust & Scratches** filter. Now, select all the sky area and remove the last remaining parti-cles and fibers in the same manner.

- To make it easy to select all of the sky, select **View** ➤ **Fit on Screen** (**Ctrl+0**) to make the entire image visible.
- Select **Select** ➤ **Deselect** (**Ctrl+D**) to remove any current selections.
- Click the **Lasso** tool (**L**) in the toolbox. Click and drag the selection marquee around the gull.
- Click the **Add to Selection** box in the **Lasso Tool** (**L**) options bar shown in **Figure 2.6**.
- As the rock that the gull is about to land on has marks on it that may be seen by the **Dust & Scratches** filter as items to remove, let's add the rock to the selection by clicking and dragging the

2.6

selection around the rock. Your selection should now include both the gull and the rock.

■ Select **Select** ➢ **Inverse** (**Shift**+**Ctrl**+**I**) to invert the selection to be just the sky.

■ When using the **Dust & Scratches** filter, you'll find that you can get settings that are more accurate when the image is shown full size. Select **View** ➢ **Actual Pixels** (**Alt**+**Ctrl**+**0**) to once again get a full size view.

■ Click the **Hand** tool (**H**) in the toolbox and then click and drag the image until you see the large textile fiber to the right of the gull's head.

■ Select **Filter** ➢ **Noise** ➢ **Dust & Scratches** to get the **Dust & Scratches** dialog box. Type in **1** for **Radius** and **0** for **Threshold**, or drag both sliders all the way to the left.

■ Drag the **Radius** slider to the right until you see the fiber disappear. At a **Radius** of **9**, it disappears.

■ Now drag the **Threshold** slider all the way to the right to **255** levels. Slowly drag it back to the left until you once again see the fiber disappear. It becomes almost unnoticeable at a setting of **9** levels. Click **OK** to apply the settings.

As you look all around the image, you will see that all the unwanted particles are now gone. In addition, the sky has *not* become blurred.

■ Select **Select** ➢ **Deselect** to remove the selection marquee.

STEP 4: SAVE FILE

■ To save the file, select **File** ➢ **Save As** (**Shift**+**Ctrl**+**S**) to get the **Save As** dialog box. Select an appropriate folder, name the file, choose a file format, and then click **Save** to save the file.

The image is now free of all the undesirables! What is more important, we were able to remove them quickly without causing any unwanted blur to the image.

ADJUSTING COLOR AND SATURATION

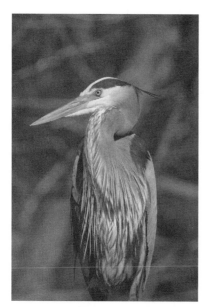

3.1 (CP 2)

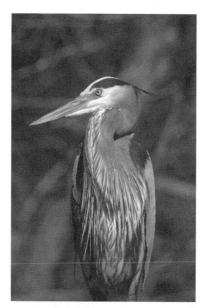

3.2 (CP 1)

ABOUT THE PHOTO

"Here's Lookin' at You Kid,"
Canon D30 digital camera,
300mm f/2.8 with 2X
teleconverter, 1,440 × 2,160
pixels, 1.0MB .jpg file

Many photographers feel strongly that their work should mirror the original scene. They avoid using colored filters or other techniques that alter colors. When the photographic process results in a print that does not match the original scene, they can use a digital image editor to correct the colors. Other photographers, like me, enjoy being able to completely transform color schemes and make photographs that are more dramatic than what might be found in real life. This technique will show you how you can adjust color and saturation to be just what you want them to be.

The photograph of the great blue heron is of a heron that visits a pond not too far from my home. While he does allow me to occasionally get quite close, the bird rarely takes his eye off me. If I make any abrupt movement, he flies away. This particular image was one of the first photographs I took with a Canon D30 digital camera. The colors are quite accurate. Nevertheless, we'll tweak them just a bit to make the image a little more exciting.

STEP 1: OPEN FILE

- Select **File** ➤ **Open** to display the **Open** dialog box. After double-clicking the **/03** folder to open it, click the **heron-before.jpg** file to select it. To open the file, click **Open**.

STEP 2: INCREASE THE SATURATION LEVEL OF YELLOW IN THE BEAK AND EYE

Portraits of people or wildlife *always* look best when there is a bright, sharply focused eye. Increasing the saturation level of yellow will not only focus the viewer's attention on the eye, it will bring out the yellow color in the beak.

- Select **Enhance** ➤ **Color** ➤ **Hue/Saturation** to get the **Hue/Saturation** dialog box shown in **Figure 3.3**. Click the **Edit** box to select **Yellows** (**Ctrl+2**). Drag the **Saturation** slider to the right until it shows **+40**. You can almost feel the eye looking straight at you now and the yellow color in the beak is more dramatic.

STEP 3: INCREASE THE SATURATION LEVEL OF THE BLUES

When the sun was shining directly on the blue heron, I was surprised at how blue he looked. When he landed on a branch and allowed me to shoot his picture, the bird was no longer in the direct sunlight and hence the blues are much less brilliant. So, why not change them?

- Click the **Edit** box in the **Hue/Saturation** dialog box to select **Blues** (**Ctrl+5**). Drag the **Saturation** slider to the right until it shows **+30**. The blue feathers now look much bluer.

STEP 4: INCREASE THE SATURATION LEVEL OF THE GREENS

This photo was taken in late February, so there was not much green in the image. However, we can increase the green to add some contrast to the blue heron.

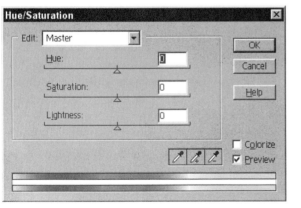

3·3

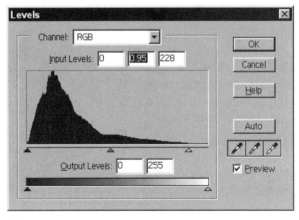

3·4

■ Click the **Edit** box to select **Greens** (**Ctrl+3**). Drag the **Saturation** slider to the right until it shows **+35**. The background is now greener. Click **OK** to apply the color settings.

STEP 5: MAKE FINAL COLOR ADJUSTMENTS

■ Select **Enhance** ➢ **Brightness/Contrast** ➢ **Levels** (**Ctrl+L**) to get the **Levels** dialog box shown in **Figure 3.4**. Drag the right slider to the left until

the third **Input Level** shows **228**. Adjust the midtones by moving the middle slider to the left until the second **Input Level** shows **0.95**. Click **OK** to apply the settings and your image should now look similar to the one shown in **Figure 3.2** (**CP 1**).

STEP 6: SAVE FILE

■ To save the file, select **File** ➢ **Save As** (**Shift+ Ctrl+S**) to get the **Save As** dialog box. Select an appropriate folder, name the file, choose a file format, and then click **Save** to save the file.

IMPROVING TONAL RANGE AND IMAGE CONTRAST

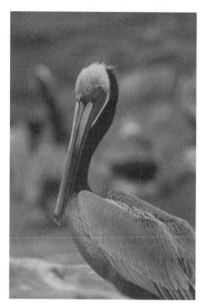

4.1 (CP 4)

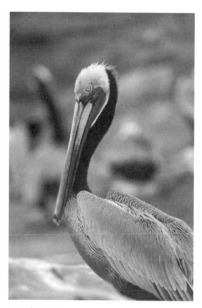

4.2 (CP 3)

In early January to mid-March, in La Jolla, California, you can find the California brown pelicans displaying their brightest colors. I shot the picture of this magnificent male early one morning when there was a light cloud cover. While the clouds helped to keep the scene from having a wider dynamic range than I could capture on digital film, they also worked to decrease the overall brightness level of the image more that I had wanted.

This technique shows how the **Levels** feature can be used to increase tonal range and overall image contrast. If you have studied any of the writings of Ansel Adams describing his Zone System, you will be well on your way to understanding how valuable the **Levels** feature can be. Ideally, most images will have some black, some white, and a good range of values in between. In this example, we will increase the tonal range and image contrast to make the final digital image.

STEP 1: OPEN FILE

■ Select **File** ➢ **Open** to display the **Open** dialog box. After double-clicking the **/04** folder to open it, click the **pelican-before.tif** file to select it. To open the file, click **Open**.

STEP 2: INCREASE TONAL RANGE

If you haven't used the **Levels** command before, I suggest that you first read the About Levels text later in this chapter. A good understanding of this command will make this technique easier to understand.

■ Select **Enhance** ➢ **Brightness/Contrast** ➢ **Levels** (Ctrl+L) to get the **Levels** dialog box shown in **Figure 4.3**.

As you might expect, the Levels histogram clearly shows that the image lacks brightness values at both ends of the tonal range. There are no really dark or black values, nor are there many white or very light values. It is the very light values that often make an

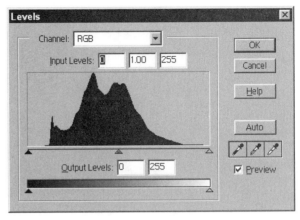

4.3

image an exceptional image, as highlights have white or near-white values.

The **Levels** command gives you the option of either making changes to the **Red**, **Green**, and **Blue** channels all at once by adjusting the **RGB** channel, or making individual changes to each color channel independently. With some practice, you will find that

ABOUT LEVELS

Of all the basic image correction features, **Levels** is possibly the most important. It is usually the first tool to be used on an image, and it often is the tool of choice for making final adjustments. **Levels** allows you to improve the tonal range of an image. Tonal range is the term used to express the range of brightness in an image and can be the key factor determining overall image quality of many images. The full range from the lightest to the darkest is called the *dynamic range*.

To get a good understanding of an image's dynamic range, select **Image** ➢ **Histogram** to get a **Histogram** box like the one shown **Figure 1**. This particular histogram shows the tonal range of the photo shown in **Figure 13.1** (**CP 14**). The horizontal brightness scale ranges from **0** to **255**. The height of each vertical line represents the number of pixels at that brightness level.

Looking at this histogram, you can see that the image does not have dark darks or black, nor does it have light lights or white, indicating it does not have an

1

optimal dynamic range. To make adjustments to the image's dynamic range, use the **Levels** command by selecting

you can consistently get better results by adjusting each individual channel. However, before we begin adjusting each channel, quickly adjust the **RGB** channel just to see how much the image can be improved.

- Drag the left slider until it is just to the edge of the left side of the histogram — the first **Input Levels** number should be around **30**. Then, slide the right slider to the left until the third **Input Levels** value shows about **217**. You'll immediately notice how much better the image looks. The black neck of the pelican is now truly black. You can also see white highlights on the rock behind the pelican and on the white areas of the pelican. If you wanted to, you could also adjust the midtones by sliding the middle slider to either side. The image looks better if it is a bit lighter or if the middle **Input Levels** slider is set to **1.15**.
- Click **Cancel** to cancel these settings and return to the original image. Now, we'll do the same thing — except we'll adjust each of the three color channels independently to get even better results.

- Select **Enhance ➢ Brightness/Contrast ➢ Levels (Ctrl+L)** to get the **Levels** dialog box. Now, click the **Channel** box and select the **Red** channel, as shown in **Figure 4.4**. Drag the left and right sliders until you get **Input Values** of **21**, **1.00**, and **208**.

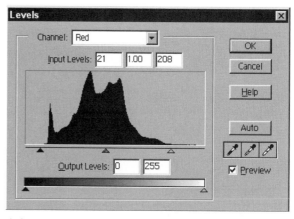

4.4

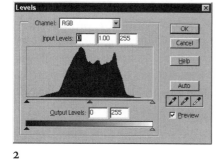

2

Enhance ➢ Brightness/Contrast ➢ Levels (Ctrl+L) to get a dialog box like the one shown in **Figure 2**. By sliding the **Input** sliders, you can extend the tonal range. **Figure 3** shows the results of setting **Input Level** values to **25, .85,** and **220.** It is important to understand that **Levels** does not create new "picture data." Rather, it merely spreads the existing tonal range out over the entire possible spectrum from **0** to **255**. As you can see, the histogram now has gaps, which means that the image suffers from a lack of tonal values across the entire spectrum, but it does now have a wider range of values, which improves the image. The image will undoubtedly look better, but it will not look as good as an image in

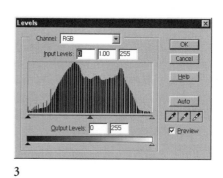

3

which the scanner or digital camera originally captured a full tonal range.

■ Click the **Channel** box and select the **Green** channel. Drag the left and right sliders until you have **Input Values** of **36**, **1.00**, and **210**, as shown in **Figure 4.5**.

■ Click the **Channel** box and select the **Blue** channel. Drag the left and right sliders until you have the **Input Values** of **29**, **1.00**, and **219** shown in **Figure 4.6**. Then, click **OK** to apply the settings. The image should now look much better than the original image.

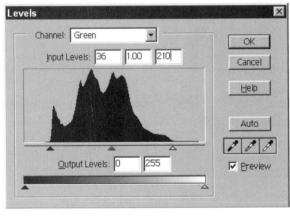

4.5

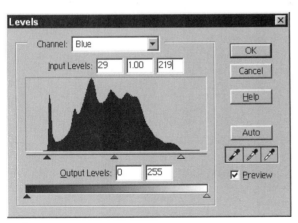

4.6

You'll notice that we used lower **Input Values** of **21**, **36**, and **29** respectively for the **Red**, **Green**, and **Blue** channels. Earlier when we adjusted only the **RGB** channel, we used a setting of **30**, which forced each separate channel to use a value of **30**. This is the reason it is usually best to adjust each individual channel.

STEP 3: ADJUST MIDTONES

■ Select **Enhance** ➢ **Brightness/Contrast** ➢ **Levels** (**Ctrl**+**L**) to once again get the **Levels** dialog box. Drag the middle slider to the left and right while looking at the image to see the results. You'll notice that as you drag it to the left, the background gets lighter and the pelican becomes more of the focal point. Dragging the slider to the right will get darker colors in the background, which make the pelican become less pronounced and more blended with the background. This is an artistic decision, and you get to make your own choice. Personally, I liked the results of setting the midtones to **1.20**. Once you have set the midtones, click **OK** to apply the settings.

STEP 4: INCREASE IMAGE CONTRAST

Even though the image looks very good now, it could look even better with a bit more contrast.

■ Select **Enhance** ➢ **Brightness/Contrast** ➢ **Brightness/Contrast** to get the **Brightness/Contrast** dialog box shown in **Figure 4.7**. Slide the **Contrast** slider to the right to increase contrast. In my opinion, a +**5** setting is just about right. Click **OK** to apply the settings and your image should now look like the one shown in **Figure 4.2** (**CP 4**).

■ To save the file, select **File** ➢ **Save As** (**Shift**+ **Ctrl**+**S**) to get the **Save As** dialog box. Select an appropriate folder, name the file, choose a file format, and then click **Save** to save the file.

To complete this technique we used the **Levels** command to adjust each of the individual color channels (red, blue, and green) and then later we used the **Levels** command again to adjust the midtone using the RGB channel. Finally, we used the **Contrast** command to adjust contrast. While each of these commands enhances the appearance of the image, repeated use of them can degrade the image by creating gaps in the histogram, which will eventually show up as posterization in subtle gradations (like skies and sunsets).

If you think that you may later want to go back and make further adjustments using **Levels** and **Contrast**, you should consider using adjustment layers. Adjustment layers add another level of flexibility to working with layers. They allow you to experiment with color and tonal adjustment to an image without making the actual changes to the underlying image. If you change your mind about the results, you can go back and edit or remove the adjustment at any time by merely clicking on the appropriate adjustment layer and making your modifications.

To create a **Levels** adjustment layer, select **Layer ➢ New Adjustment Layer ➢ Level** to get the **New Layer** dialog box shown in **Figure 4.8**. You'll notice that the **New Layer** box also gives you extra control over the **Levels** adjustment by enabling you to apply any of the blend modes, plus you can also set the **Opacity** level. After clicking **OK** to create the layer, you will be presented with the familiar **Levels** dialog box. This same approach works for the **Brightness/**

Contrast and **Hue/Saturation** commands plus several other commands.

If you did this technique with adjustment layers, **Figure 4.9** shows how the **Layers** palette would look. You'll notice there is one **Levels** layer for the adjustments that we did to each of the color channels. There is a second **Levels** layer where the change to the midtone was made. There is also a **Brightness/Contrast** layer where we made the +5 change to **Contrast**. As they are "layers," they can be rearranged in order, deleted, hidden, and duplicated in the same manner as image layers.

4.8

4.7

4.9

Once you have made all the changes that you want to make, you can flatten the adjustment layers to create your final image. Incidentally, there is no difference between the histograms of the flattened pelican image created using the adjustment layers and the image created at the beginning of the chapter where no adjustment layers were used. The significant difference between these two approaches is that using adjustment layers allows you to go back and make changes without degrading the image. Making successive changes using the first approach would result in an inferior image.

REMOVING COLOR CAST

5.1 (CP 6)

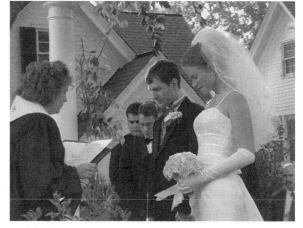

5.2 (CP 5)

ABOUT THE PHOTO

"Wedding Vows," Nikon 950 digital camera, Fine Image Quality setting, 1,600 × 1,200 pixel image size, 760KB .jpg file

I f you've taken even just a few photographs with either a film or digital camera, you are likely to have seen "too-blue," or "too-green," or "too-red" prints or digital photos. These photos suffer from what is known as an unwanted color cast. These color casts can be caused by operator error (wrong settings), badly processed and printed photographs, or by the camera or lens. The good news is that you can remove color casts with a digital image editor.

I had been shooting indoors and consequently had set the digital camera's White Balance setting to Incandescent, which is a most improper setting for an outdoor wedding! Therefore, this and about twenty other outdoor wedding photos that I shot later in the day all have a blue cast. The good news is that I was not a hired wedding photographer. Consequently, my mistake only became a good example for how to fix such a mistake and *not* a reason to make the bride, groom, and their families very unhappy with me.

STEP 1: OPEN FILE

■ Select **File** ➢ **Open** to display the **Open** dialog box. After double-clicking the **/05** folder, click the **wedding-before.jpg** file to select it. To open the file, click **Open**.

STEP 2: REMOVE A COLOR CAST

Most digital image editors offer more than one feature that may be used to accomplish a particular task. This is *especially* true in the case of removing a color cast. Often, the hardest part of getting a specific task done is to decide *what* tool to use. The choice is often between one that gives more control and takes more time and one that provides less control and is easy to use. In the case of Photoshop Elements, removing a color cast with the new **Color Cast Correction** tool is extremely easy and the results in most cases are quite good.

■ Select **Enhance** ➢ **Color** ➢ **Color Cast** to get the **Color Cast Correction** dialog box shown in **Figure 5.3**.
■ Fixing the color cast is as easy as it says in the dialog box! Just click around the image in areas where the image should be gray, white, or black until the image looks as it should. I know the wedding dress was a white dress (not one with a blue tint), so I clicked the bride's hip just below her arm. The brightest area where you can see a

highlight should be the most accurate white area in the image. Click **OK** and the photo just about looks perfect.

STEP 3: INCREASE COLOR SATURATION

Considering that it started with a horrific blue tint, the image looks quite good. However, I think it can be made to look even better if the faces were slightly "redder." In fact, maybe all the colors could be improved with an increase in color saturation.

■ Select **Enhance** ➢ **Color** ➢ **Hue/Saturation** (**Ctrl+U**) to get the **Hue/Saturation** dialog box shown in **Figure 5.4**. Make sure the **Preview** button is checked. Move the **Saturation** slider to the right until the colors reach optimum saturation. A +**20** setting for **Saturation** looks just about right to me. Click **OK** to apply the setting.

STEP 4: MAKE THE WHITES WHITER AND BRIGHTER

■ Select **Enhance** ➢ **Brightness/Contrast** ➢ **Levels** (**Ctrl+L**) to get the **Levels** dialog box. Click the **Channel** box to select the **Blue** channel shown in **Figure 5.5**. Drag the right slider to the left to about **238** to make the near-whites whiter and brighter. Click **OK** to apply the settings.

5·3

5·4

STEP 5: SAVE FILE

■ To save the file, select **File** ➢ **Save As** (**Shift**+**Ctrl**+**S**) to get the **Save As** dialog box. Select an appropriate folder, name the file, choose a file format, and then click **Save** to save the file.

I have used the **Color Cast Correction** feature on many images. In almost all cases, it performed remarkably well and it is the quickest way I know of to fix color casts. Some images, however, will not have a pure white, black, or gray tone. For example, a picture of a brightly lit green forest may not have a point where the **Color Cast Correction** Eye Dropper may be set to white, black, or gray. In those cases where the **Color Cast Correction** tool cannot be used or where the results are not what you want, try using the **Levels** filter. Instead of adjusting the **RGB** channel, select the individual color channels and adjust each one.

■ To use **Levels** to correct the **wedding-before. jpg**, select **Enhance** ➢ **Brightness/Contrast** ➢ **Levels** to get the **Levels** dialog box. Click the **Channel** box and select **Red** (**Ctrl**+**1**), as shown in **Figure 5.6**. Setting the **Input Levels** in the **Red** channel to **0**, **1.00**, and **220** almost removes all of the blue color cast. Click the **Channel** box again and select **Blue** (**Ctrl**+**3**). Set **Input Levels** to **15**, **1.00**, and **255** to make the final color adjustments.
■ Click **OK** to apply the setting and your image will be similar to **Figure 5.2** (**CP 5**).

This approach actually makes whiter and brighter whites, and the image (in my opinion) is slightly more accurate to the original scene than what we had with the **Color Cast Correction** command. The nice thing is that you have choices.

5.5

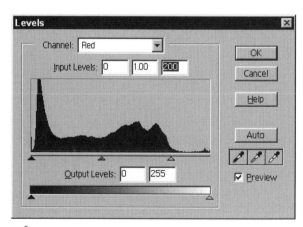

5.6

SHARPENING IMAGES

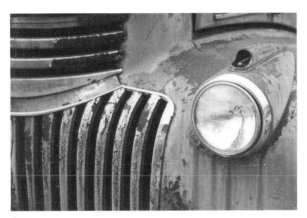

6.1

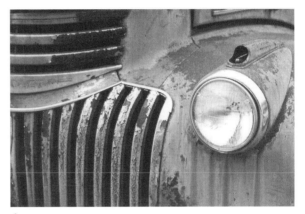

6.2

ABOUT THE PHOTO

"Chevy Truck," Canon EOS1v, 28-70mm f/2.8, Provia 100F, scanned with Polaroid SprintScan 4000, 2,400 × 1,600 pixels, 11.0MB .tif file

One of the unwelcome aspects of scanners and digital cameras is that they generally produce softer images than those created by traditional film photography. This softness arises from the digitization process, which converts continuous-tone images into images represented by dots that are placed on a grid. Consequently, many digital images can be improved by applying a *sharpen filter*.

Photoshop Elements offers four sharpening filters: **Sharpen, Sharpen Edges, Sharpen More**, and **Unsharp Mask**. My recommendation is that you avoid using the first three filters and learn to use the **Unsharp Mask** filter. The **Unsharp Mask** is by far the most capable filter, and you will always get better results once you learn how to use it. Once you sharpen a few images, you will understand why sharpening an image should be the last step in creating a master image. Many of the other filters remove the apparent sharpness of the image. Thus, you may have to apply a sharpen filter.

STEP 1: OPEN FILE

■ Select **File** ➢ **Open** to display the **Open** dialog box. After double-clicking the **/06** folder to open it, click the **chevy-before.tif** file to select it. To open the file, click **Open**.

STEP 2: SHARPEN IMAGE

■ To sharpen the image, you will use the **Unsharp Mask**. If you first enlarge the image to **100%** by selecting **View** ➢ **Actual Pixels** (**Alt+Ctrl+0**), your chances of successfully sharpening an image with the **Unsharp Mask** will be increased. A full-sized image will give you a much better idea of how the different settings affect the image.

■ Select **Filter** ➢ **Sharpen** ➢ **Unsharp Mask** to get the **Unsharp Mask** dialog box shown in **Figure 6.3**.

■ Try using the settings of **150%**, **2.0**, and **5** for **Amount**, **Radius**, and **Threshold** respectively.

6.3

ABOUT THE SHARPEN FILTERS

A good rule is to *never* use the **Sharpen**, **Sharpen Edges**, and **Sharpen More** filters. More often than not, they will damage your images more than they will improve them.

The sharpen filter to use is **Unsharp Mask** — even though its name sounds as though it might "unsharpen" an image more than sharpen it. In reality, **Unsharp Mask** does not make an image sharper. Rather, the edges are just made to have more contrast and make the image look sharper. The **Unsharp Mask** filter is a highly capable filter that is one of the more difficult filters to adjust properly. Once you learn to set it properly, it can dramatically improve your images. Consequently, it is worth the time it takes to learn how to use it.

The **Unsharp Mask** dialog box shown in **Figure 1** shows the three parameters that must be set. It is the combination of these three settings that increases the perceived sharpness along edges, which are defined as sharp color or contrast changes

The **Amount** setting controls the overall amount of sharpening; it may range from **1%** to **500%**. The **Radius**

1

- Experiment with each setting and watch the changes. To compare the original image with the current settings, click the **Preview** button on the **Unsharp Mask** dialog box. This allows you to turn on and then turn off the current **Unsharp Mask** settings.

- As I remember how the chrome was coming off the rusted grill, I felt comfortable with the exaggerated sharpening effect created with the settings of **175%**, **4**, and **35**. **Figure 6.2** shows the effects of these settings. This effect can be reduced slightly by setting **Amount** to **150**, **Radius** to **3**, and **Threshold** to **40**.

If you have experience using the **Unsharp Mask** filter, the settings may seem unusually high to you. I suggest you try using these settings and then print the image onto photo-quality paper with a photo-quality inkjet printer. My experience has taught me that sharpened settings appear less sharp on prints than they do on computer screens.

- Click **OK** to sharpen the image.

STEP 3: SAVE FILE

- To save the file, select **File** ➢ **Save As** (**Shift+Ctrl+S**) to get the **Save As** dialog box. Select an appropriate folder, name the file, choose a file format, and then click **Save** to save the file.

setting controls the width of the sharpened edge. A higher **Radius** setting makes a sharpened edge wider than a lower setting and makes it look sharper. **Radius** settings vary from **0.1** pixels to **250.0** pixels. The **Threshold** setting determines the minimum edge that may be sharpened. A **Threshold** level of **0** will allow all "edges" to be sharpened, whereas the maximum **Threshold** setting of **255** will keep all "edges" from being sharpened; essentially keeping the image from being changed at all.

With three parameters to set, the strategy of getting them just right takes either experience or considerable experimentation. My approach is to set **Amount** to **150%**, **Radius** to **2.0** pixels, and **Threshold** to **10**. When using the **Unsharp Mask**, always set image size to full size by selecting **View** ➢ **Actual Pixels** (**Ctrl+0**). Then, adjust the sliders until you get the level of sharpening you want. A **Radius** setting of over **5** pixels is quite high. Likewise, you probably want to adjust the **Threshold** in most cases down from **20** pixels. While these are good guidelines to use, many images may be further improved by using settings outside of these suggested changes. Image size also matters. A 20MB scan made for making a high quality print will require very different settings from the same image sized and compressed for use on the Internet.

Because the **Unsharp Mask** filter has a tendency to sharpen texture or grain, images that have considerable texture, digital images that were made from scans of film, or photographs that were taken with 400 or 800 ISO film will not sharpen well.

FIXING AND REPLACING "STUFF"

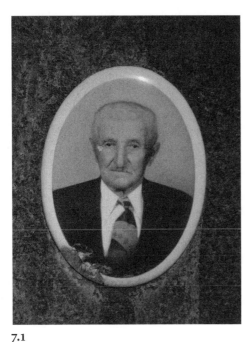

7.1

7.2

ABOUT THE PHOTO

"Great Grandfather," Nikon 950 digital camera using Fine Image Quality setting, 1,200 × 1,600 pixels, 820KB .jpg file

The process of restoring old photographs involves so much time and effort that there have been entire books written on this topic alone. In this technique, we'll look at just one of the key steps in making old photographs look like they did right after they were first printed. We'll be using a single powerful tool, the **Clone Stamp** tool, to fix and replace damaged parts of the oval-shaped ceramic photo of my great grandfather. As this is one of the few photos of my grandfather, I thought it would be worth repairing.

The photo, which was taken with a digital camera, is a photo of a ceramic photo that was placed on my great grandfather's gravestone. While the photo itself has weathered the years very well, there is a chip near the eye and some damage to the lower-left corner.

STEP 1: OPEN FILE

■ Select **File** ➢ **Open** to display the **Open** dialog box. After double-clicking the **/07** folder to open it, click the **gravestone-before.jpg** file to select it. To open the file, click **Open**.

STEP 2: REPAIR THE CHIP BY THE EYE

■ Increase the image size to full size by selecting **View** ➢ **Actual Pixels** (**Alt+Ctrl+0**).

■ Click the **Clone Stamp** tool (**S**) in the toolbox. You should now see the options bar shown in **Figure 7.3**.

■ You now need to select a small clone brush, so click the triangle in the **Brush** box in the options bar to get the painting brush palette shown in **Figure 7.4**. Click the brush just above the number **13** to get the **Soft Round** 13 pixel brush.

■ Make sure the options bar shows **Mode** as **Normal**. Set **Opacity** to **75%**.

Once you understand how it works, the **Clone Stamp** tool is an easy tool to use. It allows you to paint with a brush that allows you to clone one part of an image onto another part of the same image or even a different image. To begin using the **Clone Stamp** tool, you must first set the source image and source point by pressing **Alt** and then clicking the source image from which you want to copy. When you next click an image, you set the point where the image is to be cloned. The more you paint, the more you'll see of the source image. To change the clone

source, press **Alt** and once again click the source image to set a new source point.

■ The key to fixing the eye is to select the best part of the face to use as a clone source. If you select a part of the face that is too dark or too light, you may make the chip go away, but you will have a mark in its place. Press **Alt** and then click just below the chip mark to the left of the eye, as shown in **Figure 7.5**. This sets the clone source. You can now begin painting over the chip until it is completely removed.

It is best to click and paint just a bit and then click and paint some more rather than click and paint a lot. This way, you can easily undo any part of the repair work that doesn't look right by selecting **Edit** ➢ **Undo Clone Stamp** (**Alt+Ctrl+Z**) without having to redo everything.

STEP 3: REPAIR CERAMIC BORDER AND SURROUNDING MARBLE

The process of repairing the ceramic border and surrounding marble is the same as fixing the eye — except you'll have to pick and choose the source image more often and more carefully. While you are repairing different parts of the image, you may want to choose a different brush size. You can also change the **Opacity** level to **100%** to match the clone source. Once you have completed the work, your image should look similar to the one shown in **Figure 7.2**.

7.3

■ To save the file, select **File ➢ Save As**
(**Shift**+**Ctrl**+**S**) to get the **Save As** dialog box.
Select an appropriate folder, name the file, choose
a file format, and then click **Save** to save the file.

Now that you understand how to create a first-class
master image, you are ready to begin implementing
the many fun techniques that follow. In the next
chapter, we'll look at some quick and easy techniques
that you can use on your newly created master
images.

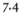

7.4

7.5

CHAPTER 2

QUICK AND EASY TECHNIQUES

Most digital image-editing applications have filters that enable you to transform your images into new and exciting images as quickly and easily as you can select and apply a single filter. In this section, we'll look at five techniques that use what might be considered "single-click" filters. In other words, a single click can apply a filter that produces quite acceptable results. The first four techniques use the **Poster Edges**, **Cutout**, **Sumi-e**, and **Dry Brush** filters. The last technique uses the **Solarize** and **Ink Outlines** filters. Although these filters can be applied without doing any preprocessing of your image, the results can often be better with some pre and/or postprocessing that will enable the filters to produce better results. Our goal in this section then is to create five quality images that can be rendered quickly with as few steps as possible.

If you are a novice to image editing, these are excellent techniques to use to start honing your image-editing skills. You may also want to use these techniques just to get things done quickly and easily. Although these techniques are quick and easy, do not underestimate how well they could work on many of your images.

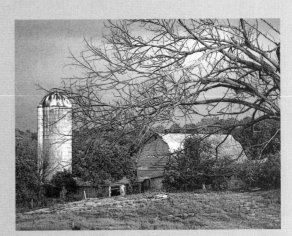

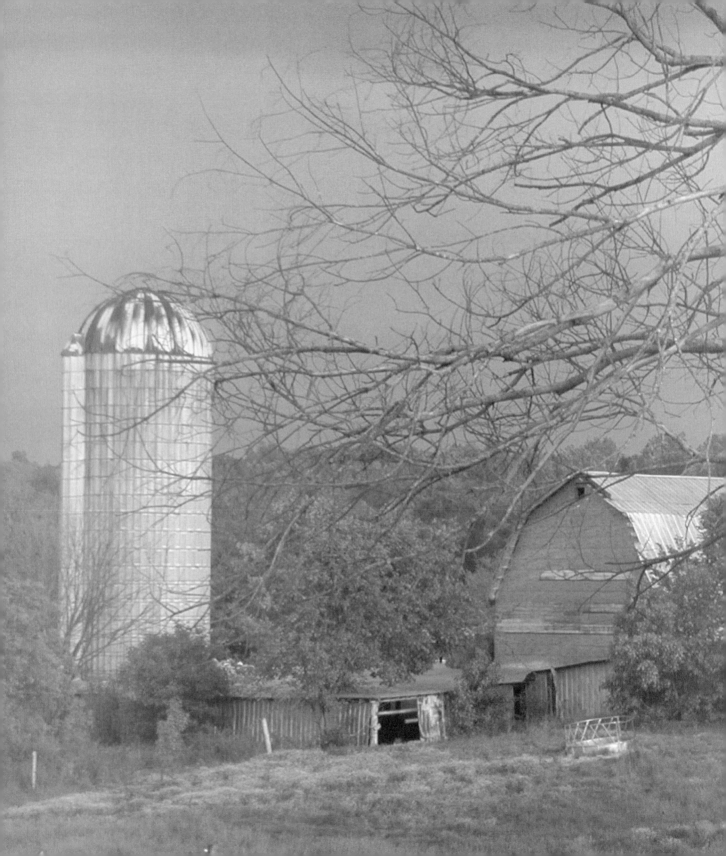

CREATING A GRAPHIC ART IMAGE

8.1 (CP8) 8.2 (CP7)

As I was driving along a country road in North Carolina, the evening sun had just begun to cast a magnificent golden glow onto the surrounding fields and farmhouses when I came upon the dairy farm shown in **Figure 8.1 (CP8)**. The magical colors lasted just long enough for me to take this picture with a digital camera. Then the light was gone. It was one of those rare occasions where I knew that I had gotten a zinger, which is an outstanding photograph. A zinger is a photograph that takes a combination of perfect light, a great subject, luck, and skill to capture it correctly on film.

You could do many things with this image. Since this chapter is on quick and easy techniques, we'll *quickly* turn this photo into an image that will make a print suitable to be framed and hung on a wall.

STEP 1: OPEN FILE

■ Select **File ➢ Open (Ctrl+O)** Using the **Open** dialog box, locate the **/08** folder and click the folder to open it. To open the image, click the file **ncdairyfarmbefore.jpg** and then **Open**.

STEP 2: IMPROVE THE TONAL RANGE

Like most images that have been created with a digital camera, this one can be improved by increasing the tonal range. In other words, you could improve the image by darkening the darkest colors and lightening the lightest colors and spreading the remaining colors between these two points. To increase the brightness and contrast, or tonal range, use the **Levels** command. Incidentally, not only will using the **Levels** command improve tonal range, but it will also improve the results of the **Poster Edges** filter that we will be using in the next step.

■ Select **Enhance ➢ Brightness/Contrast ➢ Levels (Ctrl+L)** to get the histogram shown in **Figure 8.3**. You'll notice that the histogram lacks points on the right side, indicating that the image truly suffers from a suboptimal tonal range.

■ To improve the image, you can either drag the white triangle toward the middle until the third **Input Levels** box shows **200**, or you can type **200** directly into the box.

■ Likewise, you should set the **Input Levels** black triangle to **50** and leave the middle point at **1.0**.

■ Click **OK** and the image will look much brighter with richer colors.

8.3

ABOUT THE POSTER EDGES FILTER

The **Poster Edges** filter is one of the few filters that can turn any image into a different and (usually) likable image. This filter does two things to an image. First, the **Poster Edges** filter reduces the number of colors in the image (posterizes) according to a selectable setting ranging from 0 to 6, where 0 yields the minimum number of tonal levels (or brightness values), and 6 yields a maximum number of tonal levels. Once the filter has reduced the number of colors, it draws black lines on the edges of the image. Using the **Edge Thickness** setting, which ranges from 0 to 10, you can adjust the thickness of the black lines. A 0 setting results in the narrowest line and a setting of 10 results in the widest line. In addition, an **Edge Intensity** setting enables you to set the sensitivity of the filter's capability to find edges where it will add lines. To see more lines, slide the scale toward 10. To reduce the number of lines drawn, slide the scale toward 0.

A useful feature of the **Poster Edges** dialog box is the image viewer shown in the upper-left-hand corner, as is shown in **Figure 8.6**. When you move your cursor over the image, the cursor changes into a hand and you can click and drag the image around to see the effects being applied in real-time. By clicking on the zoom in/out buttons, you can see more or less of the image. However, to get the most accurate view of the effects, you should use 100%, especially for screen resolution images.

If you are wondering how I am coming up with these seemingly mysterious numbers, try making adjustments to the **Levels** command while you watch the image change. In a short time, you will see how much the histogram helps you to see what is wrong with an image and how to improve it. As you drag the **Input Level** triangles or type numbers directly into the boxes, you can immediately see the results in your image. So magic is not necessary — you just need some sense of what looks good or bad, and a little time for experimentation.

STEP 3: APPLY THE POSTER EDGES FILTER TO POSTERIZE AND ADD LINES TO THE IMAGE

■ Now apply the **Poster Edges** filter by selecting **Filter ➢ Artistic ➢ Poster Edges**. You will get the dialog box shown in **Figure 8.4**. Try using the settings of **1, 2,** and **6** and then click **OK**.

You can see the results of your settings being applied to the portion of the image that is shown in the upper-left corner of the dialog box. If you move your cursor over the image, the cursor will change into a hand and you can click and drag the image so that you can see how the effect looks. In this case, I

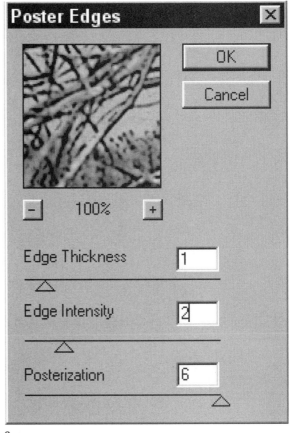

8.4

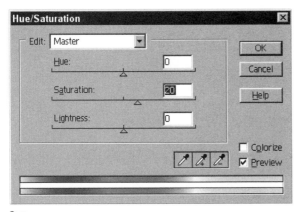

8.5

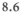

8.6

- Select **Enhance** ➢ **Color** ➢ **Hue/Saturation** (**Ctrl+H**) and then set the **Hue**, **Saturation**, and **Lightness** numbers to **0**, **20**, and **0** respectively as shown in **Figure 8.5**. You can see the results of this final change in **Figure 8.2** (**CP7**).
- Select **File** ➢ **Save As** to get the **Save As** dialog box. Select an appropriate directory and name your file, then click **Save** to save your file.

The **Poster Edges** filter worked particularly well on this image, as it adds depth to the image, especially the tree branches in the foreground.

This image (or another image created with this technique) will look wonderful on a Web page, on the front of a greeting card, on a calendar, or printed on quality paper with a photo-quality inkjet printer.

moved the image until I could see the upper corner of the grain silo and still see part of the trees.

STEP 4: ADJUST COLORS TO BRING OUT THE YELLOW SUNLIT PATCH OF GRASS IN THE MIDDLE OF THE IMAGE

Our final step is to increase the relative brightness of the yellow patch of grass that is just below the barn. Ideally, we want the overall picture to accurately reflect the late evening glow of the original scene.

CREATING A POSTER-LIKE IMAGE

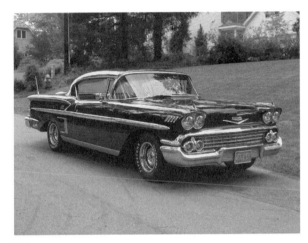

9.1

9.2

ABOUT THE PHOTO

Nikon 950 digital camera, Fine Image Quality setting, 1,600 x 1,200 pixel image size, 657KB .jpg image

One Saturday morning, I was driving downtown and became aware of an extremely shiny 1958 Chevy in the lane next to me. As I had my digital camera with me, I really wanted to ask the driver if he would allow me to take a few pictures. So, when we came to a stop light, I did. The driver and his wife were out for a leisurely drive, and they were willing to swap a few minutes of their time in exchange for a print. We drove a few blocks to find the perfect neighborhood for the car. After parking, I was able to get the image shown in **Figure 9.1**.

Since I had used a digital camera, I was able to create, print, and package the image shown in **Figure 9.2** in about fifteen minutes. There are so many advantages to using a digital camera!

Follow these steps for creating a poster-like image in minutes.

STEP 1: OPEN FILE

- Select **File ➢ Open (Ctrl+O)** Using the **Open** dialog box, locate the **/09** folder and click the folder to open it. To open the image, click the file **58chevybefore.jpg**, and then **Open**.

STEP 2: CONVERT THE IMAGE INTO A POSTER-LIKE IMAGE

- Select **Filter ➢ Artistic ➢ Cutout** to get the **Cutout** dialog box shown in **Figure 9.3**. Move your cursor over the detail image in the upper-left-hand corner of the **Cutout** dialog box until the cursor turns into a hand. Then, click and drag the image until you find the headlights and the grill.
- Using a trial and error process, you can adjust the **No. of Levels, Edge Simplicity**, and **Edge Fidelity** sliders until you get the results you want. After some experimentation, I settled on the settings of **8, 0**, and **3**. These settings kept the needed detail in the grill, yet still reduced the number of colors substantially. To apply these settings, click **OK**.

STEP 3: INCREASE COLOR SATURATION TO MAKE THE IMAGE MORE POSTER-LIKE

- Posters often feature bold colors, so I elected to increase the color saturation by selecting **Enhance ➢ Color ➢ Hue/Saturation (Ctrl+U)** to get the **Hue/Saturation** dialog box shown in **Figure 9.4**. After changing the settings to **0, 35**, and **0**, click **OK** to apply them.
- Select **File ➢ Save As** to get the **Save As** dialog box. Select an appropriate directory and name your file, then click **Save** to save your file.

The result of applying the Cutout filter and increasing color saturation is the image shown in **Figure 9.2**. An image such as this one looks wonderful when printed on a quality, smooth fine-art paper. When you do not have a photographic-quality color printer, this is an excellent technique to use to create "photographic" images. When properly framed, a print of the final image can be enjoyed for many years.

The **Cutout** filter produces results that are similar to the **Poster Edge** filter—except that it does not add the black lines around the edges of different colors.

ABOUT THE CUTOUT FILTER

The **Cutout** filter is a simple filter that has three sliders (see **Figure 9.5**) that control the way an image is posterized. Posterization is a process that significantly reduces the number of colors in an image. The results are not unlike an image that is painted with a limited number of paints that are not to be mixed. There are no gradated colors, just a limited number of solid colors.

The **Cutout** filter is very sensitive to image contrast. High-contrast images will turn out to look like silhouettes, while low-contrast images will show more solid colors. **Figure 9.6** shows the tugboat beside the New York – New York hotel in Las Vegas, Nevada, transformed with the **Cutout** filter.

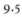

9.3

9.5

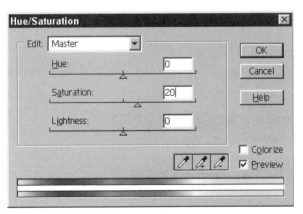

9.4

9.6

TIP

If you really enjoy creating images like the one shown in Figure 9.2, then you might want to consider attending one or more of the many antique car shows that are held all over the country. Photographing old cars can be fun. Last year I happened to be in Philadelphia when the national antique truck show was held. I was fascinated with all the old trucks and even more fascinated by the fact that many people had invested well over $100,000 in their trucks! As I went around shooting pictures just for myself, I had many owners ask me if I would take a picture for them. If you had electrical power, you could set up a notebook computer and print quality inkjet prints for them as they wait. Instant gratification is always worth a few extra bucks!

If you wanted to be even more creative, you could arrive at a show with a variety of preshot background pictures similar to the one behind the '58 Chevy. This would enable you to take photographs of vehicles and then place them in a photographic image that is much more appropriate than you are likely to get in a show environment. You'll learn more about how you can do this when you get to Techniques 20, 22, and 24 in Chapter 4.

PAINTING WITH THE SUMI-E BRUSH

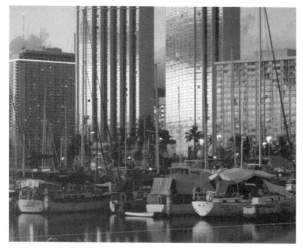

10.1 (CP10)

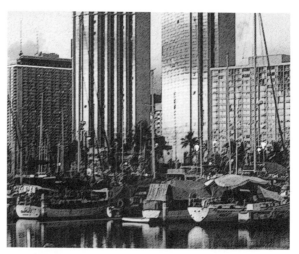

10.2 (CP9)

"Honolulu Harbor at Dusk," Canon A2e 35mm camera with EF 28-105mm f/3.5-4.5 USM zoom lens, 4" x 6" print was scanned with an HP ScanJet 4c, image cropped to 2,400 x 1,920 pixel image size, 13.2MB.tif file.

Our last two techniques resulted in wonderful final prints. For variety, this time we are going to take an image of the harbor in Honolulu, Hawaii and turn it into a "loose" sketch. Then, we'll increase color saturation for dramatic effect. We will be using a large enough file to be able to make a quality 8" x 10" print on a photographic-quality inkjet printer.

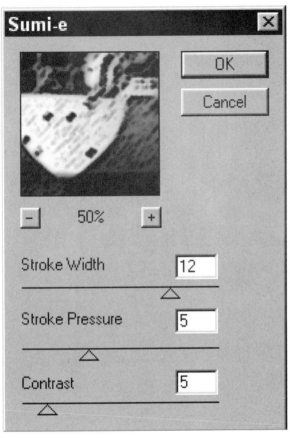

10.3

STEP 1: OPEN FILE

■ Select **File** ➢ **Open** (**Ctrl+O**) Using the **Open** dialog box, locate the **/10** folder and double-click the folder to open it. To open the image, click the file **harborbefore.tif** and then click **Open**.

STEP 2: LIGHTEN THE IMAGE

The **Sumi-e** filter that we will apply adds heavy black sketch lines to an image. If there is too much black in an image to begin with, then the image will be dark and it will lack detail. Therefore, before we apply the **Sumi-e** filter, we'll first lighten the image.

■ Select **Image** ➢ **Adjustments** ➢ **Equalize** to lighten the image.

If you intend to use the **Sumi-e** filter on an image and **Equalize** does not lighten the image sufficiently, then you should try using the **Levels** command to get the results you want.

STEP 3: APPLY BRUSH STROKES TO THE IMAGE

■ Select **Filter** ➢ **Brush Strokes** ➢ **Sumi-e** to get the dialog box shown in **Figure 10.3**.
■ Move your cursor over the preview box in the "upper-left" hand corner of the **Sumi-e** dialog box until the cursor changes into a hand. Click and drag the image until you can see one of the boat hulls. To see more of the hull, click the "minus" box to reduce the size of the preview image. You can now begin moving the three sliders until you get the results you want. I set **Stroke Width**, **Stroke Pressure**, and **Contrast** to 12, 5, and **5** respectively. Click **OK** to apply the filter.

STEP 4: INCREASE COLOR SATURATION

So far, our image is a bit on the dull side even though it has some nice brush effects. To increase color saturation, we'll once again use the **Hue/Saturation** command.

■ Select **Enhance** ➢ **Color** ➢ **Hue/Saturation** (**Ctrl+U**) to open the dialog box shown in **Figure 10.4**.
■ Try increasing **Saturation** to **+60** so that the image no longer looks washed out. To put the orange glow back on the sides of the buildings that I had remembered from the original scene, decrease **Hue** to **–10**. Click **OK** to apply the color changes. Now what do you think of the image? Pretty cool for so little work, don't you think?

■ Select **File** ➢ **Save As** to get the **Save As** dialog box. Select an appropriate directory and name your file, then click **Save** to save your file.

The harbor photo is a particularly good image to use to experiment with the **Hue/Saturation** sliders. Besides adjusting **Hue**, **Saturation**, and **Lightness** on all color channels at the same time, try selecting just one of the colors by clicking the **Edit** box in the **Hue/Saturation** dialog box and selecting: **Reds**, **Yellows**, **Greens**, **Cyans**, **Blues**, or **Magentas** — then adjust one or more colors individually. You can create outrageous results as well as more ordinary images.

TIP

The **Sumi-e** filter can produce some interesting results. Experimentation with this filter on a wide variety of images will help you learn when it will produce results you like. On a light image, it can create wonderful pencil-like sketches. If you were to start with a black and white portrait, for example, you could possibly get a wonderful pencil-sketched portrait. Try it and see what you think. If the photograph you select is color, select **Enhance** ➢ **Color** ➢ **Remove Color** (**Shift+Ctrl+U**) to turn it into a black and white image. Then try applying the **Sumi-e** filter.

10.4

MAKING A "BRUSH-LIKE" PAINTING

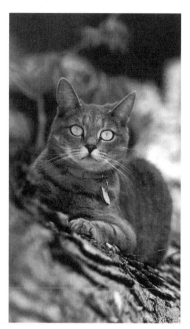

11.1

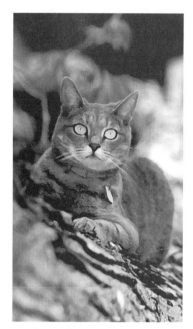

11.2

ABOUT THE PHOTO

"Yellow-eyed Cat," Canon A2E 35mm camera with 100-300mm f/4.5-5.6 EF USM, 4" x 6" print was scanned with an HP ScanJet 4c, 930 x 1,620 pixels, 4.4MB .tif file

The old saying "A dog is man's best friend" may still be true, but I doubt it. Cats *seem* to rule the world as they vastly outnumber dogs as man's favorite pet. The photograph shown in **Figure 11.1** is a great example of one cool cat. She is a mellow, yellow-eyed fur-ball that is more photogenic than any human that I have ever been able to shoot. In the picture, she is modeling her gorgeous gray coat while staring with her yellow eyes and sharpening her claws on a fallen tree trunk.

When I took this photograph, I made sure that the camera was set for a very shallow depth of field. This shallow depth of field not only helps to focus attention on her face, but it also blurs out the background, thereby removing any distractions. If you look carefully at this image, you can see that the depth of field is about eight inches — maybe six inches in front of the cat's eyes (enough to keep the paws in focus) and about two inches behind the eyes. The rest is intentionally blurred.

It is often desirable to control the depth of field when taking pictures. Shallow depths of field and blurred backgrounds can make superb images for digital editing purposes.

This image was created for use on the front of a greeting card. Many companies produce blank greeting cards with matching envelopes that are made for use with inkjet printers. International Paper makes my favorite blank greeting card. It features an embossed area for an image on a smooth vellum stock and it comes with a matching envelope. The actual image space inside of the embossed area is 3⅞" x 6¾". Using the image sizing technique described in Technique 1, the original image was scanned and cropped to fit the space before the following steps were taken.

STEP 1: OPEN FILE

■ Select **File** ➢ **Open** (**Ctrl+O**). Using the **Open** dialog box, locate the **/11** folder and double-click the folder to open it. To open the image, click the file **yelloweyedcatbefore.tif** and then click **Open**.

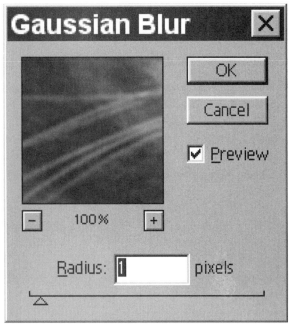

11.3

STEP 2: APPLY GAUSSIAN BLUR FILTER TO SOFTEN THE IMAGE

The **Dry Brush** filter is one of my favorite filters; however, it does not produce an image that looks as though it has been painted with a real brush. With a little pre- and postprocessing of the image, you can produce images that look more like a brushed painting.

■ To soften the edges of the image, select **Filter** ➢ **Blur** ➢ **Gaussian Blur** to get the dialog box shown in **Figure 11.3**. Move your cursor over the detail image shown in the upper-left corner of the dialog box and you will notice the cursor will turn into a hand. To see the strength of blur you are applying, you can click the image and drag it around. The cat's whiskers are an important part of the image, so I set the preview window on the whiskers. For this image, we just want to soften it a small amount, so set the **Radius** to **1.0** pixels and then click **OK** to apply the effect.

STEP 3: APPLY DRY BRUSH FILTER TO CREATE BRUSH STROKES

■ Select **Filter** ➢ **Artistic** ➢ **Dry Brush** to get the dialog box shown in **Figure 11.4**. This filter provides three sliders to give you considerable control over the effect — **Brush Size**, **Brush Detail**, and **Texture**. Using your mouse, click the triangle under **Brush Size** and slide it as you watch the real-time image preview. You'll notice that once the brush size exceeds **5**, you begin to decrease the detail in the eye that makes this a wonderful photograph. For this image, use a **Brush Size** setting of **5**.

■ Next, repeat the above bullet instructions with the **Brush Detail** and **Texture** sliders. By watching the detail image carefully, you can use the "trial and error" approach to get just the image you want. I liked the results of the settings **10** and **2**,

respectively, for the **Brush Detail** and **Texture** settings.

■ Finally, click **OK** and the image is done. Look carefully at the image and see if you can decide what can be done to improve it.

STEP 4: INCREASE IMAGE CONTRAST

I think some of the details of the image are lost in the shadows. To lighten the shadow areas, use the **Levels** command.

■ Select **Enhance ➢ Brightness/Contrast ➢ Levels** (**Ctrl+L**) to get the dialog box shown in

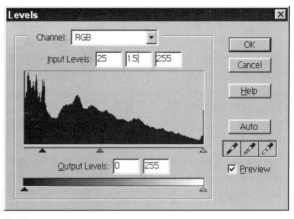

11.5

Figure 11.5. Try setting **Input Levels** at **25, 1.5,** and **255.** Then, click **OK**.

STEP 5: SOFTEN EDGES WITH SMART BLUR FILTER

If you take a close look at the image, you may wish that the edges of each color were not so pronounced. To soften these edges, we'll use one of the most useful filters — the **Smart Blur** filter.

■ Select **Filter ➢ Blur ➢ Smart Blur** to get the dialog box shown in **Figure 11.6**. Once again, you can use the image preview box to experiment with the settings until you get the results you want. After setting **Quality** to **High**, and making sure **Mode** was set on **Normal**, I set **Radius** to **2** and **Threshold** to **30**. A click on the **OK** button, and the image looks much better.

One of the time-honored rules of taking photographs of subjects with eyes is to make sure that the eyes are in-focus. Whether it is a bird, a child, an adult, a soccer player, or even the yellow-eyed cat used in this example, your pictures will usually look better with eyes that are clear and in focus. Therefore, just to get the eyes correct, we'll ignore the fact we were trying to complete this image in as few steps as possible — the eyes really need some work.

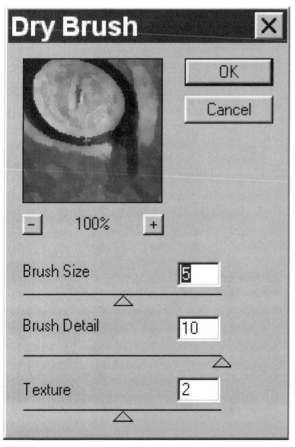

11.4

STEP 6: PAINT HIGHLIGHTS BACK ONTO THE EYES

The application of the **Dry Brush** filter removed the very important highlight (the bright white spot in the center of the eye) and the black vertical slit in each pupil. Paint them back in. Since the highlight is on top of the black slit, you should first paint the black slits in the pupils.

■ To select the **Paintbrush** tool, press **B**. You can also select the **Paintbrush** by clicking it in the tool box.

■ Before beginning to paint, make sure you have black in your brush by clicking the **Foreground**

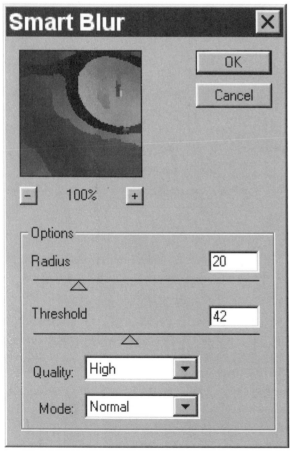

11.6

color box on the tool box and setting it to **black**. The size and quality of the **Paintbrush** can be selected by clicking the options bar directly below the menus. Click the down arrow and you will be given a choice of brushes, as shown in **Figure 11.7**. If you hold your cursor over each brush for a couple of seconds, a tool-tip will pop up showing you the name and size of each brush. Try the **Hard Round 3 Pixel** brush to paint the vertical black line in each eye to match that of the original image.

■ To paint the highlights properly, you may want to look at the original image once again to see the exact sizes and locations of the highlights. It will just take a click or two on each eye to paint the important highlights back. Once again, go to the toolbox and set the **Foreground** color, only this time set the color to white.

■ To paint the white highlight, select one of the smaller, softer brushes, such as the **Soft Round 13 Pixels** brush. With a couple of clicks in each eye, you will have two realistic eyes.

■ Select **File ➢ Save As** to get the **Save As** dialog box. Select an appropriate directory and name your file, then click **Save** to save your file.

Now the image is complete. The image is ready to be placed on a greeting card, or anywhere else you'd like to use an image of a yellow-eyed cat.

11.7

CREATING A UNIQUE IMAGE WITH MULTIPLE FILTERS

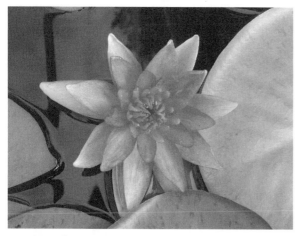

12.1 (CP12)

12.2 (CP11)

ABOUT THE PHOTO

"Water lily," Nikon 950 digital camera, Fine Image Quality setting, 1,600 x 1,200 pixels, 849KB .jpg image

In this chapter, we have looked at four techniques, which I call "single-click" filter techniques. These techniques often produce cool images with a single click. We have also looked at different kinds of pre- and postprocessing that can be done to make these filters produce even better results. For the last technique in this section, we are going to look at how you can apply multiple "single-click" filters to an image to produce some truly creative images.

STEP 1: OPEN FILE

■ Select **File ➢ Open** (**Ctrl+O**). Using the **Open** dialog box, locate the **/12** folder and double-click the folder to open it. To open the image, click the file **lilybefore.jpg** and then **Open**.

STEP 2: APPLY THE SOLARIZE FILTER JUST FOR THE FUN OF IT

■ Select **Filter ➢ Stylize ➢ Solarize** and the image is immediately changed into a strange, muddy-looking image with weird colors.

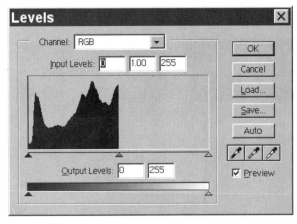

12.3

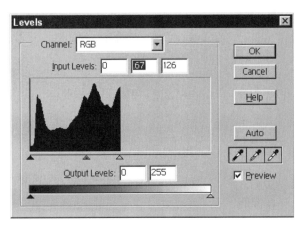

12.4

While the colors don't look particularly good, they are different and they look like they might be able to be changed into something better. So, adjust the colors by once again using the **Levels** tool.

STEP 3: ADJUST THE COLORS FOR A MORE INTERESTING LOOK

■ Select **Enhance ➢ Brightness/Contrast ➢ Levels** (**Ctrl+L**) and you will once again see the **Levels** dialog box appear. Wow! When you see the histogram shown in **Figure 12.3**, you can immediately see why the colors look so very strange. No pixels are shown on the entire right half of the histogram, indicating that there are no bright pixels in the image.

■ To spread out the tonal range, click the right white triangle under the histogram and slide it to the right end of the histogram. As you do this, the colors will improve. Keep sliding the white triangle until the third box after **Input Levels** displays **126.**

■ The mid-tones are still a little light, so slide the gray triangle over closer to the right. Move it until the middle **Input Levels** box shows **.67** as is shown in **Figure 12.4.** Click **OK.**

The image looks much better. It has a very artsy look to it and some rather cool colors, I think. If you disagree, keep experimenting until you do approve.

So that you understand the **Levels** feature a bit better, once again select **Enhance ➢ Brightness/ Contrast ➢ Levels** (**Ctrl+L**) and take a look at the new histogram. It will look like the one shown in **Figure 12.5.** The tonal range is now spread out more — that is, there are darker darks and lighter lights. However, you will also notice that we have lost some tones. The lack of a solid black histogram indicates that the tonal range was spread out, which caused the gaps that are shown in the histogram. Now, click **Cancel** to close the **Levels** dialog box.

In my opinion, and I grant you that it may vary from yours, this image is beginning to look like it has some potential. You (as the creator) always have the option of doing what you want to do to it. Sometimes, you just have to experiment. In this case, apply the **Ink Outlines** filter just to see how the filter will interact with the work we've done so far.

STEP 4: ADD INK LINES

- Select **Filter ➤ Brush Strokes ➤ Ink Outlines** and you will get the dialog box shown in **Figure 12.6**. My suggestions are to use settings of **15, 15,** and **30.** Click **OK** and you will get the final image shown in **Figure 12.2 (CP11)**.
- Select **File ➤ Save As** to get the **Save As** dialog box. Select an appropriate directory and name your file, then click **Save** to save your file.

This final image may not win any fine art awards, but my hope is that its creation and this technique illustrates that there are limitless opportunities to create unique images by combining two or more filters. As you try more combinations, you will find that you can produce amazing results.

The important lesson to learn from this technique is that you *need* to experiment. As with all other kinds of art medium (such as watercolor, acrylic paint, or even colored pencils), artistic creation with a digital image-editor is only limited by your creativity. Your creativity can be improved with experimentation and lots of practice.

Be sure to try these quick and easy techniques the next time you want to create your own greeting cards, when you are adding images to a newsletter, or when you need Web art. The possibilities are endless. In the next chapter, we will look at six techniques that will enable you to change the color in your images — in subtle and radical ways.

12.5

12.6

TIP

In **Technique 12**, the **Ink Outlines** filter was applied as the last step. Other alternative filters for **Step 4** include but are not limited to the following:

Filter ➢ **Artistic** ➢ **Dry Brush**

Filter ➢ **Brush Strokes** ➢ **Spatter**

Filter ➢ **Brush Strokes** ➢ **Sumi-e**

Filter ➢ **Brush Strokes** ➢ **Angled Strokes**

When you are trying these different combinations of filters, also try applying the same filter more than one time. To blend the ink lines or the results of one of the brush stokes, you may want to try applying the Median filter (**Filter** ➢ **Noise** ➢ **Median**) with a very low **Radius** setting such as **1**, **2**, or maybe **3**.

3

IMAGE COLORING TECHNIQUES

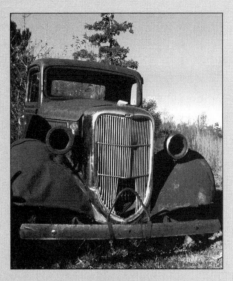

Most image editors offer dozens of color-changing features and tools. However, some of the most powerful ways to alter the colors in a digital photo have more to do with technique than the application of a filter. This chapter is dedicated to improving your color-changing abilities. Appropriately, a digital photograph of a chameleon is used to introduce basic color-changing tools in Technique 13. Atmosphere and light are added to a photo of a forest by using a color gradient in Technique 14. Technique 15 shows how to quickly, easily, and accurately change the color of specific image elements. Technique 16 shows how to perform radical color transformations. Technique 17 shows you how to make a monochromatic image. The last technique shows how one image can be used to change the colors in another image.

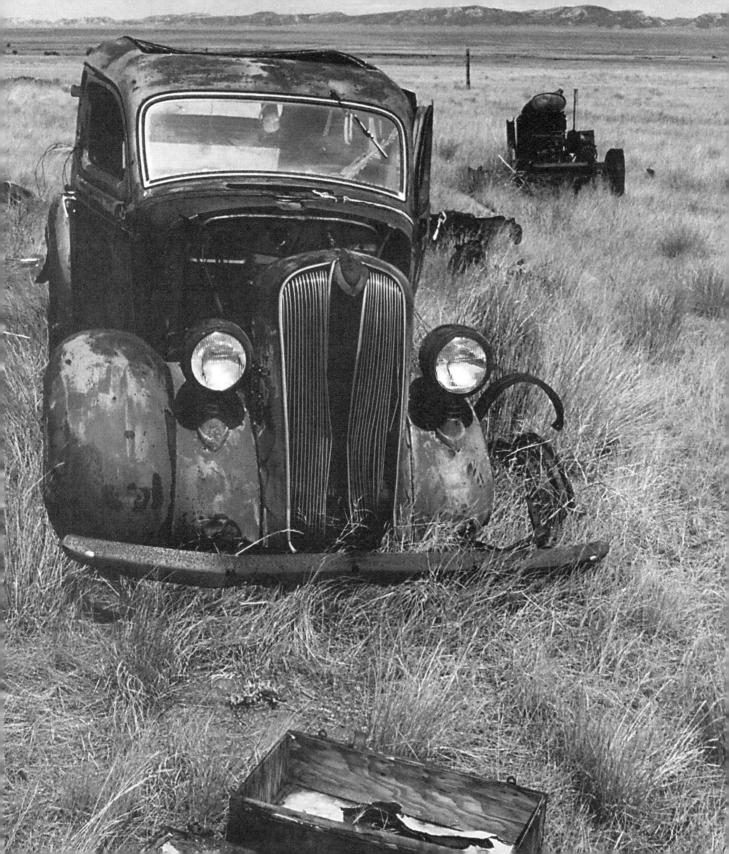

CHANGING COLORS

13.1 (CP14) 13.2 (CP13)

C hanging colors is very easy with a digital image editor. This technique shows how to increase color saturation and to change hue. The photo shown in **Figure 13.1 (CP14)** is of a chameleon that I found in my backyard; rather, I should say, my cat found it in my backyard. Although the cat usually prefers finding snakes, birds, or an occasional mole, it also enjoys watching a chameleon change colors. The photo was taken in the fall a few days after the leaves began to change to a red/orange color.

To begin this technique, we'll increase color saturation and improve the overall color of the image. Then we'll change the leaves and chameleon back to the colors they were a few days earlier before the first freeze that prompted the plants (and the chameleon) to change colors.

STEP 1: OPEN FILE

- Select **File ➤ Open** (**Ctrl+O**) to display the **Open** dialog box. Double-click the **/13** folder to open it. Then, click the **chameleon-before.jpg** file to select it. Click **Open** to open the file.

STEP 2: INCREASE TONAL RANGE AND SHARPEN IMAGE

- Select **Enhance ➤ Brightness/Contrast ➤ Levels** (**Ctrl+L**) to get the **Levels** dialog box shown in **Figure 13.3**. Set **Input Levels** to **27, 1.0,** and **218** and then click **OK** to apply the settings.
- Select **Filter ➤ Sharpen ➤ Unsharp Mask** to get the **Unsharp Mask** dialog box shown in **Figure 13.4**. Click inside the preview box with your cursor and drag the image until you see the eye. Experiment with the settings until you get just the added sharpness you want. Try using **200**, **2**, and **10** for **Amount**, **Radius**, and **Threshold** respectively.

STEP 3: CHANGE RED COLOR INTO GREEN

The image is now sharp, appears fully saturated, and looks like the subject looked when I shot it. Now, change the colors of the leaves to make them look like they looked a few days earlier before the first cold weather caused the change toward the red-orange tones.

- Select **Enhance ➤ Color ➤ Hue/Saturation** (**Ctrl+U**) to get the **Hue/Saturation** dialog box shown in **Figure 13.5**. Set **Hue**, **Saturation**, and **Lightness** to **+35, +15,** and **0** respectively and then click **OK** to apply the settings.

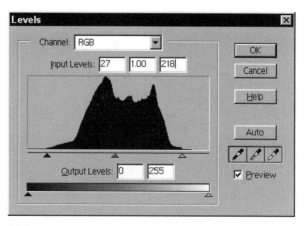

13.3

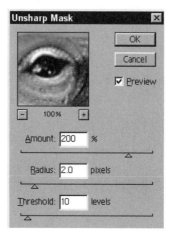

13.4

■ To remove the last bit of the red/orange color in the leaves, once again select **Enhance** ➢ **Color** ➢ **Hue/Saturation** (**Ctrl+U**) to get the **Hue/Saturation** dialog box. This time, click the **Edit** box and select **Reds** (**Ctrl+1**) to edit just the red. You can either drag the **Hue** and **Saturation** sliders until all of the red/orange color is gone, or you can enter **+40**, **+30**, and **0** for **Hue**, **Saturation**, and **Lightness** respectively. Click **OK** to apply the settings.

■ Select **File** ➢ **Save As** to get the **Save As** dialog box. Select an appropriate directory and name your file, and then click **Save** to save your file.

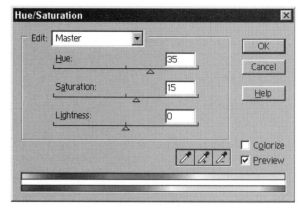

13.5

The chameleon is now back in his natural green environment without any of the red/orange colors that fall brought. In addition, the image looks much better as it has a wider tonal range; in other words, there are darker darks, lighter lights, and better midtones. The image is now sharper.

ADDING LIGHT AND ATMOSPHERE

14.1

14.2

ABOUT THE PHOTO

"Summer Rays of Light," Nikon 950 digital camera, Fine Image Quality setting, 1,200 x 1,600 pixel image size, 634KB .jpg file

f you have ever been in a slightly misty or fogging clearing in a forest an hour or so before the sun was coming up or going down, you may have seen rays of colored light shining through the trees. This technique shows how such an atmosphere may be created from an otherwise ordinary image. The photo shown in **Figure 14.1** was taken in the woods near my home about an hour and a half after sunrise.

STEP 1: OPEN FILE

■ Select **File ➤ Open (Ctrl+O)** to display the **Open** dialog box. Double-click the **/14** folder to open it. Then, click the **forest-before.tif** file to select it. Click **Open** to open the file.

STEP 2: ADJUST IMAGE

■ Select **Enhance ➤ Brightness/Contrast ➤ Levels (Ctrl+L)** to get the **Levels** dialog box shown in **Figure 14.3**. Set **Input Levels** to **0**, **1.1**, and **240**, and then click **OK** to apply the settings.

STEP 3: ADD COLOR GRADIENT

■ Select **Layer ➤ New Fill Layer ➤ Gradient** to get the **New Layer** dialog box shown in **Figure 14.4**. Click the **Mode** box to select **Overlay** as the

blend mode. Then click **OK** to get the **Gradient Fill** dialog box, as shown in **Figure 14.5**.

■ To select the gradient, click inside the **Gradient** box (not the arrow at the right side of the **Gradient** box). The **Gradient Editor** shown in **Figure 14.6** will appear. Click the right triangular arrow to the right of the **Presets** box and select **Noise Samples**.

■ The second gradient from the left on the top row should now be the **Greens** gradient. Click the **Greens** gradient and the **Name** should show as **Greens**. Click **OK**.

■ Once again, you'll see the **Gradient Fill** box shown in **Figure 14.5**. Set **Style** as **Reflected** and **Angle** as **60** degrees. Click **OK** to apply the gradient fill.

STEP 4: MAKE FINAL IMAGE ADJUSTMENTS

■ The **Layers** palette should now look like **Figure 14.7**. If you don't see the **Layers** palette, select **Window ➤ Show Layers**. Click the **Gradient** layer to make it the active layer and adjust **Opacity** to **90%** to reduce the strength of the rays of light in the image.

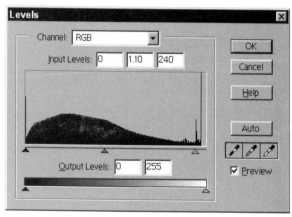

14.3

14.4

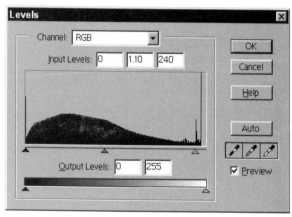

14.5

If the results from using the suggested **Opacity** setting do not produce excellent results, you may need to make further adjustments. Slightly different monitor settings can produce very unacceptable results; therefore, you will need to compensate for your monitor.

- Select **Layer ➢ Flatten Image** to flatten the image.
- Select **File ➢ Save As** to get the **Save As** dialog box. Select an appropriate directory and name your file, and then click **Save** to save your file.

14.6

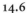
14.7

CHANGING THE COLOR OF IMAGE ELEMENTS

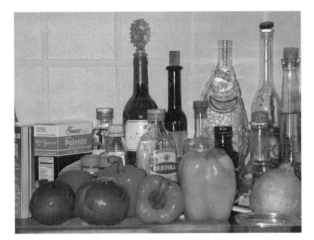

15.1

15.2

M any times the colors of a specific object need to be changed — rather than making global changes to an entire image. The photo shown in **Figure 15.1** shows a variety of ingredients that may be used to create Italian food. The photo shows both red and white onions, red tomatoes, and orange and yellow bell peppers. Using the magic capabilities of a digital image editor, you can change the colors of some of the ingredients to look like they might be ingredients for a rather unusual, yet colorful Italian feast.

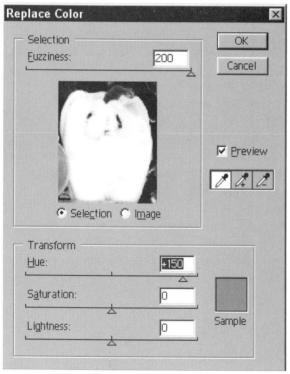

15.3

15.4

STEP 1: OPEN FILE

- Select **File ➢ Open** (**Ctrl+O**) to display the **Open** dialog box. Double-click the **/15** folder to open it and then click the **ingredients-before.jpg** file to select it. Click **Open** to open the file.

STEP 2: CHANGE COLOR OF YELLOW PEPPER

Several tools are available that may be used to change the yellow pepper into a blue pepper. Since we want to make this color transformation as easy as possible, use the **Replace Color** feature.

Replace Color selects an area according to a specified color and gives you the same control over color that you get with the **Hue/Saturation**. The good news is that you don't have to worry about making a perfect selection if the colors you want to change are unique or can easily be surrounded by a selection marquee.

As several objects in the image are yellow, use a selection marquee to quickly select an area that contains the yellow pepper only. Make sure to carefully select the area between the orange pepper and the cutting board, as they both have yellow in them.

- Click the **Lasso** tool (**L**) in the toolbox and then draw a rough selection marquee around the yellow pepper, as shown in **Figure 15.3**. This will isolate the yellow areas that will undergo a color change.
- Select **Enhance ➢ Color ➢ Replace Color** to get the **Replace Color** dialog box shown in **Figure 15.4**. Set **Fuzziness** to **200**, and then click inside the preview box or inside the image to select the area you want to color. As you click, you will see the pepper turn white in the preview box, indicating that you have selected the yellow pepper. You may want to click different spots on the pepper until you get the best possible section of the pepper.

As you select different ingredients, try varying the **Fuzziness** setting to adjust the tolerance of the selection mask. In other words, adjust the **Fuzziness** setting to adjust the degree to which related colors are included in the selection. A **200** setting is the loosest setting, which includes the most related colors, whereas a **0** setting is the tightest setting, having the least tolerance.

You can also add to selected areas by using **Shift+ Click** or the "Eye Dropper +" button to add areas; or by using **Alt+Click** or the "Eye Dropper –" button to remove areas. Additionally, you can use **Shift** +, or **Alt** +drag the Eye Dropper to add or remove all the colors over which you drag the Eye Dropper.

- If the **Preview** box is checked in the **Replace Color** dialog box and you adjust the **Hue**, **Saturation**, and **Lightness** sliders, you can see the yellow pepper's color change. For a nice blue pepper, try setting **Hue** to **150**. Click **OK** to apply the colors.

STEP 3: REPEAT STEP 2 TO CHANGE THE COLOR OF THE OTHER VEGETABLES

- Select **Select** ➢ **Deselect** (**Ctrl+D**) to remove the last selection marquee.

Repeat **Step 2** for each of the other vegetables until they all have delicious and bright colors. When you are done, you should have an image that looks similar to the one shown in **Figure 15.2**. Although you may not want to find sky blue and pink peppers or purple tomatoes in your pasta sauce, this image does illustrate the power of the **Replace Color** tool and how it can be used to control how colors are changed.

- Once all the vegetables have been appropriately colored, select **File** ➢ **Save As** to get the **Save As** dialog box. Select a directory and name your file. Then, click **Save** to save your file.

PERFORMING RADICAL COLOR TRANSFORMATION

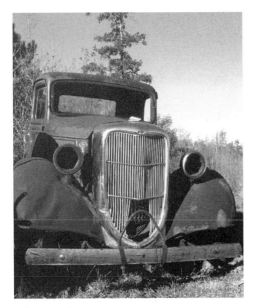

16.1 (CP16)

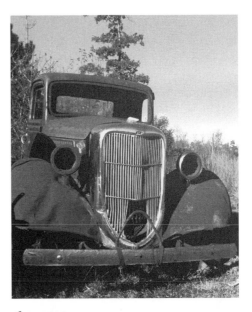

16.2 (CP15)

"1936 Ford Pickup Truck," Canon EOS1v, 28-70mm f2.8 zoom lens, Kodak Gold 400 ISA print film, negative scanned with Polaroid SprintScan 4000, 1,920 x 2,400 pixel image size, 13.2MB .tif file

The photo shown in **Figure 16.1 (CP16)** is of a 1936 Ford pickup. I shot the photo as the sun was setting. The left side of the truck was covered by a shadow from another 1936 Ford that was parked next to it, so I had to crop the picture. My camera exposure was not quite right, so the sky is burned out as it nears the horizon. I also was not able to successfully scan the negative and get an acceptable sky or rust color. Other than those few things, I really like the picture! My conclusion was to perform a radical color transformation on the image.

This technique is a simple one. To increase the tonal range, you'll duplicate the image as a layer and blend it with the background. A series of successive color changes create a green and orange image, as shown in **Figure 16.2 (CP15).**

STEP 1: OPEN FILE

- Select **File ➢ Open** (**Ctrl+O**) to display the **Open** dialog box. Double-click the **/16** folder to open it and then click the **36ford-before.tif** file to select it. Click **Open** to open the file.

STEP 2: INCREASE COLOR SATURATION

- Select **Layer ➢ Duplicate Layer** to get the **Duplicate Layer** dialog box. Click **OK** to create a new layer containing a copy of the background layer. The **Layers** palette should now look like **Figure 16.3**. If the **Layers** palette is not visible, select **Window ➢ Show Layers**.
- Make sure the "background copy" layer is high-lighted indicating it is the active layer. Set the blend mode to **Multiply** by clicking the mode box in the **Layers** palette and selecting **Multiply**. Then, set **Opacity** to **30%**.
- Select **Layer ➢ Flatten Image** to flatten the image.

16.3

- Select **Enhance ➢ Color ➢ Hue/Saturation** (**Ctrl+U**) to get the **Hue/Saturation** dialog box shown in **Figure 16.4**. Set **Hue** to **180** and leave **Saturation** and **Lightness** set to **0**. Click **OK** to apply the settings.

STEP 3: FINE-TUNE COLORS

The image looks good — except for the red tones in the sky. I would prefer an all-orange and yellow sky.

- Select **Enhance ➢ Color ➢ Hue/Saturation** (**Ctrl+U**) to once again get the **Hue/Saturation** dialog box. This time, click the **Edit** box and select **Reds** (**Ctrl+1**), as we only want to adjust the color red. Set **Hue** to **+40**.
- Click the **Edit** box and select **Yellows** (**Ctrl+2**). Set **Yellows** to **–20, 50,** and **0,** and then click **OK** to apply the color changes.
- Select **Enhance ➢ Variations** to get the **Variations** dialog box shown in **Figure 16.5**. Make sure there is a checkmark next to **Midtones**. Click once on the **Darker** image to darken the image. Click **OK** to apply final color changes.

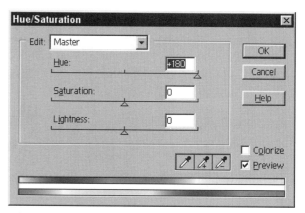

16.4

■ Select **Enhance ➢ Brightness/Contrast ➢ Levels** (**Ctrl**+**L**) to get the **Levels** dialog box shown in **Figure 16.6**. Set **Levels** to **15**, **.85**, and **255** and then click **OK** to apply the changes.

■ Select **File ➢ Save As** to get the **Save As** dialog box. Select an appropriate directory and name your file. Then, click **Save** to save your file.

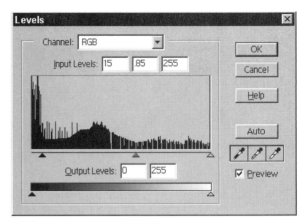

16.6

16.5

USING A MONOCHROMATIC SCHEME

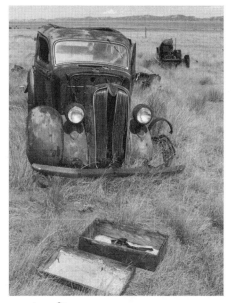

17.1 (CP18)

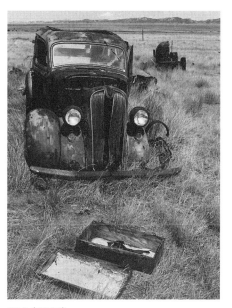

17.2 (CP17)

ABOUT THE PHOTO

"Empty and Abandoned," Canon A2E, 28-105 f/3.5-4.5 zoom lens, Kodak print film, negative scanned with Polaroid SprintScan 4000, 1,335 x 2,003 pixel image size, 7.66MB .tif file

The photo shown in **Figure 17.1 (CP18)** is one of my favorite photographs — partly because of where it was taken and partly because of the memories that I have of my visit to the site. I took the photograph about fifteen years ago when I visited a ghost town in Wyoming. It was where I lived from birth until about age three. This photo with the old car and opened suitcase has always been one of my favorites to digitally edit. Because the negative is difficult to scan, strange yellows appear in the dried grass, and the sky is washed out, it is not an easy photo to work with. Nevertheless, I love the rich rust colors in the old car and the open suitcase that has probably been there for more than fifty years! Because of the rich rust colors and the field of dry grass, I thought this would make an excellent image to use for this technique for creating a monochromatic image.

STEP 1: OPEN FILE

■ Select **File** ≻ **Open** (**Ctrl+O**) to display the **Open** dialog box. Double-click the **/17** folder to open it and then click the **suitcase-before.tif** file to select it. Click **Open** to open the file.

STEP 2: ADD COLOR LAYER

■ Select **Layer** ≻ **New Fill Layer** ≻ **Solid Color** to get the **New Layer** dialog box shown in **Figure 17.3**. Set **Mode** to **Hue** and leave **Opacity** to **100%**. Click **OK** to get the **Color Picker** dialog box shown in **Figure 17.4**. Set **H, S,** and **B** to **40, 80,** and **100** respectively. Click **OK** to create the new color layer.

STEP 3: ADD LEVELS ADJUSTMENT LAYER

■ Select **Layer** ≻ **New Adjustment Layer** ≻ **Levels** to get the **New Layer** dialog box. Set **Mode** to **Multiply** and leave **Opacity** set to **100%**. Click **OK** to get the **Levels** dialog box shown in **Figure 17.5**.
■ Set **Input Levels** to **30, 1.20,** and **210**. Click **OK** to apply the settings.

Your **Layers** palette should now appear similar to the one shown in **Figure 17.6**. The advantage of using adjustment layers is that you can double-click either the **Levels** or the **Color Fill** layer and modify the settings as often as you desire. If the car appears to have detail lost in the dark areas, double-click the **Levels** layer and reset the midtones. If you really want a green image rather than the gold one, double-click the **Color Fill** layer and choose a green color.

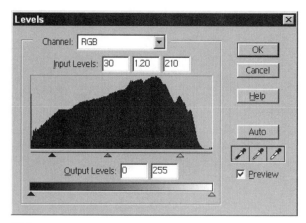

17.5

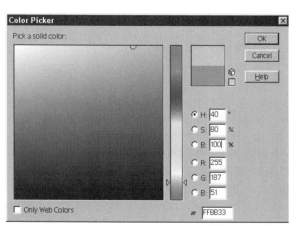

17.3

17.4

STEP 4: FLATTEN IMAGE AND MAKE FINAL ADJUSTMENTS

■ If you are happy with the image as it is, select **Layer ➤ Flatten Image** to flatten the image.

■ To sharpen the image, select **Filter ➤ Sharpen ➤ Unsharp Mask** to get the **Unsharp Mask** dialog box shown in **Figure 17.7**. Set **Amount**, **Radius**, and **Threshold** to **150%, 2.0** pixels, and **10** levels respectively.

■ Select **File ➤ Save As** to get the **Save As** dialog box. Choose an appropriate directory and name your file. Next, click **Save** to save your file.

STEP 5: ADD BLUR EFFECT (OPTIONAL)

Admittedly, I sometimes don't know when to stop working on an image. In case you would like to add a bit of a watercolor-like blur to this image, try the following:

■ Select **Filter ➤ Blur ➤ Smart Blur** to get the **Smart Blur** dialog box shown in **Figure 17.8**. Set to **Radius** to **3** and **Threshold** to **25** respectively. Click **OK** to transform the monochromatic photograph into a blurry watercolor-like image.

17.6

17.7

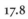

17.8

GETTING COLOR FROM
A SECOND IMAGE

18.1a (CP20)

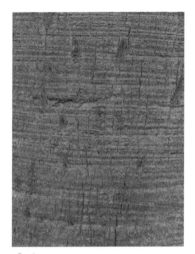

18.1b (CP20)

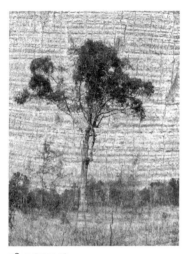

18.2 (CP19)

The tree shown in **Figure 18.1a (CP20)** was taken in Bamberg, South Carolina. The detail image of the tree trunk in **Figure 18.1b (CP20)** was taken in the desert in Sedona, Arizona. While these may seem like an unlikely combination of images to use together, the trunk image has good color and some out-of-the-ordinary texture that may work well with the rather dreary photo of the tree. **Figure 18.2 (CP19)** shows the results and how the two images were combined to create an entirely new image.

To get maximum control over each of the two images before they are blended, this technique uses adjustment layers. This allows an unlimited number of nondestructive changes to be made to each image until the results are as desired. The layers are then combined and a final few adjustments are made.

STEP 1: OPEN FILE

■ Select **File** ➢ **Open** (**Ctrl+O**) to display the **Open** dialog box. Double-click the **/18** folder to open it and while pressing **Ctrl**, click the **tree.jpg** file and the **trunk.jpg** file to select them both. Click **Open** to open the files.

STEP 2: MAKE INITIAL IMAGE ADJUSTMENTS TO THE TREE IMAGE

■ Click **tree.jpg** to make it the active image. Select **Enhance** ➢ **Brightness/Contrast** ➢ **Levels** (**Ctrl+L**) to get the **Levels** dialog box shown in **Figure 18.3**.

The histogram in the **Levels** dialog box clearly shows why the tree image is so drab. Since the tonal range is severely limited, the histogram has few pixels in almost a third of the tonal range. This is an easy fix with the **Levels** tool.

■ In the **Levels** dialog box, set **Input Levels** to **0**, **.60**, and **175** and then click **OK** to apply the settings. The image looks much better already.

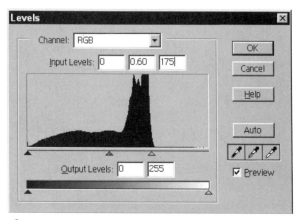

18.3

■ Increase color saturation by selecting **Enhance** ➢ **Color** ➢ **Hue/Saturation** (**Ctrl+U**) to get the **Hue/Saturation** dialog box shown in **Figure 18.4**. Set **Hue** to **+4** and **Saturation** to **40** and then click **OK** to apply the settings.

STEP 3: COPY AND PASTE TRUNK IMAGE INTO TREE IMAGE AS A NEW LAYER

■ Click the **trunk.jpg** image to make it the active image. Select **Select** ➢ **All** (**Ctrl+A**) to select the entire image, then select **Edit** ➢ **Copy** (**Ctrl+C**) to copy the image into memory.

■ Click the **tree.jpg** image to make it the active image. Select **Edit** ➢ **Paste** (**Ctrl+V**) to paste the trunk image into the tree image, as a second layer.

■ Click the **Layer 1** thumbnail in the **Layers** palette to make it the active layer. If you don't see the **Layers** palette, select **Window** ➢ **Show Layers**.

■ This is an important step! Make sure you click the blend mode box in the upper-left-hand corner of the **Layers** palette and select **Multiply** as the blend mode.

18.4

STEP 4: CREATE LEVELS ADJUSTMENT LAYERS FOR BOTH LAYERS

At this point, the **Layers** palette should look like **Figure 18.5**. We will now add a **Levels** adjustment layer to each of the two layers so that **Levels** may be adjusted on each layer until the desired results are achieved.

- Click the **Layer 1** (the trunk layer) thumbnail in the **Layers** palette to make **Layer 1** the active layer.
- Select **Layer** ➢ **New Adjustment Layer** ➢ **Levels** to get the **New Layer** dialog box shown in **Figure 18.6**. Click **OK** to get the **Levels** dialog box shown in **Figure 18.7**.
- Try setting **Input Levels** to **0**, **1.0**, and **155**. Click **OK** to apply the settings.

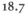

18.5

Now, we will do the same thing to the **Background** layer (the tree layer) — add a **Levels** adjustment layer and make appropriate adjustments.

- Click the **Background** layer (the tree layer) thumbnail in the **Layers** palette to make the tree layer the active layer.
- Select **Layer** ➢ **New Adjustment Layer** ➢ **Levels** to get the **New Layer** dialog box. Click **OK** to get the **Levels** dialog box. Set **Input Levels** to **15**, **1.25**, and **240**, then click **OK** to apply the settings.

18.6

18.7

18.8

Look at the **Layers** palette. It should look like **Figure 18.8**. To make further changes to either of the **Levels** adjustment layers, simply double-click the adjustment layer and the **Levels** dialog box will appear with your last settings. Make changes and click **OK** to apply them. You can continue to make adjustments to either layer until the image looks right.

STEP 5: FLATTEN IMAGE

- Select **Layers** ➢ **Flatten Layers** to flatten the image.
- Select **File** ➢ **Save As** to get the **Save As** dialog box. Select an appropriate directory and name your file, then click **Save** to save your file.

You've now reached the end of this chapter on image coloring techniques. In the next chapter, you'll learn six techniques that will help you combine two or more images.

CHAPTER **4**

COMBINING TWO OR MORE IMAGES

I n the first three chapters, eighteen techniques showed how digital photographs can be enhanced, altered, and transformed using quick and easy filters, as well as showing how colors can be manipulated in many ways. In this chapter, six useful techniques for combining two or more images are presented.

You'll learn how you can stack two or more images as layers and then combine them into a single new image by using powerful digital blending modes. Two techniques will cover the "cut and paste" technique that enables you to cut "objects" out of images and then add them seamlessly to another image. Another technique introduces Photoshop Elements' Photomerge feature, which can be used to digitally stitch two or more images together to create vertical or horizontal panoramic images. You'll also learn how you can use a clone brush to paint parts of one image directly into another image. The sixth and final technique demonstrates how several of the techniques in this chapter can be used together to create a single more complex and fascinating image.

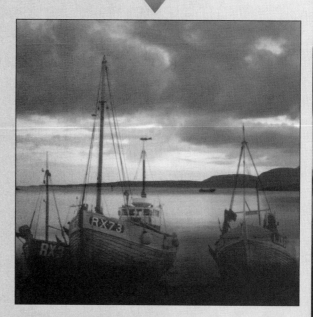

COMPOSITING TWO IMAGES

19.1 (CP22)

19.2 (CP21)

When I saw the group of three English fishing boats shown in **Figure 19.1 (CP22)**, I thought that they would make a magnificent photograph. As soon as I begin shooting, I quickly realized how difficult it would be to get a good photograph. The bright (almost white) sky was in extreme contrast with the dark (almost black) sides of the boats that were covered in shadow, thereby making it impossible to get a well-exposed image. After shooting a few photographs, I left wishing that I had time to come back and shoot them again in different light — but sadly, not all wishes come true.

Several days later, while on the coast of the Isle of Skye in Scotland, I had an opportunity to shoot the single, very small boat also shown in **Figure 19.1(CP22)**. As I took a few pictures, I could not help wondering what the three large fishing boats would look like on this stunning orange coastline. Technique 19 shows how these two images can easily be combined to create the image that I had imagined, which is shown in **Figure 19.2 (CP21)**. The best part about this technique is that it is very easy to do.

STEP 1: OPEN FILES

■ Select **File** ➢ **Open** to get the **Open** dialog box. Click the **/19** folder, press and hold **Ctrl**, and then click files **orangecoast.tif** and **fishingboats.tif** to highlight them. Click **Open** to open both files.

STEP 2: COPY THE FISHING BOATS IMAGE AND PASTE IT INTO THE COAST IMAGE

■ After clicking the "fishing boats" image to make it the active image, click **Select** ➢ **All** (**Ctrl+A**), then **Edit** ➢ **Copy** (**Ctrl+C**) to copy the image.

■ Click the "orange coast" image to make it the active image and then select **Edit** ➢ **Paste** (**Ctrl+V**).

This will create a new layer on top of the "orange coast" image.

■ If the **Layers** palette is not already visible, select **Window** ➢ **Show Layers** to get the **Layers** palette shown in **Figure 19.3**.

Even though you can no longer see the "orange coast" image where you just pasted the "fishing boats" image, you can use the **Layers** palette to see that it is one layer below the "fishing boats" image. To view the bottom layer, click the eye icon to the left of **Layer 1**. This will "turn off" **Layer 1** and enable you to view the background image. To continue, once again, click the eye icon to the left of **Layer 1** to make it visible.

19.3

ABOUT LAYERS

One of the most powerful features of advanced image editors is their capability to allow two or more images to be layered in the same digital image file. This layering of digital images is very similar to laying several sheets of tracing paper on top of each other. If you don't have too many pages of tracing paper, you can see all the drawings on all the tracing papers merged into a single picture.

In Photoshop Elements, you have extensive control over how layers are ordered and combined. **Figure 1** shows the **Layers** palette with a background image and four additional layers, which are used to make the "soccer goalie" image shown in Technique 23.

To select, create, duplicate, rename, merge, link, lock, make visible, hide, set blend mode, or **Opacity** level, use the **Layers** palette. The **Layers** palette makes it easy for you to visually keep track of the layers as it automatically keeps updated thumbnail images of each layer. Additional options for controlling layers are available from the **Layer** menu. The background layer is unlike all the other layers. It is always the bottom layer. **Blending** modes (how one layer is blended with the layers below), and **Opacity** levels (level of transparency

1

STEP 3: COMPOSITE THE TWO IMAGES TOGETHER SO THAT THEY ARE BOTH VIEWABLE

Next, we will select a **Blend** mode. This will determine how the pixels of the "fishing boats" image will *blend* with the underlying pixels of the "orange coast" image. To select a **Blend** mode, click the popup menu at the top left of the **Layers** palette to get the **Blend Mode** pop-up menu. Available **Blend** modes are: **Normal**, **Dissolve**, **Multiply**, **Screen**, **Overlay**, **Soft Light**, **Hard Light**, **Color Dodge**, **Color Burn**, **Darken**, **Lighten**, **Difference**, **Exclusion**, **Hue**, **Saturation**, **Color**, and **Luminosity**.

- Click in the **Blend** mode box to get the pop-up menu, and then select **Multiply**.

With any one of 17 different modes to select, you are likely to find at least one mode that results in an image to suit your taste. Besides choosing a **Blend** mode, an **Opacity** slider allows you to select the opacity level ranging from 0 to 100%.

The best way to learn about the many **Blend** modes is to experiment with them. Before going on to the next step, take a few minutes, select each of the **Blend** modes, and examine the results. You might find others you like more than **Multiply**. Occasionally, the image from a particular **Blend** mode can be improved by adjusting the **Opacity** slider. Just remember to select **Multiply** again before going on to the next step.

STEP 4: MERGE THE TWO IMAGES TOGETHER

- Select **Layer** ➤ **Flatten Image** to permanently merge the two layers into a single layer.

Looking at the **Layers** palette, you now will only see a single background layer. The thumbnail image now shows the results of merging the two layers.

ranging from opaque to completely transparent) may not be changed. You can, however, convert the background layer to a normal layer. Then, you can modify it.

To rearrange the order of the layers, click the layer you want to move. The layer will be highlighted, indicating it is the active layer; then drag and drop it to the desired location.

A common frustration for those new to layers comes when trying to work on a specific layer. For example, when attempting to apply a filter, apply a blend mode, or modify the layer in some way, they can't. Why? Usually, the problem is that the desired layer is not the active

layer or it is hidden. So, a word to the wise is to make sure the appropriate layer is active and that it is visible before you attempt to modify it, or you might go crazy!

One other caveat: layers take memory. Each time you add an additional layer to an image it will consume more memory. To display information about the current file size and other image characteristics, click the triangle in the bottom border of the application window. Then, select your view option from the menu shown in **Figure 2**. The information for the type that you select will be displayed just to the left of the triangle.

2

When working with large images and multiple layers, you may run out of memory. If so, you may have to merge layers or reduce the size of your image. Both the Photoshop Elements manual and the Help system offer tips on how to optimize the use of memory.

STEP 5: MAKE FINAL IMAGE ADJUSTMENTS

We have now accomplished what we set out to do. The three fishing boats are now in the Scottish orange coast photograph. However, the brilliant orange tone of the original "orange coast" image appears to have been diluted or desaturated. Chapter 1 presents several techniques that could be used to correct this problem. Chapter 3 also offers several useful techniques for improving the color. Nevertheless, Photoshop Elements is a feature-rich program, and so I'll keep illustrating new features so you know what is available.

■ Select **Enhance ➢ Variations** to get the **Variations** dialog box shown in **Figure 19.4**.

The **Variations** command is a powerful, visually oriented feature that can be used to quickly change the color in an image. Besides showing images with varying color changes, it also offers you an option to make the image lighter or darker. In the center of the **Variations** box is the **Current Pick**, or the image as it is currently. To add (or subtract) yellow to an image, click the image labeled **More Yellow** (or **Less Yellow**). To make it even more yellow (or less yellow), click the **More Yellow** (or **Less Yellow**) image again, or as many times as it takes to get the image as yellow (or as little yellow) as you want. Similarly, the colors green, red, cyan, blue, and magenta may be changed.

When adding more color to an image, the **Variations** feature also lets you choose where the color is to be added — either to **Shadows**, **Midtones**, or **Highlights**. In addition, a **Saturation** button allows you to change color saturation.

As you experiment with the **Variations** feature by selecting different images, you will want to periodically go back to the original image. To reset, press **Alt**, and the **Cancel** button will change into a **Reset** button. Click **Reset** while holding down the **Alt** key, and you are ready to continue your experimentation.

■ The image shown in **Figure 19.2 (CP21)** was created by selecting **Midtones** and performing a single click on the **Darker** image followed by a click on **OK**.

■ Select **File ➢ Save As** to get the **Save As** dialog box. Select an appropriate directory and name your file, then click **Save** to save your file.

ADDING OBJECTS TO AN IMAGE

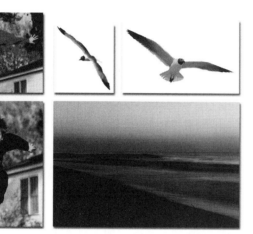

20.1 (CP24)

20.2 (CP23)

ABOUT THE PHOTO

"In-line Flight at Dusk," Canon A2e 35mm camera, EF 75-300mm f/4.0-5.6 USM and EF 28-105mm f/3.5-4.5 USM zoom lens, 4" x 6" prints were scanned with an HP ScanJet 4c, base image is 1,738 x 1,165 pixel image size, 5.8MB .tif file

This technique shows how various "objects" from multiple photographs can be combined into one photograph to create an entirely new image — in this case, even something that is impossible. This technique is a variation of Technique 19. Only instead of merging entire images, selected objects cut from other images will be merged into the background layer.

As I watched the boy and girl jump up and down on a trampoline, I noticed that, for just a split second, they were suspended motionless in mid-air, as shown in **Figure 20.1 (CP24)**. I quickly got my camera, and using a 75-300mm zoom lens, I took their picture as they reached the highest point in their jump, just as they remained motionless for a split second. Several years later, when looking at photographs of gulls that I had taken, I decided to put all the images together into a seascape background.

My hope is that this technique will become one of your favorites. If you combine some of your own photographs and you create the perfect image, please send me a copy so that I can see your work. (You can learn more about sending images to me in Appendix C.)

STEP 1: OPEN FILES

■ Select **File** ➢ **Open** to open the **Open** file dialog box. After clicking the **/20** folder, press **Ctrl** while clicking the files **seascape.tif** and **girl.tif** to open them.

STEP 2: SELECT AND CUT GIRL FROM IMAGE

To select the girl and extract her from the image, use the **Magnetic Lasso** tool, which you'll find in the toolbox (second tool down in the left column).

■ Click the **Lasso** tool icon and pause until the **Lasso** menu pops out. Make sure to select the **Magnetic Lasso** tool and not one of the others.

The **Magnetic Lasso** tool works just as its name implies. When selecting an object with an edge, the selection line acts like it is magnetic and it snaps itself to the object line. The **Magnetic Lasso** tool makes selecting an object easier and more accurate than the nonmagnetic **Lasso** tool.

Once the **Magnetic Lasso** tool has been selected, use the same settings shown in the tool options bar shown in **Figure 20.3**. All of these settings allow you to vary the control of the selection. Should you wish to learn more about these options, consult your Photoshop Elements manual or use the online **Help** by selecting **Help** ➢ **Help Contents**.

■ Using the **Magnetic Lasso** tool, click anywhere in the image that you want to set your initial selection point. To continue drawing the selection line, carefully move your cursor to follow the edge of the girl. When you get back to the starting point, click the first selection point to get an animated marquee that outlines the selection.

If you missed selecting a part of the image, you can add to your selection by clicking the **Add Selection**

icon shown in the tool options bar. Likewise, you can remove part of a selection by clicking the **Subtract Selection** icon and then selecting the part of the image you want to remove.

■ To make the edges softer, you can feather them by selecting **Select** ➢ **Feather** (**Alt+Ctrl+D**). Set **Feather Radius** to **5** pixels and click **OK**.

■ Once the girl has been selected, select **Edit** ➢ **Copy** (**Ctrl+C**) to copy the image into memory.

STEP 3: PASTE THE GIRL INTO THE SEASCAPE IMAGE

■ To paste the girl into the seascape, click anywhere on the "seascape" image to make it the active image. Then, select **Edit** ➢ **Paste** (**Ctrl+V**).

Suddenly, the girl looks like she is flying over the water! For now, don't worry about the location of the girl in the image. Once the boy and two gulls are added to the picture, they all can be arranged as desired. Now that you have taken the time to learn how to carefully select and cut an object from an image, I will point out that you can get a copy of the girl already removed from the background. The file is named **girl.psd** and you may find it in the **/20** folder.

STEP 4: COPY THE BOY AND THE TWO GULLS INTO THE SEASCAPE IMAGE

Next, the same thing needs to be done to the boy and the two gull images. To save time, both of the gulls and the boy have already been selected, cut out, and saved on a transparent background in .psd files in folder **/20**. All you need to do is open each file, select and copy the image, and paste it into the seascape image. Should you be so inclined to practice your

20.3

selection skills, you will also find the original image for the boy, fittingly named **boy.tif** in the **/20** folder.

- Select **File ➢ Open** to open the **Open** file dialog box. After clicking the **/20** folder, press **Ctrl** while clicking files **boy.psd**, **gull1.psd**, and **gull2.psd** to open all three files.
- Select the **boy.psd** image by clicking anywhere in it, then select **Edit ➢ Copy** (**Ctrl+C**). To paste this transparent image onto the seascape, click the "seascape" image, which now shows the girl. Then, select **Edit ➢ Paste** (**Ctrl+V**) to paste the boy into the image.
- Repeat the preceding two actions in this step over again for both the gull images.

STEP 5: ARRANGE THE FLYING OBJECTS

Now comes the fun part: arranging the flying objects as you want them. You may have noticed that, as you pasted each object into the seascape, the objects ended up being stacked on top of each other in the middle of the image. Each of these objects has been inserted as a layer — that is, they can be moved and their stacking order changed. If one image is on top of another and you want it the other way around, you just need to change the order of the layers by arranging their stacking order in the **Layers** palette. It is as easy as clicking, dragging, and dropping thumbnails in the **Layers** palette.

- If you do not see the **Layers** palette shown in **Figure 20.4**, select **Window ➢ Show Layers**.
- If you do not see all the layers in the **Layers** palette, click the maximize icon in the upper right corner of the **Layers** palette.
- To select a particular layer, click the thumbnail of your choice and you will see selection lines appear assuming that the **Move** tool is selected. To select the **Move** tool (**V**) click the **Move** tool in the toolbox.

The selection marquee not only shows you which object you have selected, but you can also use the

selection marquee to re-size, distort (change perspective), or rotate each of the images to make the final image as realistic as possible. As you move your cursor around the selection marquee, the cursor will change into different arrows indicating how the image can be changed when you click and drag the handles. **Figure 20.5** shows how the girl was selected and then rotated by using the selection marquee.

20.4

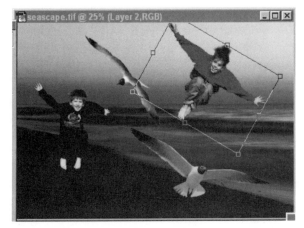

20.5

Besides being able to make a layer active by clicking on it in the **Layers** palette, you can also click directly on an image in a layer and automatically select that layer providing that you have a checkmark in **Auto Select Layer** box in the **Move** tool options bar. This is an extremely useful feature that you will want to learn to use.

STEP 6: SAVE THE FILE

Once you have completed the work on your image, you should save your work. If you want to save your file with all the layers so that you can return to it and work on it later, you must save it as a .psd file. Otherwise, you can save your file in the .tif, .bmp, or other format you choose. If you save a file with layers in any other format, such as .tif, .jpg, or .bmp, you *will* permanently lose the layer information.

WARNING

When working with a file that contains layers, you can lose the layers and force them to be flattened (all merged into one) by saving them to a file format other than the native Photoshop file format (.psd). To save a file with the layers intact, save it as a .psd file using the File ➢ Save As command and make sure that in the Save dialog box, that the file format is set to Photoshop (.psd) and that the Save Layers box is checked.

If you save images with multiple layers, such as the final image created in Technique 20, as a Photoshop file (that is, a file with the extension of .psd), then all of the layers will be saved and you can continue working with them at a later time.

- If you want to save your work with the layers intact, select **File ➢ Save As** (**Ctrl+Shift+S**) to get the **Save As** dialog box. Make sure the **Format** is listed as Photoshop (.psd) and that there is a check mark in the **Save Layers** box. After naming your file as you want, and selecting the correct folder, click **Save**.

- If you want to save a smaller file and you don't care to save all of the layers in the image, you can save the file without layers by saving it in a file type other than .psd. Or, save it as a .psd file by selecting **File ➢ Save As** and make sure the **Save Layers** box is not checked. In each case, your file will be substantially smaller in size than if you saved it with all of the layers.

The images used in this technique are excellent images to use to learn all about layers. Spend time moving objects around, distorting them, and changing their order. Also, experiment with some of the different **Blend** modes and vary the **Opacity** level for different objects. If you want to hide a layer, remember that you can do so by simply clicking the "eye" icon shown at the left of each layer in the **Layers** palette.

You can further manipulate the seascape image by adding a few "objects" from your photo collection (such as a sun or maybe a moon). You can add any object that you think might make the image more fascinating. Finish off the image by using one or more of the color techniques from Chapter 3.

MAKING A PANORAMA BY "STITCHING" IMAGES

21.1 (CP26)

(CP26)

(CP26)

21.2 (CP25)

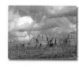

(CP26)

I f you have ever looked out over a wide expanse of mountains or a beautiful seascape and attempted to capture the view with a camera, you know how truly frustrating it can be. Even if you use an expensive wide-angle lens, the photograph will only show a small fraction of the scene that our eyes can see. Another frustrating limitation of traditional film-based photography is that it isn't easy to combine a series of two or more photographs into one panoramic picture. Although you can shoot a few pictures and then tape the prints together, the results are still unacceptable. With the advent of "digital-image stitching" software, it is now possible to use software to perfectly stitch together two or more images to create either a very wide or very tall image or print. Many of the new inkjet printers allow prints to be made up to 44" wide or even wider when using roll paper. Therefore, what you create, you can also print.

This technique will show how Photoshop Element's **Photomerge** can be used to create either wide or tall panoramic images from a series of photos. This feature is sophisticated enough that it can even merge images

that are taken without using a tripod. Both sets of images found in the **/21** folder were taken by hand holding a digital camera. A level camera supported on a tripod can produce even better results.

STEP 1: COPY FILES TO A NEW FOLDER

The easiest way to use Photoshop Element's **Photomerge** command is to place all the images that you want to merge into a separate folder.

■ After creating a new folder named "photomerge" on your hard drive, copy the files **sedona1.jpg**, **sedona2.jpg**, **sedona3.jpg**, and **sedona4.jpg** from the **/21** folder, and place them in the new **/photomerge** folder.

STEP 2: SELECT FILES

■ Select **File** ➢ **Photomerge** to get the **Photomerge** dialog box shown in **Figure 21.3**. To select the **/photomerge** folder (where you stored the four images that are to be merged), click **Add**.

21.3

You will then get the **Open** dialog box, which will allow you to select the **/photomerge** folder. Once you locate the **/photomerge** folder double-click it to open it.

■ To select all four files, press and hold the **Shift** key while clicking on the first and last file. Click **Open** to get the **Photomerge** dialog box shown in **Figure 21.3**, except it will now show the names of the four files that you selected.
■ Make sure there is a checkmark in the **Attempt to Automatically Arrange Source Images** box and the **Apply Perspective** box. Set **Image Size Reduction** to **50%** (unless you have 128MB or more of RAM and a fast processor). Click **OK** to begin the merge.

Should you encounter an error message that says, "Photomerge can't automatically arrange the images into a single panorama," click **OK** to proceed. This means that you will have to manually arrange one or more of the images into their proper order.

STEP 3: MERGE PHOTOS

After selecting the files and clicking **OK**, you will be presented with the main **Photomerge** screen shown in **Figure 21.4**. This is where you manually arrange the images if **Photomerge** was not able to do it automatically. It also offers several other selectable options such as **Cylindrical Mapping** and **Advanced Blending**. To learn more about these features, I suggest you click the **Tutorial** button in the Photomerge dialog box.

■ In the upper left corner of the **Photomerge** dialog box, you will see an image that was not automatically merged. Click on it and drag it down into the workspace with the other three images. If you need to, you may reduce the size of the images by using the Navigator that is on the **Photomerge** screen. Carefully place the image where it should be. When you release the mouse button, **Photomerge** will further fine tune its placement.

If you were to shoot this same scene again using a tripod, **Photomerge** would be able to automatically merge all the images. This set of images was selected to show that while the use of a tripod is important, it is not essential. Should you want to try a set of images that were taken with a tripod, I suggest that you try merging the eight images of the Wind River Mountains in Wyoming. This grand snow-capped vista can be perfectly merged and ready for an inkjet printer in just a few minutes. The images can be found in the **/21windriver-mtns** folder. Unless you have lots of RAM and a fast processor, you may want to just select a few of the images to merge. To learn tips about how to take the best possible pictures to merge, read the "Taking pictures for use with Photomerge" page that may be found by clicking **Help Contents (F1)**.

■ Make sure that there are check marks in the **Apply Advanced Blending** box and in the **Cylindrical Mapping** box.
■ If you would like to preview the results of the merge, click **Preview**. After viewing the preview, click **Exit Preview**.
■ Click **OK** to begin the merge. This feature is a memory and processor intensive feature, so have

patience while it performs the merge. Once the merge process has finished, the final merged image will be displayed inside Photoshop Elements' workspace as shown in **Figure 21.5**.

You may get a dialog box with the message "could not complete the Photomerge command because there is not enough memory (RAM)." If this is the case, try closing all applications except Photoshop Elements. You may even want to re-boot your computer to ensure that you have as much RAM as possible. If you still get the message, you may have to further reduce the **Image Size Reduction** setting.

STEP 4: CROP IMAGE

■ Select the **Square Marquee** tool (**M**) by clicking on it in the toolbox. Using the selection tool, drag a selection marquee around the image so that you have the largest image possible without including any white space. Your selection should look similar to the one shown in **Figure 21.6**. After making the selection, select **Image ➢ Crop** to crop the image to the selection marquee.

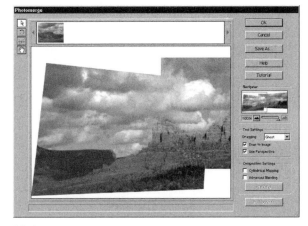

21.4

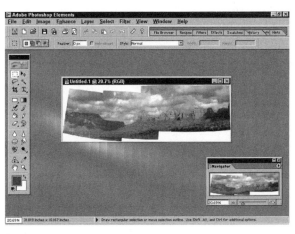

21.5

Before saving your file, perform any final image enhancements that you may want. Good tools for adjusting this image are: **Levels**, **Variations**, **Color Cast**, and **Hue/Saturation**. I also like the results of using the watercolor technique that is shown in Technique 37.

- Select **File** ➢ **Save As** to get the **Save As** dialog box. Select an appropriate directory and name your file, and then click **Save** to save your file.

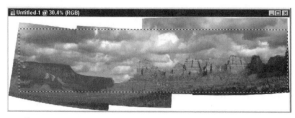

21.6

Even setting **Image Size Reduction** to **50%**, the merged photos make an image that when cropped is approximately 2,190 x 492 pixels and will occupy about 3MB of disk space. If you want to make a larger file, use a **75%** or **None** setting for **Image Size Reduction** in Step 2. Alternatively, you can use the **Image Size** command to make a larger image, although the quality will suffer somewhat depending on how much the image size is increased.

The obvious use of **Photomerge** is to merge photos horizontally. However, it works equally well when merging photos that were taken to merge vertically. I have gotten excellent results by taking up to four photos of a tall and narrow tree using a telephoto lens and shooting from a distance. The final merged print was 8" wide and 44" tall!

PUTTING SKY FROM ONE IMAGE INTO ANOTHER

22.1

22.2

ABOUT THE PHOTO

"Asheville Church," Canon EOS 1v with f/2.8 28-70mm, Fuji Velvia slide film, scanned with Polaroid SprintScan 4000 film scanner, 1,598 x 2,412 pixel image size, 11.0MB .tif files

When composing photographs outdoors, it is rare that the sky is ideal for the subject. Often, there will be a spectacular sunset, an awesome sunrise, or a sky filled with awe-inspiring clouds — yet, there is no good subject to go with them. If you have been through the earlier techniques in this chapter, you probably have a good idea of what this technique is all about. Pick and choose images, and use your digital image editor to put the right skies with your favorite subjects. The fact is, it is easy to do.

STEP 1: OPEN IMAGES

■ Select **File** ➤ **Open** to get the **Open** dialog box. After clicking the **/22** folder, press **Ctrl** while clicking the files **church.tif** and **sky.tif**. Once they have been highlighted, click **OK** to open both files.

STEP 2: SELECT JUST THE CHURCH AND PASTE IT INTO THE SKY IMAGE

■ Click the "church" image to make it the active image.
■ Click the **Magic Wand** tool (**W**), which can be found in the toolbox in the second column. This is the second tool down shown in **Figure 22.3**.
■ To select the sky, you simply need to click the **Magic Wand** tool on the sky in the "church" image. You may have to adjust the settings to match those shown in the **Options** bar shown in **Figure 22.4**.

Once again, some experimentation is needed. If you click the sky toward the top of the image, some of the sky will not be selected toward the bottom near the building, which is next to the church. Clicking more toward the middle of the sky will help to select more sky.

There are a couple of other alternatives for selecting all of the sky. While pressing the **Shift** key, click the sky that has not been selected to add it to the already selected sky. You could also change the **Tolerance** setting on the tool options bar to allow the **Magic Wand** to select more of the sky. If you set the **Tolerance** too high, it will end up selecting some of the spires on the church and the antennae on the office building. To get this setting just right, you may need to try several settings.

Another option is to click the **Add to Selection** icon on the tool options bar. Then, add to the sky by

22.3

22.4

successively clicking until all of the sky you want is selected.

The final option is to use the **Magic Eraser** tool, which may be found in the toolbox in the left column, seventh tool down. Unlike the "select, then cut" approach, the **Magic Eraser** tool simply erases the background according to the settings made in the tool options bar.

There is so much sky to remove and so many ways of removing it! Try a variety of tools and you'll have a better idea of how they work.

- At this point, all of the sky should be selected; however, we want the church selected — not the sky. To invert the selection, select **Select ➢ Inverse** and the selection marquee will now show the church as being the active selection, as shown in **Figure 22.5**.

- Select **Edit ➢ Copy** (**Ctrl+C**) to copy the church into memory. Then, click the "sky" image and select **Edit ➢ Paste** (**Ctrl+V**) to paste the church image as a layer onto the sky image. There you have it — a beautiful church with a dramatic sky!

STEP 3: FLATTEN IMAGE AND MAKE FINAL ADJUSTMENTS

- If you are happy with the image, then select **Layer ➢ Flatten Image** to flatten the image so that you may perform a few final adjustments on it.

As both of the original images were made with a digital camera, this final image ought to easily be improved using some of the techniques that were covered in Chapter 1. My suggestion is to sharpen it and to adjust the levels.

22.5

22.6

22.7

■ Select **Filter** ➢ **Sharpen** ➢ **Unsharp Mask** to get the dialog box shown in **Figure 22.6**. Try the settings of **50%**, **5** pixels, and **15** levels for **Amount**, **Radius**, and **Threshold** respectively.

■ Select **Enhance** ➢ **Brightness/Contrast** ➢ **Levels** (**Ctrl+L**) to adjust the tonal range. I set the **Input Levels** at **5**, **.95**, and **225**, as shown in **Figure 22.7**.

■ Select **File** ➢ **Save As** to get the **Save As** dialog box. Select an appropriate directory and name your file, then click **Save** to save your file.

CLONING ONE IMAGE INTO ANOTHER

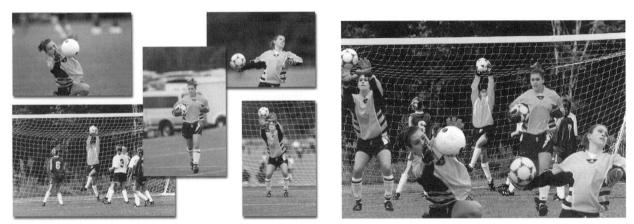

23.1 (CP28) **23.2 (CP27)**

ABOUT THE PHOTO

"Goalie in Yellow", Canon EOS1N, f/2.8 400mm EOS USM, 4" x 6" prints were scanned with an HP ScanJet 4c, base image 2,520 x 1,680 pixel image size, 12.7MB, four other images are 6.1 to 8.4MB

Technique 20 showed how an "object" can be carefully selected, cut from one image, and then pasted into another. When looking at the completed image in **Figure 23.2 (CP27)**, you may suppose that this is another "cut-and-paste" project — but it isn't. Instead, we are going to avoid taking the time and effort needed to carefully select and cut out the goalies. This will save us time, plus we will get a slightly different look to the final image.

In this project, we'll paint with a clone brush, which is known as the **Clone Stamp** tool (**S**). There are two approaches to take to clone the goalies from one image to another. Using the **Clone Stamp** tool, we could paint a goalie from one image directly into the base image. In doing this, we would be forced to figure out exactly where the goalie should be painted, as well as the correct size to make the goalie. In addition, we would risk destroying the base image as we painted. This approach eliminates any possibility of ordering, resizing, or rotating the goalies.

23.3

23.4

The second approach is to use the **Clone Stamp** tool to paint each goalie from one image onto a new *transparent layer* in the base image. This allows us lots of flexibility, as you will see as we continue.

STEP 1: OPEN BASE FILE AND ONE ADDITIONAL IMAGE

■ Select **File ➤ Open** and then locate the **/23** folder. Double-click the **/23** folder to open it. To open several images at once, press and hold **Ctrl**, then click the files **baseimage.tif**, **catch.tif**, **catch2.tif**, **walking.tif**, and **throw.tif**. Click **Open** to open the files.

If you do not have 128MB or more of RAM, you may need to open the base image and one additional image at a time. Once you have the images open, it will be easier to work if you arrange them as they are shown in **Figure 23.3**. If the **Layers** palette is not viewable, click **Window ➤ Show Layers**.

STEP 2: ADD A TRANSPARENT LAYER TO THE BASE IMAGE

Figure 23.3 shows how **baseimage.tif** has been placed on the right side of the workspace. Just to the left is the **catch2.tif** image, which contains the first player that we will paint into **baseimage.tif**.

■ To create a new transparent layer, make sure **baseimage.tif** is active by clicking anywhere in it. Select **Layer ➤ New ➤ Layer** (**Shift+Ctrl+N**) and you will get the **New Layer** dialog box shown in **Figure 23.4**. Click **OK**. You will see a new layer added to the **Layers** palette, as shown in **Figure 23.5**.

It is important that you keep the new layer active, as this layer should receive the clone paint in the next step.

23.5

STEP 3: USE THE CLONE STAMP TOOL TO PAINT THE GOALIE INTO THE BASE IMAGE

In Technique 7, the **Clone Stamp** tool was used to repair part of an image by cloning a good part of an image over a damaged part. In this case, we merely will be cloning one whole goalie from one image onto a transparent layer in **baseimage.tif**.

■ Select the **Clone Stamp** tool by clicking the **Clone Stamp** tool (**S**) icon in the toolbox. Once it is selected, you will see the **Clone Stamp** tool options bar shown in **Figure 23.6**. Brush size and type can be varied. I suggest you start out with the **Soft Round 45 Pixels** brush. Also, make sure that **Mode** is set to **Normal**, that **Opacity** is **100%**, that the **Aligned** box is checked, and that the **Use all Layers** box is not checked.

■ Click the **catch2.tif** image to make it the active image. Then, press **Alt** and click the soccer ball to set the first point to be cloned.

■ To begin painting with the **Clone Stamp** tool, click **baseimage.tif** once to make it the active image, and then click the image where you want to begin cloning the soccer ball. Each time you click the image and move the cursor, you will be cloning the **catch2.tif** image. Keep painting until you have painted the entire goalie and the soccer ball. Remember you can change brushes when needed to save time and increase accuracy.

As you are painting in **baseimage.tif**, notice that a second cursor in the **catch2.tif** image shows you the clone source. Although you should try to paint just the goalie and the ball, it is not essential that you paint it perfectly. However, you should make sure to paint all of the goalie and the ball.

STEP 4: CLEAN UP THE CLONED GOALIE IMAGE

Once the goalie and the ball have been cloned, final adjustments are easily made by turning off the background layer and using one of a variety of tools to fine-tune the image.

■ Click the eye icon to the left of the background thumbnail in the **Layers** palette to turn off the background layer.

■ Make sure that **Layer 1** is the active layer. If **Layer 1** isn't highlighted, click it to make it active.

■ You will now only see the goalie and the ball in **Layer 1**. Use any tool you choose to fine-tune the selection. I suggest you use a combination of the **Eraser** tools (**E**), the **Lasso** tools, and the **Magic Wand** tool (**W**). If you use the **Eraser** tool, use it in paintbrush mode and make it a small, soft or mostly soft-edged brush, and zoom in so you can see the edge detail clearly. If the edge of the soccer player or ball are too soft, they'll look fuzzy in the final image. If the edge is too sharp (as would occur if you select and delete or use the block eraser or use a hard-edged brush with the paint-brush eraser), the player will look as though it were pasted on top of the base image.

Once the cloned image is complete, click the eye icon to the left of the background image once again to turn it back on. You can now check to see how the images blend.

STEP 5: REPEAT STEPS 2, 3, AND 4 OVER FOR EACH OF THE OTHER THREE GOALIE IMAGES

Two of the five goalies are now shown in the background image. To add the other three goalies, repeat

23.6

Steps **2**, **3**, and **4** for the **walking.tif**, **catch.tif**, and **throw.tif** images. Once all the images have been cloned into the image, you will have four layers and the background layer as is shown in **Figure 23.7**.

STEP 6: SET CORRECT LAYER STACKING ORDER AND ADJUST LAYER SIZES IF NEEDED

Once all the goalies are in the image, you may find that one goalie is in front of, or behind, another goalie, and this makes the image look incorrect. You may also want to change the size and location of one or more of the goalies. With all of the layers turned on, your image should look similar to **Figure 23.8**.

Each goalie, or layer, can also be re-sized, rotated, or re-positioned to make the image look technically correct.

■ Select **Select** ➣ **All** (**Ctrl+A**), then **Image** ➣ **Transform** ➣ **Perspective** (**Ctrl+T**). Click and drag the corners of the layer to size it as you want. To keep the proportions the same, press and hold **Shift** as you drag the selection marquee.

To change the stacking order of the layers, simply drag and drop one layer in the **Layer**s palette to where it ought to be.

STEP 7: SAVE FILE AS A PHOTOSHOP (.PSD) FILE AND FLATTEN IMAGE

■ To save **baseimage.tif** with layers (an important thing if you intend to use the layers again), click **File** ➣ **Save As** to get the **Save As** dialog box. Make sure there is a checkmark in the **Save Layers** box in the Save As dialog box, and that **Format** is set to **Photoshop** (.psd).

■ Once you have saved your file with the layers intact so that you may use them again, you can now flatten the layers, by choosing **Layer** ➣ **Flatten Image**.

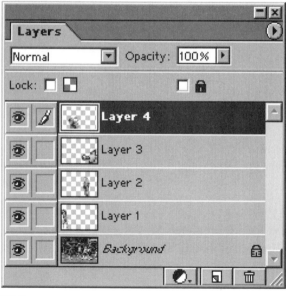

23.7

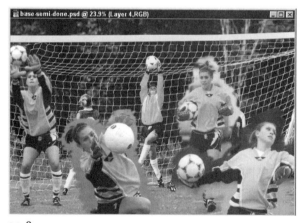

23.8

STEP 8: MAKE FINAL IMAGE ENHANCEMENTS

There are many ways you could enhance this final image. I was not particularly accurate in cloning the goalies and balls, so I decided to simply apply a filter that would help blend the edges, while still leaving the image looking as much like a photograph as possible.

- Select **Filter ➢ Brush Strokes ➢ Dark Strokes** to get the **Dark Strokes** dialog box shown in **Figure 23.9**. Try using settings of **5**, **9**, and **1**, for **Balance**, **Black Intensity**, and **White Intensity** respectively.
- Select **File ➢ Save As** to get the **Save As** dialog box. Select an appropriate directory and name your file, then click **Save** to save your file.

23.9

CREATING A PHOTOMONTAGE

24.1 (CP30)

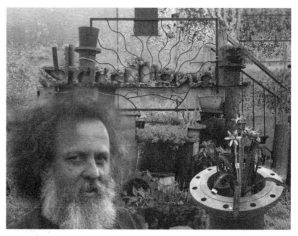

24.2 (CP29)

ABOUT THE PHOTOS

"Garden Art Creator," six images taken with a Nikon 950 digital camera, Fine Photo Quality setting, 1,600 x 1,200 pixel image size, 627 to 841KB .jpg files

One of the risks of using a computer to create art is that your work can become too precise, perfect, or predictable — unless you work hard to loosen up! Every now and then, just for the fun of it, and to make sure that I continue to be creative, I pick a few images and work with them to do wild and crazy things. Sometimes the results are less than spectacular; but, almost all the time, this exercise helps me to learn something that becomes valuable later.

In this final technique in this chapter, we are going to relax, sit back from the computer screen, and create something a bit different. There is no need to follow precise step-by-step instructions — just consider the steps and notes as suggestions. When you are finished with this technique, odds are good that you will have created something that is unlike the work of any one else. Your creativity, work ethic, and mastery of your digital image editor will be the only limits to what you create.

So far, you have learned how to combine images by copying and pasting one image into another as a layer. In addition, you learned how two or

24.3

more layers can be blended, using **Blend** modes. You should have a reasonable mastery of the selection tools. In folder **/24**, you will find six images to use.

The six images in folder **/24** are of a welder and his creations. He creates rusted metal garden art by welding a variety of rusty "found" metal scraps into artistic works of art. The objective of this technique is to create a single image that both shows his work and reveals his rustic, creative, almost "irrational" character. Wild and crazy is in. Brilliant and weird colors are OK. Dark and rusty is excellent. Anything else is great too.

STEP 1: OPEN FILES

- Select **File ➤ Open**. Using the **Open** file dialog box, locate the **/24** folder, then double-click the folder to open it. To open more than one image at a time, press the **Ctrl** key while clicking each image you want to use, and then click **Open**. I suggest opening the following images: **artist.jpg**, **irrational1.jpg**, **planter.jpg**, and **sunrisedesign.jpg**.
- Before you go on to **Step 2**, arrange your desktop as shown in **Figure 24.3**.

Getting your workspace into order allows you to concentrate more on what you are creating than on the tools that you are using. With your workspace organized like this, it allows you to select from the available images and to cut and paste them into your chosen base image.

- If the **Layers** palette is not viewable, click **Window ➤ Show Layers**. The **Navigator** palette is also useful. If the Navigator box is not viewable, click **Window ➤ Show Navigator**.

STEP 2: DECIDE ON THE IMAGE YOU WANT TO USE AS THE BACKGROUND IMAGE AND MAKE DESIRED IMAGE ADJUSTMENTS

Irrational1.jpg and **sunrisedesign.jpg** are good background images.

If you use the **irrational1.jpg** or **irrational2.jpg** images, try adjusting the colors by selecting **Enhance ➤ Auto Levels** (**Shift+Ctrl+L**) to create rich rusty colors. Alternatively, apply any other enhancement that you choose.

The **sunrisedesign.jpg** image is also another good candidate for use as a background. In case you choose to use this image, consider toning down the bright white by using **Levels** (**Ctrl+L**).

STEP 3: ADD ADDITIONAL IMAGES TO THE BASE IMAGE AND MAKE ADJUSTMENTS AND ENHANCEMENTS

Continue selecting and pasting all of the images that you want into your base image. Once the images are all there, you can size them to fit. Each time you paste an image as a **Layer**, you will see a selection border around it (assuming the **Move** tool has been selected.) This is shown in **Figure 24.4**. To move a layer, click the **Move** tool (**V**) in the toolbox. Click inside the selection while you drag the image where

you want it. To enlarge or reduce the image, click one of the square boxes at any one of the corners of the selection marquee. As you drag the corner, the image size will change. To keep the same image proportions, click and hold **Shift** while you drag the corners.

When you get to **planter.jpg**, consider cutting the planter out of the image, as the green grass may not fit well with the color scheme. To cut out the planter, use the **Lasso** tool (**W**), to make a rough first cut. You can then paste it into your base image and use the **Magic Wand** (**W**) to select and cut the remaining green grass. You may also want to try the **Magic Eraser** tool (**E**) to remove the grass.

Besides moving and resizing a layer, you can perform a variety of other transformations such as: **Free Transform** (**Ctrl+T**), **Skew**, **Distort**, or **Perspective**. Once you have all the images added as a layer to the base image, you can free up some RAM by closing all the open images except for the base image, which now contains several layers. Using the **Navigator**, increase the size of your working image to fill the screen or choose **View ➢ Fit on Screen** (**Ctrl+0**).

STEP 4: ORDER LAYERS

Once you have all of your images sized and placed where you want them, you can also change the stacking order. To order the layers, you drag and drop each layer in the **Layers** palette, as shown in **Figure 24.5**. As you order the layers, you can also begin to experiment with **Blend** modes and **Opacity**. For these images, try experimenting with the **Multiply**, **Overlay**, **Hard Light**, **Color Burn**, **Darken**, and **Luminosity** modes.

STEP 5: FLATTEN IMAGE AND MAKE FINAL IMAGE ENHANCEMENTS

At this point, your image is comprised of multiple layers. To make image adjustments to all layers at the

24.4

24.5

same time, you will need to flatten the image. If you do so without first saving your file in a format that will protect the layers, you will no longer be able to work on the individual layers. So, when you are ready to perform your final image enhancements, first save the file as a .psd file.

- Select **File** ➢ **Save As** to get the **Save As** dialog box. Make sure that **Format** is set to Photoshop (.psd.) Select an appropriate directory and name your file, then click **Save** to save your file.

- Select **Layer** ➢ **Flatten Image** to flatten all the layers into a single background image. Now, you can perform any final adjustments you want to the whole image.

In **Technique 8**, you learned about the **Poster Edges** filter. Try applying this filter to your image. I also liked the results of **Filter** ➢ **Brush Strokes** ➢ **Dark Strokes**. You can view the results of my work in folder **/24: try-1.jpg**, **try-2.jpg**, and **best-try.jpg**. Remember, do not be critical.

Once you have finished and saved your work — try, try and try again. See how different you can get your final images to look in terms of color, layout, and the way they have been merged.

CHAPTER 5

TECHNIQUES FOR PEOPLE PICTURES

People love taking people pictures. In fact, the vast majority of pictures processed in one-hour photo labs feature people. This chapter is here to help you do more with your people pictures whether you want to print them, present them online, or on the Internet. Technique 25 shows how a portrait taken with a digital camera can be turned into the best possible photographic print. Creating a digital vignette and matte board is the objective of Technique 26. The art of creating digital caricatures is the topic of Technique 27, which is the technique with a bit of humor. Although so many ways are available for sharing and enjoying digital images on a computer and online, paper-based photo albums have by no means gone the way of dinosaurs. Quite the contrary, digital image editors can be used to create excellent photo album pages, as is shown in Technique 28. Finally, Technique 29 shows how two or more digital photos may be combined into an animation suitable for display on a Web page.

Syracuse Vs. NC State
54-53

TURNING A DIGITAL PHOTO INTO THE BEST PRINT IT CAN BE

25.1

25.2

Figure 25.1 shows a digital photo taken with a hand-held digital camera on an overcast day. The objective of this technique is to enhance the image to make it look as good as it can look and then to increase its size to make the largest print possible without compromising image quality.

Most desktop photo-quality printers under $1,000 require either a 240 dpi or 300 dpi image to make a good print. For this technique, assume you are going to use a printer that needs a minimum of 240 dpi to make a quality print. **Figure 25.2** shows the enhanced photo that you'll use to make a print. For people who either don't have a printer or want to order prints online, this technique also shows how Photoshop Elements' Online Services feature can be used to upload an image and order prints online.

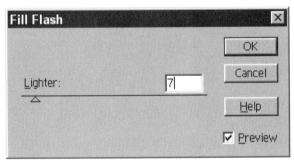

25.3

25.4

STEP 1: OPEN FILE

■ Select **File** ➢ **Open** (**Ctrl+O**) to display the **Open** file dialog box. After double-clicking the **/25** folder to open it, click the **linda-before.jpg** file to select it. Click **Open** to open the file.

STEP 2: EVALUATE THE OVERALL QUALITY OF THE PHOTO

■ Before adjusting an image, it is wise to first check tonal range using the **Histogram** feature. Select **Image** ➢ **Histogram** to get the **Histogram** box shown in **Figure 25.3**. This histogram shows a good tonal range; the image has good darks and lights, as well as good midtones. Thus, for now,

skip making adjustments with the **Levels** tool. Click **OK** to close the **Histogram** dialog box.

If the **Histogram** lacked points on either end of the scale, then the image may have been improved by adjusting the tonal range using the **Levels** tool as was shown in Technique 4.

Taking a close look at the photo, you can see that the face is darker than it ought to be. The photo might have been better if a fill flash had been used. A *fill flash* is a weak flash that adds light to a close subject, but not to the background. Since a fill flash wasn't used, you will have to fix the photo with a digital fill flash!

■ Before applying a digital fill flash, first select the subject. Click the **Lasso** tool (**L**) in the toolbox. Carefully select the subject by clicking and dragging a selection marquee all around the subject.

■ To soften the edges of the selection, select **Select** ➢ **Feather** (**Alt+Ctrl+D**) to get the **Feather** dialog box. Type **5** for the **Feather Radius** in pixels and click **OK**.

■ Select **Enhance** ➢ **Fill Flash** to get the **Fill Flash** dialog box shown in **Figure 25.4**. Make sure the **Preview** box is checked and then drag the slider until the subject is properly lit. I found a setting of **7** to be just about right. Click **OK** to apply the digital fill flash.

■ Select **Select** ➢ **Deselect** (**Ctrl+D**) to remove the selection.

STEP 3: INCREASE IMAGE SHARPNESS

Most images that have been created with a digital camera are soft images and can generally be improved by using a sharpening filter, such as the **Unsharp Mask**.

■ When applying the **Unsharp Mask,** it is advisable to enlarge an image to 100% in order to see the effects of the **Unsharp Mask** settings. Select **View** ➢ **Actual Pixels** (**Alt+Ctrl+0**) to view the image at 100% size.

■ Select **Filter** ➤ **Sharpen** ➤ **Unsharp Mask** to get the **Unsharp Mask** dialog box shown in **Figure 25.5**. Try setting **Amount**, **Radius**, and **Threshold** to **150**, **2.0**, and **10** respectively. These are usually good settings to use to begin adjusting the **Unsharp Mask**. Looking at the results of this low setting, I chose not to sharpen the image at all. The **Unsharp Mask** did not appear to add sharpness to the image in a way that improved it. In fact, the **Unsharp Mask** seemed to make the subject's hair look gray. Since her hair is not gray, I clicked **Cancel** and did not apply any sharpening to the image.

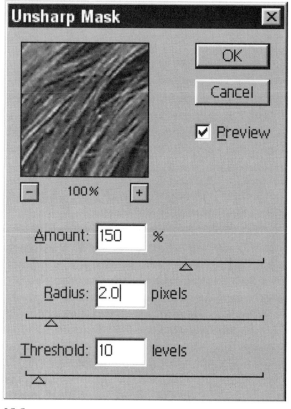

25.5

STEP 4: INCREASE BRIGHTNESS OF THE EYE HIGHLIGHTS

Portrait photographers usually focus their cameras on the eyes. A key element to a good people photograph is sharp, in-focus eyes. See what you can do to improve the highlights in the eyes.

■ Leave the image at the **Actual Pixels** settings. Click the **Hand** tool (**H**) in the toolbox, and click and drag the image until you can see most of the subject's face, especially both of her eyes.

■ Click the **Paintbrush** tool (**B**) in the toolbox. The options bar should now look similar to the one shown in **Figure 25.6**. Click the **Brush** box and select the **Soft Round 5 Pixels** brush. **Mode** should be set to **Normal** and **Opacity** to **50%**.

■ Set the **Foreground** color to white by typing **D**, and then **X**.

■ Click each of the highlights in both eyes. Make sure that you are merely strengthening the existing highlights, not adding to them or making them bigger. When you have finished, select **View** ➤ **Fit on Screen** to see the entire image. You'll quickly see what a major difference this seemingly inconsequential change made to the image.

STEP 5: REMOVE RED TINT IN THE SUBJECT'S FACE

After taking one last look at the image, I decided that there is too much red in the subject's face. This very subtle red tone appears on my monitor — it may not appear on yours. You could, in fact, decide that more red is needed. In any case, you can make the color adjustments with the **Levels** dialog box.

■ Select **Enhance** ➤ **Brightness/Contrast** ➤ **Levels** (**Ctrl+L**) to get the **Levels** dialog box. To remove some of the red tint, click inside the

25.6

Channel box and select **Red** (**Ctrl**+1) and then set the **Input Levels** to **0**, **.93**, and **255**. Click **OK** to apply these settings.

STEP 6: SAVE FILE AND PRINT IMAGE

At this point, your image is as close to being as good as it can be and is almost ready to be printed. To make a large print, the image will have to be enlarged. Enlarging the image can reduce image quality to some degree. So, first save the image to a file.

- Select **File** ➢ **Save As** to get the **Save As** dialog box. Select an appropriate directory and name your file. Click **Format** and select **TIFF** to choose a non-compressed file type. Click **Save** to save the file.
- To increase the size of the image, select **Image** ➢ **Resize** ➢ **Image Size** to get the **Image Size** dialog box shown in **Figure 25.7**. At the top of the dialog box, notice that the current **Pixel Dimensions** make a 5.5MB file. Set **Resolution** to **240 pixels/inch**. Make sure that there is a checkmark in the **Constrain Proportions** box. Type **10**

in the **Height** box (in the Document Size box). This will increase the **Width** to **7.5** inches and the resulting file is now shown as being 12.4MB — a far larger file size than the original 5.5MB file — and consequently it will not make as good a print as one that is closer to the original 5.5MB. To get the best print, you need dimensions that correspond fairly

25.7

ABOUT ONLINE SERVICES PLUG-INS

The incredible world of digital photography offers many exciting new products and services to make it easy to enjoy and share photographs. Leading the wave of these exciting new technologies are online photo-printing services. Many of these new services have been designed from the beginning to optimize the quality of prints made from images created with digital cameras. While awesome photographic prints can be made with an under-$300 photo-quality inkjet printer, some of the online services can produce even better prints.

To facilitate using online services, such as photo-printing and photos-sharing services, Photoshop Elements allows "plug-ins" where online services can be "plugged in" and used seamlessly within the Photoshop Elements application. To access the **Online Services** feature, select **File** ➢ **Online Services** to get the **Online Services** box shown in **Figure 1**.

To upload one or more digital photos, select **Shutterfly** and click **Next**. You will then be presented with an introductory screen. Click **Next** again to get the dialog box shown in **Figure 2**. In the Authentication dialog box, you have the choice of entering your e-mail address

and password (if you have already signed up for the service) or sign up for the service. Once you have signed up for the service, enter your e-mail address and password and click **Next** to get the dialog box shown in **Figure 3**. Click **Add** to get an **Open** file dialog box. Select the image or images you want to upload, click **Open**, and then **Upload**.

Once the file(s) have been uploaded, you can either select **View on Web** or **Upload More**. Click **View on Web** to view the uploaded images on the Shutterfly site as shown in **Figure 4**. With just a few additional mouse clicks, it is possible to place an order for a 5" × 7"

print, photo card, photo gift, etc. — it really is that easy.

In addition, you can invite others to view your gallery and order prints themselves. Using Shutterfly is a superb, no-hassle way of sharing your photographs and making prints available to your invited guests for very little money. Currently, Shutterfly's prices for prints are:

4" × 6" — $0.49 each

5" × 7" — $0.99 each

8" × 10" — $3.99 each

Wallet – $1.79 for 4

You can even save names and addresses online so that it is easy to order and send photographs to friends, family members, or business colleagues.

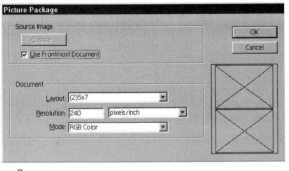

25.8

closely to 5.5MB. The next smaller standard photo-
graphic print size is 5" × 7". Thus, type **7** in the
Height box. This makes the **Width 5.25** inches,
and the overall file size is now 6.06MB. Since this is
much closer to the original size, the print will likely
be a better print. Click **OK** to enlarge the image.

■ In order for the print to fit in a standard 5" × 7"
frame or to be ordered as a 5" × 7" print from an
online printing service, the image will need to be
cropped. Click the **Square Selection Marquee**
tool (**M**) in the toolbox. Click the **Style** box on the
Options bar and set it to **Constrained Aspect
Ratio**. Set **Width** to **5** and **Height** to **7**.

■ Click just outside the bottom-left corner of the
image and drag the selection marquee up to the
right corner. Select **Image** ➢ **Crop** to crop the
image to make it 5" × 7". The image is now ready
to be printed on a photo-quality printer or
uploaded to an online photo-printing service.

■ Select **File** ➢ **Save As** to get the **Save As** dialog
box. Select an appropriate directory and name
your file, and then click **Save** to save your file.

If you want to print two 5" × 7" prints on the same
piece of paper, select **File** ➢ **Automate** ➢ **Picture
Package** to get the **Picture Package** dialog box
shown in **Figure 25.8**. Click the box next to **Use
Frontmost Document** to select the image we have
open in the workspace. Click **Layout** and select
(2)5x7. Set **Resolution** to **240 pixels/inch** (the exact
setting for the printer) and click **OK** to create a new
document with two images. To begin printing select
File ➢ **Print** to get the **Print** dialog box for your
printer. After choosing the appropriate printer set-
tings click **OK** to begin printing. Once the image has
been printed, select **File** ➢ **Close** (**Ctrl+W**) to close
the file without saving it. If you want to use an online
printing service instead of your own printer, read
About Online Services Plug-ins.

CREATING A VIGNETTE

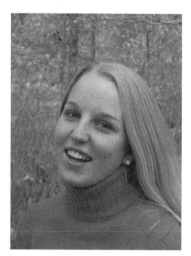

26.1

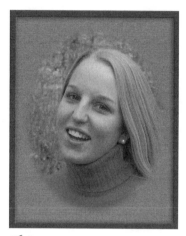

26.2

ABOUT THE PHOTO

"Sophie," Nikon 950 digital camera using Fine Image Quality setting, 1,200 × 1,600 pixel image size, original 610KB .jpg file has been digitally enhanced and saved as a 5.5MB .tif file

Traditional photography techniques have served us well for years. In many ways, they have set the standard for how we want digital photographs to appear. As more digital technologies become available, I find myself trying to fashion digital techniques that result in traditional-looking photographs. This technique shows how a digital image editor can be used to create a vignette blended on a fine-grained matte board.

Many digital image editors, including Photoshop Elements, offer excellent frames or vignettes that may be applied to a digital photo with a single click. However, the use of this technique will allow more control over the vignette used to frame Sophie, the subject shown in the photo in **Figure 26.1**. **Figure 26.2** shows how the vignette was further enhanced by overlaying the image onto a digitally created, fine-grained matte board.

STEP 1: OPEN FILE

■ Select **File** ➢ **Open** to display the **Open** file dialog box. After double-clicking the **/26** folder to open it, click the **sophie-before.tif** file to select it. Click **Open** to open the file.

STEP 2: CROP AND SIZE TO FIT AN 8" × 10" FRAME

As most standardized frames are made for an 8" × 10" photograph, you will first crop the image so that it has the correct proportions. Then, you'll enlarge it so that it has enough pixels to make a reasonably good print on a 240 dpi printer. I used the phrase "reasonably good," as our original 1,200 × 1,600 pixel (or two-megapixel) digital photo is a bit on the small size to make a really good 8" × 10" print. Nevertheless, it is worth trying to make an 8" × 10" print.

■ Click the **Square Marquee** tool (**M**). Maximize the image window by clicking in the maximize button in the upper-right corner of the image window. This will make it easier to crop the image.

■ Once you click the **Square Marquee** tool, the options bar shown in **Figure 26.3** will appear. **Feather** should be set to **0**. Click **Style** to select **Constrained Aspect Ratio**. Type **8** in the **Width** box and **10** in the **Height** box to ensure that you crop using the intended proportions.

■ Click just outside the image window at the bottom-right corner and drag the selection marquee up and to the left until you are just outside the image. Then, release the mouse button.

■ Select **Image** ➢ **Crop** to crop the image to the selection marquee.

■ To enlarge the image, select **Image** ➢ **Resize** ➢ **Image Size** to get the **Image Size** dialog box shown in **Figure 26.4**. Make sure that **Constrain Proportions** and **Resample Image** are both

checked. The **Resample Image** method should be set to **Bicubic** to get the best results.

■ Set **Resolution** to **240 pixels/inch** and then set **Height** to **10** inches (inside the Document Size box), which should automatically cause the **Width** to be changed to **8**. At the top of the dialog box, you can see the image size increased from 5.16MB to 13.2MB, which is a factor of more than 2.5. Click **OK** to enlarge the image.

Increasing the size of an image with the **Image Size** command unquestionably reduces the quality of the resulting image. The more the image size is increased, the less good the image will look. To learn how much you can enlarge an image and still be happy with it, experiment by trying different sizes. Generally speaking, a three-mega pixel or larger image is necessary to make a reasonably good 8" × 10" print. The 1,600 × 1,200 pixel image used in this technique is a two-mega pixel image. However, many people enjoy 8" x10" prints made from their two-mega pixel cameras.

STEP 3: CREATE MATTE BOARD LAYER

■ Select **Layer** ➢ **Duplicate Layer** to get the **Duplicate Layer** box and then click **OK** to create a second layer. The **Layers** palette should now look like the one shown in **Figure 26.5**. If you don't see the **Layers** palette, select **Window** ➢ **Show Layers**.

Now, make the background layer become the matte board while leaving the image on top.

■ Click the **Background** layer thumbnail in the **Layers** palette to make the bottom layer the active layer. Click the eye icon on the **Background copy** layer to make the bottom layer visible.

■ Click the **Eye Dropper** tool (**I**) in the toolbox. Click one of the colors in the image to use as the color for the matte board. When you click the

image, you can see the color you selected show in the **Foreground** color box at the bottom of the toolbox.

■ I chose a medium brown color found in the leaves. To set your color to the same one I used, click the **Foreground** color box in the toolbox to get the **Color Picker** dialog box shown in **Figure 26.6**. Set **H**, **S**, and **B** to **28**, **38**, and **58** and then click **OK**.

26.4

26.5

■ Select **Edit** ➢ **Fill** to get the **Fill** dialog box shown in **Figure 26.7**. If the **Use** box doesn't show **Foreground Color**, click it and select **Foreground Color**. Click **OK** to fill the layer with the selected color.

■ Select **Filter** ➢ **Texture** ➢ **Texturizer** to get the **Texturizer** dialog box shown in **Figure 26.8**. Click the **Texture** box and select **Canvas** as the texture. Scaling should be **100%**, and **Relief** should be set to **4**. Click **OK** to apply the texture.

26.6

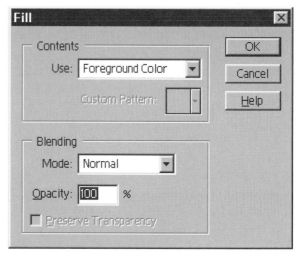

26.7

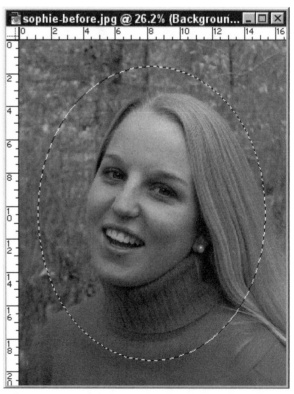

26.8

STEP 4: CREATE VIGNETTE

■ Click the **Background copy** layer to make it the active layer. Make the layer visible by clicking the left-most box just to the left of the thumbnail image. You should once again see the image of Sophie.

■ Click the **Square Marquee** selection tool (**M**) in the toolbox and hold the mouse button until a pop-up menu gives you the option of selecting the **Elliptical Marquee Tool**; click the **Elliptical Marquee** tool.

■ The **Options** bar should still show **Style,** as **Constrained Aspect Ratio. Width** and **Height** should be set to **8** and **10** respectively.

■ Click in the upper left-hand corner of the image and drag the cursor down to the bottom-right corner to make a selection similar to the one shown in **Figure 26.9**. It is important to leave a wide enough area outside the selection area for a feathered edge. If you need to select the area again, select **Select ➢ Deselect** (**Ctrl+D**) and try again. Once you have the right size area selected, you can use the arrow keys to precisely center the selection marquee.

■ Select ➢ **Feather** (**Alt+Ctrl+D**) to get the **Feather Selection** dialog box. Set **Feather Radius** to **25** pixels and then click **OK** to feather the selection area.

■ At this point, you have selected the area of the image you want to keep *instead* of the area that

26.9

you are to cut. Therefore, select **Select** ➤ **Inverse** (**Shift**+**Ctrl**+**I**) to invert the selection.

■ Click **Edit** ➤ **Cut** (**Ctrl**+**X**) or press **Backspace** to remove the outside of the image, leaving a nice vignette of the subject.

■ If you are not happy with the color of the matte, click the matte layer (labeled **Background layer**) in the **Layers** palette to make it the active layer. Using the **Eye Dropper** tool, you can select another color from the image and fill the layer using the **Fill** command. Keep repeating the process until you have one you like. Once the color has been decided, once again apply the texture using **Texturizer**.

■ When your image is as you'd like it to be, select **File** ➤ **Save As** to get the **Save As** dialog box. Select an appropriate directory and name your file, and then click **Save** to save your file.

The image is now ready to be printed on a photo-quality printer and then placed in a standard 8" × 10" frame or in a photo album. Alternatively, you can add your own digitally created frame as shown in **Figure 26.2**.

To create the frame shown in **Figure 26.2**, use the **Eye Dropper** tool (**I**) to select a frame color. I chose the color with **H**, **S**, and **B** set to **6**, **100**, and **41** respectively. Click in the **Effects** palette and select **Frames**. Double-click the **Foreground Color Frame** effect to apply a narrow dark frame around the image. Once the frame has been created, you will get a dialog box asking: Do you want to keep this effect? Click **Yes** to keep it. This makes a nice frame for a print that will be put in a photo album instead of being framed for hanging on a wall.

CREATING DIGITAL CARICATURES

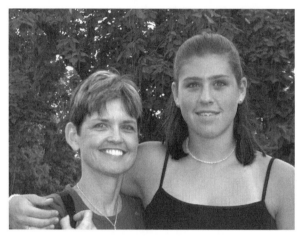

27.1 (CP 32)

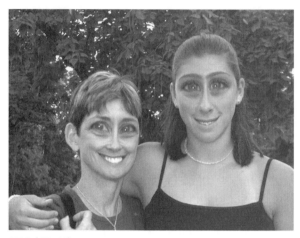

27.2 (CP 31)

ABOUT THE PHOTO

"Like Mother, Like Daughter,"
Nikon 950 digital camera,
Fine Image Quality setting,
1,600 × 1,200 pixel image
size, 172KB .jpg file

A caricature is a comically distorted drawing, typically done to satirize or ridicule a subject. The use of a digital image editor allows you to take this traditional art form to the next level. This technique shows how you can use the **Liquify** filter to transform digital photos into digital caricatures. **Figure 27.1 (CP 32)** shows a digital photo of a mother and her daughter, which was transformed into the caricature shown in **Figure 27.2 (CP 31)**.

A warning should be issued here. If you have managed to get a digital photo of an ex-spouse, an unlikable boss, or any other person you are not particularly fond of you may find yourself consumed for hours reworking their face! This technique is an exceedingly fun technique that has been known to waste lots of time and offend others — use it at your own risk.

STEP 1: OPEN FILE

While I have included a digital photo for your use, I suggest that you find one of your own. You'll enjoy wreaking havoc on your own photo so much more than my family members. (Remember to always respect copyright laws).

- Select **File** ➢ **Open** to display the **Open** file dialog box. After double-clicking the **/27** folder to open it, click the **caricature-before.jpg** file to select it. Select **Open** to open the file.

STEP 2: BEGIN DISTORTING SUBJECT FEATURES

- Select **Filter** ➢ **Liquify** (**Shift+Ctrl+X**) to get the **Liquify** dialog box shown in **Figure 27.3**.
- Click one of the tools in the **Liquify** toolbox, shown in **Figure 27.4**, and then click in the image to begin distorting the image. You can click and drag, or just hold the mouse button down to distort the image. In addition, you can change the brush size and brush pressure settings.

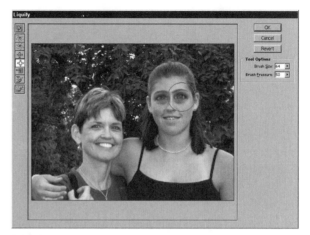

27.3

- When you are happy with the distortions you've made, click **OK** to close the **Liquify** dialog box and place the newly distorted image into the original image window.
- Any time you are working in the **Liquify** workspace and you are not happy with the results, click the **Revert** button and the image will revert to its

ABOUT THE LIQUIFY FILTER

The Liquify filter is an image distortion tool that allows you to paint "distortions." To get the **Liquify** dialog box, select **Filter** ➢ **Liquify** (**Shift+Ctrl+X**). The dialog box features the eight-tool toolbox shown in **Figure 1** and two selectable tool options.

Click any one of the tools and then click the image to apply distortions. Each tool has its own shortcut key, which you may view by holding the cursor over a tool for a few seconds to get a pop-up box as noted in **Figure 1**. To change the

size of the area where distortions occur, change the **Brush Size** setting from **1** to **150**. The **Brush Pressure** setting, which ranges from **1** to **100%**, determines how fast changes occur. Using a setting of **30%** will make it easier to stop applying distortion at exactly the right time. A higher setting makes the changes occur more quickly.

If you make changes that you do not want, click the **Revert** button to revert to the original image. Then, try again until you get what you want.

1

initial state. To change one part of an image back to its original state, click the **Reconstruct** tool (**E**), which is the bottom tool in the toolbox. Then, click the area that you want to return to its original state.

■ Once your image is as you'd like it to be, select **File ➢ Save As** to get the **Save As** dialog box. Select an appropriate directory and name your file, and then click **Save**.

I got carried away and created the extra two images shown in **Figures 27.5** and **27.6**. These images give you a good idea of the many ways a caricature may be created. I like the way these digital caricatures turn out looking like real photographs. If you want a line drawing caricature, try applying the **Poster Edges** filter, or use one of the line drawing techniques presented in Technique 36. You can create some incredibly strange beings if you first use the mirror

technique discussed in Technique 49 and then apply distortions using the **Liquify** tool. It won't take you long to find that there are no limits to how you can remodel a fellow human being's face.

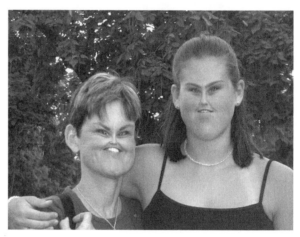

27.5

27.4

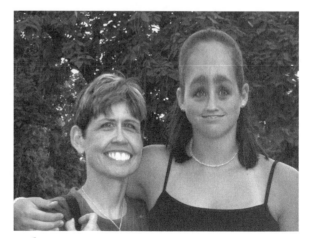

27.6

 27.7

Another fun filter to use to create caricatures is the **Distort** filter. Select **Filter ➢ Distort ➢ Pinch** to get the **Pinch** dialog box. You can set the **Amount** of pinch from **–100%** to **+100%**, where a setting less than **0** increases the size of the center of the image. A setting greater than **0** reduces or "pinches" the center of the image. The image shown in **Figure 27.7** was created with the Pinch filter.

MAKING AN ALBUM PAGE

Syracuse Vs. NC State
54-53

28.1 (CP 34)

28.2 (CP 33)

ABOUT THE PHOTO

"Cheering for a Win," Canon EOS1v, 28-70mm f/2.8 zoom lens or 300mm f.2.8mm, 4" × 6" prints scanned with HP DeskScan 4c, 1,680 × 2,520 pixel image size, 12.7MB .tif file

O nline photo-sharing sites, screen-savers, Web photo galleries, CD-ROM-based slide shows, and digital photo albums are just a few ways to enjoy digital photos. However, paper-based photo albums are still one of the best ways to enjoy and share your photographs. Paper-based albums can be enjoyed away from a computer screen, which makes them essential for those that want to enjoy albums but don't have a computer.

Creating photo albums with photographs can be a laborious *and* time-consuming task. The process is even more time-consuming if more than one copy is needed, as the correct negatives need to be found and taken to a photofinisher to make additional copies. Using a digital image editor, you can get extra pages by simply increasing the setting for the number of pages to be printed using your printer software. You can also edit, crop, and resize the images as you wish.

Creating a printed photo album from digital photos can be easy and fun with the right approach and technique. This technique shows the basic steps for arranging, cropping, and sizing digital photos to create perfect album pages. The four photos in **Figure 28.1 (CP 34)** show two good friends who are college cheerleaders. **Figure 28.2 (CP 33)** shows the completed album page that will preserve the memories of a very close basketball game — the final score was 54-53!

STEP 1: CREATE ALBUM PAGE

The first step is to create a new document that will become the album page. Since 8½" × 11" photo albums are readily available, you'll make an album page of the same size. Before you create the file, you need to determine the optimal dpi setting for your printer. Most printers make quite good prints with either 240 dpi or 300 dpi. For this technique, assume you have a 240 dpi printer.

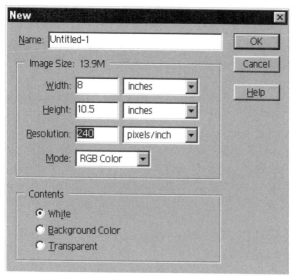

28.3

■ Select **File** ➢ **New** (**Ctrl+N**) to get the **New** file dialog box shown in **Figure 28.3**. As most printers will not print in the outer ¼ border of a page, create a new page that is 8" × 10½". Type **8.0** for the **Width** setting; if **Inches** is not the dimension setting, click to select **Inches**. Type **10.5** as the **Height** and set **Resolution** to **240** Pixels/Inch. Make sure **Contents** is set to **White** and then click **OK** to create a new 13.9MB image file.

STEP 2: ADD DIGITAL PHOTOS TO ALBUM PAGE

■ Select **File** ➢ **Open** to display the **Open** file dialog box. After double-clicking the **/28** folder to open it, click **1.tif** and then click **Open**.

There are two ways to copy one image into another image. After clicking on the image that you want to copy to make it the active image, you can select **Select** ➢ **All** (**Ctrl+A**), then select **Edit** ➢ **Copy** (**Ctrl+C**) to copy the image. Then click on the image where you want to copy the first image, to make it the active image; then select **Edit** ➢ **Paste** to paste it as a new layer into the second image.

Alternatively, to copy the active image into a second image, you may simply click and drag the background layer from the **Layers** palette onto the document window where you want to place the image. This second approach is much easier than the first and it uses less memory.

■ Click the **1.tif** image page to make it the active image. Then click on the **Background layer** thumbnail in the **Layers** palette and drag it onto the photo album page image.

■ Click on the **Close** icon (**Ctrl+W**) (if the image is active) in the upper right corner of the **1.tif** image to close it.

■ Repeat this step for the **2.tif**, **3.tif**, and **4.tif** files.

STEP 3: ARRANGE, CROP, AND SIZE EACH PHOTO

The album page should now contain four digital photos plus a white background layer. Additionally, the **Layers** palette should look similar to **Figure 28.4**.

■ Click the **Move** tool (**V**) in the tool box and begin moving the photos around on the page until they are arranged approximately like you want them. For now, ignore the problem of the photos not fitting the page or needing to be cropped. To make it as easy as possible to arrange the images, select **View** ➤ **Fit** on **Screen** (**Ctrl+0**) to maximize the image on your screen.

■ Using the **Move** tool (**V**), move the first image to where you want it. I chose to place the photo of the basketball players in the bottom left-hand corner. To make it be the top layer, click **Layer** ➤ **Arrange** ➤ **Bring to Front** (**Shift+Ctrl+]**). Alternatively, you could click and drag the thumbnail in the **Layers** palette into the top position.

■ Since the player photo is too large, you need to reduce its size. Select **Image** ➤ **Transform** ➤ **Free Transform** (**Ctrl+T**) to get the **Transform** marquee. This marquee has six boxes, or handles, placed around the image. If you click one, you can stretch or reduce the image in either one or two directions. As you want to reduce the image, while keeping the same proportions, click the box in the upper right-hand corner while pressing the **Shift** key. Drag the corner down to the left to resize the image. Pressing the **Shift** key keeps the height-width proportions the same. Because you selected the upper-right box, the image was reduced while keeping the left and bottom edges of the photos where they were. Once you are happy with the size of the photo, press **Enter** to set the size. You can go back and resize the image later if you choose.

■ Click the other photos using the **Move** tool (**V**) and place and size them as you wish.

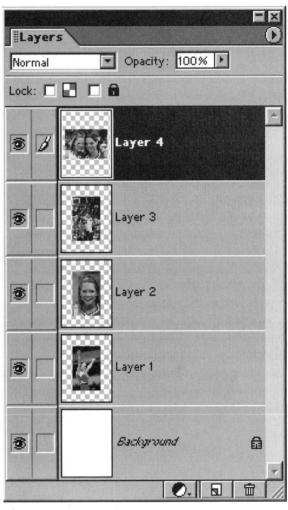

28.4

■ If your arrangement requires that a photo be cropped, move the layer to the top of the **Layers** palette by clicking and dragging the appropriate layer in the **Layers** palette to the top layer position. Click the **Square Selection Marquee** (**M**). Click the image where you want it cropped. Then, drag and drop the marquee around the part of the image that you want to keep, as shown in **Figure 28.5**. Since you want only the selected part of the photo, select **Select** ➢ **Inverse** (**Ctrl+I**) to invert the image. Select **Edit** ➢ **Cut** (**Ctrl+X**) or press **Backspace** to delete the part of the image you no longer need. You can now resize and place the cropped photo *exactly* where you want it.

STEP 4: ADD DROP-SHADOW EFFECTS

■ Once again, click the **Move** tool (**V**) in the toolbox. Click one of the photos to select a layer.
■ For the shadow effects, space will be needed to the right and below of each of the images. Thus, move each of the images that touch the right and bottom edges away from the edge as shown in **Figure 28.6**.
■ Click the **Layer Styles** palette in the palette well and then drag and drop it to your workspace. Click the effects box to select **Drop Shadows** to get the **Drop Shadows** palette shown in **Figure 28.7**. Click the **Soft Edge** effects box. Click each of the other photos one at a time and apply the **Drop Shadow** effect in the same manner.

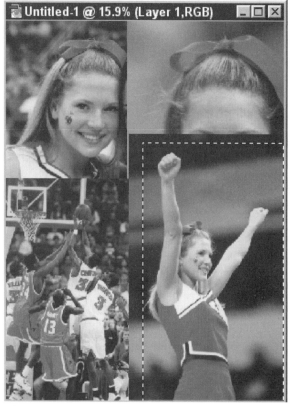

28.5

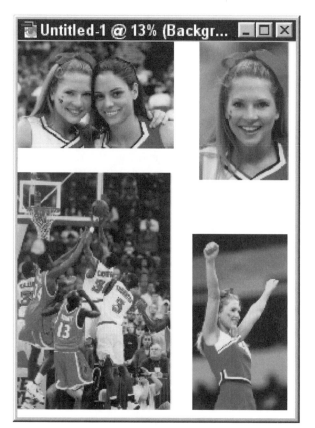

28.6

STEP 5: FLATTEN IMAGE AND ADD TEXT

- When your album page is as you'd like it, select **Layers** ➤ **Flatten Image** to flatten the image.
- You can now add text in multiple places on the page by clicking the **Type** tool (**T**) and clicking the image where you want to place text. Press **Enter** after typing each piece of text, then click with the **Text** tool (**T**) in a new location and begin typing again. You can then move the pieces of text independently. The easiest way is to select the **Move** tool (**V**), and insure that the "**Auto Select Layer**" option is checked in the **Options bar**. You can then just click and drag any piece of text to any location you want. The **Text** (**T**) **Options bar** allows you to select the **Font** and **Font size**. I chose **Lucida Calligraphy** in an **18pt.** size to add the score and the team names.
- Once your image is as you'd like it to be, select **File** ➤ **Save As** to get the **Save As** dialog box. Select an appropriate directory and name your file, then click **Save** to save your file.

This technique has shown how to do the basic tasks necessary to create a photo album page. However, using a little creativity and the power of a digital image editor, you can vary this technique to make the pages even more appealing. Other options you might want to consider include: rotating the photos or maybe even twisting them, adding text around or on the photos, adding borders to the page or to the photos, and applying edge effects. There are many possibilities. Experiment and see what you can create.

28.7

ANIMATING TO SHOW PERSONALITY

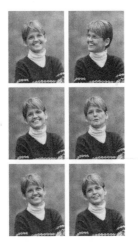

29.1

29.2

Once you begin displaying photographs digitally, you'll find you will have all kinds of fun new technologies to use, such as animated GIFs. GIF files are small, fast-to-download images that are excellent for displaying on Web pages. While a single portrait can often reveal lots of personality, a series of photographs layered together and then animated can show even more. This technique shows how to combine more than one image into an animated GIF file, which almost looks like a movie when animation begins.

All six of the photographs shown in **Figure 29.1** were shot with a hand-held film camera. Even better results may be obtained with a digital camera mounted on a tripod. To get the best effects, set your camera on manual and use the settings that you get with an automatic exposure setting. This will eliminate any variation in light levels that you get with slightly varying exposure settings. If you use a digital camera with the proper settings on a tripod, the images should align precisely.

To view the final animated image shown in **Figure 29.2**, drag and drop the **animation.gif** file found on the companion disk in the **/29** folder onto a Web browser.

STEP 1: OPEN FILES

■ Select **File** ➤ **Open** to display the **Open** file dialog box. After double-clicking the **/29** folder to open it, press **Ctrl** while clicking all the six image files labeled **1.jpg**, **2.jpg**, **3.jpg**, **4.jpg**, **5.jpg** and **6.jpg** to select them. To open the files, click **Open**.

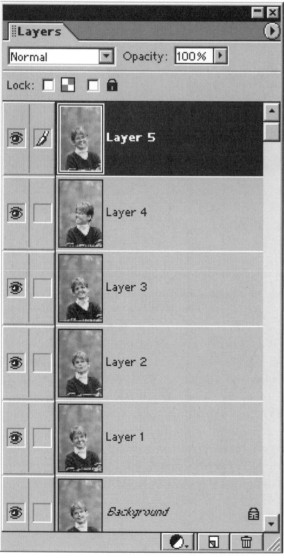

29.3

STEP 2: COMBINE ALL PHOTOS INTO A SINGLE MULTILAYERED IMAGE

■ Click the **1.jpg** file to make it the active image and drag it away from the other images.
■ Click the **2.jpg** file to make it the active file.
■ Select **Select** ➤ **All** (**Ctrl+A**) to select the entire image.
■ Select **Edit** ➤ **Copy** (**Ctrl+C**) to copy the image to the clipboard.
■ Click the **1.jpg** image to again make it the active image and then select **Edit** ➤ **Paste** (**Ctrl+C**) to paste **2.jpg** as a layer.
■ Click **2.jpg** to make it the active image, and then select **Image** ➤ **Close** to close the file, as we will no longer need it.

STEP 3: ADD OTHER PHOTOS

■ Repeat Step 2 for the files **2.jpg**, **3.jpg**, **4.jpg**, and **5.jpg**.

STEP 4: ALIGN IMAGES

At this point, the **Layers** palette should appear as shown in **Figure 29.3**. If you don't see the **Layers** palette, click **Window** ➤ **Show Layers**. The challenge now is to align all of the images so that the background doesn't jump each time a new frame is shown in the animation.

As these photos were taken without the benefit of a tripod and the digital images were created by scanning 4" × 6" prints with a desktop scanner, exact matching of the backgrounds is nearly impossible. However, we can get close enough to make a nice animation. One way to align the images as accurately as possible is to put a single black dot on the same place in each image. Then, align the images by aligning the dots. To save you the time it takes to place the dots, I have placed one dot using the **Paint Brush** tool on each image in the upper-right corner, which will be cropped. It is just above a blurred tree branch and right next to a bright highlight. When using this technique to align images that won't be cropped, align the images and use the **Clone Stamp tool** to remove each dot.

■ Select the **Move** tool (**V**) by clicking it in the toolbox.

■ Click the eye icon to the left of each layer to turn off all layers except **Layer 1** and **Background**.

■ Click **Layer 1** to make it the active layer.

■ Click the mode box in the upper left-hand of the **Layer** palette to select **Soft Light** as the mode.

■ Click the image and drag it with the **Move** tool until you get the two tiny dots to match up as closely as possible. To precisely align the dots, tap the appropriate arrow keys until the dots match up exactly.

■ Click the mode box and set the blend mode back to **Normal**.

■ Repeat the process of selecting a layer, making it visible, changing its mode to **Soft Light**, aligning the dots, and changing the mode back to **Normal** again for each of the other four layers.

STEP 5: CROP IMAGE

Before you crop the image, make sure that the blend mode for each layer is set to **Normal**. You can do this quickly by clicking each thumbnail in the **Layers** palette and checking to see that **Normal** is the chosen blend mode.

■ Click the **Square Marquee** selection tool (**M**) in the toolbox. You'll then see the Options toolbar shown in **Figure 29.4**.

■ To make an animation with the same proportions as an 8" × 10" print, set **Style** in the Options bar to **Constrained Aspect Ratio,** type **8** in the **Width** box, and **10** in the **Height** box. This is shown in **Figure 29.4**.

■ Click just inside the bottom right-hand corner of the image window and drag the selection marquee up and to the left until you are a small distance away from the edge of the image.

■ To make sure you have not selected a part of a layer that is transparent, click each of the eye icons again starting from **the top layer** and turn each of them off. If you find that you have selected part of a layer that contains white space, then go back and redo the selection.

■ To crop the image, select **Image ➣ Crop** and your image should now look similar to the one shown in **Figure 29.5**.

STEP 6: REDUCE FILE SIZE

■ To reduce the file size, click **Image ➣ Size** to get the **Image Size** dialog box shown in **Figure 29.6**. Make sure that the **Constrain Proportions** box is checked, then type **320** in the **Height** box. Click **OK** to reduce the size of the image.

29.5

STEP 7: SAVE IMAGE AS AN ANIMATED GIF FILE

- To save the image as an animated GIF file, select **File ➤ Save for Web** (**Alt+Shift+Ctrl+S**) to get the **Save for Web** dialog box.
- Click the **Settings** box and select **GIF 128 Dithered** as the optimization setting. Click in the **Animate** box to add a checkmark. You'll then have access to the options shown in **Figure 29.7**.
- If you want the animation to repeat continuously, click the **Loop** box to add a checkmark. This animation looks best with a **Frame Delay** setting of **0.5**.

You can now preview the animation in your Internet browser by clicking the **Preview In Box**. Besides viewing the animated GIF, you'll also get some useful image information and HTML code, which can be cut and pasted into an HTML editor.

- To create the GIF file, click **OK** to get the **Save Optimized As** file dialog box shown in **Figure 29.8**. After selecting and naming the folder where you want to save the file, you can also click the **Save HTM File** box to create an HTML page plus the GIF file. Then, click **Save**.

This is a very simple animation consisting of just six digital photos. Imagine what you can do with this feature! Using some of the techniques in the other chapters, you can create animated GIF files that feature an ink drawing that is painted while you watch, a motorcycle racing across the page, light changing in a forest, or maybe even a changing depth-of-field just like you might see in a camera. You could even take various "snapshots" of a face that is being distorted, as you will see in Technique 27. Animated GIFs are great fun, and when done carefully, they can add considerable appeal to a Web page.

That's it for this chapter! The next chapter focuses on using traditional photographic techniques digitally.

29.7

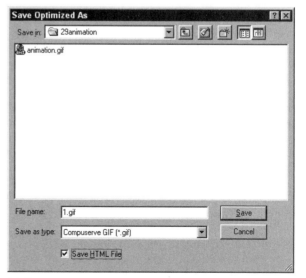

29.6

29.8

CHAPTER 6

TRADITIONAL PHOTOGRAPHIC TECHNIQUES

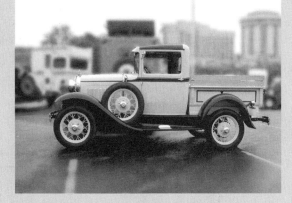

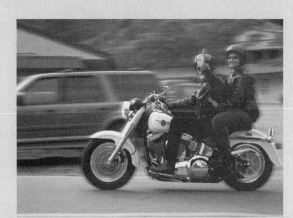

Although master photographers have been able to constantly push the boundaries of what they can do with their cameras and in traditional darkrooms, these master photographers also face considerable limitations. Hand-painted images and the tones that can be used in making sepia prints are limited to a small number of colors. The amount and quality of grain in an image is set partly when a film is chosen and set partly by the limits of the photograph paper. If a photograph is taken with little depth-of-field, then the final print will show little depth-of-field. Likewise, an image that is to show motion must be taken to show motion at the time the picture is taken.

Digital image editors, such as Photoshop Elements, substantially remove photographic process–related limitations and increase creative possibilities. This chapter shows how a color image may be turned into a high-quality black and white print. It also shows a digital technique for making a sepia print and a hand-colored black and white print without many of the limitations of the traditional photographic process. The final two techniques show how to simulate depth of field and motion in an image when it previously had none.

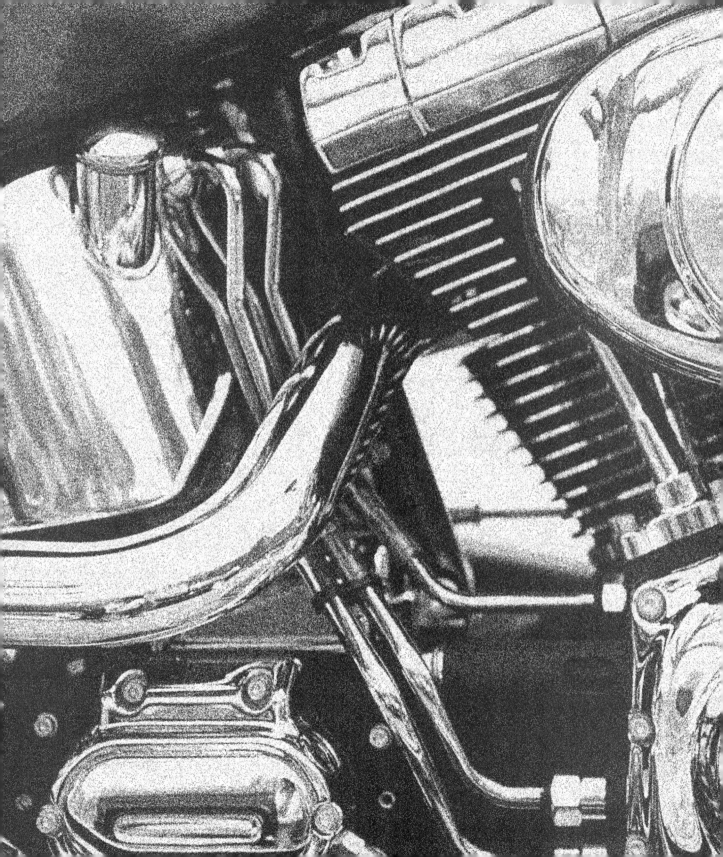

TURNING A COLOR PHOTO INTO A BLACK AND WHITE PHOTO

30.1

30.2

ABOUT THE PHOTO

"1932 DeSoto Grill," Canon EOS1v, f/2.8 28-70mm zoom lens, Fuji Provia slide film scanned with Polaroid SprintScan 4000, 2,400 × 1,600 pixel image size, 11.5MB .tif file

D o you remember the DeSoto automobile? No? Neither do I. That's why I thought I ought to include a picture of one (or at least half of the front grill) in this book as shown in **Figure 30.1**. In 1928, Chrysler bought Dodge and launched Plymouth and DeSoto. Believe it or not, body streamlining began with Chrysler and the DeSoto Airflow in 1934. The last DeSoto was built in 1961. This one, I am told, was built late in 1931 and registered as a 1932 model.

Many photography purists feel strongly about the need to shoot black and white film to get a good black and white print. The fact is, it is entirely possible to make excellent black and white photographic prints by digitally converting a color image to a black and white image. This technique will show you just that.

Although I took this picture because of the rich red rust colors, I knew that it would also make an excellent black and white photo. The grill lines and the "DeSoto" name should offer enough interest to make it an interesting photo.

STEP 1: OPEN FILE

■ Select **File** ➢ **Open** (**Ctrl+O**) to display the **Open** file dialog box. Double-click the **/30** folder to open it; click the **desoto-before.tif** file to select it, and then click **Open**.

STEP 2: SHARPEN IMAGE

■ Before using the **Unsharp Mask** you should always display the image at **100%** so that you can get an accurate view of the effects. To display the image at **100%**, select **View** ➢ **Actual Pixels** (**Alt+Ctrl+0**).

■ Select **Filter** ➢ **Sharpen** ➢ **Unsharp Mask** to get the **Unsharp Mask** dialog box shown in **Figure 30.3**. If you have the **Preview** box checked, you can experiment with the sliders and see the results in the image. Try using **150%**, **4.0**, and **5** for the **Amount**, **Radius**, and **Threshold** settings respectively. Click **OK** to get a sharpened image.

STEP 3: REMOVE COLOR

■ As we will not want to introduce any color into this black and white image in the future, change the **Mode** to **Grayscale** by selecting **Image** ➢ **Mode** ➢ **Grayscale**. If you get a warning box asking if you want to discard color information, click **OK** to convert the image to grayscale.

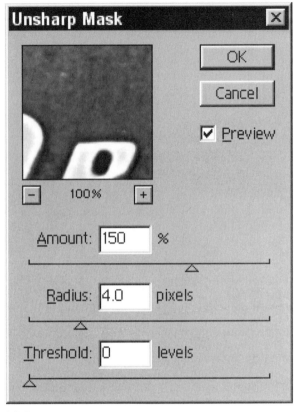

30.3

If you wanted to you use the **Remove Color** command instead of the **Grayscale** command, read **About Desaturate Versus Grayscale**.

ABOUT DESATURATE VERSUS GRAYSCALE

There are two ways to remove color from an image. You can select **Enhance** ➢ **Color** ➢ **Remove Color** (**Shift+Ctrl+U**). Or, you can select **Image** ➢ **Mode** ➢ **Grayscale**. Either way you get a black and white image. So,

why choose one approach over the other?

The advantage of changing the **Mode** to **Grayscale** is that it will dramatically reduce your file size, thereby taking less disk space, taking less RAM, and saving you time (as all of your digital editing steps will process much faster). Changing

the DeSoto image from color to grayscale in Technique 30 reduced the file from 11.5MB to 3.7MB, which is quite a dramatic drop in size. The reason for the file reduction is that the hue and saturation information from each pixel is removed, leaving only the brightness values, which take considerably less space.

STEP 4: ENHANCE TONAL RANGE

■ Select **Enhance ➢ Brightness/Contrast ➢ Levels** (**Ctrl+L**) to get the **Levels** dialog box shown in **Figure 30.4**. As a purely artistic choice, I wanted to deepen the shadows, increase the high-lights, and lower the midtones. To do so, set **Input Levels** to **8**, **.80**, and **225**. Click **OK** to apply the settings.

30.4

An alternative approach to setting the **Input Levels** is to use the Eye Dropper tools in the **Levels** dialog box. See the **About Levels** note to learn how to use this feature.

You are now ready to print the image. Many photographers prefer working with black and white images, so for them, this technique is used frequently to convert color photos into black and white images. Others enjoy creating hand-colored black and white images. So, this technique is the first step to that end.

The disadvantage of using the **Grayscale** mode is that you can no longer use *any* of the features that involve color. When you select **Enhance ➢ Color**, you'll find that the **Color** menu item is grayed out. Thus, none of the **Color** submenu features are available. This may be okay, or it may be unacceptable, depending on what you want to do. I frequently create duotones or sepia-toned images from a black and white image. In those cases, I'll use **Remove Color** so that I can later intro-duce color back into my image. Technique 32 is a good example of when you want to use **Remove Color**. When there is no reason to add color, change **Mode** to **Grayscale**.

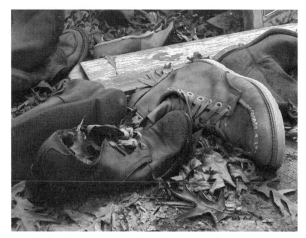

31.1 (CP 36)

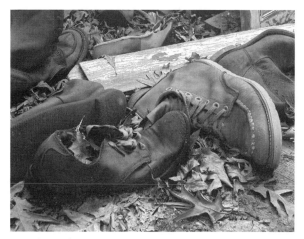

31.2 (CP 35)

CREATING A HAND-PAINTED BLACK AND WHITE PHOTO

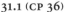

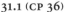**ABOUT THE PHOTO**

"Old Leather Work Boots," Nikon 950 digital camera, Fine Image Quality setting, original 1,600 × 1,200 pixel image size, 700KB image was enlarged with Photoshop Elements to be a 2,400 × 1,800 pixel image size, 13MB .tif file

Hand-painting black and white photographs with special paints or dyes is a technique some of the more skilled photographers have used for many years. Many common hand-painted black and white photographs depict a child or lady holding colored flowers or wearing a colored hat or dress. Usually, only one or two colors have been used and the colors stand out against an otherwise black and white photograph.

In this technique we examine two different approaches for simulating a hand-painted photograph. First, the original colors from a color photograph are used to paint the colors back into a black and white copy of the color photo. Then, you'll paint a black and white photo when there is no color photograph to use to get colors. This second approach creates photos that look more like the traditional hand-painted photos with fewer colors.

STEP 1: OPEN FILE

■ Select **File ➢ Open** to display the **Open** file dialog box. Double-click the **/31** folder to open it; click the **boots-before.tif** file to select it. To open the file, click **Open**.

STEP 2: CREATE A SECOND LAYER

■ Select **Layer ➢ Duplicate Layer** to get the **Duplicate Layer** dialog box shown in **Figure 31.3**. Click **OK** to create the new layer.

STEP 3: REMOVE COLOR FROM THE TOP LAYER AND LIGHTEN IMAGE

■ Select **Enhance ➢ Color ➢ Remove Color** (**Shift+Ctrl+U**) to remove all of the color from the top layer.

■ Because the black and white image is too dark, select **Enhance ➢ Brightness/Contrast ➢ Levels** (**Ctrl+L**) to get the **Levels** dialog box. Set the **Input Levels** to **10**, **1.25**, and **230**.

■ The very dark areas are too dark for the colors we will apply to show through. Thus, lighten the very dark areas by setting the **Output Levels** to **20** and **255**. Click **OK** to apply the settings.

If you have all the settings correct, the **Levels** dialog box should appear as shown in **Figure 31.4**.

STEP 4: SHARPEN IMAGE

■ Select **Filter ➢ Sharpen ➢ Unsharp Mask** to get the **Unsharp Mask** dialog box shown in **Figure 31.5**. Set **Amount** to **130%**, **Radius** to **1.0** pixels, **Threshold** to **0** levels, and then click **OK** to apply the settings.

At this point, we have a sharpened black and white image layer on top of a less-sharp, colored image layer. You can see the two layers by looking at the **Layers** palette, which should look like the one shown in **Figure 31.6**.

■ At the beginning of this technique, I mentioned we would look at two different approaches to hand-painting photos. To save yourself from having to redo these first four steps, select **File ➢ Save As** (**Shift+Ctrl+S**) to get the **Save As** file dialog box. After selecting a folder to save a temporary file, type **bootsbw** in the **File Name** box, select **TIFF** for **Format** and click **Save**.

31.3

31.4

STEP 5: CAREFULLY SELECT EACH BOOT AND DELETE THE SELECTION TO ALLOW THE COLOR IMAGE TO SHOW THROUGH

Choose a selection tool and make sure you set **Feather** in the options bar to **3** pixels. By now, you should have had a chance to use most of the selection tools. You might want to start with the **Lasso** tool (**L**).

- After selecting a boot, or a part of a boot, delete the selection by pressing **Backspace** or by selecting **Edit** ➢ **Cut** (**Ctrl+X**). Continue selecting more of the same boot or another boot until you have selected all of the boots and have color versions showing.

With images containing big color differences (this isn't one), it might be easier to hide the black and white layer and use the magic wand on the original color image. When you're done making the selection you can switch back to the B&W layer to cut out the areas where you want to show color. If you have carefully selected all of the boots and none of the background materials, you'll have an image that looks like **Figure 31.7**.

- Select **File** ➢ **Save As** to get the **Save As** dialog box. Select an appropriate directory and name your file, then click **Save** to save your file.

31.6

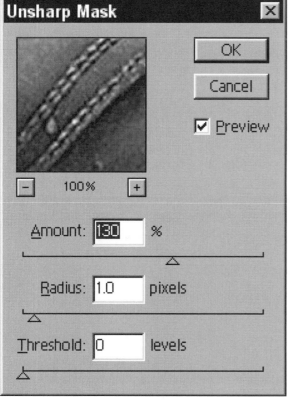

31.5

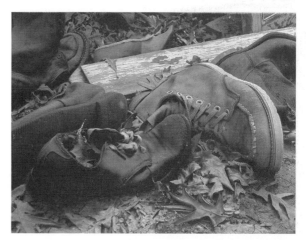

31.7

One advantage to this digital approach to a "hand-painted" photograph is that you can have a much richer palette of colors showing in your work. You can see how the once-dark black shoe fades into an almost green color. If you had used a photographic dye or paint, the entire shoe would have had to be painted with a single hue, possibly just blue, and no green would show at all.

Another advantage to this approach is that you have complete and separate control over what each layer looks like. If you want to darken or lighten the top black and white layer, you can. You could even use another technique to create an entirely different black and white image. For example, you could turn the black and white layer into an ink drawing if you wanted, which would offer contrast in color and in technique. Likewise, you can also make further adjustments to the background layer (the colored image).

ALTERNATIVE STEP 5: CHANGE COLORS TO LOOK MORE LIKE PHOTO PAINTS OR DYES

If you are a purist and you want a more traditional-looking hand-painted photograph, or if you only have a black and white photograph to begin with, then try this alternative approach.

■ Select **File** ➢ **Open** to get the **Open** file dialog box. Double-click on the folder where you saved the **bootsbw.tif** file, at the end of Step 4. Click **Open** to open the file.

You now have the option of making all the boots and shoes the same color by selecting them all and applying one color setting, or you may select different pairs of boots and shoes and apply different color settings to each of them.

■ To select one boot, click the **Magnetic Lasso** tool (**L**) and make sure that **Feather** in the options bar shows **3** pixels so that the selection is feathered.

■ Click the image where you want to start the selecting and drag the selection marquee all around one boot.

■ Select **Enhance** ➢ **Color** ➢ **Hue/Saturation** (**Ctrl+U**) to get the **Hue/Saturation** dialog box shown in **Figure 31.8**. Click on the **Colorize** box in the lower right corner and you will immediately see a colored boot. Adjust the **Hue**, **Saturation**, and **Lightness** settings to get the color you want. Try using settings of **34**, **43**, and **0**. Click OK to apply the settings.

Repeat the selection and color process until you have colored all the boots and shoes in the image that you want to color. The final image shown in **Figure 31.2** (**CP 35**) looks much more as if it has been hand painted with a yellow photographic paint or dye. If you want, you could adjust different shoes or boots to make them different colors. Maybe one set of boots gets a yellow cast as we have done, and the other set gets a bluer cast. It is all your choice.

■ Once your image is as you want it to be, select **File** ➢ **Save As** to get the **Save As** dialog box. Select an appropriate directory and name your file, then click **Save** to save your file.

31.8

MAKING A SEPIA-TONED PHOTO

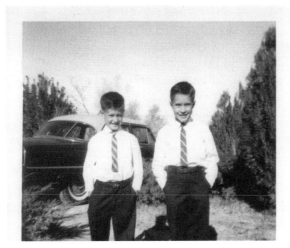

32.1

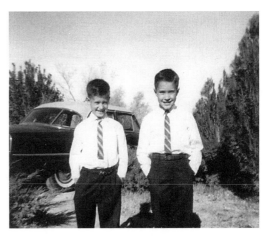

32.2

ABOUT THE PHOTO

"Two Brothers Wearing Ties," Unknown camera, 3 1/2" × 3 1/2" b&w photograph scanned with an HP ScanJet 4c, 1,920 × 1,920 pixel image size, 10.7MB .tif file

The original photo shows my brother and me years ago! It was a rare occasion when we got into nice slacks, a white shirt, and a tie. As a SOHO (Small Office/Home Office) person who is usually either in front of a PC in a home office or in the field taking pictures, I feel that the ties look very uncomfortable. I really like this picture, but the original is small and it needs something — maybe a sepia tone? In addition, a bit of sharpening is needed and the border ought to be whiter. Adjusting the tonal range might also bring out more detail in the faces.

STEP 1: OPEN FILE

■ Select **File** ➢ **Open** to display the **Open** dialog box. Double-click the **/32** folder to open it, choose the **brothers-before.tif** file, and then click **Open** to open the file.

STEP 2: MAKE A WHITE BORDER

■ Select the **Square Marquee** tool (**M**) by clicking it in the tool box. Make sure that **Style** is set to **Normal** in the options bar. Click just inside the image (not in the border) in the upper-left corner and drag the marquee down and to the right just inside the image (again, not in the border) to select the image.

32.3

■ Select **Select** ➢ **Inverse** (**Shift+Ctrl+I**) to select just the border.
■ Make sure that the background color is set to white (**D**), and then press **Backspace** or select **Edit** ➢ **Cut** (**Ctrl+X**) to make a pure white border.

STEP 3: SHARPEN IMAGE

■ Before sharpening the image, choose **Select** ➢ **Deselect** (**Ctrl + D**).
■ Select **Filter** ➢ **Sharpen** ➢ **Unsharp Mask** to get the **Unsharp Mask** dialog box shown in **Figure 32.3**. Set **Amount** to **100%, Radius** to **4.0** pixels, and **Threshold** to **4** levels. Click **OK** to sharpen the image.

STEP 4: IMPROVE TONAL RANGE

In Technique 25, the **Fill Flash** command was used to lighten shadows and revel more detail in a portrait that was underexposed. In this technique, we need the opposite effect. Because this image has been over-exposed, it lacks detail. Instead of using the **Fill Flash** to lighten shadows, the **Backlight** filter will be used to darken the shadows. It should be noted that there is a limit to how much detail may be made visible in an overexposed digital photo. If the image is "blown out" or very bright, there will simply not be enough "picture data" in the image to the make the image look good.

■ To darken the image enough to bring detail back into the faces of the two subjects and to bring out more of the background trees, select **Enhance** ➢ **Adjust Backlighting** to get the **Adjust Backlighting** dialog box shown in **Figure 32.4**. Either type in **50** or drag the triangular slider over to the middle until **50** is shown. Click **OK** and you will get the desired effect.

STEP 5: ADD SEPIA TONE

■ Now we want to add a sepia tone to the image while keeping the pure white border white. To do this, select **Enhance ➢ Color ➢ Hue/Saturation** (**Ctrl+U**) to get the **Hue/Saturation** dialog box shown in **Figure 32.5**.

■ Click the **Colorize** box at the bottom right-hand corner of the **Hue/Saturation** dialog box to check the **Colorize** box. You'll instantly see the color added. Set **Hue** to **25** to make the color less red and more of a sepia color. Set **Saturation** to **35**, and leave **Lightness** set to **0**. Click **OK** to apply the settings.

■ Select **File ➢ Save As** to get the **Save As** dialog box. Select an appropriate directory and name your file, then click **Save** to save your file.

32.4

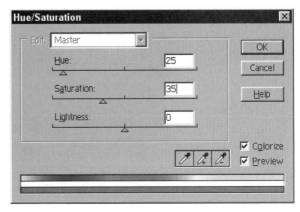

32.5

The result of these simple five steps is the dramatically improved image that is shown in **Figure 32.2**. It makes a much larger and far more interesting print than the original. In this example, the original photograph was black and white and we sepia-toned it. However, the same technique could be applied to a color photograph. Just remove the color using the **Enhance ➢ Color ➢ Remove Color** command (**Shift+Ctrl+U**) and follow the same steps we just covered.

ADDING GRAIN TO A BLACK AND WHITE PHOTO

33.1

33.2

ABOUT THE PHOTO

"Harley-Davidson 'Fatboy'," Canon EOS1v, f/2.8 28-70mm zoom lens, Fuji Provia slide film scanned with Polaroid SprintScan 4000, 2,400 × 1,600 pixel image size, 11.5MB .tif file

I have always liked the *pointillism* technique where an entire image is made up of nothing but dots or "points." I also like intentionally grainy black and white photographs made by printing on especially grainy paper. Rather than seeing smooth gradations, you see lots of grains. While this particular photo of the side of a Harley-Davidson motorcycle was taken with slow film (ISO 100) to minimize graininess, it is the perfect image to use to show how to add grain!

This technique shows how you can intentionally add grain to an image. When the right image is used, the prints made using this technique will look as if they were made with a grainy film or printed on a grainy photographic paper. You can use it on color images as well. This technique works best on high-contrast images and on images with lots of detail (or edges) like the detail image of the motorcycle. It works least well on images with lots of smooth tones or gradations and little detail.

STEP 1: OPEN FILE AND TURN COLOR IMAGE INTO A BLACK AND WHITE IMAGE

- Select **File ➢ Open** (**Ctrl+O**) to display the **Open** file dialog box. Double-click the **/33** folder to open it; click the **fatboy-before.tif** file to select it, and then click **Open**.
- Select **Image ➢ Mode ➢ Grayscale** to turn the color image into a black and white image. You may be presented with a dialog box asking if you want to discard color information; if so, click OK to convert the image to a grayscale image.

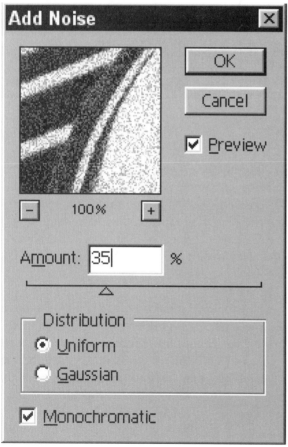

33·3

STEP 2: ADD GRAIN

- When you use the **Add Noise** filter, it is best to view the image at 100% as you will be able to get a more accurate view of effects as you adjust settings. Click **View ➢ Actual Pixels** (**Alt+Ctrl+O**).
- Select **Filter ➢ Noise ➢ Add Noise** to get the **Add Noise** dialog box shown in **Figure 33.3**. Set **Amount** to **35%**, click **Uniform Distribution**, and make sure there is a checkmark in the **Monochromatic** box. Click **OK** to apply noise.

STEP 3: ADJUST GRAIN

At this point, the image is very grainy. In fact, it is perfectly grainy over the entire image. This is almost too perfect to be like the grain produced in a wet-lab photography darkroom. Therefore, make a few additional adjustments.

- Select **Image ➢ Adjustments ➢ Posterize** to get the **Posterize** dialog box shown in **Figure 33.4**. If you have the **Preview** box checked in the lower-right-hand corner of the dialog box, you can see the results of the current **Levels** setting. I found that a **Level** of **5** or **6** reduced the grain pattern

33·4

about as much as I wanted. Once you are happy with the preview, click **OK** to apply your setting.

The added benefit of applying the **Posterize** filter is that it has increased the brightness of the highlights and made the near whites, whiter. In my opinion, the image is looking better. However, I would still like to see more definition of the grains.

■ To increase the look of the grain pattern, select **Filter ➢ Sharpen ➢ Unsharp Mask** to get the **Unsharp Mask** shown in **Figure 33.5**. Try the settings of **40%** for **Amount**, a **4.0** setting for **Radius**, and **0** levels for **Threshold**. Click **OK** to apply these settings.

■ Select **File ➢ Save As** to get the **Save As** dialog box. Select an appropriate directory and name your file, then click **Save** to save your file.

With the final adjustments applied, the grain becomes much more pronounced, which can be seen in the detail image shown in **Figure 33.6**. This image makes a very nice print when made with a photo-quality inkjet printer on a high-quality photographic paper. With my Epson 1270 inkjet printer set to 1440 dpi, I got an excellent print on Pictorico's Premium Photo Glossy Paper using Epson's Photo Quality Glossy Film printer setting. Of all the "after" images in this book, this is one of my favorites.

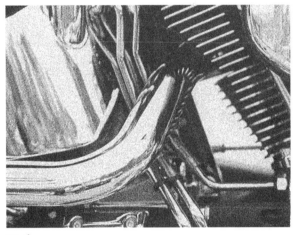

33.6

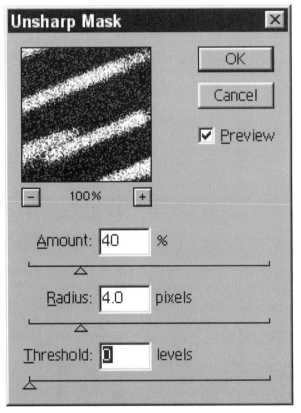

33.5

CREATING DEPTH OF FIELD

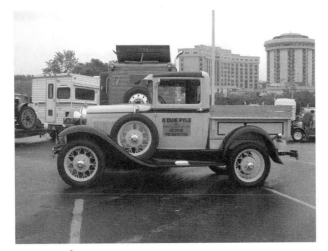

34.1 (CP 38)

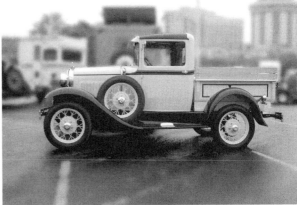

34.2 (CP 37)

When taking pictures, controlling the depth-of-field is always a challenge. In fact, depth-of-field can often determine the overall success or failure of a picture. Many variables control depth-of-field including: distance to subject, lens focal length and quality, aperture, lighting, and film speed. Sometimes these variables cannot be altered enough to get the effect that you want. This technique shows how you can use your digital image editor to digitally control depth-of-field.

Using a digital camera, I took the picture of the antique truck. If you look closely at the photograph, you'll see that nearly everything in the photograph is sharply focused — except for the hotel buildings in the far right background. To put more emphasis on the antique truck, you will limit the depth of field to about ten feet; two feet in front of the truck, the width of the truck, and about four feet behind it.

STEP 1: OPEN FILE AND MAKE A FEW IMAGE ENHANCEMENTS

■ Select **File ➢ Open** (**Ctrl+O**) to display the **Open** file dialog box. Double-clicking the **/34** folder to open it, click the **truck-before.tif** file to select it. To open the file, click **Open**.

■ Select **Enhance ➢ Brightness/Contrast Levels ➢ Levels** to get the **Levels** dialog box. Set **Input Levels** to **9**, **1.10**, and **220**, then click **OK** to slightly brighten the image.

■ In an effort to make this look like a real, working truck, rather than the carefully maintained collectable that it is, I used the **Clone Stamp** tool to remove the orange-colored sign on the door and the wood stop behind the rear wheel.

STEP 2: CAREFULLY SELECT ALL OF THE TRUCK

The objective of this step is to carefully select the truck, which will become the "in-focus" part of the image. Intricate selections like this, even with the powerful selection tools that are available, can become tedious and time-consuming. My suggestion is to try a variety of tools *and* to combine them. Use a straight selection tool when you have a straight edge area such as the hood to select. If contrasting colors define the edge, use the **Magic Wand** tool. In most areas, though, you'll just have to carefully drag the cursor around with either the **Magnetic Lasso** or the regular **Lasso**.

In the more complex areas, I suggest that you increase the image size to 100% or even as much as 300% (depending on your screen resolution). This will be especially useful when you get to the rear bumper and license plate. Varying image size is easy when using the **Navigator** palette. Not only does it enable you to increase/decrease image size, but it also lets you quickly move the image around to display the area that you want.

One last tip is to select small areas at a time and keep adding to your selection. If you do this, you can easily undo the prior selection (**Alt+Ctrl+Z**), or **Step Backwards** (**Ctrl+Z**) if it was not what you wanted. You can also use the **Subtract from Selection,** or **Add to Selection** feature that may be found in the options bar for most of the selection tools. Additionally, you can add to a selection by pressing **Shift** while selecting, or subtract from a selection while pressing **Alt**.

■ Click the **Lasso** tool (**L**) in the tool box. **Figure 34.3** shows the **Lasso** tool **options** bar that appears once the **Lasso** tool has been selected. Besides clicking the **Add to Selection** icon, you'll also want to make sure that **Feather** is set to **5** pixels and that there is a check in the **Anti-aliased** box. Now, you can begin selecting the truck.

■ Once the entire truck has been selected, you'll need to deselect the background showing through the side window by clicking the **Subtract from Selection** icon in the **Lasso** tool options bar.

If you have successfully selected the truck and unselected the portion in the window, you'll have a marquee showing your selection that is similar to the one shown **in Figure 34.4**.

STEP 3: ADD A FEATHERED HORIZONTAL SELECTION TO THE TRUCK SELECTION

If you were to invert the selection and blur the image, it would be technically incorrect. You still need to select the ground that is in focus all the way across the image.

34.3

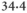
34.4

■ Select the **Square Marquee** tool (**M**) by clicking it in the tool box. Once the tool is selected, you see the options bar.

■ As you don't want to have a sharp-edged selection defining the in-focus part of the image, set **Feather** to **35** pixels.

■ Before you select the horizontal portion of the image, make sure that you click the **Add to Selection** icon so that you do not remove your earlier selection. Then, select a rectangular area that begins just below the truck and goes to almost the top of the tires, as shown in **Figure 34.5**.

STEP 4: INVERT SELECTION AND BLUR

■ As we want to blur the entire image *except* the truck and the horizontal area selected in the last step, select **Select ➢ Inverse** (**Shift+Ctrl+I**).

■ Select **Filter ➢ Blur ➢ Gaussian Blur** to get the **Gaussian Blur** box shown in **Figure 34.6**. Set Radius to **8.0** and click **OK** to apply the blur to get the image shown in **Figure 34.2** (**CP 37**).

Unquestionably, the truck now stands out from its background. In fact, I guess one could make the case that it is a little too dramatic of a depth-of-field. If you think so, use a **Gaussian Blur** setting of **3** or maybe **5** at the most. This is an excellent technique to use for photographs of flowers or portraits where you want to blur out the background to keep viewer's attention on the subject. A good example of a successful shallow depth-of-field, done all with the camera, is the photo of the chameleon shown in **Figure 45.1** (**CP 56**).

■ Select **File ➢ Save As** to get the **Save As** dialog box. Select an appropriate directory and name your file, then click **Save** to save your file.

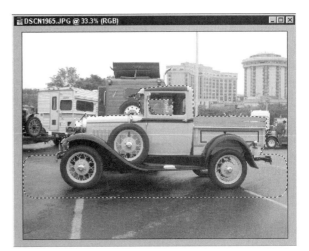

34.5

34.6

ADDING MOTION TO AN IMAGE

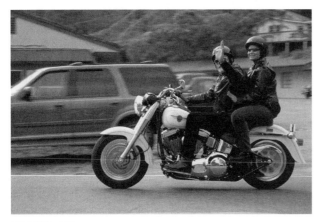

35.1 (CP 40) 35.2 (CP 39)

ABOUT THE PHOTO

"Out for a Sunday Cruise,"
EOS1v with F/2.8 28-70mm
wide-angle lens, Fuji Provia
film was scanned with a
Polaroid SprintScan 4000,
2,400 × 1,600 pixel image
size, 11.5MB .tif file

P anning a camera with a moving object is a good technique to use to show motion. It increases visual interest when taking photographs of moving subjects like that of the motorcycle. While this is a commonly used technique, getting it just right takes time, experience, right speed of film, good lighting, and proper equipment.

However, adding a sense of motion to an image after it has been taken with a digital image editor is as simple as it is to select and blur the background of the moving subject. You can even control how fast the object appears to move. The steps to accomplish this technique are very similar to Technique 34 in which the depth-of-field was shortened.

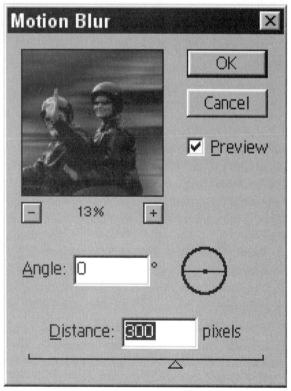

35·3

35·4

STEP 1: OPEN FILE

■ Select **File ➢ Open** to display the **Open** file dialog box. Double-click the **/35** folder to open it. Click the **motorcycle-before.tif** file to select it. To open the file, click **Open**.

STEP 2: SELECT THE MOTORCYCLE AND THE RIDERS

Once again, we are faced with detailed objects to select. If the **Navigator** is not showing, select **Window ➢ Show Navigator**. Use the **Navigator** to both enlarge and move the image as you select various parts of it.

■ Click the **Lasso** tool (**L**) in the tool box. Make sure the options bar that appears once the **Lasso** tool has been selected has the **Add to Selection** icon highlighted. You'll also want to make sure that **Feather** is set to **3** pixels and that a check appears in the **Anti-Aliased** box. Now, you can begin selecting the motorcycle and the two riders. You may want to increase the image size to 100% or even as large as 300% to more clearly see detail and make accurate selections.

■ Keep adding to the selection until you have all of the motorcycle and two riders. Then, select the shadows under the motorcycle as the shadow moves with the motorcycle. Once you have everything selected, your image should look similar to the one shown in **Figure 35.3**.

STEP 3: INVERT SELECTION AND ADD MOTION BLUR

■ Since you want to blur everything but the motorcycle, the riders, and the shadow, select **Select ➢ Inverse** (**Ctrl+I**).

■ To add the motion blur, select **Filter ➢ Blur ➢ Motion Blur** to get the **Motion Blur** dialog box shown in **Figure 35.4**.

■ Make sure a checkmark appears in the **Preview** box in the **Motion Blur** dialog box so that you can see the results of the settings. Set the **Angle** to **0** degrees. Then begin dragging the **Distance** slider as you watch the image. Using a **Distance** setting of **75** pixels, you will get an image as shown in **Figure 35.2 (CP 39)**.

■ Select **File ➢ Save As** to get the **Save As** dialog box. Select an appropriate directory and name your file, then click **Save** to save your file.

If you want to crank up the speed a bit more, slide the **Distance** slider over more to **300** pixels or so. **Figure 35.5** shows the results of a **Distance** setting of **300** pixels. It makes the riders look like they are going about 100 mph. Although, I did spend time one weekend shooting moving motorcycles to get this effect with a camera, it took more time and film than I will admit to having used! In the end, I got the results I wanted, but look what you can do in the digital darkroom and the control it provides you.

Incidentally, after several people looked at the results of this technique, they made comments about the blur around the riders and said that it made the image look technically incorrect. In fact, when you take a photograph of a moving object like the riders and the motorcycle, you will get such a halo, or second blur unless you can pan exactly at the same speed as the motorcycle. You can see such an effect in the unedited photo shown in **Figure 35.6**.

What happens is you have one blur speed for the stationary background and a second blur (the halo-looking) blur from not tracking the moving object at the exact speed. However, I admit that you will not see the blur in front of the moving object. To make this image look perfect, simply use the **Clone Stamp** tool (**S**) and paint over the most obvious halos that are in front of the moving objects. This will make this image "picture perfect!"

■ Select **File ➢ Save As** to get the **Save As** dialog box. Select an appropriate directory and name your file, then click **Save** to save your file.

The end of this technique is also the end of this chapter on traditional photographic techniques. In the next chapter, Chapter 7, you'll examine six techniques that transform photographs into prints that look like "natural media."

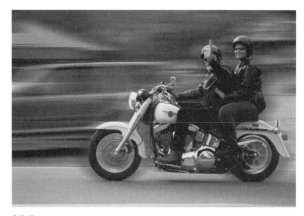

35.5

35.6

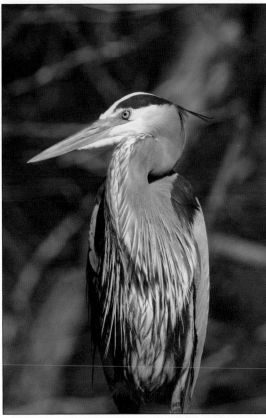

CP.2

Technique 3: Adjusting color and saturation

Most digital photos or scans can be improved with the Hue/Saturation and Levels commands, as was this photo of a blue heron.

CP.1

CP.4

Technique 4: Improving tonal range and image contrast

Using Levels and making minor adjustments with the Brightness/Contrast command improved the tonal range of this digital photo of a California Brown Pelican.

Technique 5: Removing a color cast

An improper digital camera setting caused an unwanted blue color cast.
Color Cast and other features can often fix problems like this one.

Technique 8: Creating a graphic art image

The application of a couple of quick and easy-to-use filters transformed the original digital photo into an image suitable for printing, framing, and hanging on a wall.

CP.8

CP.7

Technique 10: Painting with the Sumi-e brush

I applied the Sumi-e brush filter to the digital photo of the harbor in Honolulu, Hawaii. (See below). Although it appears to be painstakingly hand-drawn with colored markers, all the lines were added in just seconds.

Technique 12: Using multiple filters to create a unique image

Applying one filter is good. Applying two filters may be better. Applying more than two filters is even better? Well—not necessarily, but experimentation is the key to getting new and unique effects as illustrated in this waterlily photo.

CP.12

CP.11

Technique 13: Changing colors

Chameleons change colors and a good digital image editor can too. A digital image editor was used to remove the red tone from the plant and background and turn it back into the green color that it had prior to a cold spell.

CP.14

CP.13

Technique 16: Performing radical color transformation

Photos do not always need realistic colors. Sometimes it is fun to radically change the color of an image, as shown in this photo of the old truck.

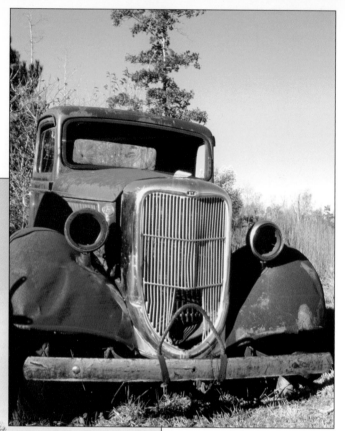

CP.16

CP.15

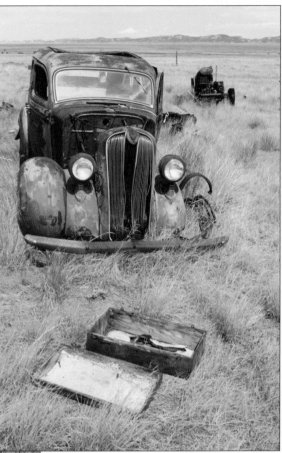

CP.18

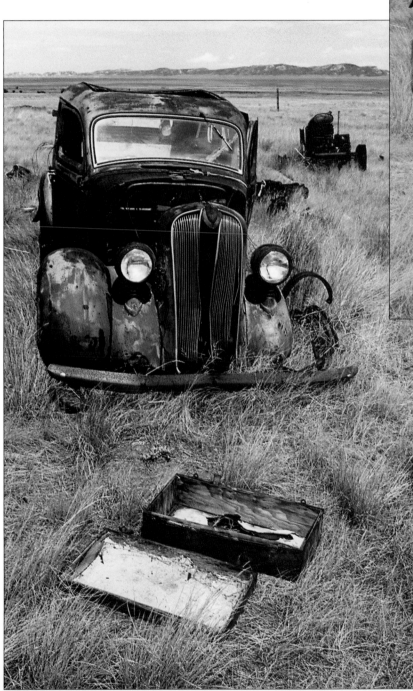

CP.17

Technique 17: Using a monochromatic scheme

A monochromatic color scheme can be used to create dramatic works of art. The use of a monochromatic color scheme fixed the color problems that resulted from a scan of an old slide.

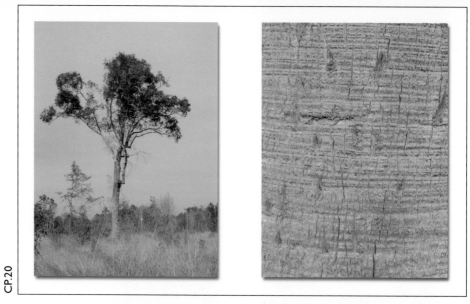

CP.20

Technique 18: Getting color from a second image

You can use an image to add color and texture in another image. That is how this image was created. An image of a tree trunk was merged with a photo of a tree in an open field. It makes a wonderful print.

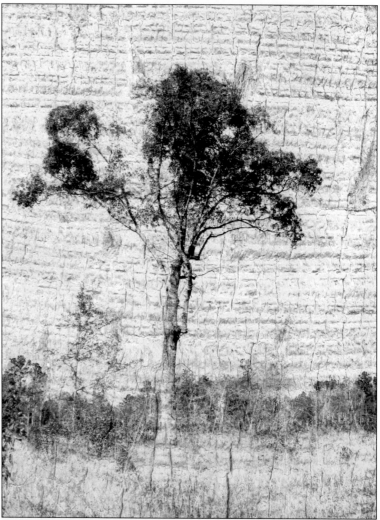

CP.19

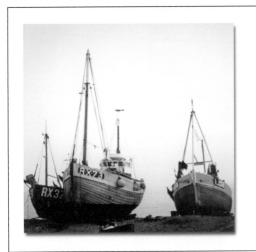

Technique 19: Combining two or more images

Blending two photos creates an image that is much better than either of the photos by itself. This is a great technique to create unique images.

CP.22

CP.21

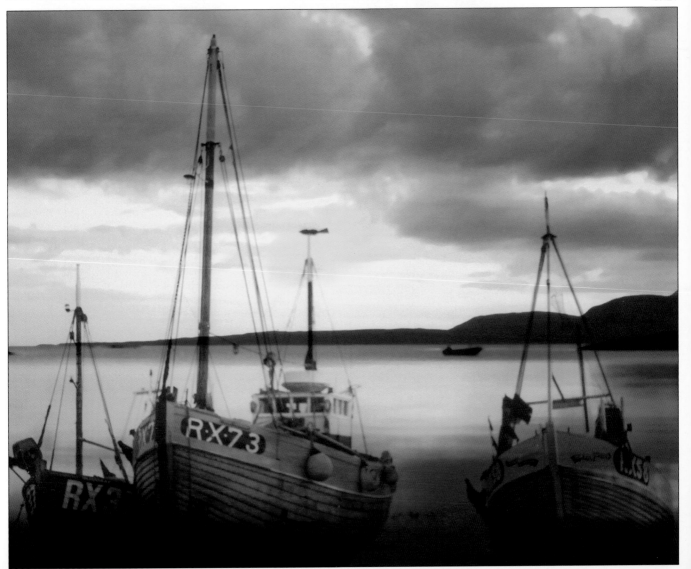

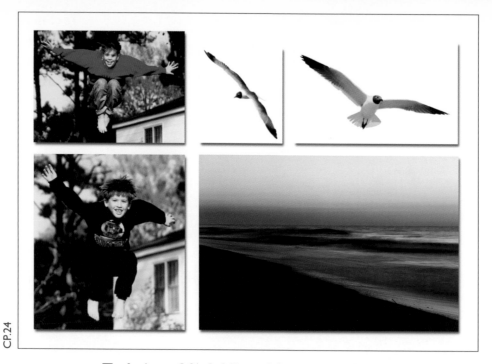

Technique 20: Adding objects to an image

Cutting objects from one image and pasting them into another image is just one of the many powerful capabilities offered by advanced image editors. It is a terrific way to get everything you want in the right place and into one picture.

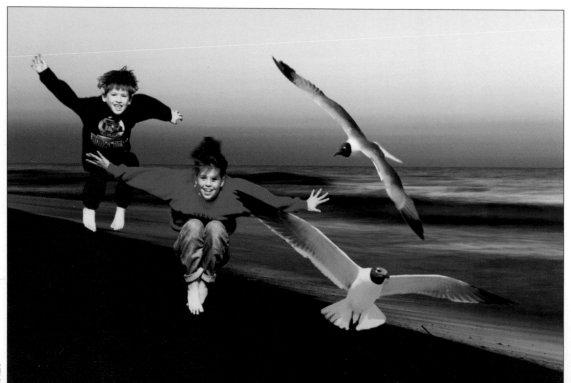

Technique 21: Making a panorama by stitching images

One of the great frustrations of traditional photography is the inability to capture wide panoramic views on film. The Photomerge feature solves this problem by enabling two or more images to be digitally stitched together to make a single wide panoramic print like the one shown of the mountains in Sedona, Arizona.

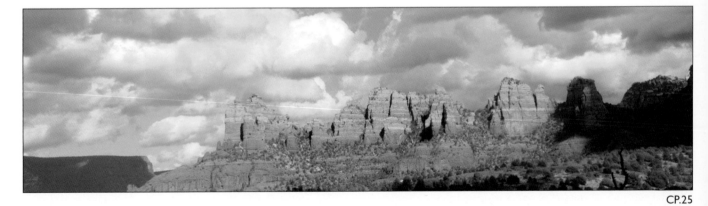

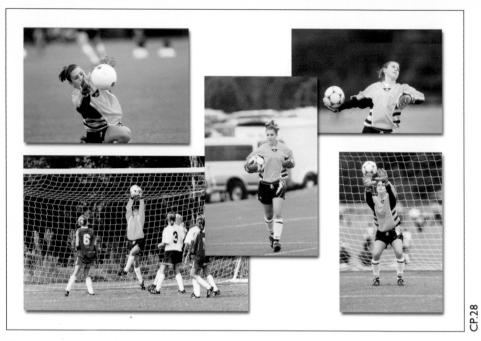

Technique 23: Cloning one image into another

Using a clone brush, you can digitally paint one portion of an image into another image. The soccer goalie was cloned with a clone brush from five separate images and merged into a single image.

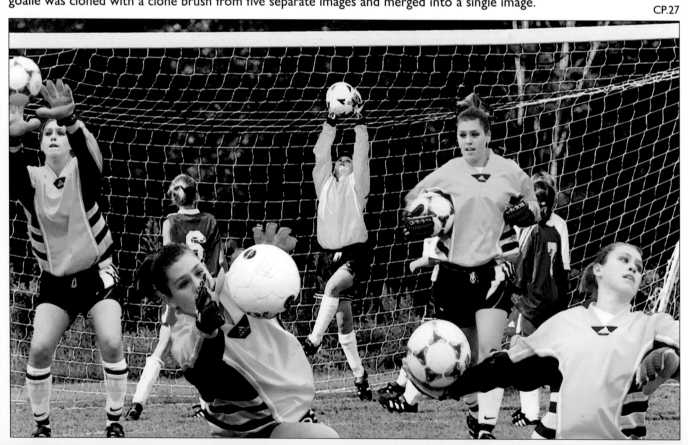

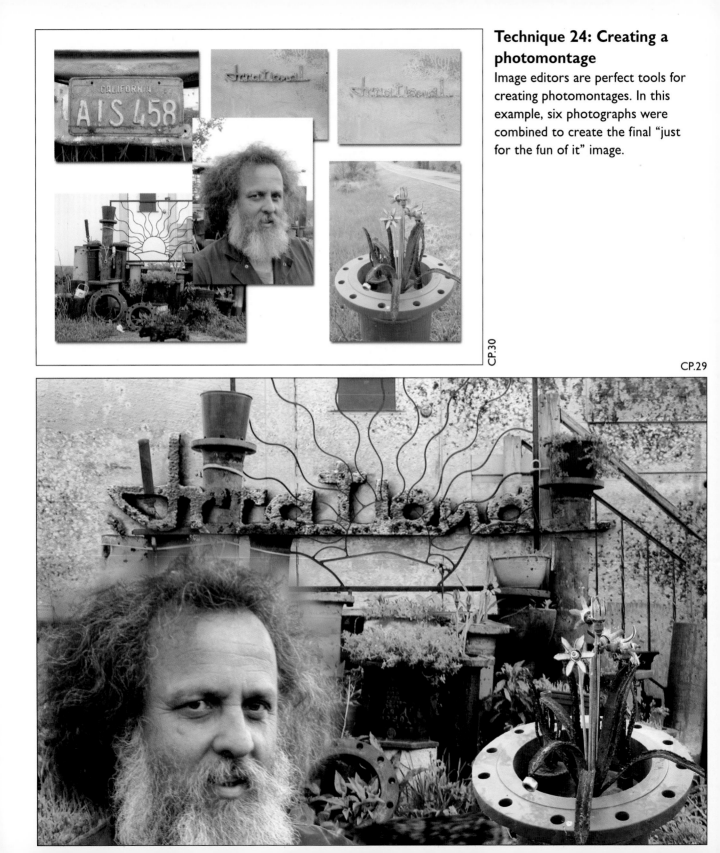

Technique 24: Creating a photomontage

Image editors are perfect tools for creating photomontages. In this example, six photographs were combined to create the final "just for the fun of it" image.

CP.30

CP.29

CP.32

Technique 27: Creating digital caricatures

Editing digital photos can be great fun — especially when using this technique for creating caricatures. The possibilities are endless for wreaking havoc on the face of a neighbor, a boss, spouse, or anyone else.

CP.31

Technique 28: Making an album page

Making photo album pages with traditional photographic prints is time-consuming and tedious. A digital image editor enables you to crop, drag and drop, scale, or twist all your images onto the page just as you want them. You can even add text or a background.

Syracuse Vs. NC State
54-53

Technique 31: Creating a hand-painted black and white photo

Some of the most captivating photos are traditional hand-painted black and white photos. This technique shows how an image editor can produce similar results without the mess and fuss of using photo paints.

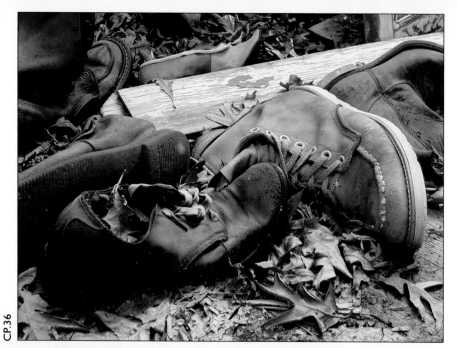

CP.36

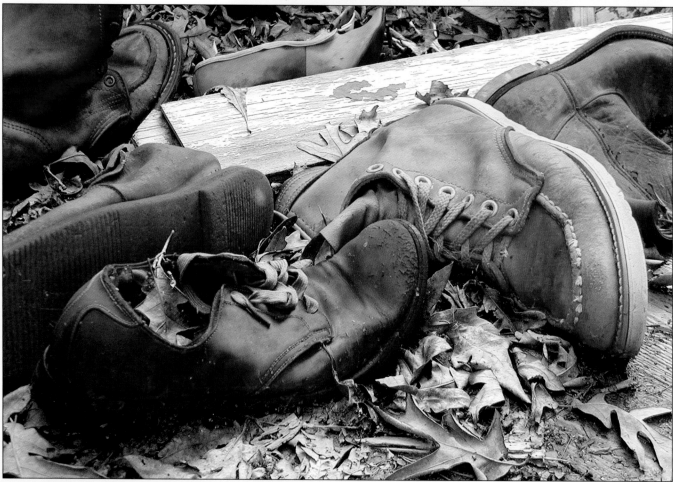

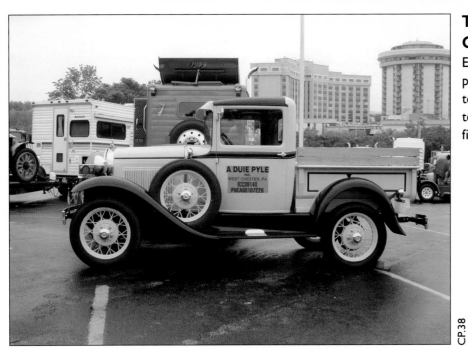

Technique 34:
Creating depth-of-field

Experienced photographers take good photographs because they know how to control depth-of-field. Using this technique, you can control depth-of-field with an image editor.

CP.38

CP.37

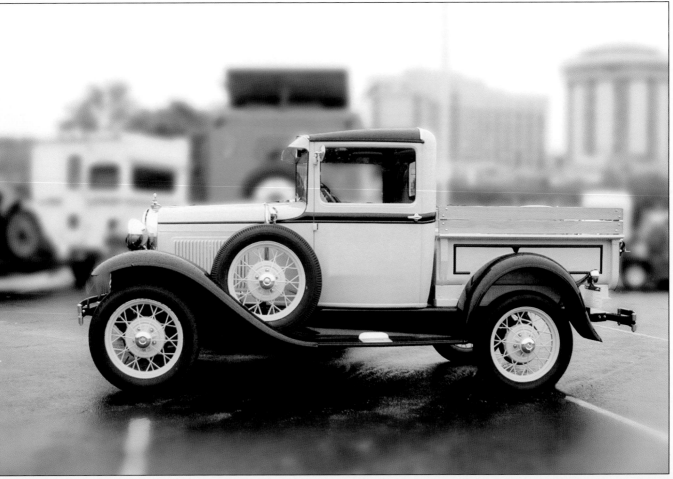

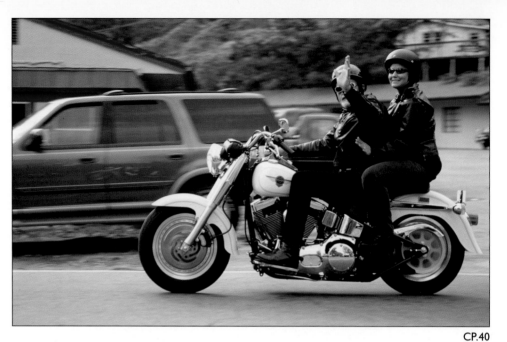

CP.40

Technique 35: Adding motion to an image

Panning a camera with a moving object is one way to show motion in a photo, but requires the proper equipment and skill. Similar results may occur using this technique. You can even change the speed of the moving object to suit your requirements!

CP.39

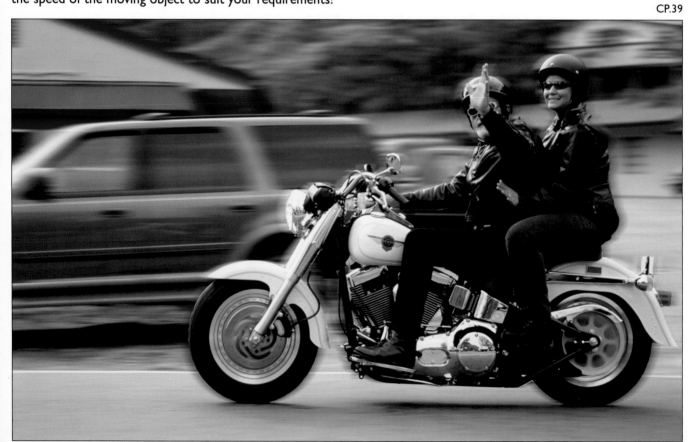

Technique 37: Simulating a watercolor painting

This watercolor painting technique creates images that make excellent prints. To get results that are good enough to be framed, use a photographic-quality printer and print on a high-quality fine-art paper.

Technique 38: Creating a "pen & ink" sketch with a watercolor wash

The digital photo of the urn was altered to look like a "pen & ink" sketch with a watercolor wash. First, a copy of the photo was made to look like a "pen & ink" sketch. A second copy was made to look like a watercolor painting. Finally, they were blended together.

g. georges '01

Technique 39: Creating an
inventive digital painting

One of the fun aspects of digital photography is that an image editor may be used to transform a digital photo into something entirely different. A few clicks of a mouse button and the pond becomes a magical and symmetrical forest with unusual colors.

CP.45

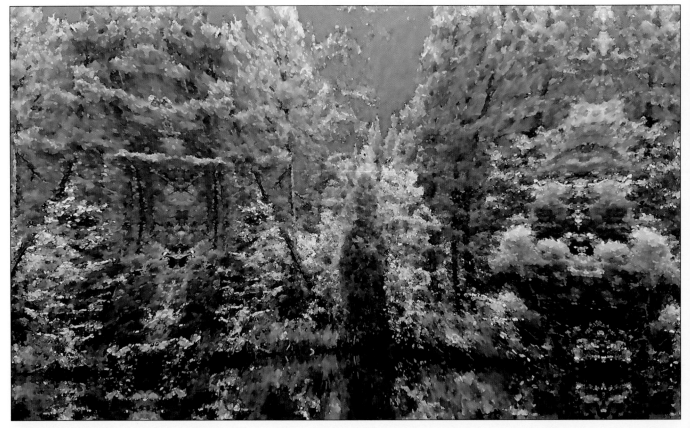

Technique 40: Simulating a gouache or tempera painting

A digital photo can be transformed into a print that no longer looks like a photograph. The quality of the printer, the paper, and the editing technique all contribute to the success (or failure) of a "paint like" effect as shown in the image of the barn and oak tree.

CP.48

CP.47

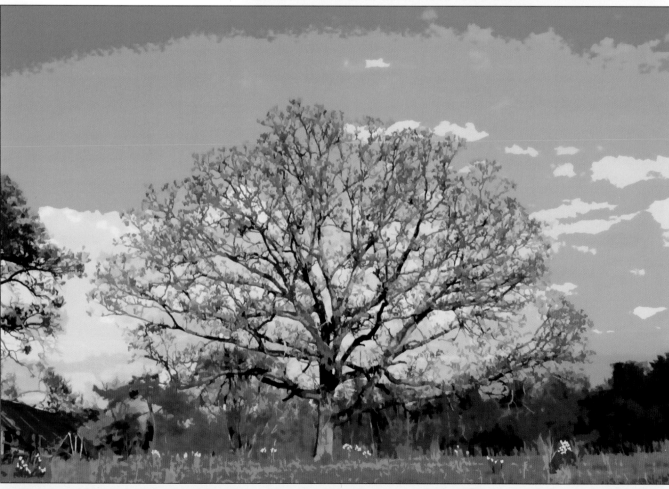

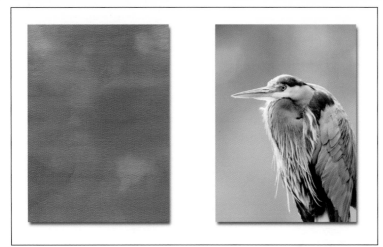

CP.50

Technique 41: Creating multimedia artwork

The application of a single filter can often produce an image that looks good, but looks like it was made with a specific filter. The application of two or more filters is one way to create an unusual image like the one of the blue heron.

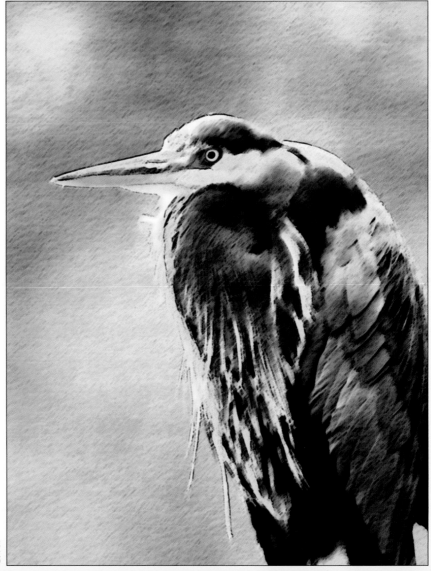

Technique 42: Making your own digital backgrounds

Digitally creating your own backgrounds is possible with filters like Add Noise, Blur, Clouds, and Distort. The original image of a bird in a tree is dramatically improved with a new, digitally-created background.

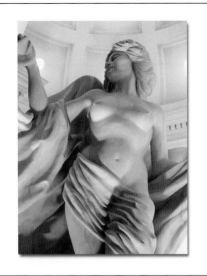

CP.54

Technique 43: Using an image to make texture

Texture and color can be added to an image by blending one or more other images together. This digital photo of a statue has been changed considerably by simply merging it with a digital photo of water.

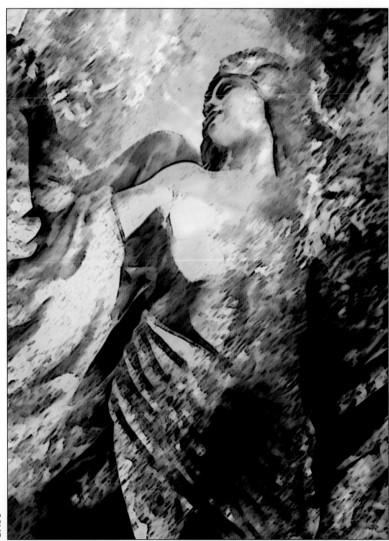

CP.53

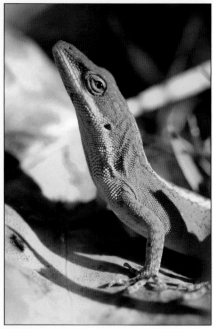

CP.56

Technique 45: Adding a matte frame to an image

Most professional picture framers use one or more matte to bring out the colors in a framed print. Use your image editor to create the perfect matte to frame your images.

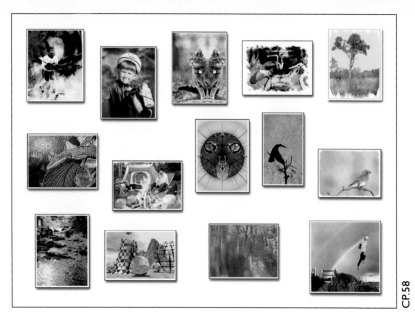

Technique 46: Framing images for online viewing

Photographs and other artwork generally look better when they are properly framed. This technique shows an easy way to make good-looking frames that are suitable for use in on-line galleries.

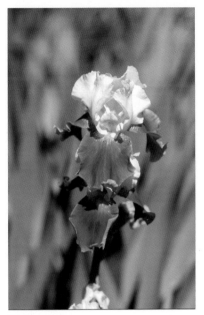

CP.60

Technique 48: Using scanned backgrounds

Expand the creative potential of your digital artwork by creating your own backgrounds. Watercolor paints were applied to a watercolor paper, and then the scanned image was merged with the photo of the iris. The result is an image with watercolor paper texture and the transparent look of watercolors.

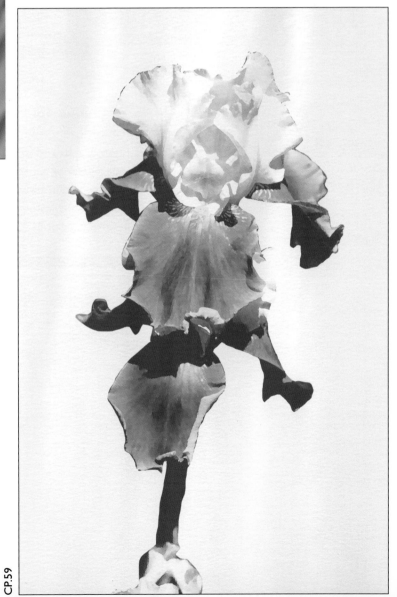

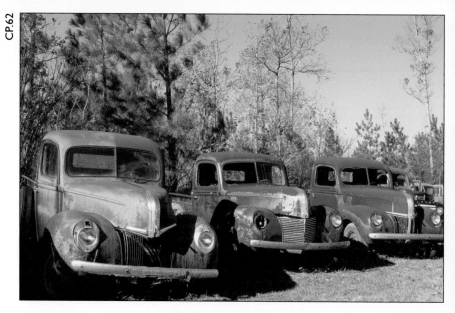

Technique 49: Flipping portions of an image

Image editors provide a vast opportunity to create unique images that look unlike anything that we may find in the real world. This row of old trucks was modified by merely cutting and flipping two different portions of the image and then pasting them back into their original locations.

CP.61

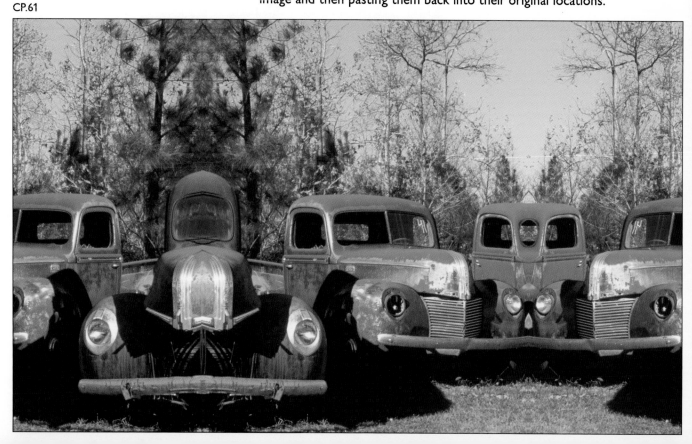

CP.64

Technique 50: Using
plug-in modules

Adding additional capabilities to an image editor is possible by using "plug-ins," which are application modules that work seamlessly with many image editors. In this example, Auto FX Software's Photographic Edges plug-in was used to create edge effects.

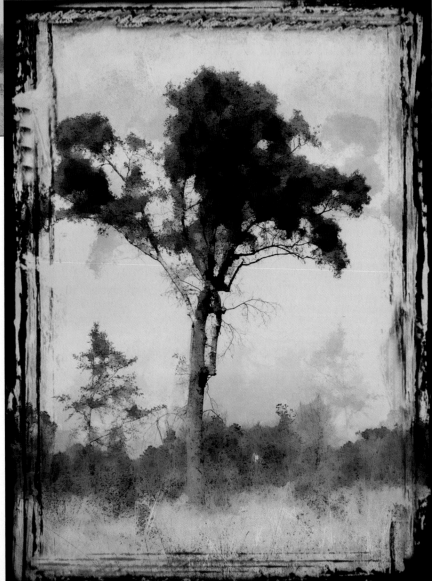

CP.63

CHAPTER 7

NATURAL MEDIA TECHNIQUES

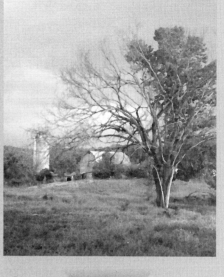

Watercolor, gouache, tempera, acrylic, and oil paintings all serve as inspirations to those who are serious about digitally editing their digital photos. The brush strokes, transparent colors, soft edges, and other characteristics help to make a painting appear different than a photograph. In this chapter, six techniques will be presented to show how digital photos can be made to closely resemble paintings.

Technique 36 presents three different approaches for turning a digital photograph into a line drawing. Techniques 37 and 39 show how digital photos can be made to look like transparent watercolor paintings. Technique 38 shows how one of the line drawing techniques can be combined with one of the watercolor techniques to create a "pen and ink" sketch with a watercolor wash. The last two techniques show how digital photos can be transformed into a gouache or tempera painting, or into multimedia art.

CREATING A LINE DRAWING

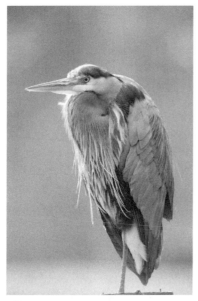

36.1

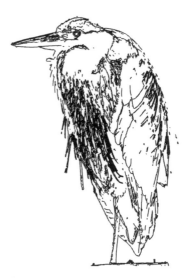

36.2

ABOUT THE PHOTO

"Blue Heron Does Balancing Act IV," EOS1v, 300mm f/2.8, Kodak 100 ASA Supra negative film scanned with Polaroid SprintScan 4000, 1,600 × 2,400 pixel image size, 11.5MB .tif file

Because the line drawing is often the first of a series of steps taken to create most artwork, it seems logical to start this chapter on natural media techniques with a few different techniques for creating line drawings. A line drawing created from a digital photograph can be used for many purposes. For example, you can print a line drawing on fine-art paper and use the drawing to begin a natural media painting. A digital photo turned into a line drawing can also be used as the starting sketch for a digital painting. Line drawings can also be incorporated into other digital techniques, as shown in Technique 38, where a digital photograph is turned into a very elegant "pen and ink" sketch with a watercolor wash.

Because the line drawing is so important both for natural media and for digital art, we'll look at three different approaches to creating line drawings. Not only will these three approaches help ensure that you can get a successful line drawing from most digital photos, they will also enable you to vary the style of your line drawings.

Although it is possible to make line drawings from a grayscale digital photo by applying a single filter, far superior results may be obtained by taking a few more steps. This five-step process is the basis for the three line drawing techniques — the only significant difference is that each of the three different techniques uses a different "find edge" filter — either the **Find Edges**, **Smart Blur**, or **Poster Edges** filter.

1. *Convert image into a grayscale* image either by selecting **Image ➢ Mode ➢ Grayscale**, or **Enhance ➢ Color ➢ Remove Color**. See the **About Grayscale versus Remove Color** feature in Chapter 6 to determine which approach is best.

2. *Preprocess the image* to get optimal results from the filter that will be applied to find edges. As most of the edge-finding filters work on contrast, you can often get much better effects by adjusting contrast by selecting either **Enhance ➢ Brightness/Contrast ➢ Brightness/Contrast** or **Enhance ➢ Brightness/Contrast ➢ Levels** (**Ctrl+L**). Some images will have so much texture that it is difficult to differentiate the texture's edges from the important edges. In this case, you may be able to reduce some of the texture by experimenting with either the **Gaussian Blur** or **Median** filter. You may have to experiment with both filters and several different settings until you get the results that you want.

3. *Apply an edge-finding filter* that will create lines. Although many filters can be used to find edges, try the **Find Edges**, **Smart Blur**, and **Poster Edges** filters. I generally get the best results with the **Edges Only** feature in the **Smart Blur** filter. Nonetheless, you still ought to try the other two filters because they can produce good results and possibly the exact effects that you want.

4. *Adjust the resulting line drawing* to improve contrast and remove undesirable effects. Depending on the image and the results of the prior three steps, you may have some work to do to "clean" up your line drawing. The results you

want will help you decide what is needed. Often, you'll use the **Levels** or **Brightness/Contrast** filters to increase the darkness of the lines and remove unwanted artifacts. The **Eraser** tool may be used to remove "spots." Larger unwanted areas may be selected using one of the many selection tools and then deleted.

5. *Apply one or more filters to add character to the lines.* Once you have lines where you want them (and have eliminated additional spots, dots, or other unwanted artifacts) you can use one or more filters to add character to the lines. My favorite character-adding filters are the **Poster Edges** and **Dark Stroke** filters. There are others, but these two filters can add lots of character. If you don't get what you want after applying them once, apply them more than once or use them in conjunction.

You might now appreciate a quality line drawing made with lines that have lots of character. These line creation techniques can be exceedingly useful and the basis for some outstanding work as you will see in Technique 39.

FIND EDGES FILTER APPROACH TO CREATING A LINE DRAWING

The **Find Edges** filter may be the most commonly used filter to create line drawings. Nevertheless, the filter results in grey shaded lines. The reason for this is that **Find Edges** makes low-contrast areas white, medium-contrast areas gray, and high-contrast areas black. It also turns hard edges into thin lines and soft edges into fat lines. The result is a line drawing that is very different from the thin lines that we will get using the **Smart Blur** filter. It can, however, transform some digital photos into some interesting line drawings.

STEP 1: OPEN FILE AND REMOVE COLOR

■ Select **File ➢ Open** (**Ctrl+O**) to display the **Open** dialog box. Double-click the **/36** folder to

open it and then click the **heron-before.tif** file to select it. Click **Open** to open the file.

■ Select **Image ➢ Mode ➢ Grayscale** to remove the color from the image.

After some experimenting with the **Brightness/Contrast** and **Levels** filters, I concluded there was not any obvious preprocessing that I could do to improve the ability of the **Find Edges** filter to find edges.

STEP 2: FIND EDGES AND CREATE LINES

■ Select **Filter ➢ Stylize ➢ Find Edges** to apply the **Find Edges** filter.

After applying the **Find Edges** filter, you will have a good line drawing — except it will have lines that are made of three shades of gray not just black lines. You can see the results in the detail drawing shown in **Figure 36.3**.

STEP 3: REMOVE SOME LINES AND MAKE THE REST BLACK

■ Select **Image ➢ Adjustments ➢ Threshold** to get the **Threshold** dialog box shown in **Figure 36.4**. Set the **Threshold Level** to **200** and then click **OK** to apply the setting.

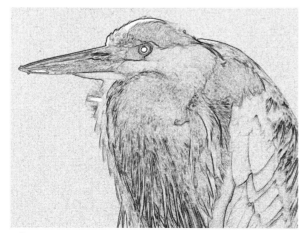

36.3

STEP 4: CLEAN UP THE DRAWING

■ Click the **Eraser** tool (**E**) in the toolbox and drag the cursor over the few stray marks that ought not to be there. You may want to change to a very large brush size to make the cleanup easier and faster.

The final line drawing is shown in **Figure 36.5**.

36.4

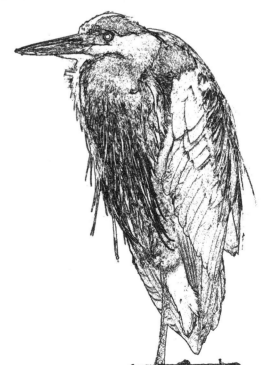

36.5

SMART BLUR FILTER APPROACH TO CREATING A LINE DRAWING

Due to **Smart Blur's Radius** and **Threshold** settings and **Smart Blur's** ability to make very fine lines, this filter has become my favorite for creating line drawings. Once you have lines where you want them, several other filters can be used to change the character of the lines.

STEP 1: OPEN FILE AND REMOVE COLOR

■ Select **File** ➢ **Open** (**Ctrl+O**) to display the **Open** dialog box. Double-click the **/36** folder to open it and then click the **heron-before.tif** file to select it. Click **Open** to open the file.

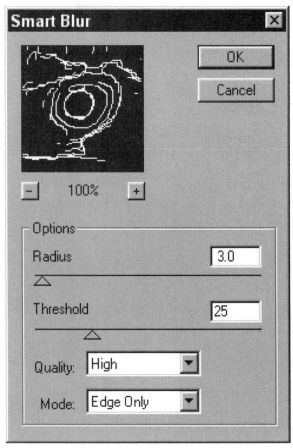

36.6

■ Select **Image** ➢ **Mode** ➢ **Grayscale** to remove the color from the image.

After some experimenting with the **Brightness/Contrast** and **Levels** filters, I once again concluded there was no obvious preprocessing that I could do to improve the ability of the "find edges" filter (in this case, the **Smart Blur** filter) to find edges. This is an especially good image to use to create a line drawing, as it requires little work to get excellent results.

STEP 2: FIND EDGES AND CREATE LINES

■ Select **Filter** ➢ **Blur** ➢ **Smart Blur** to get the **Smart Blur** filter dialog box shown in **Figure 36.6**. Set **Quality** to **High** and **Mode** to **Edge Only**.
■ The preview box in the **Smart Blur** dialog box will show white lines on a black background. Click the preview window and drag the preview image around until you find the heron's eye. Begin sliding the **Radius** and **Threshold** sliders around until you get enough detail in the eye, but not too much. Once you have a setting that works on the eye, drag the preview image until you see the back of the bird; make sure that the edge can be seen and that you don't see too many lines showing too much feather detail.
■ Try using a **Radius** setting of **3.0** and a **Threshold** setting of **25.0**. Click **OK** to apply the settings.

Using **3.0** and **25.0** as the settings for **Radius** and **Threshold** will produce a line drawing with as few lines as is needed to outline the heron. Increasing the **Threshold** setting will increase the number of lines and add increasing detail to the drawing. Depending on the desired effects, a higher setting can create an even more visually interesting line drawing.

■ Invert the white lines on a black background image by selecting **Image** ➢ **Adjustments** ➢ **Invert** (**Ctrl+I**).

After applying the **Smart Blur** filter, you will have an excellent line drawing. You can see the results in the detail drawing shown in **Figure 36.7**. This drawing has very fine lines and can be used as a sketch to begin a painting or other kind of artwork.

STEP 3: INCREASE THE WIDTH OF THE LINES

■ To make the all of the lines in the image darker and wider, select **Filter** ➢ **Artistic** ➢ **Poster Edges** to get the **Poster Edges** dialog box shown in **Figure 36.8**. Set **Edge Thickness**, **Edge Intensity**, and **Posterization** to **0**, **10**, and **0** and click **OK** to apply the settings.

The results of applying the **Poster Edges** filter are shown in **Figure 36.9**. If you want even thicker and bolder lines, apply the **Poster Edges** filter once or twice more. If you want lines that look as though they were created with a marker, select **Filter** ➢ **Brush Strokes** ➢ **Dark Strokes** to get the **Dark Strokes**

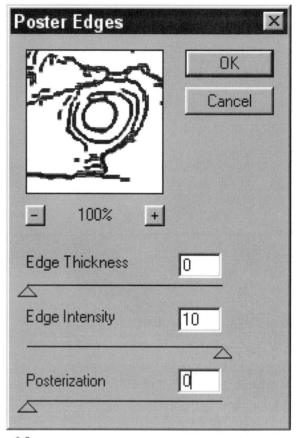

36.8

36.7

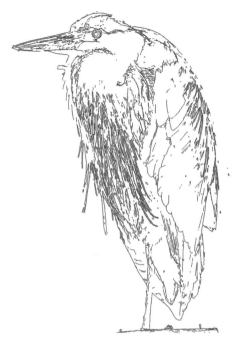

36.9

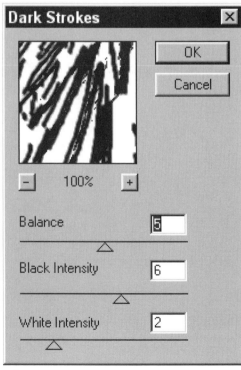

36.10

dialog box shown in **Figure 36.10**. Try using settings of **5**, **6**, and **2** for **Balance**, **Black Intensity**, and **White Intensity** respectively, which will result in the image shown in **Figure 36.11**.

POSTER EDGES FILTER APPROACH TO CREATING A LINE DRAWING

The **Poster Edges** filter reduces the number of colors (or shades of gray) in an image according to your chosen settings. Besides drawing lines between contrasting edges, it also shades areas. Thus, it does not *directly* create a line drawing. These shaded areas can be used to create solid black areas, which can result in what may look more like a line drawing with black ink shades. This filter does require some experimentation to get good results.

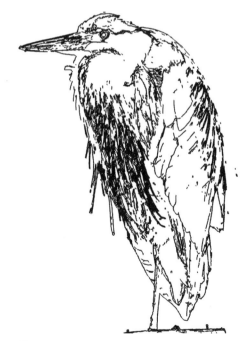

36.11

STEP 1: OPEN FILE AND REMOVE COLOR

- Select **File ➤ Open** (**Ctrl+O**) to display the **Open** dialog box. Double-click the **/36** folder to open it and then click the **heron-before.tif** file to select it. Click **Open** to open the file.
- Select **Image ➤ Mode ➤ Grayscale** to remove the color from the image.

STEP 2: ADJUST LEVELS

- Select **Enhance ➤ Brightness/Contrast ➤ Levels** (**Ctrl+L**) to get the **Levels** dialog box. Set **Input Levels** to **0**, **.65**, and **180** and then click **OK** to apply the settings.

STEP 3: FIND EDGES AND CREATE LINES

- Select **Filter ➤ Artistic ➤ Poster Edges** to get the **Poster Edges** filter dialog box shown in **Figure 36.12**. Set **Edge Thickness**, **Edge Intensity**, and **Posterization** to **0**, **10**, and **0** respectively. Click **OK** to apply the filter.

STEP 4: REDUCE SHADES OF GRAYS AND SOME LINES

After applying the **Poster Edges** filter, you will begin to see a semblance of a line drawing. Now, we need to remove some of the shades of gray and some lines.

- Select **Image ➤ Adjustments ➤ Posterize** to get the **Posterize** filter dialog box shown in **Figure 36.13**. Set **Levels** to **2** and then click **OK** to apply the filter.

STEP 5: REMOVE SOME LINES AND MAKE THE REST BLACK

Although the image is almost finished, some lines need to be removed and the unnecessary background must be eliminated.

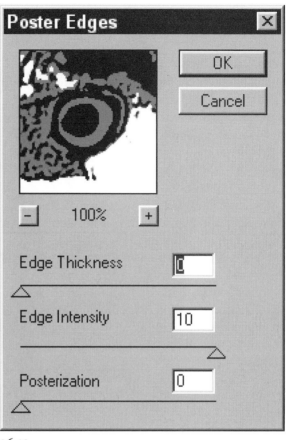

36.12

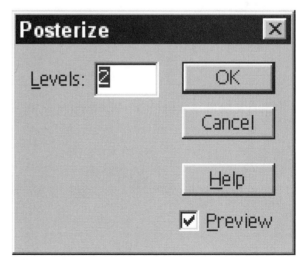

36.13

- Click the **Eraser** tool (**E**) in the tool box. Carefully erase a path of the unwanted dots all around the outside edge of the heron.
- Click the **Lasso** tool (**L**) in the tool box.
- Click and drag the selection marquee around the heron where you just erased a path.
- Once the heron has been selected, select **Selection** ➢ **Inverse** (**Shift+Ctrl+I**) to invert the selection.
- Click **Edit** ➢ **Cut** (**Ctrl+X**) to delete all of the remaining background.

You can see the results of this technique in the detail image shown in **Figure 36.14**. The full-sized image is shown in **Figure 36.15**.

If you don't get the results you want from any of these "find edges" filters, I suggest you investigate the possibilities of the **Filter** ➢ **Stylize** ➢ **Trace Contour**, **Filter** ➢ **Other** ➢ **High Pass**, and **Filter** ➢ **Stylize** ➢ **Glowing Edges** filters.

Okay. Enough of these line drawing techniques. In the next technique, we'll look at how to create a watercolor-like painting.

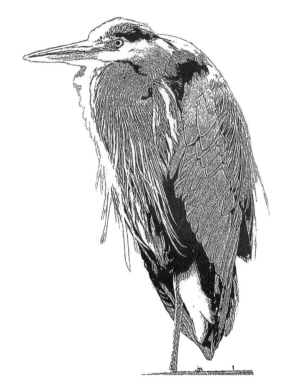

36.15

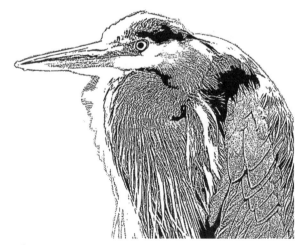

36.14

CREATING A WATERCOLOR-LIKE PAINTING

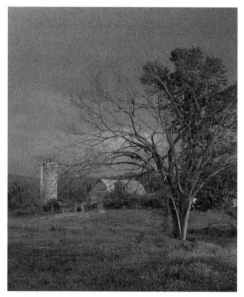

37.1 (CP 42)

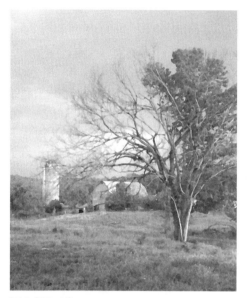

37.2 (CP 41)

ABOUT THE PHOTO

"NC Dairy Farm," Nikon 950 digital camera, Fine Quality Photo setting, 1,200 × 1,600 pixel image size, 623KB .jpg file

I took the photo of the North Carolina dairy farm within a minute or so of the photo shown in **Figure 8.1** (**CP 48**). The only significant difference between the two photos is that this one was taken in a vertical orientation, while the other one was shot horizontally. This digital photo will demonstrate how a digital photo can be turned into a realistic-looking watercolor painting.

This technique, which uses the **Watercolor** filter, shows a different approach than Technique 38, which also shows how to create a water-color-like effect. The **Watercolor** filter can produce widely varying results. The size of an image, its sharpness, and its level of contrast are just three of *many* variables that help or hinder the effectiveness of the **Watercolor** filter. This technique shows just a few steps to take before and after applying the **Watercolor** filter to improve the results. Although these steps work well on *this* image, they may work less well (or maybe even better)

on other images. Experimentation and an under-standing of the various filters are paramount to the successful creation of watercolor effects. As when painting with real watercolor paints, a certain amount of skill and familiarity with tools is essential for success.

STEP 1: OPEN FILE

■ Select **File** ➢ **Open** (**Ctrl+O**) to display the **Open** dialog box. Find and double-click the **/37** folder to open it and then click the **farm-before .jpg** file to select it. Click **Open** to open the file.

STEP 2: INCREASE IMAGE SIZE

The **Watercolor** filter ordinarily works best on large files, 10MB and larger. Therefore, increase the file size to make an 7½" × 10" print with a printer resolution of 240 dpi.

■ Select **Image** ➢ **Resize** ➢ **Image Size** to get the **Image Size** dialog box shown in **Figure 37.3**. Make sure there is a checkmark in the **Constrain**

Proportions box in the lower left-hand corner. Set **Resolution** to **240** pixels/inch and then set **Width** in the Document Size section to **7.5** inches. The **Height** should automatically change to **10** inches and the file size will now be shown as 12.4MB. Click **OK** to increase the file size.

37.3

ABOUT GAUSSIAN BLUR AND SMART BLUR

Gaussian Blur and **Smart Blur** are both very useful filters. While they both blur images, they can produce very different effects. The simplest one is **Gaussian Blur**, which offers a single setting. That setting is **Radius in Pixels**, which can range from 0.1 to 250.0.

In basic terms, the **Gaussian Blur** filter distributes a weighted average of pixel colors within the selection area according to a bell-shaped Gaussian distribution curve; hence, the name **Gaussian**

Blur. In other words, Gaussian Blur modifies each pixel based on the average of the surrounding pixels. If all the surrounding pixels are the same as the target pixel, nothing changes. If the target pixel is very different from its surroundings, then it will change a lot. To get the **Gaussian Blur** dialog box shown in **Figure 1**, select **Filter** ➢ **Blur** ➢ **Gaussian Blur**.

Unlike **Gaussian Blur**, the **Smart Blur** filter has **Quality** and **Mode** settings in addition to **Radius** and **Threshold** settings, as is shown in **Figure 2**. These set-

tings allow much more precise control over blurs. The quality of the blur can be set to **High**, **Medium**, or **Low** using the **Quality** setting. The results are much smoother at the higher quality settings.

There are three mode options: **Normal**, **Edge Only**, and **Edge Overlay**. A **Normal** setting allows the blur to be applied throughout the selection area. The **Edge Only** and **Edge Overlay** filters work in terms of contrast. Where significant contrast occurs, **Edge Only** applies black and white edges, and **Overlay Edge** applies white. The **Radius** setting

1

2

defines how far the filter searches for dissimilar pixels to blur, whereas the **Threshold** setting enables specification of how different the pixels' values should be before they are eliminated. As with **Unsharp Mask**, if you start with a noisy and low resolution image, using **Threshold** can leave you with strange looking speckles. In general, what **Smart Blur** is trying to do is blur some details while preserving others. With some settings it will blur things that are already a little blurry while leaving sharp edges alone.

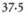

37.4

settings until you get a realistic-looking water-color effect. I used the settings of **7**, **0**, and **1** for **Brush Detail**, **Shadow Intensity**, and **Texture** respectively. Click **OK** to apply the settings. Have patience, as this filter takes time to complete once you click **OK**.

STEP 5: MAKE FINAL ADJUSTMENTS

■ To view the image in full size, select **View ➤ Actual Pixels** (**Alt+Ctrl+O.**) If you look carefully, you'll see a not-so-watercolor-like edge on everything. That's okay. This can be improved with another blur filter, the **Smart Blur** filter.

STEP 3: SOFTEN THE IMAGE BY APPLYING A BLUR

Watercolor paintings are typically soft-edged, "transparent looking" paintings. To help the Watercolor filter produce a realistic watercolor painting, we will first apply a blur. As this image was taken with a digital camera, which generally will be somewhat soft already, we'll only need to apply a minimal blur.

■ Select **Filter ➤ Blur ➤ Gaussian Blur** to get the **Gaussian Blur** dialog box shown in **Figure 37.4**. Set **Radius** to **2.0** pixels and then click **OK** to apply the blur.

STEP 4: APPLY WATERCOLOR FILTER

■ Select **Filter ➤ Artistic ➤ Watercolor** to get the **Watercolor** dialog box shown in **Figure 37.5**. Click in the preview box and slide the image around until you see the branches at the top of the tree in the foreground. Experiment with the

37.5

- Select **Filter** ➤ **Blur** ➤ **Smart Blur** to get the **Smart Blur** dialog box shown in **Figure 37.6**. Once again, it is time to experiment with different settings while viewing the results in the preview box. The objective here is to soften the edges so that they look like real watercolors. After setting **Quality** to **High**, and **Mode** to **Normal**, try setting **Radius** to **3.0** and **Threshold** to **65.0**. Click **OK** to apply the filter.

37.6

Our digital photo is looking more and more like a watercolor painting. At this point, however, it is too dark to look like real transparent watercolors, which are generally painted in bright and light colors. Therefore, let's lighten the image.

- Select **Enhance** ➤ **Brightness/Contrast** ➤ **Levels** to get the **Levels** dialog box. Set **Input Levels** to **0**, **1.45**, and **210** and then click **OK** to lighten the image.
- Select **File** ➤ **Save As** to get the **Save As** dialog box. Select an appropriate directory and name your file, then click **Save** to save your file.

You now have a good enough digital image to fool some people, some of the time, into thinking you are able to paint with watercolors! After spending considerable time adjusting the various settings on my photo-quality inkjet printer, I honestly was able to fool a friend, who paints with real watercolors, into thinking that I was once again painting.

When looking at the final image on your computer screen, you may not be fully convinced of how well this technique works. My suggestion is to try printing it on a quality watercolor paper with a photo-quality inkjet printer. Most inkjet printers have a considerable number of print options that can make this image look terrific — once you figure out which image and paper settings to use! Although there are a few variables here, there are not as many as you might find using the real watercolor paints.

CREATING A "PEN AND INK" SKETCH WITH A WATERCOLOR WASH

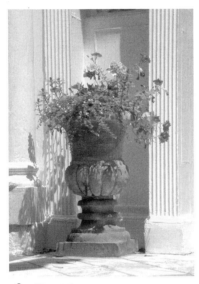

38.1 (CP 44)

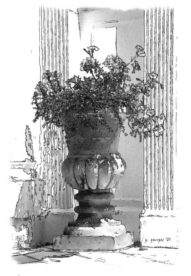

38.2 (CP 43)

ABOUT THE PHOTO

"Flowering Urn in Charleston, South Carolina," Nikon 950 digital camera, Fine Image Quality setting, original 1,200 × 1,600 pixel image was cropped and converted to a 1,152 × 1,600 pixel, 5.8MB .tif file

O f all the different art media I prefer watercolors with their blurry edges and transparent colors. Very artistic "pen and ink" sketches (with loosely defined shapes and lines with lots of character) also fascinate me. I think the looseness of these two types of artwork is what appeals to me. They can be suggestive and, yet, leave enough undefined to allow your imagination to fill in the remaining parts — quite like reading a book versus seeing a movie made from the same story.

The photograph of the flowering urn was taken from the street in front of a fancy home in Charleston, South Carolina. You might not think that it is possible to turn this digital photograph into a fine-art-quality print on watercolor paper, but it is. This is one image that doesn't show well printed in the book compared to what it looks like printed full-sized on quality fine-art paper with a photo-quality inkjet printer — it really does look quite good.

This technique shows how to transform a digital photo into a watercolor-like image and a "pen and ink" sketch. Then, it shows how the two

images can be combined to become a "pen and ink" sketch with a watercolor wash. Because it *really* is two techniques in one, Technique 38 is a long technique. However, it is well worth attempting on the urn image, and then on one or more of your own photos. I think you will like the results.

STEP 1: OPEN FILE

- Select **File ➤ Open** (**Ctrl+O**) to display the **Open** dialog box. Double-click the **/38** folder to open it and then click the **urn-before.tif** file to select it. Click **Open** to open the file.

STEP 2: MAKE A COPY OF THE IMAGE TO BE USED FOR THE WATERCOLOR PAINTING

- Both a watercolor painting and a "pen and ink" sketch are needed. Therefore, duplicate the image by selecting **Edit ➤ Duplicate Image**. When the **Duplicate Image** dialog box appears, type in **pen-ink** to name the image, as shown in **Figure 38.3**, and then click **OK**.

STEP 3: TRANSFORM ONE IMAGE INTO A WATERCOLOR PAINTING

Photoshop Elements does have a watercolor filter. However, in most cases, I find that it makes the images too dark with too many odd-looking brush strokes. Therefore, we'll use another approach.

- Click the "**urn-before**" image to make it the active image.
- Select **Filter ➤ Artistic ➤ Dry Brush** to get the **Dry Brush** dialog box. Click in the preview window and drag the image around until you can see a few flowers. Begin experimenting with the settings for **Brush Size**, **Brush Detail**, and **Texture**. I used **2**, **8**, and **1**, as shown in **Figure 38.4**. Click **OK** to apply the settings.

To soften the brush strokes and make them look more like a watercolor wash, use a blur filter.

- Select **Filter ➤ Blur ➤ Smart Blur** to get the **Smart Blur** dialog box. Try using a **Radius** of **10**

38.3

38.4

and a **Threshold** of **50**, as shown in **Figure 38.5**. Also, make sure you have **Quality** set to **High**, and that **Mode** is set to **Normal**, before clicking **OK** to apply the settings.

For this particular image, these few steps produce a realistic-looking watercolor. After using many images and trying many different techniques to create watercolor paintings, I've concluded there are many variables and settings for each of many different techniques. In other words, what works on one image may work poorly on another. In general, the steps in this technique work well on images that are taken with a digital camera at approximately 1,600 × 1,200 pixels in size.

When working with photographs that have been scanned with a flatbed scanner, or negatives or slides that have been scanned with a film scanner the same techniques work if you first apply a light **Gaussian Blur** to the image. The larger the files, the better this technique seems to work — provided that the image is a good-quality image with minimal grain. Sometimes, you may also find that an image can be made to look more like a watercolor painting if you apply some of these filters more than once. Experimentation is the key to getting what you want.

38.5

STEP 4: TRANSFORM SECOND IMAGE INTO A "PEN AND INK" SKETCH

The next step is to turn the second image into a "pen and ink" sketch. Although many digital imagers use and recommend the **Find Edges** filter to make line drawings, I find I get much better results with a hidden option in the **Smart Blur** filter. The results can be quite outstanding.

- Click the "**pen-ink**" image to make it the active image.
- Select **Enhance** ➤ **Color** ➤ **Remove Color** (**Ctrl+U**) to remove all color.
- Select **Filter** ➤ **Blur** ➤ **Smart Blur** to get the **Smart Blur** dialog box shown in **Figure 38.6**. Set **Quality** to **High**, and **Mode** to **Edge Only**.

It is important to find settings that show the vertical lines on the columns while not adding too many lines around the flowers. To do this, click in the preview box inside the **Smart Blur** dialog box and drag the preview image until you see the column, as shown in **Figure 38.6**.

38.6

the same digital photo. We now want to combine these two images.

■ Click the **urn-before.tif** image to make it active. Now, select **Select ➤ Select All** (**Ctrl+A**) and select **Edit ➤ Copy** (**Ctrl+C**) to copy the image into memory.

■ Click the **pen-ink.tif** image to make it active. Select **Edit ➤ Paste** (**Ctrl+V**) to paste the image as a new layer.

■ Looking at the **Layers** palette in **Figure 38.8**, you can see two layers. Click the "**Layer 1**" thumbnail in the **Layers** palette once to make sure it is the active layer. Then, set the **blend** mode to **Multiply** and **Opacity** to **100%**.

■ Try setting **Radius** to **25** and **Threshold** to **35**. Click **OK** to apply the settings.

■ You may be surprised to see what now looks like white lines on a black ink scratchboard, but this is okay. If you select **Image ➤ Adjustments ➤ Invert** (**Ctrl+I**), you will see black lines on a white background sketch, as shown in **Figure 38.7**.

STEP 5: COMBINE IMAGES

At this point, you have learned two techniques and you have two entirely different images (a watercolor-like image and a "pen and ink" sketch) made from

38.7

STEP 6: MAKE FINAL COLOR ADJUST-MENTS AND ADD YOUR SIGNATURE

■ Select **Layer** ➢ **Flatten Image** to flatten the layers into one.

You have lots of filters for adjusting color, such as: **Levels**, **Color Cast**, and **Hue/Saturation**.

■ To lighten the image, select **Enhance** ➢ **Brightness/Contrast** ➢ **Levels** (**Ctrl+L**) to get the **Levels** dialog box. Set **Input Levels** to **0**, **.75**, and **160**, as shown in **Figure 38.9**. Click **OK** to apply the settings.

The final step is to adjust the colors. As I have both Photoshop Elements *and* an artistic license to create, I decided to make the image turquoise, purple, and green with yellow flowers, as shown in **Figure 38.2**(**CP43**). Feel free to experiment with the colors.

■ Click **Enhance** ➢ **Color** ➢ **Hue/Saturation** (**Ctrl+U**) to get the **Hue/Saturation** dialog box. Set **Hue**, **Saturation**, and **Lightness** to **100**, **20**, and **0**, as shown in **Figure 38.10**.

If you aren't into turquoise, purple, and green, use **Hue/Saturation** or even **Replace Color** to get the colors you want. It is great fun to create something out of the ordinary. Make adjustments to suit your taste. You will find a more "reasonably" colored image on the companion disk in folder **/38** in a file named **urn-after2.jpg**.

Also, don't forget to add your signature. It adds a nice touch to your painting. If you want, you can also hand-paint more of the flowers yellow. Some of them seem to be lacking a bit of color on the left side of the image. A good tool for painting the flowers is the **Airbrush** tool. You also might want to put a soft edge on the image by using a soft eraser. Save your file and it is ready to be printed.

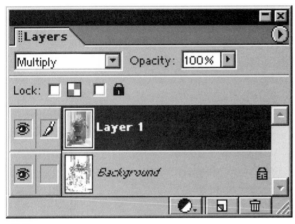

38.8

38.9

38.10

While this image looks reasonably good on a com-
puter screen, it *really* does look exceptional when
printed on a fine-art watercolor paper with a photo-
quality inkjet printer. I used an Epson 1270 printer
and Saunders-Waterford DI Extra White CP water-
color paper distributed by Legion Paper Corporation
(`www.legionpaper.com`) Printing on quality
fine-art paper is essential to getting a print that you'll
be proud to frame.

CREATING AN INVENTIVE DIGITAL PAINTING

39.1 (CP 46)

39.2 (CP 45)

O nce you have a good understanding of what a dozen or more filters are capable of doing, you can begin to create images without having any preconceived idea of what one will look like until it is done. It is great fun to take such a loose approach to creating artwork. Sometimes a somewhat circuitous or random path will result in an image that you'll be pleased to have created.

The objective of this technique is not to demonstrate another specific technique, but to show how you can start out with a digital photo (albeit not a very good one) and end up with something worthwhile. The digital photo was shot across a pond that is full of fish that usually spend most of their time trying to avoid being eaten by a pair of hungry blue herons. The magical forest of symmetry ended up the way you see it after I applied a few filters without a plan.

STEP 1: OPEN FILE

The original 1,600 × 1,200 pixel photo is overexposed and does not look as nice as the original scene. My first inclination is to crop it and use a mirror technique. As the mirror technique will be covered later, in **Technique 49** we'll start with an already cropped and mirrored image and see what we can do with it. If you are interested in seeing the original digital photo, it can be found in the **/39** folder and named **forest-original.jpg**.

■ Select **File ➢ Open** (**Ctrl+O**) to display the **Open** dialog box. Double-click the **/39** folder to open it and then click the **forest-before.tif** file to select it. Click **Open** to open the file.

STEP 2: INCREASE FILE SIZE AND ASPECT RATIO

The cropped image is small at only 1,130 × 747 pixels. In order to get a good print size and to have enough pixels to allow several filters to be more effective, the image size must be increased. One caveat here though is that any image increased this much will lose detail and may not print well. Nevertheless, let's proceed and see what we can do with it.

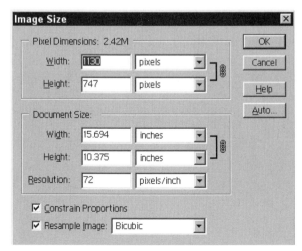

39.3

■ Select **Image ➢ Resize ➢ Image Size** to get the **Image Size** dialog box shown in **Figure 39.3**.

Due to an earlier editing process, this image has a strange width-to-height proportion. As I like the proportion of 1:1.5 (the approximate proportion of 35mm film), let's change this image to those proportions while we increase the overall size of the image. If we were to do this to most images, they would look distorted; much like what you see in the "funny" mirrors at carnivals where people become long and skinny or short and fat. However, as this image is all trees and their reflections, it still might look like a forest.

■ If there is a checkmark in the **Constrain Proportions** box at the bottom of the **Image Size** dialog box, click it to remove it. Set **Width** to **2,400** pixels and **Height** to **1,600** pixels to increase the image size to 11MB. Click **OK** to increase image size.

STEP 3: APPLY THE WATERCOLOR FILTER

Normally, the **Watercolor** filter produces an unacceptably dark image that must be lightened first. As this image is already underexposed, the image will not need to be lightened. I normally like to apply one of the blur filters to remove some of the sharpness in an image, which will help to minimize the number of edges that the watercolor filter will create. Because the image is not a sharp image (as we have greatly increased its size), we can skip this step, which makes it a soft image. Therefore, no preprocessing of the image is needed before we apply the **Watercolor** filter.

■ Select **Filter ➢ Artistic ➢ Watercolor** to get the **Watercolor** dialog box shown in **Figure 39.4**. Set **Brush Detail**, **Shadow Intensity**, and **Texture** to **4**, **1**, and **1** respectively and then click **OK** to apply the filter.

I think the filter worked wonderfully. It has added some detail to the trees, but it does not look very much like a watercolor painting. Since this is a chapter on fine-art techniques, let's now apply a blur to make it a bit more like watercolor.

STEP 4: APPLY BLUR TO MAKE THE IMAGE MORE WATERCOLOR-LIKE

■ Select **Filter** ➢ **Blur** ➢ **Smart Blur** to get the **Smart Blur** dialog box shown in **Figure 39.5**. Set **Radius** to **3.0**, **Threshold** to **45**, **Quality** to **High**, and **Mode** to **Normal**, and then click **OK** to apply the filter.

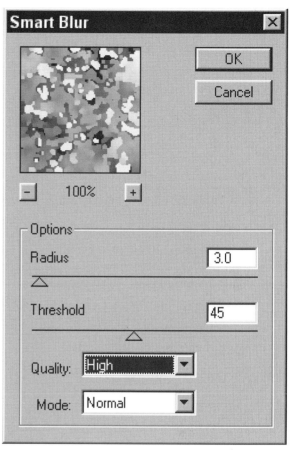

39.5

STEP 5: ADJUST COLORS

Once again, I think the image is improving; there is no need to select **Step Backward** and try something else. As this magical and symmetrical forest does not look like anything on this planet, change the colors to some that we ordinarily wouldn't find on this planet.

■ Select **Enhance** ➢ **Color** ➢ **Hue/Saturation** to get the **Hue/Saturation** dialog box shown in **Figure 39.6**. You can make any color adjustments you like. I set **Hue** to **70**, **Saturation** to **60**, and left **Lightness** set to **0** to get a rich purple and turquoise image. Click **OK** to apply the color changes.

39.4

39.6

STEP 6: DISTORT IMAGE

I am beginning to like this image — except that it is too perfect! Being one who is not generally fond of perfect symmetry, I'd like to distort or warp the image slightly to make it more interesting.

- Select **Filter ➢ Distort ➢ Pinch** to get the **Pinch** dialog box shown in **Figure 39.7**. Set **Amount** to **25** and click **OK** to add an inlet to the pond and slightly ruin the perfect symmetry that existed before.
- Select **File ➢ Save As** to get the **Save As** dialog box. Select an appropriate directory and name your file, then click **Save** to save your file.

The image should now look like the one shown in **Figure 39.2** (**CP 45**). At the beginning of this technique, I mentioned that I was concerned over how well this image would print as the image size was increased a sizeable amount. After using several different printer settings, I did end up with some reasonably good prints.

The important lesson to learn from this technique is how you can use your digital image editor to create things that can become quite good works of art. For this image to *really* succeed, I will need to go back out to the pond and shoot again, only this time with the intent of producing a large print.

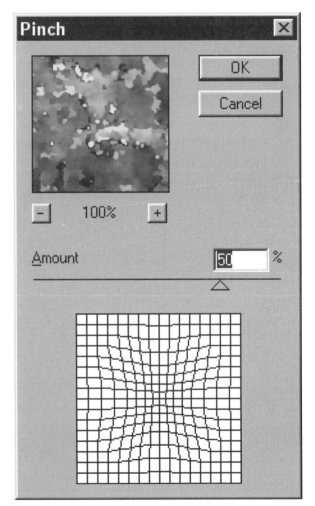

39.7

SIMULATING A GOUACHE OR TEMPERA PAINTING

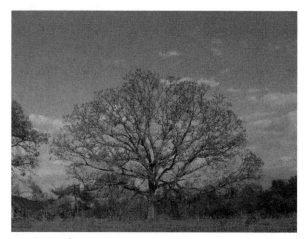

40.1 (CP 48)

40.2 (CP 47)

ABOUT THE PHOTO

"Daffodils Under the Georgia Walnut Tree," Nikon 950 digital camera, Fine Image Quality setting, 1,200 × 1,600 pixel image size 634KB .jpg

If you want a hand-painted look, this technique is for you. The concept is straightforward, but you will have to make many of your own adjustments when you apply this technique to other images. For most of the other techniques in this book, you can just apply a set sequence of filters without understanding what they do, but here, you'll need to have a good understanding of what each of the filters does to use them on other images. Fine-tuning the various filters is an important part of the technique.

The photo of the magnificent walnut tree was taken within an hour of sunset in Georgia, which helped to create very low-light and rich colors. What is not particularly clear in the photo is that there were many bright yellow daffodils underneath the walnut tree and around the collapsed barn. The final step in this technique will be to paint lots of daffodils to add a splash of color into the painting.

STEP 1: OPEN FILE

■ Select **File** ➢ **Open** (**Ctrl+O**) to display the **Open** dialog box. Double-click the **/40** folder to open it and then click the **tree-before.jpg** file to select it. Click **Open** to open the file.

STEP 2: INCREASE BRIGHTNESS AND CONTRAST

Increasing brightness and contrast is usually best done with the **Levels** tool. In this case, however, it is okay to lose some color information. We really do want to reduce the number of colors and the brightness so that some of the other filters can make more artistic brush effects.

■ Select **Enhance** ➢ **Brightness/Contrast** ➢ **Brightness/Contrast** to get the **Brightness/Contrast** dialog box shown in **Figure 40.3**. Set **Brightness** to **15** and **Contrast** to **20**, then click **OK** to apply the settings.

STEP 3: DUPLICATE LAYER

■ Create a duplicate layer by selecting **Layer** ➢ **Duplicate Layer** to get the **Layer** dialog box. Click **OK** and a second layer will be added to the image.

STEP 4: FURTHER REDUCE THE NUMBER OF COLORS AND BLUR THE EDGES

In this step, we want to turn off the top layer and work on the background layer. We'll further reduce the number of colors and blur the resulting image.

■ If the **Layers** palette is not showing, select **Window** ➢ **Show Layers**. Click the eye icon to the left of the thumbnail for the top layer, which is named **Background copy**. This will turn off the top layer so that it cannot be seen, allowing the bottom or background layer to become the visible layer.

■ Click the background layer to make it the active layer.
■ Select **Filter** ➢ **Artistic** ➢ **Cutout** to get the **Cutout** dialog box shown in **Figure 40.4**. Set **Number of Levels** to **8**, **Edge Simplicity** to **3**, and **Edge Fidelity** to **3**. Click **OK** to apply these settings.

Why use these settings for the **Cutout** filter? We want the maximum number of colors, fairly high edge detail, and very high edge fidelity. The **Cutout** filter will give us part of the brush strokes. Therefore, the settings need to be somewhat loose, but tight enough to show detail in the tree branches and ground area.

STEP 5: BLEND TOP PHOTO LAYER WITH THE BACKGROUND LAYER

Now, we get to the "magical part" of this technique. In this step, the two layers will be blended together. Then, the layers will be flattened.

■ Click the "**Background copy**" layer in the layers palette to select it and to make it visible.
■ Select the **Soft Light** blend mode in the **Layers** palette and set **Opacity** to **80%** to see a dramatically changed image.
■ Flatten image by selecting **Layer** ➢ **Flatten Image**.

40.3

40.4

STEP 6: ADJUST BRUSHSTROKES

Now, look closely at the image. You may want to increase the view size to **100%** with the **Navigator**. Do you think the image looks as if it were painted with a brush? The colors are too even and the edges are too defined. To fix this, do the following.

- Once again, use the **Smart Blur** filter by selecting **Filter** ➢ **Blur** ➢ **Smart Blur** to get the **Smart Blur** dialog box.

- Drag the preview image around in the **Smart Blur** dialog box so that you can see details of the branches. Set **Radius** to **2.0**, **Threshold** to **20.0**, **Quality** to **Low**, and **Mode** to **Normal**, as shown in **Figure 40.5**. Click **OK** to apply the settings.

The application of the **Smart Blur** filter helps to soften the edges created by the **Cutout** filter, as well as to make the different colors look more like they were painted with a brush. At this point, you should see some real depth in the painting (especially in the tree branches), as shown in **Figure 40.6**.

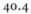

40.5

40.6

STEP 7: MAKE FINAL COLOR ADJUSTMENTS

The image looks better; however, the colors are muddy and need to be improved.

■ Select **Enhance** ➢ **Color** ➢ **Hue/Saturation** (**Ctrl+U**) to get the **Hue/Saturation** dialog box. Try setting **Hue**, **Saturation**, and **Lightness** to **+5**, **+20**, and **0** respectively. Click **OK** to apply these settings.

The image will now have a brighter and deeper blue sky, and the light colors in the grass will have more contrast with the dark grass. To get the image shown in **Figure 40.2** (**CP 47**), select a muted yellow color and use the **Paintbrush** tool to hand-paint lots of yellow daffodils into the image. You might also want to add your signature with the **Text** tool and a hand-lettered style font.

This image makes an excellent print. I hope you have a photo-quality inkjet printer and some fine-art paper to print it. It certainly no longer looks like a photograph! I'm not sure if it looks more like a tempera or gouache painting, but it does look hand-painted, and that was our intent. I hope you have time and a few images of your own to try this technique as it will produce good results on a wide variety of images.

CREATING MULTIMEDIA ARTWORK

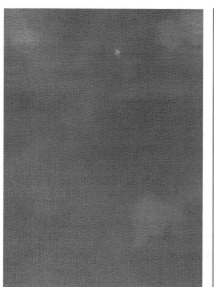

41.1 A (CP 50)

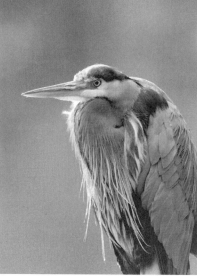

41.1 B (CP 50)

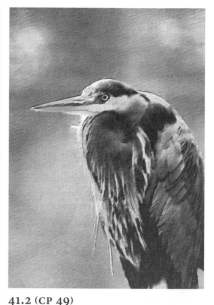

41.2 (CP 49)

ABOUT THE PHOTO

"Male Blue Heron," Canon EOS1v, 300mm f/2.8mm with 2X teleconverter, Kodak 100 ISA Supra film scanned with Polaroid 4000 SprintScan film scanner, 1,401 × 1,911 7.7MB.tif file; hand-painted watercolor paper scanned with an HP ScanJet 4c, 1,401 × 1,911 7.7MB .tif file

The magnificent male blue heron was in all ways a perfect subject. He stood motionless on one leg for over an hour until the sun came from behind the clouds and I was able to get this shot. After having used this same image in Technique 36 to create a variety of different line drawings, I thought it might be fun to see if it could be turned into a rough and colorful multimedia sketch.

To turn the photo of the blue heron into a multimedia artwork, we'll use a scanned image of a piece of watercolor paper that has had several layers of watercolor applied to it. Techniques 43 and 48 further demonstrate how useful these easy-to-make backgrounds watercolor paintings can be. To make this painting, I used a 1"-wide watercolor brush and painted three layers of different watercolors in a rather haphazard fashion. This textured background will be used to add color and looseness to an otherwise tight, very "in focus" photograph. The scanned watercolor painting blends beautifully with the intentionally blurred background that was created by the shallow depth-of-field made by the 300mm f12.8 lens with a 2x teleconverter.

STEP 1: OPEN FILES

■ Select **File ➤ Open** (**Ctrl+O**) to display the **Open** dialog box. Double-click the **/41** folder to open it. Press and hold **Ctrl** while clicking the **heron-before.tif** and **background.tif** files to select them. Click **Open** to open the files.

STEP 2: PASTE HERON IMAGE INTO BACKGROUND IMAGE AS A LAYER

■ Click the **heron-before.tif** window to make it the active image.
■ Select **Select ➤ All** (**Ctrl+A**) to select the entire image.
■ Select **Edit ➤ Copy** (**Ctrl+C**) to copy the image.
■ Select **File ➤ Close** (**Ctrl+W**) to close the **heron-before.tif** image.

41.3

■ Select **Edit ➤ Paste** (**Ctrl+V**) to paste the heron image into the background image as a new layer.

STEP 3: COPY THE HERON'S EYE AND PASTE IT AS A NEW LAYER

The clarity of the blue heron's eye is a feature that helps make this an excellent photograph. To make sure that subsequent filters do not diminish this feature, make a separate layer containing just the eye.

■ Click the **Zoom** tool (**Z**) in the toolbox. Using the **Zoom** tool, click the heron's eye a few times until the eye is large enough to enable you to make an accurate selection with the **Lasso** tool.

One of the most useful key shortcuts to know is to hold down **Ctrl + Space** to activate the zoom-in tool — it stays active only as long as you hold down those keys, so you don't lose your previous tool. Once the **Zoom** tool is active, you can use it to drag out a rectangle with it, as with the **Square Marquee** tool (**M**). The window will zoom in as far as it can while showing everything in the square. It's particularly handy in this case — just hold down **Ctrl + Space**, drag out a square around the eye, and release–you're zoomed in just right and you've got your **Lasso** tool back.

■ Click the **Lasso** tool (**L**) in the toolbox. Click the black area outside the yellow part of the eye and drag the selection marquee around the eye.
■ Once the eye is selected, select **Select ➤ Feather** to get the **Feather** dialog box. (**Ctrl+Alt+D**). Type in **5** as the **Feather Radius** and then click **OK** to feather the edge of the selected area.
■ To copy the selected eye as a new layer, select **Layer ➤ New ➤ Layer via Copy** (**Ctrl+J**) to paste the eye into a new layer of its own.
■ If you don't see the **Layers** palette, select **Window ➤ Show Layers** to get the **Layers** palette. The **Layers** palette should now look like **Figure 41.3**.

■ Select **View ➤ Fit on Screen** (**Ctrl+0**) to reduce the image so that it fits on the screen.

STEP 4: BLEND AND FLATTEN HERON AND BACKGROUND LAYERS

■ Click **Layer 1** (the layer containing the heron) to make it the active layer.

■ Click the **Layer** blending mode box in the upper-left corner of the **Layers** dialog box and select the **Hard Light** blend mode to blend the pixels of the two layers.

■ Select **Layer ➤ Merge Down** (**Ctrl+E**) to combine the two layers.

41.4

STEP 5: APPLY BRUSH FILTER

■ Select **Filter ➤ Brush Strokes ➤ Sumi-e** to get the **Sumi-e** dialog box shown in **Figure 41.4**. Try using the settings of **6**, **2**, and **6** for **Stroke Width**, **Stroke Pressure**, and **Contrast** respectively. You may want to click in the preview box and drag the image around to see the results of the filter. Look carefully at the feathers on the heron's back and make sure that we have not lost detail as the feathers make the image. Click **OK** to apply the brush strokes.

STEP 6: MAKE COLOR ADJUSTMENTS

■ Just to make this image more dramatic, select **Enhance ➤ Color ➤ Hue/Saturation** (**Ctrl+U**) to get the **Hue/Saturation** dialog box shown in **Figure 41.5**. Try using the settings of **−5**, **+20**, and **0** for **Hue**, **Saturation**, and **Lightness** respectively. It makes the background brighter. Click **OK** to make the color changes.

■ To make the eye a little bolder, click the eye layer (labeled **Layer 2**) in the **Layers** palette to make it the active layer. Select **Enhance ➤ Brightness/Contrast ➤ Brightness/Contrast** to get the **Brightness/Contrast** dialog box. Slide the **Brightness** and **Contrast** sliders to the right to

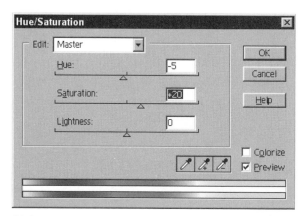

41.5

make the eye more vivid. I liked the setting of **+20** for **Brightness** and **+35** for **Contrast**. Click **OK** to apply the setting.

■ To flatten the image, select **Layer** ➢ **Flatten Image**.

■ Select **File** ➢ **Save As** to get the **Save As** dialog box. Select an appropriate directory and name your file, then click **Save** to save your file.

That concludes the last of the six natural media techniques in this chapter. In Chapter 8, you'll learn how to digitally create backgrounds, textures, edges, and frames.

CHAPTER **8**

CREATING BACKGROUNDS, TEXTURES, AND FRAMES

T his chapter is the "make-your-images-look-better" chapter. Technique 42 shows how you can use the power of Photoshop Elements to digitally create your own background from scratch. This is a useful technique for those images that look good but need a better background. In Technique 43, you'll learn how one image can be used as texture in another image. Creating realistic hand-painted picture edges is the topic of Technique 44. Technique 45 shows you how to create realistic-looking mattes to frame your images. Finally, Technique 46 provides you with a quick and easy way to frame images that you want to show online.

 None of these techniques are particularly difficult, but they have plenty of steps. So, begin this chapter with both time and patience.

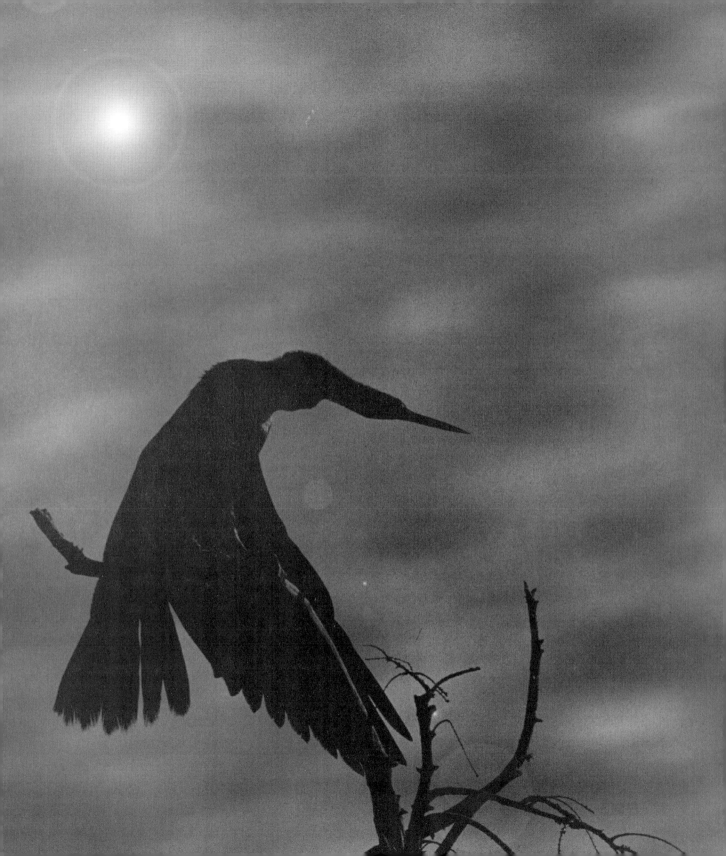

MAKING YOUR OWN DIGITAL BACKGROUND

42.1 (CP 52)

42.2 (CP 51)

ABOUT THE PHOTO

"Adult Male Anhinga Stretching," Canon EOS1v, f/2.8 300mm telephoto with 2x teleconverter, Fuji Provia slide film was scanned on a Polaroid SprintScan 4000, 1,680 x 2,520 pixel image size, 12.7MB .tif file

One of the most magnificent birds I have ever seen is the dark, black, adult male anhinga shown in the photo. I sighted this anhinga near Charleston, South Carolina, in a swamp in the Audubon Swamp Garden. Known as the "snake bird," anhingas often swim with only their snake-like head and neck above water.

Unfortunately, the anhinga was very skittish and I could only shoot him as a backlit subject, which left me with nothing but a dark silhouette. I watched him for over an hour and shot a full roll of slide film as he posed.

This technique will address the challenge of *digitally* creating a new background to make this photo and others more appealing.

STEP 1: OPEN FILE

■ Select **File** ➢ **Open** (**Ctrl+O**) to get the **Open** dialog box. After double-clicking the **/42** folder to open it, click the **bird-before.tif** file to select it. To open the file, click **Open**.

STEP 2: DUPLICATE BACKGROUND AS A LAYER

In this technique, a new digitally created image will be blended with the "bird" image. Because background layers (the "bird" image in this case) can't be blended, it will need to be duplicated and copied as a new layer. Then, the background layer will be used for creating a new background image.

42.3

42.4

■ Select **Layer** ➢ **Duplicate Layer** to get the **Duplicate Layer** dialog box shown in **Figure 42.3**. In the **As** box, type in "**bird**," which will become the name of the layer. Click **OK** to create the new layer.

■ If the **Layers** palette isn't showing, select **Window** ➢ **Show Layers** to get the **Layer** palette shown in **Figure 42.4**.

STEP 3: CREATE BACKGROUND TEXTURE

■ To work on the background image, click the eye icon, which is just to the left of the "bird" layer thumbnail in the **Layers** palette. This will turn off the layer, and the background layer will now be the visible layer.

■ To make the background layer the active layer, click the background thumbnail and the layer will become highlighted.

■ Click the **Eye Dropper** tool (**I**) in the toolbox and then click anywhere in the image to select the blue color as the foreground color.

■ Switch foreground and background colors (**X**) by clicking the double-headed arrow at the bottom of the toolbox.

42.5

■ Click inside of the **Foreground** color box in the toolbox to get the **Color Picker** dialog box shown in **Figure 42.5**. Type **0, 0**, and **255** in the **R, G**, and **B** boxes respectively. Click **OK** to select the new foreground color.

You should now have two different blue colors showing in the foreground and background color boxes at the bottom of the toolbox. The background color ought to be the sky blue selected from the "bird" image, and the background should be a pure, bright blue.

■ Select **Filter ➢ Render ➢ Clouds** to render clouds made from our two selected colors.

The **Clouds** filter uses a random number as a seed to generate a different cloud pattern each time you apply the filter. By selecting **Ctrl+F**, you can easily generate new cloud patterns until you get one that you like.

■ Select **Filter ➢ Blur ➢ Motion Blur** to get the **Motion Blur** dialog box shown. After setting **Angle** to **10** and **Distance** to **250** pixels, the **Motion Blur** dialog box should look like **Figure 42.6**. Click **OK** to blur the clouds.

STEP 4: ADD COLOR GRADIENT TO THE TEXTURED BACKGROUND

■ To add some color to the image, click the **Gradient** tool (**G**) in the toolbox. As soon as the **Gradient** tool is selected, you'll get the option bar shown in **Figure 42.7**.

■ Click the triangle (not inside the actual gradient) in the gradient selection box at the left of the option bar to get the **Gradient** selection palette shown in **Figure 42.8**. Select the **Violet, Orange** gradient. If you hold your cursor over each gradient for a couple of seconds, the Tool Tips feature will give you the name of the gradient under your cursor.

■ Next, click the **Radial Gradient** button, which is the second button from the left of five buttons

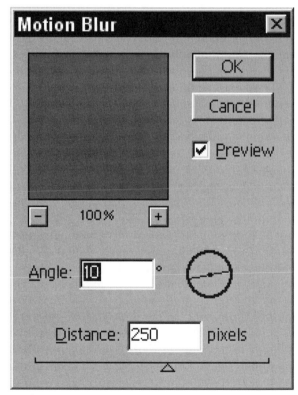

42.6

42.7

42.8

in the **Gradient** option bar. Set **Mode** to **Lighten**, set **Opacity** to **100%**, and put a check in the **Dither** box. If you have all the correct settings, the option bar should look like **Figure 42.7**.

■ To apply the gradient, click in the lower right corner, drag your cursor up to the upper left corner, and release the mouse button. Presto! You should have a beautifully colored and textured

background image. If you were to click in the upper left corner and drag to the lower right corner, the gradation would be reversed, so the starting point does matter.

■ Select **Enhance ➢ Brightness/Contrast ➢ Levels (Ctrl+L)** to get the **Levels** dialog box. Set the **Input Levels** to **30**, **1.00**, and **225**, and click **OK**.

■ Click the eye icon box to the left of the "bird" layer in the **Layers** palette to make the bird layer visible again. Click the "bird" layer to make it the active layer.

■ Select **Multiply** as the blend mode as is shown in **Figure 42.9**.

STEP 5: FLATTEN IMAGE AND MAKE FINAL COLOR ADJUSTMENTS

■ Select **Layer ➢ Flatten Image** to combine the two layers.

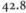

TEXTURE AND BACKGROUND CREATION TIPS

Photoshop Elements offers many tools that can be used to create textures and backgrounds.

To generate textures, try:

■ **Filter ➢ Render ➢ Clouds**
■ **Filter ➢ Render ➢ Difference Clouds**
■ **Filter ➢ Noise ➢ Add Noise**

Clouds, **Difference Clouds**, and **Noise** all work with a random number, so each time you apply them, the results will be slightly different.

To modify textures, try:

■ Any of the **Filter ➢ Blur** filters, especially **Gaussian Blur** and **Motion Blur**
■ Any of the **Filter ➢** Brush **Strokes**, including **Dark Strokes** and **Sumi-e**
■ Most of the **Filter ➢ Artistic** filters
■ **Filter ➢ Stylize ➢ Wind**

To soften textures, try:

■ Any of the **Filter ➢ Blur** filters, especially **Gaussian Blur** and

Motion Blur
■ **Filter ➢ Noise ➢ Median**
■ **Filter ➢ Other ➢ Minimum**

To get the look you want, keep applying filters. Often, you'll want to try applying a single filter more than once. The more you experiment, the more you will be able to create spectacular effects such as rusted metal, stains, or other realistic effects.

42.9

■ Select **Levels** to get the **Levels** dialog box. Set **Input Levels** to **0, 1.00**, and **200,** and then click **OK.**

■ As one final step, I selected **Filter ➢ Render ➢ Lens Flare** to add a camera lens flare indicating the backlit nature of the photo.

■ Select **File ➢ Save As** to get the **Save As** dialog box. Select an appropriate directory and name your file, then click **Save** to save your file.

At this point, you should have an image similar to the one shown in **Figure 42.2** (CP 52). I say similar, as the randomness of the **Clouds** filter will make each image look different.

USING AN IMAGE TO MAKE TEXTURE

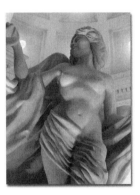

43.1 (CP 54)

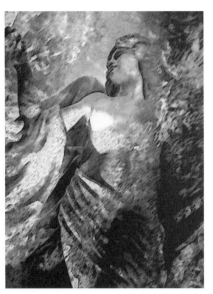

43.2 (CP 53)

ABOUT THE PHOTO

"Caesar's Palace Statue," Nikon 950 digital camera, Fine Image Quality Setting, 1,600 x 1,200 pixel image size, 800KB .jpg files

I f you have ever been to Caesar's Palace in Las Vegas, you may have seen this or some of the other statues. The digital photo of the statue was taken late at night without a tripod. Although I was surprised at how well it turned out, I wanted to turn the photo into something more artsy.

After trying a few of my favorite techniques on this image, I decided that I would have to add some texture to the image to end up with what I wanted. Digging through a couple of folders of possible background and texture images, I came upon water in a stream. It looked as if it could provide the perfect texture that I wanted. This may seem to you like a crazy idea, but try this technique and see what you think. My bet is you'll want to use this water image as texture for many other images when you are done with this one. It is a masterpiece background image for all kinds of images.

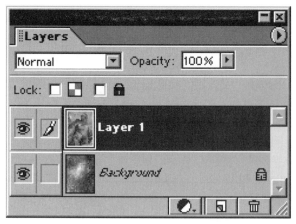

43.3

STEP 1: OPEN FILE

■ Select **File ➢ Open** (**Ctrl+O**) to display the **Open** dialog box. After double-clicking the **/43** folder to open it, press **Ctrl** and click the **statue.jpg** and **water.jpg** files to select them. Click **Open** to open them.

STEP 2: ENHANCE THE COLORS OF THE WATER IMAGE

■ Click the "water" image to make sure it is the active image. If you don't see it, click in the title bar of the statue image and drag it to one side so that you can see the "water" image. Select **Enhance ➢ Auto Levels** (**Shift+Ctrl+L**) to add lots of color to the image.

STEP 3: COPY THE STATUE IMAGE INTO THE WATER IMAGE

■ Click the "statue" image to make it the active image. Select **Select ➢ All** (**Ctrl+A**), then select **Edit ➢ Copy** (**Ctrl+C**), to copy the image.
■ Click the "water" image to make it the active image. Select **Edit ➢ Paste** (**Ctrl+V**) to paste the "statue" image into the "water" image as a layer.

■ If the **Layers** palette is not showing, select **Window ➢ Show Layers** to get the **Layers** palette shown in **Figure 43.3**. You should now see two layers in the **Layers** palette.
■ Click the "statue" image and then close it by clicking the close icon on the upper-right corner of the document window, as the image will no longer be needed.

STEP 4: APPLY A BLEND MODE AND FLATTEN THE IMAGE

■ Using the **Layers** palette, select the **Multiply** blend mode and leave **Opacity** at **100%**.
■ Flatten the image by selecting **Layer ➢ Flatten Image**.

STEP 5: ADJUST COLORS

■ Select **Enhance ➢ Brightness/Contrast ➢ Levels** (**Ctrl+L**) to get the **Levels** dialog box shown in **Figure 43.4**. Set **Input** levels to **0, 1.0,** and **160**. Then, click **OK** to apply the settings.
■ Select **Enhance ➢ Color ➢ Hue/Saturation** to get the **Hue/Saturation** dialog box shown in

43.4

Figure 43.5. Try settings of **0**, **+20**, and **0** for **Hue**, **Saturation**, and **Lightness** respectively.

Don't just take my suggestions on settings used in these steps. You can create all kinds of outstanding colors by adjusting colors with either **Hue/ Saturation** or **Color Cast,** or both. For blending modes try: **Screen**, **Overlay**, **Hard Light**, **Color Burn**, and especially **Difference**.

STEP 6: APPLY BRUSH STROKES

■ Select **Filter** ➤ **Brush Strokes** ➤ **Sumi-e** to get the **Sumi-e** dialog box shown in **Figure 43.6**. Set **Stroke Width**, **Stroke Pressure**, and **Contrast** to **10**, **2**, and **10** respectively. Click **OK** to get the image shown in **Figure 43.2 (CP 53)**.

When determining the Sumi-e settings, I used the zoom feature in the preview box in the left corner of the Sumi-e dialog box, as shown in **Figure 43.6**. I zoomed out to a **16%** view so that I could more easily see the results of the real-time adjustments I made with the sliders. My objective was to add enough dark strokes to add extreme contrast to the deeply saturated colors, but without losing detail in the face.

■ Select **File** ➤ **Save As** to get the **Save As** dialog box. Select an appropriate directory and name your file, then click **Save** to save your file.

The statue and water images are terrifically fun images use. Try using them together and then use them with other images you might have, or that can be found on the companion CD-ROM. One of the keys to digital imaging success is experimentation. The more you experiment, the more you'll begin to understand how various software features work. It is only then that you can begin to create as you'd like, rather than letting the software control you!

43·5

43·6

By the way, I got a particularly good print made from this image on an Epson 1270 printer using Somerset Photo Enhanced paper. The colors are deeply saturated and the black is black as can be just like I wanted them.

For fun, I have included a few other background images for your use. They are in the **/43/ extra-bkgrnds** folder. I hope you enjoy them.

CREATING PICTURE EDGES

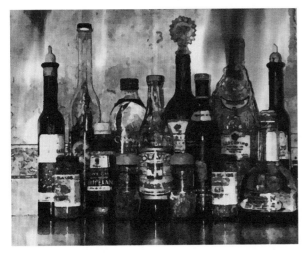

44.1

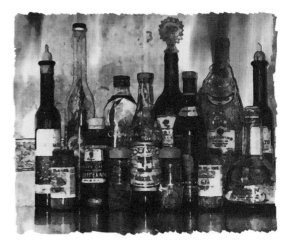

44.2

I admit it. I love fresh pasta and quality olive oils — especially light, lemon-flavored oils. Consequently, it ought to come as no surprise that I've spent considerable time taking pictures and digitally editing lots of images of olive oil bottles. You'll find that the more passionate you are about the things in your images, the more you'll enjoy working on them. Your work will also be better than if you just work on any image that you might have stumbled upon.

If you have an especially dear pet, sailboat, vintage automobile, piece of jewelry, pottery collection, or anything else you are passionate about, take some pictures of those things and manipulate those images. The image shown in **Figure 44.1** is the result of the blending of an image of a rusty 1946 Chevy car door (just below the door handle) and a digital photo of a collection of olive oil bottles on my kitchen counter. I used Technique 43 to blend the images and then applied multiple color, blur, and brush filters.

I liked the image when it was done, but it lacked the painted look that I *really* wanted. The image needed brushed edges. Even though I have

several excellent edge treatment plug-ins (plug-ins are covered in Chapter 9) and Photoshop Elements offers edge treatment filters, I like to make my own edges with this technique. The significant benefit of this approach is that you can actually apply brush strokes that look as if they were painted, as the strokes move logically with the painting. Edge effect plug-ins and Photoshop Element edge filters, in contrast, apply random patterns of strokes that have no relationship to the actual image.

Although this may look like a long technique, it really is straightforward. We'll just be deleting part of the image and painting it back in with a clone brush to leave a nice brushed edge effect, as shown in **Figure 44.2**. So, try it on this image and many others!

STEP 1: OPEN FILE

■ Select **File ➢ Open** (**Ctrl+O**) to display the **Open** dialog box. After double-clicking the **/44** folder to open it, click the **oil-bottles-before.tif** file to select it. To open the file, click **Open**.

44·3

STEP 2: ADD ¼" WHITE SPACE ALL AROUND THE IMAGE AND REDUCE IMAGE SIZE

■ Before adding canvas, press **D** to choose default colors (the background color will be set to white) or you may end up with a non-white canvas. Select **Image ➢ Resize ➢ Canvas Size** to get the **Canvas Size** dialog box shown in **Figure 44.3**. Click inside the **Width** box and type **10.5**, then type **8.5** in the **Height** box. Click **OK** to add ¼" white space all around the image.

■ To resize the image so that it can be printed as an 8 x 10" paper, select **Image ➢ Resize ➢ Image Size** to get the **Image Size** dialog box. In the **Document Size** area, make sure that **Width** and **Height** are set to **10.0** and **8.0** inches respectively as is shown in **Figure 44.4**. Click **OK** to reduce image to the desired size.

STEP 3: CREATE CLONE OF IMAGE

Now create a clone image to be used as the source image for painting in the original where part of the image will be removed leaving a brush-stroke edge.

■ Select **Edit ➢ Duplicate Image** to get the **Duplicate Image** dialog box. This new file will

44·4

automatically be named **oil-bottles-before copy**. Click **OK** to duplicate the image.

STEP 4: ERASE PART OF THE ORIGINAL IMAGE

- Click the original "oil bottles" image to make it the active image.
- Select the **Rectangular Marquee** tool (**M**) by clicking it in the toolbox. Make sure that the **Rectangular Marquee** tool option bar **Style** is set to **Normal** and that **Feather** is set to **0 px**. Click the upper-left corner of the image, about ½" from each side. Drag the marquee down to the lower-right corner about ½" from each side, as shown in **Figure 44.5**. Release the mouse button to set the selection.

44.5

- Select **Select** ➤ **Inverse** (**Shift+Ctrl+I**) to invert the selection. Select **Edit** ➤ **Cut** (**Ctrl+X**) to delete the outer part of the image or press **Backspace**.
- Remove selection marquee by choosing **Select** ➤ **Deselect** (**Ctrl+D**).

STEP 5: SET UP BRUSH FOR PAINTING EDGE

- Select the **Clone Stamp** tool (**S**), which is the second tool from the bottom in the left column of the toolbox.
- Once the **Clone Stamp** tool has been selected, the option bar, as shown in **Figure 44.6**, will appear. Click the down arrow in the **Brush** selection box and you will be presented with a variety of brushes. Click the **Chalk 60 Pixel** brush shown in **Figure 44.7**.
- Make sure the **Clone Stamp** tool option bar shows **Mode** as **Normal** and that **Opacity** is set to **100%**.

STEP 6: ARRANGE WORKSPACE

Your results will be much better if you arrange your workspace so that it is easy to work.

- Maximize Photoshop Elements by clicking the maximize icon in the upper-right corner of the window.
- Rearrange and zoom out each of the two images, as shown in **Figure 44.8**.

44.6

44.7

44.8

STEP 7: PAINT BACK PART OF THE IMAGE, LEAVING BRUSHED EDGES

The objective here is to accurately set the clone source and begin painting back the deleted part of the original image.

■ To set the clone source, click the image window, which is named "**oil-bottles-before copy**," to make it the active window.

■ Press **Alt** and hold it while you click a specific part of the "copy" image. It is important that you select corresponding points or you'll be painting the wrong part of the image into the original. I used the point shown at the center of the brush icon pointer shown in **Figure 44.9**.

■ Next, click the original "oil bottle" image (the image will be titled "**oil-bottles-before.tif**") to make it the active image.

■ Now, click the corresponding point that you selected in the other image to set the matching clone point.

■ You can now begin to paint the edges back as you'd like by painting along the edge, as shown in **Figure 44.10**. Click often while painting. This way, if you paint into a straight part of the edge or you want to redo part of what you painted, you can select **Edit ➤ Step Backward** (**Ctrl+Z**) to back up one or more strokes without having to repaint the entire edge you've just painted.

44.9

Continue painting all around the edge of the painting. When you need to, you can scroll the image window as well as change the scale. Paint as though you were painting with a brush with a single color. Thus, your brush effect will look much more realistic than if you painted oblivious to the photo (as the automated effects do). On the right side of the image, you can make long, smooth strokes down the edge of the olive oil bottle just as if you were applying real paint.

- Select **File** ➢ **Save As** to get the **Save As** dialog box. Select an appropriate directory and name your file, then click **Save** to save your file.

There are many ways to vary the effects of this technique. You can change the brush size and shape as well as the **Mode** and **Opacity Level**. Once again, experimentation will take you to the next level!

Don't forget to add the finishing touch — your signature. You can add a hand-painted signature with the type tool using an appropriate hand-lettered font and a contrasting color. As you complete other techniques in this book, practice this technique by adding a brushed-edge effect. You'll find lots of good images to work with in Chapter 7.

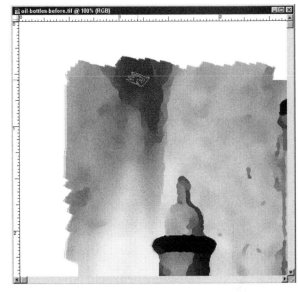

44.10

ADDING A MATTE FRAME TO AN IMAGE

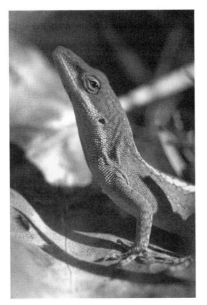

45.1 (CP 56)

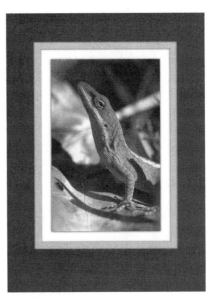

45.2 (CP 55)

ABOUT THE PHOTO

"Wuzz up?" Canon D30 digital camera, f/2.8 100mm macro lens, 1,440 x 2,160 pixel image size, 9.3MB original image was cropped and reduced to a 960 x 1,440 pixel image size, 4.0MB .tif file

The photo of the North Carolina chameleon is proof that you never know when an exceptional photo opportunity will present itself. My cat caught this little feller, carried him to my back porch, and dropped him — it's just a cat thing. If you have a cat, you know what I mean. The chameleon was pretty worn out by the time I rescued him, which made him a little slower than he ordinarily would have been.

After getting my camera, I set him on top of an orange leaf to see how quickly he would change colors. I took the photo right after I set him on the leaf. If you look carefully, you can see that his underside is already beginning to turn orange to match the leaf.

The Canon D30 camera and lens created such an extraordinary image that I thought that this image should just be framed. No editing that I could do would improve it! Therefore, this was the perfect image to use for this matting technique. (Oh yes, the moral of the story is to always shoot chameleons after a cat has worn them out). By the way, after just a few photographs, the chameleon bolted for the bushes and has never been seen since!

STEP 1: OPEN FILE

■ Select **File** ➢ **Open** (**Ctrl+O**) to display the **Open** dialog box. After double-clicking the **/45** folder to open it, click the **chameleon-before.tif** file to select it. To open the file, click **Open**.

STEP 2: INCREASE IMAGE SIZE TO ALLOW ⅜" WHITE SPACE ALL AROUND IMAGE

■ Click the small black and white squares icon (**D**) at the very bottom of the toolbox to set the background color to white so that white canvas is added.

■ To add a white border all around the image, select **Image** ➢ **Resize** ➢ **Canvas Size** to get the **Canvas Size** dialog box shown in **Figure 45.3**.

As we want to add ⅜" white space all around the image, leave the **Anchor** setting set to the middle square in the box of nine squares shown at the bottom of the dialog box. The width and height of the new canvas will need to be increased by 2 x ⅜" (or .75") to 4.75 and 6.75 respectively.

■ Type **4.75** in the **Width** box and **6.75** in the **Height** box and click **OK** to add the desired white canvas.

STEP 3: ADD DROP SHADOW TO THE PHOTO

■ Click the **Magic Wand** tool (**W**). Make sure that the **Tolerance** setting in the option bar is **10** or less and then click once inside the white border to select the border.

■ To select just the photo, select **Select** ➢ **Inverse** (**Shift+Ctrl+I**).

■ Select **Edit** ➢ **Copy** (**Ctrl+C**) to copy the image.

■ Select **Edit** ➢ **Paste** (**Ctrl+V**) to paste the image as a new layer.

You can see this new layer by looking at the **Layers** palette. If the **Layers** palette is not visible, select **Window** ➢ **Show Layers**. The **Layers** palette should now look like **Figure 45.4**.

To apply a drop shadow, you need the **Layer Styles** palette. If it isn't showing, you can select **Window** ➢ **Show Layer Styles** or you can click on the **Layer**

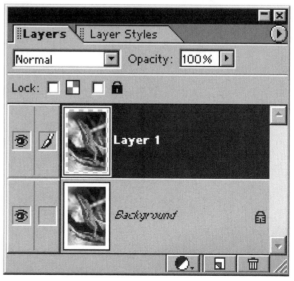

45.3 **45.4**

45.5

Styles tab in the palette well and drag it into the workspace. The **Layer Styles** palette lets you apply a variety of layer styles including drop shadows.

- Click in the selectable layer styles box at the top of the **Layer Styles** palette as is shown in **Figure 45.5** to select **Drop Shadows**.

- Click the **Low** style to apply a drop shadow.
- Flatten the image by selecting **Layer ➤ Flatten Image**.

STEP 4: ADD A NARROW YELLOW MATTE

This step and the next step are similar to Step 3. You are just adding borders and dropping shadows two more times.

- Select **Image ➤ Resize ➤ Canvas Size** to get the **Canvas Size** dialog box. Set **Width** to **5.25** and **Height** to **7.25**. Click **OK** to add to border space.
- Click the **Rectangular Marquee** tool (**M**) in the toolbox to get the option bar shown in **Figure 45.6.**
- Set **Feather** to **0** pixels, **Style** as **Fixed Size**, **Width** to **4.75**, and **Height** to **6.75**. The current size settings may be something like "**640 px.**" The "px" means pixels. Since you want inches and not pixels, type in "**4.75 in**" and "**6.75 in**" to make the settings inches.
- Click in the white border area of the image to place the new fixed size selection marquee. Using the arrow keys, move the selection marquee until there is an equal amount of space between the marquee and the outside edge horizontally and vertically.

| | Feather: 0 px | ☐ Anti-aliased | Style: Fixed Size | Width: 4.75 in | Height: 6.75 in |

45.6

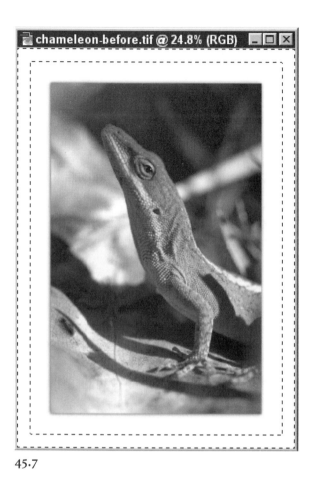

45.7

45.8

- Select **Select** ➢ **Inverse** (**Shift+Ctrl+I**) to invert the selection marquee and select the outside border, as shown in **Figure 45.7**.
- Click the **Eye Dropper** tool (**I**) and click inside the image where it is bright yellow to select a matte color. You should now see yellow in the foreground color box at the bottom of the toolbox.
- To fill the border, select **Edit** ➢ **Fill** to get the **Fill** dialog box shown in **Figure 45.8**. For **Contents**, make sure to use **Foreground Color** and that the **Blending Mode** is set to **Normal** with **Opacity** of **100%**. Click **OK** to fill the border with the selected yellow color.
- Select **Filter** ➢ **Texture** ➢ **Texturizer** to get the **Texturizer** dialog box shown in **Figure 45.9**. Set the **Texture** to **Canvas**, **Scaling** to **100%**, **Relief** to **4**, and **Light Direction** to **Top Right**. To see the results of the current selection, click inside the preview box and keep dragging until you get to the selected yellow border. Click **OK** and you'll have a matte-textured yellow border.
- Select **Edit** ➢ **Copy** and then **Edit** ➢ **Paste** to create a new layer with just the yellow border.
- To add a drop shadow to the new yellow matte, once again click **Low** in the **Drop Shadow**, **Layer Styles** palette.
- Once again, flatten the image by selecting **Layer** ➢ **Flatten Image**.

STEP 5: ADD GREEN OUTSIDE MATTE

Admittedly, this is a long technique. However, you are just repeating the same steps over three times. You'll do nearly the same thing that you did in the last step — except add a wider piece of matte to the bottom just as a professional framer would.

- Select **Image** ➢ **Resize** ➢ **Canvas Size** to get the **Canvas Size** dialog box. Set **Width** to **7.25** and **Height** to **9.25** to add one full inch of border to all sides. Click **OK** to add to border space.

outside matte. I chose an almost black/green color.

- Select the **Magic Wand** tool (**W**) in the toolbox and then click the outside of the image, where the new green matte will be, to select the space.

Although we could simply fill this last border with color, we really ought to add a layer so that we can add a drop shadow as we did with the yellow border and the photo.

- Select **Edit+Copy** (**Ctrl+C**), then **Edit** ➢ **Paste** (**Ctrl+V**) to paste the new border into the image as a layer.
- Once again, select the **Magic Wand** tool (**W**) from the toolbox and click in the outer white border to select it.
- Select **Edit** ➢ **Fill**, and click **OK** to fill the outside border with the selected color. If you don't like the color, you can select another with the **Eye Dropper** tool and fill it again and again until you have the results that you want.
- To apply the canvas texture to this new matte, select **Filter** ➢ **Texture** ➢ **Texturizer** and click **OK**.

45.9

- Select **View** ➢ **Fit on Screen** (**Ctrl+0**) so that you can see the entire image.
- Now add ½" more matte space just to the bottom of the canvas. Select **Image** ➢ **Resize** ➢ **Canvas Size** to once again (and for the last time) get the **Canvas Size** dialog box. Set **Height** to **9.75** to make just the bottom border 1½" wide. You now need to set the **Anchor** — the notation for telling Photoshop Elements where to add the new canvas. Click the middle box in the upper row, as shown in **Figure 45.10**. Click **OK** to add the border space.
- We are just about done. Click the **Eye Dropper** tool (**I**) in the toolbox, and then click in a dark green area of the image to pick the color for the

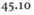

45.10

- Click **Low** in the **Drop Shadow, Layer Styles** palette to add the final drop shadow.
- Flatten the image by selecting **Layer ➤ Flatten** image and you are done.
- Select **File ➤ Save As** to get the **Save As** dialog box. Select an appropriate directory and name your file, then click **Save** to save your file.

You now have a very nicely framed 4" x 6" photo ready to be printed on a fine art paper with a photo-quality printer. I printed this image on Epson Matte Paper – Heavyweight on an Epson 1270 printer and obtained excellent results.

Although this probably seems like an exceedingly long technique, I'll bet you have had enough practice doing the canvas-add-color-apply-texture-drop-shadow-and-do-it-all-over-again-thing that you could do it on your own image! Good luck!

FRAMING IMAGES FOR ONLINE VIEWING

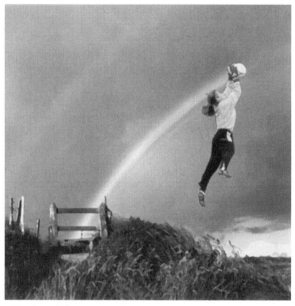

46.1 (CP 58)

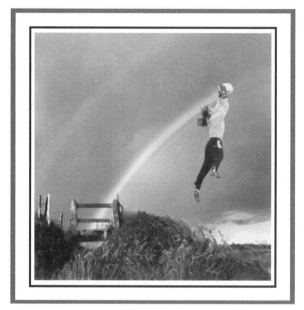

46.2 (CP 57)

ABOUT THE PHOTO

"Goalie Putting Up the Rainbow," Kowa medium format camera, $3^1/_2$" x $3^1/_2$" photograph was scanned with an HP ScanJet 4c and reduced to a 350 x 350 pixel image size, 395KB .tif file

The goalie and rainbow photo shows time and distance can be collapsed with a digital image editor such as Photoshop Elements. The rainbow image was taken many years ago in a sheep pasture in England. I always liked the image, but it never seemed quite right. Because it had been raining, all my camera gear was packed in waterproof bags. Because the rainbow lasted for only a couple of minutes, I got my camera set up just in time to catch the last of the rainbow. Ten years later, I wanted to do something unusual with my favorite soccer goalie. Therefore, I combined the two images.

Photographs and other kinds of artwork usually look better framed. In Technique 45, you learned how to make a very realistic-looking matte frame with hand-picked colors and poster board texture. Although this technique produces outstanding results for photos that are printed on paper, the technique is not useful for online presentations that must download quickly. This technique offers a simple and quick way to frame images that are to be displayed online.

46.3

STEP 1: OPEN FILE

■ Select **File** ➢ **Open** to display the **Open** dialog box. After double-clicking the **/46** folder to open it, click the **rainbow-before.tif** file to select it. To open the file, click **Open**.

STEP 2: CREATE A NEW AND LARGER FILE WITH A WHITE BACKGROUND

As you don't want to cover any of the photo with frames or lines, a new and larger image must be created with enough room for some white space, a line, and a frame. The image, which is 350 x 350 pixels, will need to be enlarged by 35 pixels on all sides to make the new image 420 x 420 pixels.

■ Select **Select** ➢ **All** (**Ctrl+A**), then **Edit** ➢ **Copy** (**Ctrl+C**). Select **File** ➢ **New** (**Ctrl+N**) to get the **New** file box dialog box shown in **Figure 46.3**.

Photoshop Elements automatically enters **350** for the **Width** and **Height** fields, which is the size of the image that we just copied. Both the **Width** and **Height** settings will need to be increased by 70 pixels to **420** to make room for the border.

■ Double-click in the **Width** box and enter **420**, then do the same for the **Height** box. Make sure the **Contents** setting is set to **White**, then click **OK** to create a new image.

STEP 3: PASTE RAINBOW IMAGE INTO A NEW IMAGE

■ Select **Edit** ➢ **Paste** (**Ctrl+V**) to paste the image into the white background image.

When you paste an image into another image, Photoshop Elements automatically places the new image in the exact center of the first one. Therefore, there is no need to worry about making sure the image is in the exact center.

STEP 4: ADD BACK LINE AROUND IMAGE

■ Select the **Rectangular Marquee** tool (**M**) by clicking it in the toolbox. Make sure that the **Rectangular Marquee** option bar shows **Feather** as **0** and **Style** as **Normal.** Click just above and to the left of the upper-left corner of the photo (in the white border) and drag the selection marquee down to the right. Click again to select an area like the one shown in **Figure 46.4**.

When making the selection, select an area that has equal space all around the image. Once a selection has been made, it can be adjusted by using the arrow keys to fine-tune its location. Next, we'll add a black line inside this selection. Some of the better picture framers often hand-draw a colored ink line around a photo such as the one we are about to create.

46.4

46.6

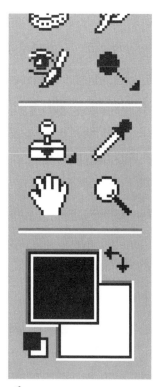

46.5

- Click the black and white squares icon (**D**) (see **Figure 46.5**) at the very bottom of the toolbox to set the current colors to black and white.
- Select **Edit** ➢ **Stroke** to get the **Stroke** dialog box shown in **Figure 46.6**. Set the Width to 3 pixels and **Location** to **Inside**. **Blending** should be set to **Normal** with **Opacity** of 100%. Click **OK** to apply a three-pixel-wide black line inside the selection.

STEP 5: ADD COLORED OUTSIDE BORDER

To create the outside border, we'll again use the **Stroke** feature. This time, a color from the image will be selected and the width will be set to **7** instead of **3**. It takes a good sense of color to pick matte colors for frames. My recommendation is that you select one of the darker colors in the image with the **Eye Dropper** tool, as this usually results in a successfully framed image.

■ Click the **Eye Dropper** tool (**I**) in the toolbox and then click inside the image until you get a color that you like. I clicked the bright navy blue to the right of the flying goalie's lower foot.

■ Click **Select ➢ All** (**Ctrl+A**) to select the entire image.

■ Select **Edit ➢ Stroke** to get the **Stroke** dialog box. This time set the **Width** to **7**.

Notice that the color that you have selected with the **Eye Dropper** tool is now shown in the **Color** box. If you click it, you will get the **Color Picker** dialog box shown in **Figure 46.7**. This allows you to modify your color selection or to set a color exactly. The navy blue color I selected has **R, G, B** values of **62, 76**, and **128** respectively. Click **OK** to close the dialog box.

■ Click **OK** to apply the navy blue border, which will result in the image shown in **Figure 46.2** (**CP 57**).

■ Select **File ➢ Save As** to get the **Save As** dialog box. Select an appropriate directory and name your file, then click **Save** to save your file.

You've now reached the end of this chapter. In the next chapter, we are going to look at some techniques that will help you become more creative in your approach to digital image editing.

ABOUT ADOBE PHOTOSHOP ELEMENTS' PHOTO GALLERY FEATURE

With a few digital photos and the fifty techniques in this book, you're likely to want to present your digital photos in an online gallery. Adobe Photoshop Elements' **Web Photo Gallery** feature is an easy and quick way to create a gallery.

To view a digital photo gallery created for online viewing, double-click the file **\46\web-gallery\FrameSet.htm**. This will launch your default Internet browser and display the gallery shown in **Figure 1**.

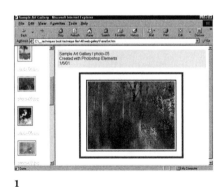

1

After viewing the gallery, you can easily create a gallery like this one, using your own images. To access the **Web Photo Gallery** feature, select **File ➢**

Automate ➢ Web Photo Gallery and you will get the dialog box shown in **Figure 2**.

You can choose from four different gallery styles which allow you to create: a simple gallery, a table-based gallery, a horizontal frame–based gallery, or a vertical frame–based gallery. Depending on your style selection, you can set other options, including page title, font style and size, thumbnail sizes, background colors, and border sizes.

If you select **Gallery Images** in the options box, you will be presented with an option to automatically resize your images as well as set the level of .jpg

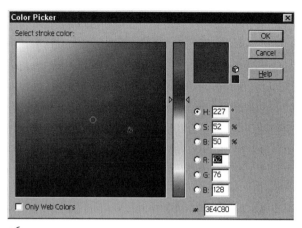

46.7

2

compression, which is extremely useful for creating Web-based images. Once you've selected the folder with your source files and a folder for the destination files, you click **OK** and the gallery is created for you; HTML (Hypertext Markup Language) pages, reduced thumbnail image files, adjusted images are all according to your specifications. Just upload the folders to a Web site and you have an online gallery; it's really that easy to share your work. If you have ever created a gallery from scratch using HTML, you'll understand why this is such a terrific and timesaving feature.

If you're familiar with HTML, you can even edit the templates the **Web Photo Gallery** uses to create its results, which is far easier and less time consuming than tweaking the output pages and then having to do it all over again each time a change is made. To edit the templates, open the Photoshop Elements application folder, then the **/Presets** folder, then **/WebContactSheet** folder. Each folder inside represents one of the styles available for the web photo gallery. Duplicate the folder that's closest in appearance to what you want, rename it, then edit the .htm files inside to customize your template. Then you open it with **Web Photo Gallery** just like the styles that came with Elements (except that you won't see a preview within the **Web Photo Gallery** dialog box).

If you'd like to try creating a Web gallery, you'll find 14 images that have been framed using Technique 46 in the folder **/46/framed-images.**

CHAPTER **9**

THINKING "OUTSIDE THE BOX" TECHNIQUES

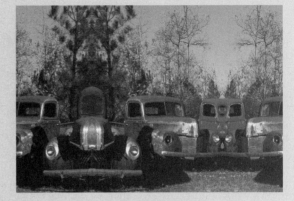

I n this final chapter, the techniques will be as the title suggests — a bit out of the ordinary. The sole purpose of this chapter, besides presenting you with four new and useful techniques, is to demonstrate how you can "think outside the box" to get even more from your digital image editor. In other words, it addresses how you can approach digital imaging in such a way that your creativity is increased and you can truly begin to create images that are new, are different, and reflect your own style.

Technique 47 shows how you can create mixed media images — how a line drawing can blend into a watercolor painting or even a photograph. Technique 48 shows you how you can create your own background images with textured paper and watercolor. Then, it shows how to turn a digital photograph of a flower into a very realistic watercolor painting with transparent washes and watercolor paper textures. Technique 49 illustrates how one part of an image can be repeatedly pasted into a base image to create an unusual, yet perfect photograph. Finally, in Technique 50, you'll learn how to use plug-in modules and how they can be used to further extend the power of your digital image editor.

CREATING MIXED MEDIA

47.1

47.2

ABOUT THE PHOTO

"Architecture in Need of Repair," Canon EOS1v, f/2.8 28-70mm zoom lens, scanned with Polaroid SprintScan 4000, 1,680 × 2,520 pixel image size, 12.7MB .tif file

I f you are ever in search of a city where you can find photographic subjects of any type to shoot, you ought to think about visiting Charleston, South Carolina. Whether you are after landscapes, seascapes, cityscapes, wildlife, birds, flowers, magnificent gardens, or architecture, Charleston has it all. On one of my many visits, I filled two 80MB digital image storage cards with digital photographs. Besides taking pictures of lots of well-maintained buildings, I found a few buildings that were in need of considerable repair, as shown in **Figure 47.1**. Even poorly maintained buildings can reveal plenty of character for those with a camera.

My intention was to make a print of this façade that portrayed the life cycle of the building, from original sketch, to a completed building, to a run-down building in need of repair. Once you start working on this image with this technique, you are likely to discover a myriad of different approaches that you will want to take. In case you would like to have a few other Charleston architectural images to use, you will find nine other digital photos in the folder **47/extras**. I hope you enjoy using them.

STEP 1: OPEN FILE

■ Select **File ≻ Open** (**Ctrl+O**) to display the **Open** dialog box. After finding and double-clicking the **/47** folder to open it, click the **details-before.tif** file to select it. To open the file, click **Open**.

STEP 2: DUPLICATE IMAGE AS A SECOND LAYER TO BE USED TO CREATE AN INK DRAWING

■ Select **Layer ≻ Duplicate Layer** to get the **Duplicate Layer** dialog box shown in **Figure 47.3**. Click **OK** to create the new layer.

STEP 3: TRANSFORM THE BACKGROUND LAYER INTO AN INK DRAWING

As shown in Techniques 36 and 38, use the **Smart Blur** filter to create a pen and ink drawing. To improve the **Smart Blur** filter's results, first increase the contrast of the image. Overall, more contrast means there will be fewer lines. Where lines do occur, they will be more clearly defined.

■ Select **Enhance ≻ Brightness/Contrast ≻ Levels** (**Ctrl+L**) to get the levels dialog box shown in **Figure 47.4**. Then, set the **Input Levels** to **48**, **1.20**, and **240**. Click **OK** to apply the settings.

■ Select **Filter ≻ Blur ≻ Smart Blur** to get the **Smart Blur** dialog box shown in **Figure 47.5**. Set **Quality** to **High**, and **Mode** to **Edge Only**. Click the preview window and drag it until it shows an area where it is important to show detailed lines. The arched window directly over the door is a good place to experiment with the **Radius** and **Threshold** settings. Try using a **Radius** of **3.0** and a **Threshold** of **25.0**. Click **OK** to apply the settings and you will get a black image with white lines.

■ To invert the image, select **Image ≻ Adjustments ≻ Invert** (**Ctrl+I**). You should now have a quality line drawing.

■ To increase line width and add character to the lines, select **Filter ≻ Artistic ≻ Poster Edges** to get the **Poster Edges** dialog box shown in **Figure 47.6**. Set **Edge Thickness**, **Edge Intensity**, and **Posterization** to **10**, **0**, and **0** respectively. Then, click **OK** and the ink drawing is complete.

47.3

47.4

STEP 4: SELECT A PORTION OF THE INK DRAWING AND CUT IT OUT TO REVEAL THE UNDERLYING IMAGE

The area to be cut out can be selected with any of the selection tools. You might consider using the **Elliptical** or **Square Marquee** tool, one of the **Lasso** tools, or one of the shape tools such as **Rounded Rectangle**, **Elliptical**, or even the **Heart**. You could even select a large brush shape for the **Eraser** tool and erase large strokes from the image.

■ **Figure 47.7** shows the selection marquee that was created by using the **Polygonal Lasso** tool (**L**).

The selection was made carefully to choose the part of the image that will become "painted."

■ To soften the edge of the selection, you may want to use **Selection** ➢ **Feather** (**Atl+Ctrl+D**) to feather the selection. Try using a **Feather Radius** of at least **50** pixels. Click **OK** to apply the **Feather** setting.

■ Select **Edit** ➢ **Cut** (**Ctrl+X**) to cut the line drawing and reveal the underlying photo. The image now looks like a photograph has been painted onto a line drawing.

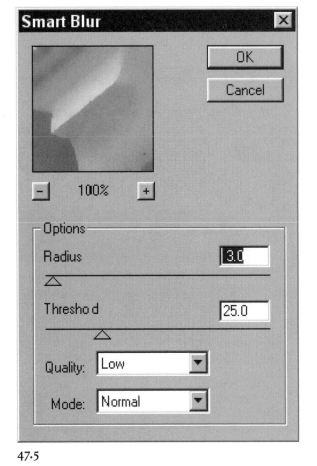

47.5

47.6

STEP 5: APPLY BRUSH STROKES AND FLATTEN THE IMAGE

- As the **Brush Strokes** filter is only to be applied to the background layer, make sure that the background layer is highlighted in the **Layers** palette. If it isn't, click on it to make it the active layer.
- Select **Filter ➢ Brush Strokes ➢ Dark Strokes** to get the **Brush Strokes** dialog box shown in **Figure 47.8**. I used the settings of **5**, **6**, and **2** for **Balance**, **Black Intensity**, and **White Intensity** repectively. The results of this filter are shown in **Figure 47.2**.

This image and this technique offer many possibilities. I suggest that you save your work as a Photoshop .psd file so that the layers remain intact, allowing you to experiment with the work you have done so far.

- Select **Layer ➢ Flatten Image** to flatten the image.
- Select **File➢Save As** to get the **Save As** dialog box. Select an appropriate directory and name your file, then click **Save** to save your file.

You may want to consider trying one of the following additional steps to further enhance your image:

- Transform the background photograph into a watercolor painting using **Technique 37**. This will result in an ink drawing that is only partially covered in a soft wash of watercolors.
- Select **Filter ➢ Texture ➢ Texturizer** to apply a background texture such as a watercolor paper or canvas texture.

47.7

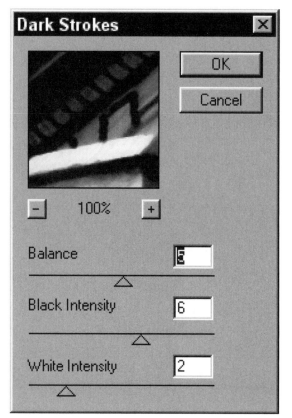

47.8

USING SCANNED BACKGROUNDS

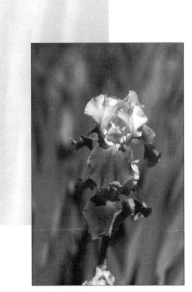

48.1 (CP60)

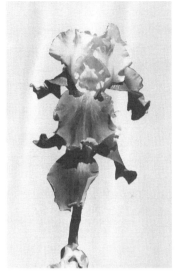

48.2 (CP59)

In Technique 37, several techniques for creating watercolor-like paintings from digital photos were presented. In this technique, we'll use the same technique. However, the "thinking outside the box" part of this technique is that we'll actually paint a background on watercolor paper with real watercolors. Don't worry, it is easy. Get an inexpensive set of watercolors, a watercolor brush, and some watercolor paper. Wet the paper with pure water and then paint in the colors. Once it is dry, you are ready to scan it. Don't worry; if you don't have the paints and paper, or if you don't want to get into the wet paint stuff, it has been done for you.

Your scanned painting or one that is provided on the companion CD-ROM will be used as the background image. The photograph of the iris shown in **Figure 48.1 (CP60)** will then be turned into a watercolor painting and placed on top of the background image.

This technique results in the image shown in **Figure 48.2 (CP59)**. The texture of the scanned watercolor paper and the background colors blend in well with the digital photo to create an image that makes an excellent

fine art print on fine art paper when printed with a photo-quality inkjet printer.

STEP 1: OPEN FILES

■ Select **File ➢ Open** to display the **Open** dialog box. After finding and double-clicking the **/48** folder, press **Ctrl** and click the **iris-before.tif** and **background.tif** files to select them. To open the files, click **Open**.

STEP 2: SELECT AND CUT OUT THE IRIS

■ Using the selection technique that was presented in Technique 20, select the iris in the "iris" image. Alternatively, you can avoid practicing your selection and cutting techniques and use the transparent image version of the iris, which may be found in the **/48** folder. It is named **selected-iris.psd**.

■ If you have selected the iris yourself, select **Edit ➢ Copy** (**Ctrl+C**) to copy the selected iris into memory. Alternatively, if you have used the already selected version found in the **selected-iris.psd** file, select **Select ➢ All** (**Ctrl+A**), then **Edit ➢ Copy** (**Ctrl+C**) to copy the selected iris into memory.

STEP 3: PASTE IRIS IMAGE ONTO WATERCOLOR PAPER BACKGROUND AND SIZE IT

■ Make **background.tif** the active image by clicking it. Select **Edit ➢ Paste** (**Ctrl+V**) to paste the iris into the watercolored background image.

■ Select the **Move** tool (**V**) from the toolbox and drag the flower to the bottom of the image by clicking the iris with the tool. Click the upper-right corner handle while pressing **Shift** (to maintain image proportions) and drag the image up to

the right corner of the image to enlarge it. Then, click **Enter** to set the size and location. Using the **Move** tool, move the iris image until you get it exactly where you want it.

STEP 4: APPLY WATERCOLOR FILTER TO IRIS IMAGE

Next, the sharply focused photo of the iris needs to be transformed into a more watercolor-like form. As the **Watercolor** filter makes most images much darker than they were to begin with, we need to first lighten the image before applying the watercolor filter.

■ To lighten the image, select **Enhance ➢ Brightness/Contrast ➢ Levels** (**Ctrl+L**) to get the **Levels** dialog box shown in **Figure 48.3**. Set the input levels to **0**, **1.75**, and **240**. To further reduce the amount of dark, almost-black shadows, slide the **Output Levels** sliders to **20** and **255**. Click **OK** to apply the settings.

■ Select **Filter ➢ Artistic ➢ Watercolor** to get the **Watercolor** dialog box shown in **Figure 48.4**. Set **Brush Detail** to **10**, **Shadow Intensity** to **1**, and **Texture** to **1**. Click **OK** to apply the filter.

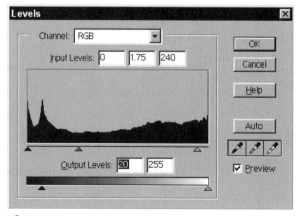

48.3

To soften the edges of the **Watercolor** filter, a blur effect needs to be applied. For this purpose, I like to use the **Smart Blur** filter, which softens the **Watercolor** effect, making it look much more like a real watercolor painting.

■ Click **Filter** ➢ **Blur** ➢ **Smart Blur** to get the **Smart Blur** dialog box shown in **Figure 48.5**. Set **Quality** to **High**, and **Mode** to **Normal**. Click the preview image and drag the image until you find a

part of the flower that shows some detail. This preview lets you see the results of your settings. The idea is to blur the image somewhat, but not so much that flower detail is lost. Try using **Radius** and **Threshold** settings of **3.0** and **20**. Click **OK** to apply the effects and you should immediately notice the improved look of the iris. It is really beginning to look like a watercolor.

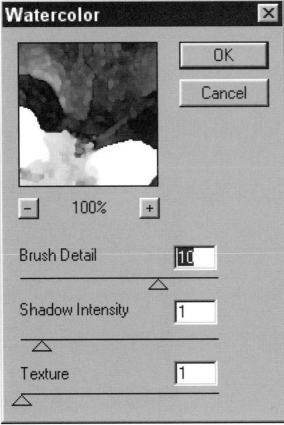

48.4

48.5

48.6

STEP 5: BLEND IRIS WITH BACK-GROUND WATERCOLOR PAPER IMAGE

At this point, we have a fairly good looking water-colored iris sitting on top of a piece of watercolor paper that has nice streaks of watercolor running down it. Watercolor is a transparent medium that is usually painted on a textured watercolor paper, as the background image shows. Therefore, we need to add some texture to the iris image and possibly let some of the soft watercolor background show through.

- If the iris layer in the **Layers** palette is not the active layer (if it is, it will be highlighted), click the layer with the thumbnail of an iris. Then, select the **Multiply** blend mode and set the **Opacity** to 75%, as shown in **Figure 48.6**.

Once the blend mode has been set, the texture of the watercolor paper will show in the iris and you can see the vertical streaks of blue and purple watercolor flow from the paper into the iris image, just as they might in a real watercolor painting. You can see the results of this final step in **Figure 48.2 (CP59)**.

STEP 6: FLATTEN IMAGE AND SAVE FILE

- Select **Layers** ➤ **Flatten Image** to flatten the image.
- Select **File** ➤ **Save As** to get the **Save As** dialog box. Select an appropriate directory and name your file, then click **Save** to save your file.

FLIPPING PORTIONS OF AN IMAGE

49.1 (CP62)

49.1 (CP61)

ABOUT THE PHOTO

"Sinister Gathering of Old Trucks," Canon EOS1v 35mm camera with f/2.8 28-70mm zoom lens, negative film scanned with Polaroid SprintScan 4000, 2,520 × 1,680 pixel image, 12.7MB .tif file

When I saw the row of vintage 1940s Ford trucks shown in **Figure 49.1** (**CP62**), I had to stop and take a few pictures. Taking a good picture was a challenge. The low evening sun was casting large black shadows down the sides of the trucks. Another row of cars made it impossible to shoot where I would have preferred to stand to take pictures. However, I could not pass on taking a few shots, because I have the powers of a digital image editor! There was no question in my mind — these trucks would make one or more awesome images fit to be printed, framed, and hung on a wall.

Figure 49.2 (**CP61**) was created by selecting the middle portion of the image, then flipping it horizontally, and pasting it back into the original image twice. My bet is you'll love this technique, as it can be used in so many fun ways on all kinds of images. Although this technique has quite a few steps, it is very easy to do. When you've done it once, you are likely to be able to repeat it from memory.

STEP 1: OPEN FILE

■ Select **File ➢ Open** to display the **Open** file dialog box. After finding and double-clicking the **/49** folder to open it, click the **trucks-before.tif** file to select it. To open the file, click **Open**.

STEP 2: ARRANGE YOUR WORKSPACE

Arrange your workspace so that it is easy to view and work on any part of the "trucks" image.

■ Click the maximize button ("square box") in the upper-right corner of the "trucks" image window to maximize it.

■ To make the "trucks" image fill the workspace, select **View ➢ Fit on Screen (Ctrl+0)**.

STEP 3: SELECT THE MIDDLE PORTION OF THE IMAGE AND PASTE IT BACK INTO THE IMAGE

■ Click the **Square Marquee** tool (**M**) in the toolbox to make the selection tool active.

■ Carefully look at the location of the selection marquee in **Figure 49.3**. Click just outside of the "truck" image, and then drag the selection marquee to select the same portion of the image that

is shown in **Figure 49.3**. Once you let go of the mouse button (again, I suggest you do so just outside of the image to select all of the pixels), the selection marquee will be displayed.

■ Select **Edit ➢ Copy (Ctrl+C)** to copy the selected portion of the image.

■ Select **Edit ➢ Paste (Ctrl+V)** to paste the middle portion of the "trucks" image back into the image as a new layer.

STEP 4: FLIP THE NEW LAYER ALONG THE HORIZONTAL AXIS AND THEN SLIDE IT TO THE LEFT SIDE OF THE BACKGROUND IMAGE

■ Select **Image ➢ Rotate ➢ Flip Horizontal** to flip the image.

■ Now comes the fun part. Click on the **Move** tool in the tool box.

■ Using your left arrow key, tap to move the middle portion of the image toward the left. To move the image faster, press and hold **Shift** while tapping the left arrow key. Keep moving the image until you like the way it looks or until it looks like **Figure 49.4**. Your image will look best if the truck on the far left looks perfectly symmetrical.

49.3

49.4

STEP 5: PASTE THE SELECTED MIDDLE PORTION OF THE IMAGE INTO THE "TRUCKS" IMAGE AGAIN AND SLIDE IT TO THE RIGHT

■ Click the "trucks" image to make sure it the active image.

■ Select **Edit ➤ Paste** (**Ctrl+V**) to again paste the copied middle portion of the image into the "trucks" image as a third layer.

■ Select **Image ➤ Rotate ➤ Flip Horizontal** to flip the image.

■ Using your right arrow key, tap it to move the middle portion of the image toward the right. To move the image faster, press and hold **Shift** while tapping the right arrow key. Keep moving the image until you like the way it looks or until it looks like **Figure 49.5**.

STEP 6: FLATTEN THE IMAGE AND MAKE A FEW FINAL IMAGE ADJUSTMENTS

■ To flatten the image, choose **Layer ➤ Flatten Image**.

■ Select **Enhance ➤ Color ➤ Hue/Saturation** (**Ctrl+U**) to get the **Hue/Saturation** dialog box shown in **Figure 49.6**. See what you think of the colors you get by setting **Hue** to **–180** and **Saturation** to **+50**. Click **OK** to apply your settings.

■ Select **Enhance ➤ Brightness/Contrast** to get the dialog box shown in **Figure 49.7**. I like the results of setting **Brightness** to **+10** and **Contrast** to **+20**. Click **OK** to apply these settings.

■ Select **File ➤ Save As** to get the **Save As** dialog box. Select an appropriate directory and name your file, then click **Save** to save your file.

That's it — the image is done. Now, just think of the possible uses for this technique. I have used this technique on just a single large tree in a field. Rather than selecting and flipping an entire portion of the image, I selected and flipped only half of the tree. This produced a perfectly symmetrical tree in an otherwise not-so-symmetrical field — suggesting a natural phenomenon not yet seen in real life.

This is also a fun technique to use on a face or a pet. One of my favorite images was created by applying this technique to a picture of my cat, which resulted in a perfect photograph of a two-headed cat — each head looking a different way.

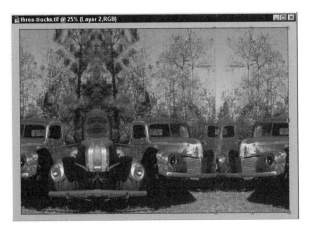

49.5

49.6

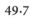

Hue/Saturation ☒

Edit: Master ▼

 Hue: -180 OK

 Saturation: 50 Cancel

 Lightness: 0 Help

 ☐ Colorize
 🖊 🖊 🖊 ☑ Preview

49.7

USING PLUG-IN MODULES

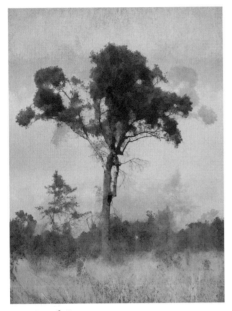

50.1 (CP64)

50.1 (CP63)

"South Carolina Tree in a Field," Nikon 950 digital camera, Fine Photo Quality setting, 1,600 × 1,200 pixel image size, 830KB .jpg file enlarged with Photoshop Elements to a 13.6MB .tif file

Although the purpose of this book is to present fifty digital photo editing techniques for Photoshop Elements (or one of the other advanced image editors), it would be a disservice to write a book on this topic without mentioning "plug-in modules." Plug-in modules (or simply plug-ins) are software, that — yes, you guessed it — *plug in* to Photoshop Elements (or Photoshop plug-in compatible applications) and provide you with additional capabilities.

There are many, many Photoshop plug-ins available. You may find some of the more popular third-party plug-ins listed at: http://www.adobe.com/store/plugins/photoshop/main.html.

Plug-in modules provide an incredible variety of functionality. For example, Genuine Fractals Print Pro (www.altamiragroup.com) offers significant improvement over the **Image Size** command, allowing you to generate large output files from a smaller source file by utilizing

complex mathematical algorithms to maintain image quality (with some limitations of course.) Andromeda Software (www.andromeda.com) offers several innovative plug-ins including VariFocus Filter, which provides true selective focus that replicates photography. Xaos Tools (www.xaostools.com) offers Total Xaos; a package of special effects filters that includes Terrazzo, which lets you create backgrounds and seamless tiles via a digital kaleidoscope; and Paint Alchemy, an amazing "brushing engine" filter. Wacom Technology Company (www.wacom.com) offers Pen Tools 3.0 for adding additional brush capabilities to their line of pressure-sensitive pen-tablets. Corel Corporation (www.corel.com) offers the popular and exceedingly fun, if not always useful, KPT filters.

If you want to add some almost unbelievable cool digital painting capabilities to Photoshop, you may want to download a trial version of Right Hemisphere's Deep Paint: http://www.us.deeppaint.com/dpaint/download.htm. If you have a pen tablet and some painting skills, the use of a trial version of Deep Paint could get you hooked on digital painting. Painting over digital photos can be a fantastic way to create outstanding works of art (without all the mess of real paints).

If you are interested in automating the process of improving your digital photographs, both the Extensis Intellihance Pro 4.0 (www.extensis.com) and Auto F/X Software's AutoEye 1.0 (www.autofx.com) plug-ins can be useful. These products not only allow you to manually fine-tune adjustments for each image, but they also allow you to use preset enhancements or to automatically enhance entire batches of images unattended.

Two other useful plug-ins are Extensis Product Group's Mask Pro and Corel Corporation's KnockOut. Both of these masking plug-ins are designed to make the process of cutting out objects, such as those shown in Technique 20, accurate, quick, and easy. While it is possible to use these tools to remove objects with out-of-focus edges and difficult to mask things like hair, the process can still be difficult and time-consuming. As many plug-ins can be downloaded in tryout versions, my recommendation is to always try the plug-in prior to buying it.

If your financial well-being allows, it may be tempting to swiftly grow your collection of plug-ins. However, it is very worthwhile to first learn how to use your digital image editor — as most of them are capable of doing so much under the direction of a skilled user.

With that bit of background on plug-ins behind us, let's look at how a plug-in can be used to create a frame or edge effect on the image shown in **Figure 50.1 (CP64)**. Both Extensis PhotoFrame and Auto FX Photo/Graphic Edges are excellent tools that allow you to interactively design frames and edge effects. For this technique, we will use the Auto FX Photo/Graphic Edges plug-in.

WARNING

Note that you will *not* be able to do Technique 50 unless you have the Auto FX Photo/Graphic Edges plug-in installed. If you do not have a copy, you may get a demo version at: www.autofx.com/demo_pages/form.htm.

The purpose of this technique is to show you how plug-ins can be used. The "before" and "after" images can be found in folder **/50**.

STEP 1: OPEN FILE

■ Select **File** ➢ **Open** to display the **Open** dialog box. After finding and double-clicking the **/50** folder to open it, click the **sctree-before.tif** file to select it. To open the file, click **Open**.

STEP 2: LAUNCH THE EDGE EFFECTS PLUG-IN MODULE AND APPLY THE EFFECT

Most plug-in modules are accessed from the bottom of the **Filter** menu, as shown in **Figure 50.3**. All of the items below the second horizontal line, from **Xaos Tools** to **Pen Tools**, are available plug-ins that I have installed on my PC. If you don't have any plug-ins installed, there will be no menu items.

■ Select **Filter** ➢ **Auto F/X** ➢ **Photo/Graphic Edges** to get the dialog box shown in **Figure 50.4**.
■ Click the **Select Edge** window to select one of the many edge effects.
■ Click any of the additional menu items to further refine the character of your edge effect.
■ Once you have the intended effect, click **Apply**.

After you click **Apply**, the edge effect will be applied to the image and then presented in an image window in Photoshop Elements. Using a plug-in can be that easy!

■ Once your edge effects are complete don't forget to save your file. Select **File** ➢ **Save As** to get the **Save As** dialog box. Select an appropriate directory and name your file, then click **Save** to save your file.

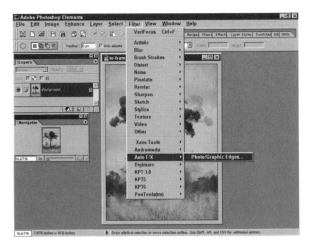

50.3

50.4

50.5

If you do not have any of the frame and edge effects plug-ins, you do have other options. There are many ways to create frames and edge effects without additional plug-ins. Several of the techniques shown in Chapter 8 will help you learn some basic steps to frame your images. Photoshop Elements also offers frame effects that can be accessed from the **Effects** palette shown in **Figure 50.5**. Using these effects is as easy as double-clicking the effect of your choice, or selecting it and clicking **Apply**.

This concludes this fiftieth and final technique. While each of these techniques showed you how you can transform one or more specific images into an entirely new image, these techniques should be viewed as building blocks to use to create your own works of art. Mix and match techniques, modify them when need be, apply one or more of them several times, grow and transform them into your own unique techniques. Create your own techniques from scratch. You should continually experiment with new images and new approaches to your digital imaging. Over time and with some work, you can become a Photoshop Elements master and you will then have control over your own digital imaging universe!

APPENDIX A
WHAT'S ON THE CD-ROM

This appendix provides you with information on the contents of the CD-ROM that accompanies this book.

CD-ROM CONTENTS

The CD-ROM contains:

- Over 100 full-sized, original digital photos for completing each of the fifty step-by-step techniques and fifty "after" images showing the final results.
- A 30-day full-featured, try-out version of Adobe Photoshop Elements.
- A 30-day full-featured, try-out version of Jasc Software Paint Shop Pro.
- A 30-day full-featured, try-out of Ulead Systems PhotoImpact.
- Internet browser-based slide show that features "before" and "after" images for each of the fifty techniques. To run the slide show, locate the folder **\show** on the companion CD-ROM. Double-click on **intro.htm** to run the slide show in your Internet browser. The show may also be viewed at: `www.reallyusefulpage.com/50techniques/show`.

APPENDIX B
IMAGE EDITOR FEATURE TRANSLATION TABLES

The techniques in this book have all been presented using Adobe Photoshop Elements because of its reasonable cost and menu commands, tools, and workspace features are similar to those of the more advanced Adobe Photoshop (Adobe Photoshop 4, 5, 5.5, and 6), which is the most widely used digital image editor in the world. It is also very similar to the lower-priced Adobe Photoshop LE, a "lite" version of Adobe Photoshop. Because of the prevalence of Photoshop software, Photoshop Elements might be considered as *the* common language for discussing image-editing techniques. With a street price of $99, it is also good value in view of its many features and capabilities.

However, similar results may be obtained with at least four other advanced image editors. These feature translation tables have been provided to help those who are using image editors other than Adobe Photoshop Elements. They will enable you to complete *many*, but not all, of the techniques. These tables will help you translate blend modes, menu commands, palettes, tools, and workspace features for the following products:

- Adobe Photoshop 5.0 LE
- Adobe Photoshop 6.0
- Adobe Photoshop Elements
- Corel PHOTO PAINT 10
- Ulead PhotoImpact 6
- Jasc Software Paint Shop Pro 7

Please be aware that there are many versions of each of these image editors and that your version may vary from the one that was used to create these tables.

Some notes about the tables:

- If you are *not* using Adobe Photoshop Elements, you will find that it is not possible to complete some of these techniques, as capabilities such as Photomerge, Animate, or other features are not available in all the image editors.
- While there may be equivalent features, the settings and/or options may not be the same, and so some experimentation will be required.
- This table is not a comprehensive list of all the blend modes, menu commands, palettes, tools, and workspace features in Adobe Photoshop Elements — it only shows those that are used in one or more of the fifty techniques included in this book.
- Some features may have the same names, but produce different results. If you are using an image editor other than Adobe Photoshop Elements, you may find you may need to modify the technique extensively but still end up with different results.

■ Some techniques in this book use specific settings to make the technique work. Although a similar feature may be found in this table for the non-Photoshop Elements editor that you are using, the lack of a specific option or setting may prevent you from completing the technique. One example is the Smart Blur filter. While there are similar "blur" filters to the Smart Blur filter, the one found in all of the Photoshop products has a useful mode setting called Edge Only that is not found in any of the other editors. This Edge Only setting is used in many of the techniques including Technique 38.

■ Duplicating the steps from one image editor to another image editor may not be the most effective way to get the same results.

■ When a technique calls for a *specific* color, texture, or gradient, you will need to find a similar one if you are using a non-Photoshop Elements product.

PHOTOSHOP LE AND 6.0 FEATURES

Tables B-1 through B-4 translate Photoshop Elements features to Photoshop LE 5.0 and Photoshop 6.0 features.

TABLE B-1

BLEND MODES

FEATURE	PHOTOSHOP ELEMENTS	PHOTOSHOP LE 5.0	PHOTOSHOP 6.0
Layer Blend Mode – Hard Light	Blend – Hard Light	Blend – Hard Light	Blend – Hard Light
Layer Blend Mode – Multiply	Blend – Multiply	Blend – Multiply	Blend – Multiply
Layer Blend Mode – Soft Light	Blend – Soft Light	Blend – Soft Light	Blend – Soft Light

TABLE B-2

MENU COMMANDS

FEATURE	PHOTOSHOP ELEMENTS	PHOTOSHOP LE 5.0	PHOTOSHOP 6.0
Copy	Edit ➢ Copy	Edit ➢ Copy	Edit ➢ Copy
Cut	Edit ➢ Cut	Edit ➢ Cut	Edit ➢ Cut
Paste	Edit ➢ Paste	Edit ➢ Paste	Edit ➢ Paste
Step Backward (Undo)	Edit ➢ Step Backward	Edit ➢ Undo	Edit ➢ Step Backward
Stroke	Edit ➢ Stroke	Edit ➢ Stroke	Edit ➢ Stroke
Adjust Backlighting	Enhance ➢ Adjust Backlighting	Image ➢ Adjust ➢ Curves	Image ➢ Adjust ➢ Curves
Auto Levels	Enhance ➢ Auto Levels	Image ➢ Adjust ➢ Auto Levels	Image ➢ Adjust ➢ Auto Levels
Levels	Enhance ➢ Brightness/ Contrast ➢ Levels	Image ➢ Adjust ➢ Levels	Image ➢ Adjust ➢ Levels
Color Cast	Enhance ➢ Color ➢ Color Cast	Image ➢ Adjust ➢ Color Balance	Image ➢ Adjust ➢ Selective Color
Hue/Saturation	Enhance ➢ Color ➢ Hue/ Saturation	Image ➢ Adjust ➢ Hue/ Saturation	Image ➢ Adjust ➢ Hue/ Saturation
Remove color	Enhance ➢ Color ➢ Remove Color	Image ➢ Adjust ➢ Hue/ Saturation (set Hue to – 180, Saturation to – 100)	Image ➢ Adjust ➢Desaturate

FEATURE	PHOTOSHOP ELEMENTS	PHOTOSHOP LE 5.0	PHOTOSHOP 6.0
Replace Color	Enhance ➤ Color ➤ Replace Color	n/a	Image ➤ Adjust ➤ Replace Color
Fill Flash	Enhance ➤ Fill Flash	Image ➤ Adjust ➤ Curves	Image ➤ Adjust ➤ Curves
Variations	Enhance ➤ Variations	Image ➤ Adjust ➤ Variations	Image ➤ Adjust ➤ Variations
Picture Package	File ➤ Automate ➤ Picture Package	n/a	File ➤ Automate ➤ Picture Package
Web Photo Gallery	File ➤ Automate ➤ Web Photo Gallery	n/a	File ➤ Automate ➤ Web Photo Gallery
File Close	File ➤ Close	File ➤ Close	File ➤ Close
Online Services	File ➤ Online Services – Shutterfly	n/a	n/a
File Open	File ➤ Open	File ➤ Open	File ➤ Open
Photomerge	File ➤ Photomerge	n/a	n/a
File Save As	File ➤ Save As	File ➤ Save As	File ➤ Save As
Cutout	Filter ➤ Artistic ➤ Cutout	Filter ➤ Artistic ➤ Cutout	Filter ➤ Artistic ➤ Cutout
Dry Brush	Filter ➤ Artistic ➤ Dry Brush	Filter ➤ Artistic ➤ Dry Brush	Filter ➤ Artistic ➤ Dry Brush
Poster Edges	Filter ➤ Artistic ➤ Poster Edges	Filter ➤ Artistic ➤ Poster Edges	Filter ➤ Artistic ➤ Poster Edges
Watercolor	Filter ➤ Artistic ➤ Watercolor	Filter ➤ Artistic ➤ Watercolor	Filter ➤ Artistic ➤ Watercolor
Gaussian Blur	Filter ➤ Blur ➤ Gaussian Blur	Filter ➤ Blur ➤ Gaussian Blur	Filter ➤ Blur ➤ Gaussian Blur
Motion Blur	Filter ➤ Blur ➤ Motion Blur	Filter ➤ Blur ➤ Motion Blur	Filter ➤ Blur ➤ Motion Blur
Smart Blur	Filter ➤ Blur ➤ Smart Blur	Filter ➤ Blur ➤ Smart Blur	Filter ➤ Blur ➤ Smart Blur
Angled Strokes	Filter ➤ Brush Strokes ➤ Angled Strokes	Filter ➤ Brush Strokes ➤ Angled Strokes	Filter ➤ Brush Strokes ➤ Angled Strokes
Dark Strokes	Filter ➤ Brush Strokes ➤ Dark Strokes	Filter ➤ Brush Strokes ➤ Dark Strokes	Filter ➤ Brush Strokes ➤ Dark Strokes
Spatter	Filter ➤ Brush Strokes ➤ Spatter	Filter ➤ Brush Strokes ➤ Spatter	Filter ➤ Brush Strokes ➤ Spatter

FEATURE	PHOTOSHOP ELEMENTS	PHOTOSHOP LE 5.0	PHOTOSHOP 6.0
Sumi-e	Filter ➢ Brush Strokes ➢ Sumi-e	Filter ➢ Brush Strokes ➢ Sumi-e	Filter ➢ Brush Strokes ➢ Sumi-e
Pinch	Filter ➢ Distort ➢ Pinch	Filter ➢ Distort ➢ Pinch	Filter ➢ Distort ➢ Pinch
Liquify	Filter ➢ Liquify	n/a	Image ➢ Liquify
Add Noise	Filter ➢ Noise ➢ Add Noise	Filter ➢ Noise ➢ Add Noise	Filter ➢ Noise ➢ Add Noise
Dust & Scratches	Filter ➢ Noise ➢ Dust & Scratches	Filter ➢ Noise ➢ Dust & Scratches	Filter ➢ Noise ➢ Dust & Scratches
Median filter	Filter ➢ Noise ➢ Median	Filter ➢ Noise ➢ Median	Filter ➢ Noise ➢ Median
High Pass	Filter ➢ Other ➢ High Pass	Filter ➢ Other ➢ High Pass	Filter ➢ Other ➢ High Pass
Clouds	Filter ➢ Render ➢ Clouds	Filter ➢ Render ➢ Clouds	Filter ➢ Render ➢ Clouds
Difference Clouds	Filter ➢ Render ➢ Difference Clouds	Filter ➢ Render ➢ Difference Clouds	Filter ➢ Render ➢ Difference Clouds
Lens Flare	Filter ➢ Render ➢ Lens Flare	Filter ➢ Render ➢ Lens Flare	Filter ➢ Render ➢ Lens Flare
Unsharp mask	Filter ➢ Sharpen ➢ Unsharp Mask	Filter ➢ Sharpen ➢ Unsharp Mask	Filter ➢ Sharpen ➢ Unsharp Mask
Find Edges	Filter ➢ Stylize ➢ Find Edges	Filter ➢ Stylize ➢ Find Edges	Filter ➢ Stylize ➢ Find Edges
Glowing Edges	Filter ➢ Stylize ➢ Glowing Edges	Filter ➢ Stylize ➢ Glowing Edges	Filter ➢ Stylize ➢ Glowing Edges
Solarize	Filter ➢ Stylize ➢ Solarize	Filter ➢ Stylize ➢ Solarize	Filter ➢ Stylize ➢ Solarize
Trace Contour	Filter ➢ Stylize ➢ Trace Contour	Filter ➢ Stylize ➢ Trace Contour	Filter ➢ Stylize ➢ Trace Contour
Wind	Filter ➢ Stylize ➢ Wind	Filter ➢ Stylize ➢ Wind	Filter ➢ Stylize ➢ Wind
Texturizer	Filter ➢ Texture ➢ Texturizer	Filter ➢ Texture ➢ Texturizer	Filter ➢ Texture ➢ Texturizer
Help Contents	Help ➢ Help Contents	Help ➢ Contents	Help ➢ Contents
Invert	Image ➢ Adjustments ➢ Invert	Image ➢ Adjust ➢ Invert	Image ➢ Adjust ➢ Invert
Poster	Image ➢ Adjustments ➢ Posterize	Image ➢ Adjust ➢ Posterize	Image ➢ Adjust ➢ Posterize
Threshold	Image ➢ Adjustments ➢ Threshold	Image ➢ Adjust ➢ Threshold	Image ➢ Adjust ➢ Threshold

FEATURE	PHOTOSHOP ELEMENTS	PHOTOSHOP LE 5.0	PHOTOSHOP 6.0
Crop	Image ➤ Crop	Image ➤ Crop	Image ➤ Crop
Histogram	Image ➤ Histogram	Image ➤ Adjust ➤ Levels	Image ➤ Histogram
Grayscale	Image ➤ Mode ➤ Grayscale	Image ➤ Mode ➤ Grayscale	Image ➤ Mode ➤ Grayscale
Image Size	Image ➤ Resize ➤ Image Size	Image ➤ Image Size	Image ➤ Image Size
Canvas Size	Image ➤ Resize ➤ Canvas Size	Image ➤ Canvas Size	Image ➤ Canvas Size
Canvas 90 Right	Image ➤ Rotate ➤ Canvas 90 Right	Image ➤ Rotate Canvas ➤ 90 CW	Image ➤ Rotate Canvas ➤ 90 CW
Canvas Custom	Image ➤ Rotate ➤ Canvas Custom	Image ➤ Rotate Canvas ➤ Arbitrary	Image ➤ Rotate Canvas ➤ Arbitrary
Flip Canvas Horizontal	Image ➤ Rotate ➤ Flip Canvas Horizontal	Image ➤ Rotate Canvas ➤ Flip Horizontal	Image ➤ Rotate Canvas ➤ Flip Horizontal
Free Transform	Image ➤ Transform ➤ Free Transform	Edit ➤ Transform ➤ Rotate	Edit ➤ Free Transform
Perspective	Image ➤ Transform ➤ Perspective	n/a	Edit ➤ Transform ➤ Perspective
Skew	Image ➤ Transform ➤ Skew	n/a	Edit ➤ Transform ➤ Skew
Distort	Image ➤ Transform ➤ Distort	n/a	Edit ➤ Transform ➤ Distort
Bring to Front	Layer ➤ Arrange ➤ Bring to Front	Layer ➤ Arrange ➤ Bring to Front	Layer ➤ Arrange ➤ Bring to Front
Duplicate layer	Layer ➤ Duplicate Layer	Layer ➤ Duplicate Layer	Layer ➤ Duplicate Layer
Flatten Image	Layer ➤ Flatten Image	Layer ➤ Flatten Image	Layer ➤ Flatten Image
Merge Down	Layer ➤ Merge Down	Layer ➤ Merge Down	Layer ➤ Merge Down
Levels	Layer ➤ New Adjustment Layer ➤ Levels	n/a	Layer ➤ New Adjustment Layer ➤ Levels
Gradient	Layer ➤ New Fill Layer ➤ Gradient	n/a	Layer ➤ New Fill Layer ➤ Gradient
Solid Color	Layer ➤ New Fill Layer ➤ Solid Color	n/a	Layer ➤ New Fill Layer ➤ Solid Color
Layer	Layer ➤ New ➤ Layer	Layer ➤ New ➤ Layer	Layer ➤ New ➤ Layer

FEATURE	PHOTOSHOP ELEMENTS	PHOTOSHOP LE 5.0	PHOTOSHOP 6.0
All	Select ➤ All	Select ➤ All	Select ➤ All
Deselect	Select ➤ Deselect	Select ➤ None	Select ➤ Deselect
Feather	Select ➤ Feather	Select ➤ Feather	Select ➤ Feather
Inverse	Select ➤ Inverse	Select ➤ Inverse	Select ➤ Inverse
Actual Pixels	View ➤ Actual Pixels	View ➤ Actual Pixels	View ➤ Actual Pixels
Fit on Screen	View ➤ Fit on Screen	View ➤ Fit on Screen	View ➤ Fit on Screen
Show Layers	Window ➤ Show Layers	Window ➤ Show Layers	Window ➤ Show Layers
Show Navigator	Window ➤ Show Navigator	Window ➤ Show Navigator	Window ➤ Show Navigator

TABLE B-3

PALETTES

FEATURE	PHOTOSHOP ELEMENTS	PHOTOSHOP LE 5.0	PHOTOSHOP 6.0
Drop Shadows	Layer Styles palette – Drop Shadows	n/a	Layer ➤ Layer Style ➤ Drop Shadow
Layers palette	Layers palette	Layers palette	Layers palette
Navigator	Navigator palette	Navigator palette	Navigator palette
Tool options bar	Tool options bar	Options palette	Tool options bar

TABLE B-4

TOOLS

FEATURE	PHOTOSHOP ELEMENTS	PHOTOSHOP LE 5.0	PHOTOSHOP 6.0
Clone Stamp tool	Clone Stamp tool	Rubber Stamp tool	Clone Stamp tool
Crop tool	Crop tool	n/a	Crop tool
Custom Shape tool	Custom Shape tool	n/a	Custom Shape tool
Elliptical Marquee tool	Elliptical Marquee tool	n/a	Elliptical Marquee tool
Eraser tool	Eraser tool	Eraser tool	Eraser tool
Eye Dropper tool	Eye Dropper tool	Eye Dropper tool	Eye Dropper tool

FEATURE	PHOTOSHOP ELEMENTS	PHOTOSHOP LE 5.0	PHOTOSHOP 6.0
Gradient tool	Gradient tool	Linear Gradient tool	Gradient tool
Hand tool	Hand tool	Hand tool	Hand tool
Lasso tool	Lasso tool	Lasso tool	Lasso tool
Magic Eraser tool	Magic Eraser tool	n/a	Magic Eraser tool
Magic Wand tool	Magic Wand tool	Magic Wand tool	Magic Wand tool
Magnetic Lasso tool	Magnetic Lasso tool	Magnetic Lasso tool	Magnetic Lasso tool
Move tool	Move tool	Move tool	Move tool
Paintbrush tool	Paintbrush tool	Paintbrush tool	Paintbrush tool
Polygonal Lasso tool	Polygonal Lasso tool	Polygonal Lasso tool	Polygonal Lasso tool
Square Marquee tool	Square Marquee tool	Square Marquee tool	Square Marquee tool
Rounded Rectangle tool	Rounded Rectangle tool	n/a	Rounded Rectangle tool
Type tool	Type tool	Type tool	Type tool
Zoom tool	Zoom tool	Zoom tool	Zoom tool
Set Background Color	Set Background Color	Set Background Color	Set Background Color
Set Colors to Black and White	Set Colors to Black and White	Set Colors to Black and White	Set Colors to Black and White
Set Foreground Color	Set Foreground Color	Set Foreground Color	Set Foreground Color
Switch Foreground and Background Colors	Switch Foreground and Background colors	Switch Foreground and Background colors	Switch Foreground and Background colors

PAINT SHOP PRO, PHOTO-PAINT AND PHOTOIMPACT FEATURES

Tables B-5 through B-8 translate Photoshop Elements features to Paint Shop Pro 7.0, PHOTO-PAINT 10, and PhotoImpact 6.0 features.

TABLE B-5

BLEND MODES

FEATURE	PHOTOSHOP ELEMENTS	PAINT SHOP PRO 7.0	PHOTO-PAINT 10	PHOTO IMPACT 6.0
Layer Blend Mode – Hard Light	Blend – Hard Light	Blend – Hard Light	Merge Mode – Hard Light	Merge – Hard Light
Layer Blend Mode – Multiply	Blend – Multiply	Blend – Multiply	Merge Mode – Multiply	Merge – Multiply
Layer Blend Mode – Soft Light	Blend – Soft Light	Blend – Soft Light	Merge Mode – Soft Light	Merge – Soft Light

TABLE B-6

MENU COMMANDS

FEATURE	PHOTOSHOP ELEMENTS	PAINT SHOP PRO 7.0	PHOTO-PAINT 10	PHOTO IMPACT 6.0
Copy	Edit ➢ Copy	Edit ➢ Copy	Edit ➢ Copy	Edit ➢ Copy
Cut	Edit ➢ Cut	Edit ➢ Cut	Edit ➢ Cut	Edit ➢ Cut
Paste	Edit ➢ Paste	Edit ➢ Paste ➢ as New Layer	Edit ➢ Paste as New Object	Edit ➢ Paste
Step Backward (Undo)	Edit ➢ Step Backward	Edit ➢ Undo...	Edit ➢ Undo...	Edit ➢ Undo Before
Stroke	Edit ➢ Stroke	Image ➢ Add Borders	Mask ➢ Shape ➢ Border	Right-click selection – Border
Adjust Backlighting	Enhance ➢ Adjust Backlighting	Colors ➢ Adjust ➢ Highlight/Midtone/ Shadow	Image ➢ Adjust ➢ Tone Curve	Format ➢ Tone Map
Auto Levels	Enhance ➢ Auto Levels	Colors ➢ Adjust ➢ Levels (not automatic)	Image ➢ Adjust ➢ Auto Equalize	Format ➢ Level
Levels	Enhance ➢ Brightness/ Contrast ➢ Levels	Colors ➢ Adjust ➢ Levels	Image ➢ Adjust ➢ Histogram Equalization	Format ➢ Level

FEATURE	PHOTOSHOP ELEMENTS	PAINT SHOP PRO 7.0	PHOTO-PAINT 10	PHOTO IMPACT 6.0
Color Cast	Enhance ➤ Color ➤ Color Cast	Effects ➤ Enhance Photo ➤ Automatic Color Balance	Image ➤ Adjust ➤ Color Balance	Format ➤ Color Balance
Hue/Saturation	Enhance ➤ Color ➤ Hue/Saturation	Colors ➤ Adjust ➤ Hue/Saturation/ Lightness	Image ➤ Adjust ➤ Hue/Saturation/ Lightness	Format ➤ Hue & Saturation
Remove color	Enhance ➤ Color ➤ Remove Color	Colors ➤ Grey Scale	Image ➤ Adjust ➤ Hue/Saturation/ Lightness — set Hue to −180, Saturation to −100	Format ➤ Hue & Saturation — set Hue to −180, Saturation to −100
Replace Color	Enhance ➤ Color ➤ Replace Color	Color Replacer tool ➤ or Colors ➤ Adjust ➤ Hue Map	Image ➤ Adjust ➤ Replace Colors	Format ➤ Color Balance – Smart tab
Fill Flash	Enhance ➤ Fill Flash	Colors ➤ Adjust ➤ Hue/ Saturation/ Lightness	Image ➤ Adjust ➤ Tone Curve	Format ➤ Tone Map
Variations	Enhance ➤ Variations	n/a	Image ➤ Adjust ➤ Color Hue or Color Tone	EasyPalette
Picture Package	File ➤ Automate ➤ Picture Package	File ➤ Print Multiple Pictures	n/a	n/a
Web Photo Gallery	File ➤ Automate ➤ Web Photo Gallery	n/a	n/a	File ➤ Export ➤ Web Album
File Close	File ➤ Close	File ➤ Close	File ➤ Close	File ➤ Close
Online Services	File ➤ Online Services – Shutterfly	File ➤ Export ➤ StudioAvenue.com	n/a	File ➤ Export ➤ Post to iMira
File Open	File ➤ Open	File ➤ Open	File ➤ Open	File ➤ Open
Photomerge	File ➤ Photomerge	n/a	Image ➤ Stitch	Edit ➤ Stitch
File Save As	File ➤ Save As	File ➤ Save As	File ➤ Save As	File ➤ Save As
Cutout	Filter ➤ Artistic ➤ Cutout	Effects ➤ Artistic Effects ➤ Brush Strokes-Small thin oil	n/a	n/a
Dry Brush	Filter ➤ Artistic ➤ Dry Brush	Effects ➤ Artistic Effects ➤ Brush Strokes—Large drybrush	Effects ➤ Custom➤ Alchemy – Brush Strokes	Effect ➤ Creative ➤ Painting

FEATURE	PHOTOSHOP ELEMENTS	PAINT SHOP PRO 7.0	PHOTO-PAINT 10	PHOTO IMPACT 6.0
Poster Edges	Filter ➢ Artistic ➢ Poster Edges	n/a	n/a	n/a
Watercolor	Filter ➢ Artistic ➢ Watercolor	Effects ➢ Artistic Effects Brush Strokes — Watercolor	Effects ➢ Art Strokes ➢ Watercolor	Effect ➢ Natural Painting ➢ Watercolor
Gaussian Blur	Filter ➢ Blur ➢ Gaussian Blur	Effects ➢ Blur ➢ Gaussian Blur	Effects ➢ Blur ➢ Gaussian Blur	Effect ➢ Blur & Sharpen ➢ Gaussian Blur
Motion Blur	Filter ➢ Blur ➢ Motion Blur	Effects ➢ Blur ➢ Motion Blur	Effects ➢ Blur ➢ Motion Blur	n/a
Smart Blur	Filter ➢ Blur ➢ Smart Blur	n/a	Effects ➢ Blur ➢ Smart Blur	n/a
Angled Strokes	Filter ➢ Brush Strokes ➢ Angled Strokes	n/a	Effects ➢ Custom ➢ Alchemy – Brush Strokes	EasyPalette
Dark Strokes	Filter ➢ Brush Strokes ➢ Dark Strokes	n/a	Effects ➢ Custom ➢ Alchemy – Brush Strokes	EasyPalette
Spatter	Filter ➢ Brush Strokes ➢ Spatter	n/a	n/a	EasyPalette
Sumi-e	Filter ➢ Brush Strokes ➢ Sumi-e	n/a	n/a	EasyPalette
Pinch	Filter ➢ Distort ➢ Pinch	Effects ➢ Geometric Effects ➢ Pinch	Effects ➢ Distort ➢ Mesh Warp	Effects ➢ Warping
Liquify	Filter ➢ Liquify	n/a	Effects ➢ HSoft ➢ SQUIZZ 1.5	n/a
Add Noise	Filter ➢ Noise ➢ Add Noise	Effects ➢ Noise ➢ Add Noise	Effects ➢ Noise ➢ Add Noise	Effects ➢ Add Noise
Dust & Scratches	Filter ➢ Noise ➢ Dust & Scratches	Effects ➢ Enhance Photo ➢ Automatic Small Scratch Removal	Effects ➢ Noise ➢ Dust & Scratch	Retouch Remove Scratch tool – Remove Scratch
Median filter	Filter ➢ Noise ➢ Median	Effects ➢ Noise ➢ Median Filter	Effects ➢ Noise ➢ Median	n/a
High Pass	Filter ➢ Other ➢ High Pass	n/a	Effects ➢ Sharpen ➢ High Pass	n/a

FEATURE	PHOTOSHOP ELEMENTS	PAINT SHOP PRO 7.0	PHOTO-PAINT 10	PHOTO IMPACT 6.0
Clouds	Filter ➢ Render ➢ Clouds	n/a	Edit ➢ Fill ➢ Texture Fill – select texture	EasyPalette
Difference Clouds	Filter ➢ Render ➢ Difference Clouds	n/a	Edit ➢ Fill ➢ Texture Fill – select texture	EasyPalette
Lens Flare	Filter ➢ Render ➢ Lens Flare	Effects ➢ Illumination Effects ➢ Sunburst	Effects ➢ Render ➢ Lens Flare	Effect ➢ Creative Lighting ➢ Lens Flare
Unsharp mask	Filter ➢ Sharpen ➢ Unsharp Mask	Effects ➢ Sharpen ➢ Unsharp Mask	Effects ➢ Sharpen ➢ Unsharp Mask	Effects ➢ Blur & Sharpen ➢ Unsharp Mask
Find Edges	Filter ➢ Stylize ➢ Find Edges	Effects ➢ Edge ➢ Find All	Effects ➢ Contour ➢ Find Edges	Effect ➢ Blur & Sharpen ➢ Find Edges
Glowing Edges	Filter ➢ Stylize ➢ Glowing Edges	n/a	n/a	n/a
Solarize	Filter ➢ Stylize ➢ Solarize	Colors ➢ Solarize	Effects ➢ Color Transform ➢ Solarize	n/a
Trace Contour	Filter ➢ Stylize ➢ Trace Contour	Effects ➢ Edge ➢ Trace Contour	Effects ➢ Contour ➢ Trace Contour	n/a
Wind	Filter ➢ Stylize ➢ Wind	Effects ➢ Geometric Effects ➢ Wind	Effects ➢ Distort ➢ Wind	Effect ➢ Camera Lens ➢ Motion Blur
Texturizer	Filter ➢ Texture ➢ Texturizer	Effects ➢ Texture Effects ➢ Texture	Effects ➢ Texture ➢ Canvas	EasyPalette – Fill Gallery
Help Contents	Help ➢ Help Contents	Help ➢ Help Topics	Help ➢ Help Topics	Help ➢ Ulead PhotoImpact Help
Invert	Image ➢ Adjustments ➢ Invert	Colors ➢ Negative Image	Image ➢ Adjust ➢ Invert	Format ➢ Invert
Poster	Image ➢ Adjustments ➢ Posterize	Colors ➢ Posterize	Image ➢ Adjust ➢ Posterize	n/a
Threshold	Image ➢ Adjustments ➢ Threshold	Colors ➢ Adjust ➢ Threshold	Image ➢ Adjust ➢ Threshold	n/a
Crop	Image ➢ Crop	Image ➢ Crop	Use Crop tool, press Enter	Edit ➢ Crop
Histogram	Image ➢ Histogram	View ➢ Toolbars ➢ Histogram window	Image ➢ Histogram	Format ➢ Histogram
Grayscale	Image ➢ Mode ➢ Grayscale	Colors ➢ Grayscale	Image ➢ Mode ➢ Grayscale	Format ➢ Data Type ➢ Grayscale

FEATURE	PHOTOSHOP ELEMENTS	PAINT SHOP PRO 7.0	PHOTO-PAINT 10	PHOTO IMPACT 6.0
Image Size	Image ➤ Resize ➤ Image Size	Image ➤ Resize	Image ➤ Image Size	Format ➤ Dimensions
Canvas Size	Image ➤ Resize ➤ Canvas Size	Image ➤ Canvas Size	Image ➤ Canvas Size	Edit ➤ Expand Canvas
Canvas 90 Right	Image ➤ Rotate ➤ Canvas 90 Right	Image ➤ Rotate	Image ➤ Rotate ➤ 90 Clockwise	Edit ➤ Rotate & Flip ➤ Rotate Right 90
Canvas Custom	Image ➤ Rotate ➤ Canvas Custom	Image ➤ Rotate	Image ➤ Rotate ➤ Canvas Custom	Edit ➤ Expand Canvas
Flip Canvas Horizontal	Image ➤ Rotate ➤ Flip Canvas Horizontal	Image ➤ Flip	Image ➤ Flip ➤ Flip Horizontally	Edit ➤ Rotate & Flip ➤ Flip Horizontally
Free Transform	Image ➤ Transform ➤ Free Transform	Effects ➤ Geometric Effects ➤ – various	Mask Transform tool – Select options from Properties Bar	Edit ➤ Rotate & Flip ➤ Use the Transform tool
Perspective	Image ➤ Transform ➤ Perspective	Effects ➤ Geometric Effects ➤ Horizontal or Vertical	Mask Transform tool – Perspective Mode	Edit ➤ Rotate & Flip ➤ Use the Transform tool
Skew	Image ➤ Transform ➤ Skew	Effects ➤ Geometric Effects ➤ Skew	Mask Transform tool – Skew Mode	Edit ➤ Rotate & Flip ➤ Use the Transform tool
Distort	Image ➤ Transform ➤ Distort	Effects ➤ Geometric Effects ➤ Pinch	Effects ➤ Distort ➤ Mesh Warp	Effect ➤ Warping
Bring to Front	Layer ➤ Arrange ➤ Bring to Front	Layers ➤ Arrange ➤ Bring to Top	Object ➤ Arrange ➤ To Front	Object ➤ Arrange ➤ Bring to Front
Duplicate layer	Layer ➤ Duplicate Layer	Layers ➤ Duplicate	Object ➤ Duplicate	Object ➤ Duplicate
Flatten Image	Layer ➤ Flatten Image	Layers ➤ Merge ➤ Merge All (Flatten)	Object ➤ Combine ➤ Combine all Objects with Background	Object ➤ Merge All
Merge Down	Layer ➤ Merge Down	Layers ➤ Merge Visible	Object ➤ Combine ➤ Combine Objects Together	Object ➤ Merge
Levels	Layer ➤ New Adjustment Layer ➤ Levels	Layers ➤ New ➤ Adjustment Layer ➤ Levels	Object ➤ Create ➤ New Lens – Contrast Enhancement	n/a
Gradient	Layer ➤ New Fill Layer ➤ Gradient	Layers ➤ New Raster Layer – add gradient fill	Object ➤ New Object, then use Fill tool	n/a

FEATURE	PHOTOSHOP ELEMENTS	PAINT SHOP PRO 7.0	PHOTO-PAINT 10	PHOTO IMPACT 6.0
Solid Color	Layer ➤ New Fill Layer ➤ Solid Color	Layers ➤ New Adjustment Layer ➤ Color Balance	Object ➤ New Object, then use Fill tool	n/a
Layer	Layer ➤ New ➤ Layer	Layers ➤ New Raster Layer	Object ➤ New Object	Object ➤ New
All	Select ➤ All	Selections ➤ Select All	Mask ➤ Select All	Selection ➤ All
Deselect	Select ➤ Deselect	Selections ➤ Select None	Mask ➤ Remove	Selection ➤ None
Feather	Select ➤ Feather	Selections ➤ Modify ➤ Feather	Mask ➤ Shape ➤ Feather	Selection ➤ Soften
Inverse	Select ➤ Inverse	Selections ➤ Invert	Mask ➤ Invert	Selection ➤ Invert
Actual Pixels	View ➤ Actual Pixels	View ➤ Normal Viewing (1:1)	Use Zoom tool in Standard bar	View ➤ Actual View
Fit on Screen	View ➤ Fit on Screen	Window ➤ Fit to Image	Use Zoom tool in Standard bar	View ➤ Fit in Window
Show Layers	Window ➤ Show Layers	View ➤ Toolbars – Layer Palette	Window ➤ Objects	EasyPalette ➤ Layer Manager
Show Navigator	Window ➤ Show Navigator	View ➤ Toolbars – Overview Window	Navigator at bottom right-hand corner of document window	n/a

TABLE B-7

PALETTES

FEATURE	PHOTOSHOP ELEMENTS	PAINT SHOP PRO 7.0	PHOTO-PAINT 10	PHOTOIMPACT 6.0
Drop Shadows	Layer Styles palette – Drop Shadows Layer Styles palette – Drop Shadows	Layer Styles palette – Drop Shadows	Interactive DropShadow tool in Toolbox	Object ➤ Shadow
Layers palette	Layers palette	Layer Palette	Objects Docker	Layers Manager – EasyPalette
Navigator	Navigator palette	Overview window	Navigator palette	n/a
Tool options bar	Tool options bar	Tool Options window	Property bar	Attribute toolbar

TABLE B-8
TOOLS

FEATURE	PHOTOSHOP ELEMENTS	PAINT SHOP PRO 7.0	PHOTO-PAINT 10	PHOTOIMPACT 6.0
Clone Stamp tool	Clone Stamp tool	Clone Brush tool	Clone tool	Clone-Paintbrush
Crop tool	Crop tool	Crop tool	Deskew Crop tool	Crop tool
Custom Shape tool	Custom Shape tool	Selection tool — pick shape	Mask ➤ Load ➤ Load Mask from Disk	EasyPalette
Elliptical Marquee tool	Elliptical Marquee tool	Selection tool — Ellipse	Circle Mask tool – Normal	Standard Selection tool – Ellipse
Eraser tool	Eraser tool	Eraser tool	Eraser tool	Object Paint Eraser tool
Eye Dropper tool	Eye Dropper tool	Dropper tool	Eye Dropper tool	Eye Dropper tool
Gradient tool	Gradient tool	Flood Fill tool	Fill tool – Fountain Fill	Linear Gradient Fill tool
Hand tool	Hand tool	Mover tool	Hand tool	Pick tool
Lasso tool	Lasso tool	Lasso tool-Freehand	Lasso Mask tool	Lasso tool
Magic Eraser tool	Magic Eraser tool	n/a	n/a	Object Magic Eraser tool
Magic Wand tool	Magic Wand tool	Magic Wand tool	Magic Wand Mask tool	Magic Wand tool
Magnetic Lasso tool	Magnetic Lasso tool	Freehand tool – Smart Edge	Magnetic Lasso tool	Lasso tool – Snap to edges
Move tool	Move tool	Mover tool	Object Pick tool	Pick tool
Paintbrush tool	Paintbrush tool	Paint Brush tool	Paint tool	Paint -Paintbrush tool
Polygonal Lasso tool	Polygonal Lasso tool	Freehand tool – Point to Point	Mask ➤ Load ➤ Load Mask from Disk	Bezier curve tool
Square Marquee tool	Square Marquee tool	Selection tool – Rectangle	Rectangle Mask tool	Standard Selection tool – Rectangle
Rounded Rectangle tool	Rounded Rectangle tool	Selection tool – Rounded Rectangle	Rectangle Mask tool – Roundness on Properties Bar	n/a
Type tool	Type tool	Text tool	Text tool	Text tool
Zoom tool	Zoom tool	Zoom tool	Zoom tool	Zoom tool
Set Background Color	Set Background Color	Color Palette	Set Paper Color	Set Background Color

FEATURE	PHOTOSHOP ELEMENTS	PAINT SHOP PRO 7.0	PHOTO-PAINT 10	PHOTOIMPACT 6.0
Set Colors to Black and White	Set Colors to Black and White	Color Palette	Reset Colors to Default	Set Colors to Black and White
Set Foreground Color	Set Foreground Color	Color Palette	Paint Color	Set Foreground Color
Switch Foreground and Background Colors	Switch Foreground and Background colors	Color Palette	Swap Paint and Paper Colors	Switch Foreground and Background colors

APPENDIX C
OTHER RESOURCES

Do you want to learn more about digital photo editing and share your work with others? This appendix tells you where and how you can interact with others online to continue to develop your image editing skills.

VISIT THIS BOOK'S COMPANION WEB SITE

A companion Web site has been created especially for this book at: `www.reallyusefulpage.com/50techniques`. What is on the site?

- Updates to this book
- "50 Techniques" Readers' Image Gallery — View the work of other readers and share your best work too! If you have created an outstanding image that you would like to share with others, please e-mail a .jpg file version to `curator@reallyusefulpage.com`. Make sure that the images that you e-mail fit within a 640 x 640 pixel space and are under 75KB. Future editions of this book may contain images (with credit to the creator) submitted to this gallery.
- A useful list of online photography and image editing resources
- A FAQ (Frequently Asked Questions) section for getting answers to common questions
- A recommended book reading list to further your skills
- A list of online galleries to visit

JOIN AN ONLINE FORUM HOSTED BY THE AUTHOR

The author of this book has created and hosts an online forum at Yahoo! Groups for anyone that has an interest in digital photo editing. To join, visit: `http://groups.yahoo.com/group/digital-photo-editing` Subscribe to the e-mail service to participate. You can post images and share tips and techniques with other readers of this book. There will even be an occasional online chat session.

CONTACT THE AUTHOR

Gregory Georges welcomes comments from readers. He may be contacted by e-mail at `ggeorges@reallyusefulpage.com` or occasionally on ICQ using pager # 8706892. His Web site is: `www.reallyusefulpage.com`. Although he reads all e-mail, the heavy volume makes it impossible to respond to all messages.

INDEX

ABOUT THE AUTHOR

Gregory Georges has been an active photographer for more than 25 years. He has had a long lasting passion for photography as an art form and enjoys capturing fun and important events. Greg has also been a long-time user of computers both personally and professionally ever since his first computer class in 1969. Using medium-format, 35mm, and digital cameras, Gregory's personal portfolio now includes more than 18,000 photographs and over 1,500 digitally edited images.

He is the author of Digital Camera Solutions, a best-selling book on digital cameras. He is also a contributing writer for eDigitalPhoto magazine, and provides photographs to a growing list of online and print magazines. His Web site www.reallyusefulpage.com is a web page for learning how to get the most from new digital technologies and has been featured in a number of the country's largest newspapers.

COLOPHON

This book was produced electronically in Indianapolis, Indiana. Microsoft Word 97 was used for word processing; design and layout were produced using QuarkXPress 4.11 and Abobe Photoshop 5.5 on Power Macintosh computers. The typeface families used are: Chicago Laser, Minion, Myriard, Myriad Multiple Master, Prestige Elite, Symbol, Trajan, and Zapf Dingbats

Acquisitions Editor: **Michael Roney**

Project Editors: **Amanda Munz, Colleen Dowling**

Technical Editor: **Russell Williams**

Copy Editor: **Robert Cambell**

Permissions Editor: **Carmen Krikorian**

Production Coordinator: **Jennifer Bingham**

Book Designer: **Deborah Reineiro**

Cover Art: **Gregory Georges**

Production: **Sean Decker, LeAndra Johnson, Laurie Stevens**

Proofreading and Indexing: **TECHBOOKS, Inc.**

HUNGRY MINDS, INC.
END-USER LICENSE AGREEMENT

READ THIS. You should carefully read these terms and conditions before opening the software packet(s) included with this book ("Book"). This is a license agreement ("Agreement") between you and Hungry Minds, Inc. ("HMI"). By opening the accompanying software packet(s), you acknowledge that you have read and accept the following terms and conditions. If you do not agree and do not want to be bound by such terms and conditions, promptly return the Book and the unopened software packet(s) to the place you obtained them for a full refund.

1. License Grant. HMI grants to you (either an individual or entity) a nonexclusive license to use one copy of the enclosed software program(s) (collectively, the "Software") solely for your own personal or business purposes on a single computer (whether a standard computer or a workstation component of a multi-user network). The Software is in use on a computer when it is loaded into temporary memory (RAM) or installed into permanent memory (hard disk, CD-ROM, or other storage device). HMI reserves all rights not expressly granted herein.

2. Ownership. HMI is the owner of all right, title, and interest, including copyright, in and to the compilation of the Software recorded on the disk(s) or CD-ROM ("Software Media"). Copyright to the individual programs recorded on the Software Media is owned by the author or other authorized copyright owner of each program. Ownership of the Software and all proprietary rights relating thereto remain with HMI and its licensers.

3. Restrictions On Use and Transfer.

(a) You may only (i) make one copy of the Software for backup or archival purposes, or (ii) transfer the Software to a single hard disk, provided that you keep the original for backup or archival purposes. You may not (i) rent or lease the Software, (ii) copy or reproduce the Software through a LAN or other network system or through any computer subscriber system or bulletin-board system, or (iii) modify, adapt, or create derivative works based on the Software.

(b) You may not reverse engineer, decompile, or disassemble the Software. You may transfer the Software and user documentation on a permanent basis, provided that the transferee agrees to accept the terms and conditions of this Agreement and you retain no copies. If the Software is an update or has been updated, any transfer must include the most recent update and all prior versions.

4. Restrictions on Use of Individual Programs. You must follow the individual requirements and restrictions detailed for each individual program in Appendix A of this Book. These limitations are also contained in the individual license agreements recorded on the Software Media. These limitations may include a requirement that after using the program for a specified period of time, the user must pay a registration fee or discontinue use. By opening the Software packet(s), you will be agreeing to abide by the licenses and restrictions for these individual programs that are detailed in Appendix A and on the Software Media. None of the material on this Software Media or listed in this Book may ever be redistributed, in original or modified form, for commercial purposes.

5. Limited Warranty.

(a) HMI warrants that the Software and Software Media are free from defects in materials and workmanship under normal use for a period of sixty (60) days from the date of purchase of this Book. If HMI receives notification within the warranty period of defects in materials or workmanship, HMI will replace the defective Software Media.

(b) **HMI AND THE AUTHOR OF THE BOOK DISCLAIM ALL OTHER WARRANTIES, EXPRESS OR IMPLIED, INCLUDING WITHOUT LIMITATION IMPLIED WARRANTIES OF MERCHANTABILITY AND FITNESS FOR A PARTICULAR PURPOSE, WITH RESPECT TO THE SOFTWARE, THE PROGRAMS, THE SOURCE CODE CONTAINED THEREIN, AND/OR THE TECHNIQUES DESCRIBED IN THIS BOOK. HMI DOES NOT WARRANT THAT THE FUNCTIONS CONTAINED IN THE SOFTWARE WILL MEET YOUR REQUIREMENTS OR THAT THE OPERATION OF THE SOFTWARE WILL BE ERROR FREE.**

(c) This limited warranty gives you specific legal rights, and you may have other rights that vary from jurisdiction to jurisdiction.

6. Remedies.

(a) HMI's entire liability and your exclusive remedy for defects in materials and workmanship shall be limited to replacement of the Software Media, which may be returned to HMI with a copy of your receipt at the following address: Software Media Fulfillment Department, Attn.: *50 Fast Digital Photo Techniques*, Hungry Minds, Inc., 10475 Crosspoint Blvd., Indianapolis, IN 46256, or call 1-800-762-2974. Please allow four to six weeks for delivery. This Limited Warranty is void if failure of the Software Media has resulted from accident, abuse, or misapplication. Any replacement Software Media will be warranted for the remainder of the original warranty period or thirty (30) days, whichever is longer.

(b) In no event shall HMI or the author be liable for any damages whatsoever (including without limitation damages for loss of business profits, business interruption, loss of business information, or any other pecuniary loss) arising from the use of or inability to use the Book or the Software, even if HMI has been advised of the possibility of such damages.

(c) Because some jurisdictions do not allow the exclusion or limitation of liability for consequential or incidental damages, the above limitation or exclusion may not apply to you.

7. U.S. Government Restricted Rights.
Use, duplication, or disclosure of the Software for or on behalf of the United States of America, its agencies and/or instrumentalities (the "U.S. Government") is subject to restrictions as stated in paragraph (c)(1)(ii) of the Rights in Technical Data and Computer Software clause of DFARS 252.227-7013, or subparagraphs (c) (1) and (2) of the Commercial Computer Software - Restricted Rights clause at FAR 52.227-19, and in similar clauses in the NASA FAR supplement, as applicable.

8. General.
This Agreement constitutes the entire understanding of the parties and revokes and supersedes all prior agreements, oral or written, between them and may not be modified or amended except in a writing signed by both parties hereto that specifically refers to this Agreement. This Agreement shall take precedence over any other documents that may be in conflict herewith. If any one or more provisions contained in this Agreement are held by any court or tribunal to be invalid, illegal, or otherwise unenforceable, each and every other provision shall remain in full force and effect.

CD-ROM INSTALLATION INSTRUCTIONS

Each software item on the 50 Fast Digital Photo Techniques CD-ROM is located in its own folder. To install a particular piece of software, open its folder with My Computer or Internet Explorer. What you do next depends on what you find in the software's folder:

1. First, look for a `ReadMe.txt` file or a `.doc` or `.htm` document. If this is present, it should contain installation instructions and other useful information.

2. If the folder contains an executable (`.exe`) file, this is usually an installation program. Often it will be called `Setup.exe` or `Install.exe`, but in some cases the filename reflects an abbreviated version of the software's name and version number. Run the `.exe` file to start the installation process.

The `ReadMe.txt` file in the CD-ROM's root directory may contain additional installation information, so be sure to check it.

For a listing of the software on the CD-ROM, see Appendix A.